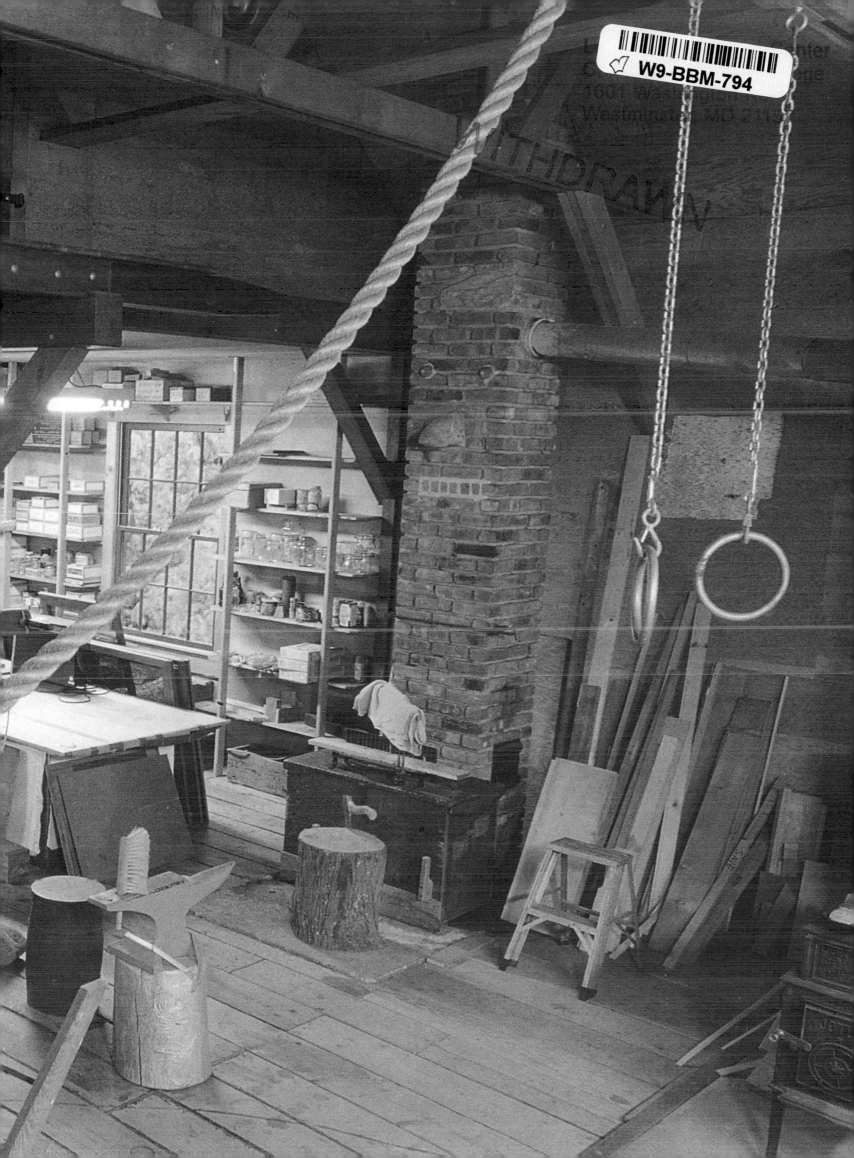

H.C. Westermann

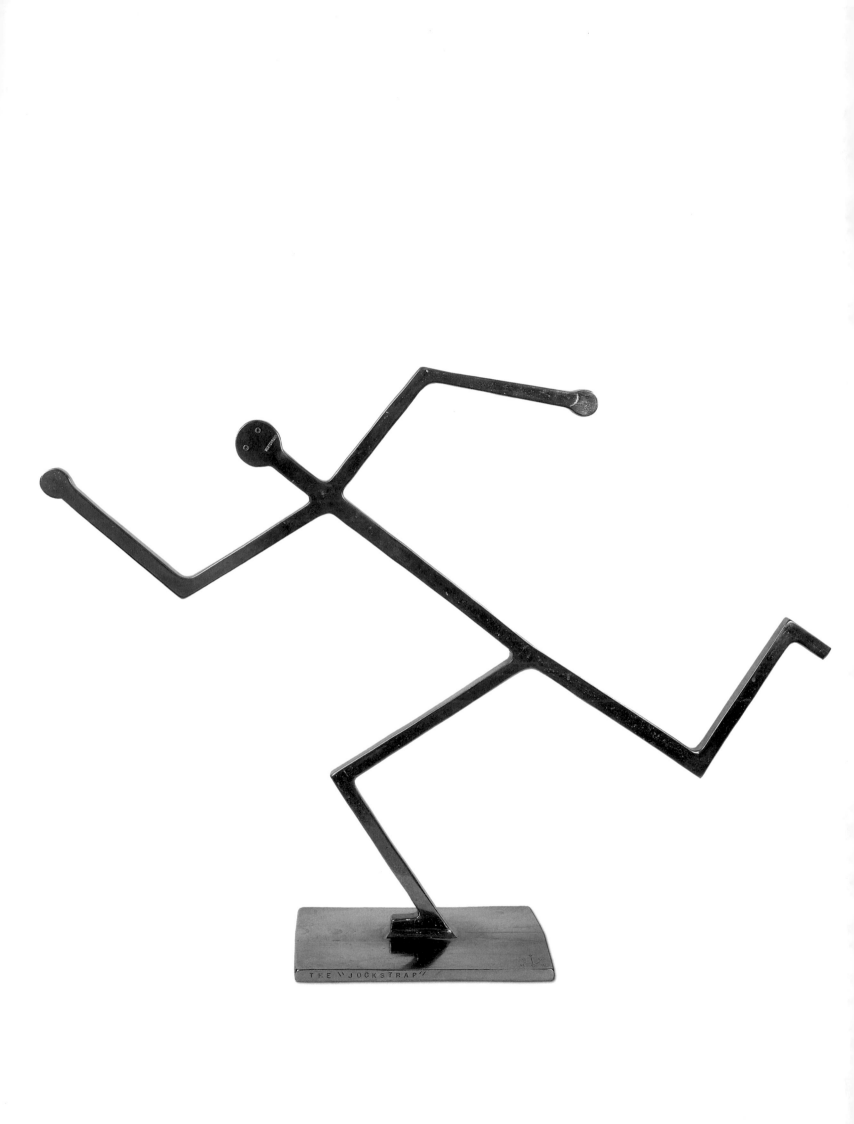

H.C. Westermann

Exhibition curators
Lynne Warren and Michael Rooks
With essays by
Dennis Adrian, Michael Rooks, Robert Storr,
and Lynne Warren

Museum of Contemporary Art, Chicago, in association with Harry N. Abrams, Inc., Publishers

This catalogue is published in conjunction with the exhibition *H. C. Westermann* held at the Museum of Contemporary Art, Chicago, from June 30 to September 23, 2001. The exhibition was also presented at:

Hirshhorn Museum and Sculpture Garden, Smithsonian Institution, Washington, D.C. February 14–May 12, 2002

Museum of Contemporary Art, Los Angeles June 9–September 8, 2002

Menil Collection, Houston October 4, 2002–January 5, 2003

Support for this exhibition and associated publications is generously provided by Mary and Roy Cullen, The LLWW Foundation, Anstiss and Ronald Krueck, Henry and Gilda Buchbinder, Ruth P. Horwich, Susan and Lewis Manilow, Dorothy and Alan Press, The Kovler Family Foundation, the National Endowment for the Arts, Marie Krane Bergman and Robert H. Bergman, Carol and Douglas Cohen, The Judith Rothschild Foundation, Mrs. Edwin A. Bergman, Robert and Sylvie Fitzpatrick, and Thurston and Sharon Twigg-Smith. The *H. C. Westermann Film Series* is made possible in part by a grant from the Illinois Humanities Council, the National Endowment for the Humanities, and the Illinois General Assembly. The Elizabeth Morse Charitable Trust is the generous sponsor of education programs for this exhibition.

Produced by the Publications Department of the Museum of Contemporary Art, Chicago, Hal Kugeler, Director of Design and Publications; Michael Sittenfeld, Associate Director of Publications; and Kari Dahlgren, Editor.

Edited by Michael Sittenfeld, Britt Salvesen, and Kari Dahlgren

Designed by Maria Grillo and Julie Klugman, The Grillo Group Inc., Chicago

For Harry N. Abrams, Inc.: Diana Murphy, Senior Editor

Printed in Germany by Cantz

Color separations by Professional Graphics, Rockford, Illinois

Library of Congress Catalog Card Number: 2001-086587

ISBN 0-933856-68-7 (MCA: softcover)
ISBN 0-8109-4564-9 (Abrams: hardcover)

The hardcover edition of this catalogue is distributed by Harry N. Abrams, Incorporated, New York.

Harry N. Abrams, Inc.
100 Fifth Avenue
New York, N.Y. 10011
www.abramsbooks.com

Cover *Memorial to the Idea of Man If He Was an Idea*, 1958. Museum of Contemporary Art, Chicago, Gift of Susan and Lewis Manilow (1993.34).

Frontispiece *Jockstrap*, 1966. Anstiss and Ronald Krueck, Chicago.

Page 6 *Pine Construction*, 1976. Mary and Roy Cullen, Houston.

Page 8 *Rosebud*, 1963. Museum of Contemporary Art, Chicago, Partial gift of Ruth P. Horwich.

Page 11 Untitled (string of galvanized hearts), 1978. Private collection.

Pages 14–15 H. C. Westermann to Martha Westermann Renner, April 7, 1954. Courtesy Martha Westermann Renner, Atherton, Calif.

Back cover *The Evil New War God (S.O.B.)* (detail), 1958. Whitney Museum of American Art, New York, Gift of Howard and Jean Lipman (97.113.10).

All works by H. C. Westermann copyright the Estate of Joanna Beall Westermann/ Licensed by VAGA, New York.

Contents

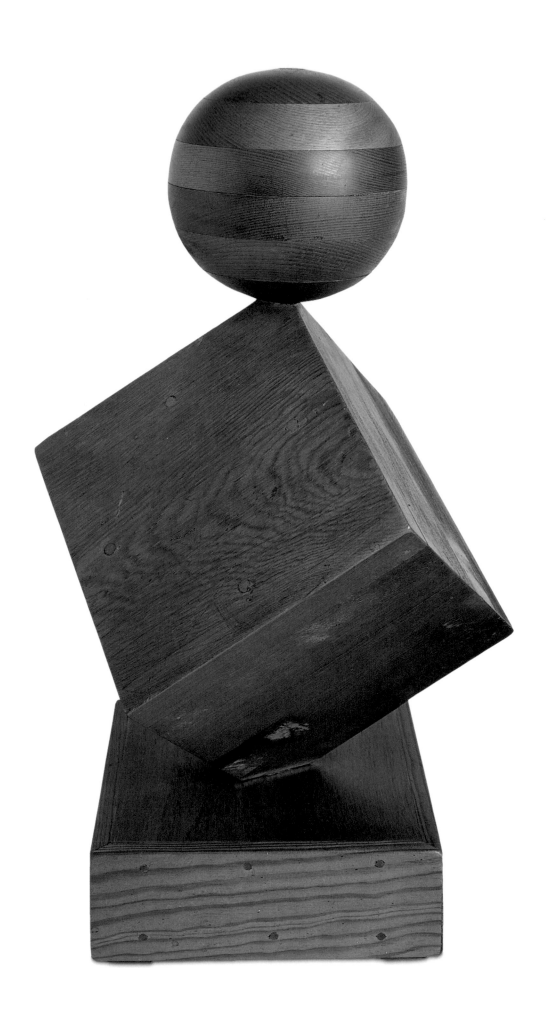

Director's Foreword

This volume is published on the occasion of the first retrospective of H. C. Westermann's work since his death in 1981, documenting the totality of the artist's sculptural oeuvre on a scale that has never before been seen. *H. C. Westermann* brings to fruition the Museum of Contemporary Art's long-standing commitment to this artist, who has emerged as a powerful, unique voice in American art. His extraordinary and deeply humanistic sculptures continue to speak clearly and plainly to national and international audiences.

In 1969, the newly established MCA hosted Westermann's first retrospective, organized by the Los Angeles County Museum of Art. Since that time the MCA has amassed the largest public collection of Westermann's objects. This exhibition—which includes Westermann works from major American art museums and international collections—signals the artist's importance in postwar art.

We are grateful for the enthusiastic participation of the institutions that are hosting the traveling exhibition, and I wish to thank James Demetrion, Director of the Hirshhorn Museum, Jeremy Strick; Director of the Los Angeles Museum of Contemporary Art; and Ned Rifkin, Director of the Menil Collection, for their commitment to help make Westermann's art available to a wide and diverse audience.

It was acknowledged from the earliest stages of planning for the exhibition and organizing the tour that this project would require the patience, cooperation, and extraordinary generosity of the many individuals and institutions whose works together constitute our exhibition. We are enormously grateful to all the lenders of the exhibition who are acknowledged elsewhere in this volume. We owe a special thanks to the lenders of multiple works, who will be deprived of their Westermanns for the duration of the exhibition's tour.

A project on this scale necessarily entails extraordinary costs. We are indebted to Roy and Mary Cullen, Laura Lee Woods and the LLWW Foundation, Anstiss and Ronald Krueck, Henry and Gilda Buchbinder, Ruth P. Horwich, Susan and Lewis Manilow, Dorothy and Alan Press, The Kovler Family Foundation, the National Endowment for the Arts, Marie Krane Bergman and Robert H. Bergman, Carol and Douglas Cohen, the Judith Rothschild Foundation, Mrs. Edwin A. Bergman and Sharon and Thurston Twigg-Smith for their substantial support of the H. C. Westermann exhibition and catalogue raisonné, which will remain an essential reference book for years to come, thanks to their foresight and conviction. We are also grateful to the Illinois Humanities Council, the National Endowment for the Humanities, and the Illinois General Assembly for their generous sponsorship of the H. C. Westermann Film Series, and to the Elizabeth Morse Charitable Trust for supporting education programs related to the exhibition.

Finally, this project is the achievement of MCA Curator Lynne Warren and MCA Assistant Curator Michael Rooks. My profound thanks are extended to both curators, who contributed their deep knowledge of and love for the subject and their particularly intense commitment.

Robert Fitzpatrick
Pritzker Director, Museum of Contemporary Art, Chicago

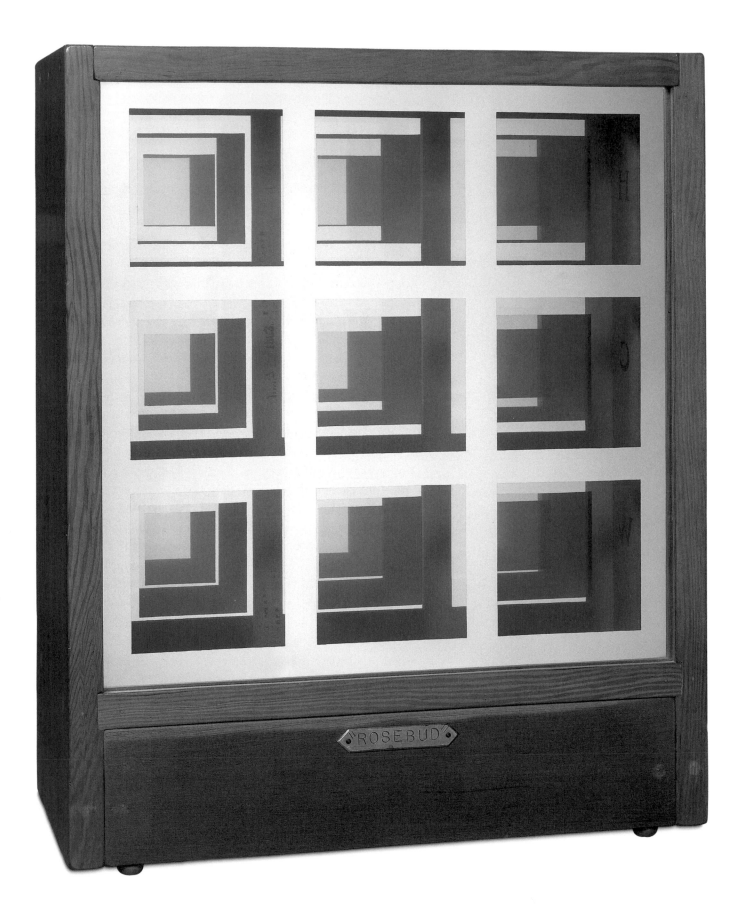
ROSEBUD

Acknowledgments

The aim of this exhibition and these publications is manifold: to give a comprehensive overview of Westermann's nearly thirty-year career; to clarify his contributions to postwar American art; to show how his life and philosophy influenced his work; and to reveal the complexity and sophistication in his art, which, because it is difficult to categorize, has often been erroneously described as quirky, folksy, and even naïve. With this project, we attempt to bring new understanding to Westermann's deliberately hermetic combination of personal references; literary, cinematic, and popular sources; sociopolitical discourse; and unconventional materials and methods.

We undertook the catalogue raisonné of sculptures upon the suggestion of Westermann's friend, the critic Dennis Adrian, who, with Rolf Achilles, began initial research with a grant from the Guggenheim Foundation in 1982. Our research for the catalogue raisonné set the groundwork for this exhibition. We owe a profound thanks to Dennis Adrian for his early championing of Westermann and for his commitment to this project. We are deeply indebted to the artist's sister Martha Westermann Renner and her husband Mike Renner for sharing a life's worth of documents, photographs, and memories. The artist's principal dealer Allan Frumkin, George Adams of the George Adams Gallery, and Jill Weinberg Adams and Tom Adams of Lennon, Weinberg, Inc. have made substantial contributions to our research. We owe a special thanks to Jill Weinberg Adams and Tom Adams, who devoted an extraordinary amount of time and resources to this project. Their enthusiasm and unqualified expertise are great sources of inspiration. None of our research would have been possible without the enthusiastic and early friendship and support of Roy and Mary Cullen.

At the MCA, we thank Pritzker Director Robert Fitzpatrick for his unwavering commitment to this project, and MCA Associate Director Greg Cameron, James W. Alsdorf Chief Curator Elizabeth Smith, and Manilow Senior Curator Francesco Bonami for their steady support. We also extend our gratitude to Design and Publications Director Hal Kugeler, former Associate Director of Publications Michael Sittenfeld, Editor Kari Dahlgren, and Assistant Editor Tony Neuhoff for their work on the catalogues. Former Rights and Reproductions Coordinator Stacey Gengo and the current holder of that position, Zoe Donnell, provided valuable assistance. In garnering financial support for the Westermann projects, we thank Director of Development Chris Jabin and his staff, including Janine Maltz Perron, Teka Selman, Warren Davis, Benjamin Kim, and Cynthia Myers. We also acknowledge Lela Hersh, Director of Collections and Exhibitions, whose consummate skill and diplomacy helped to secure a first rate tour for the exhibition, and Associate Registrar Meridith Gray, who devoted prodigious care and planning to the formidable task of bringing fragile works from many different locations. Furthermore we owe our gratitude to the MCA's facilities staff, preparators, and crew including Director of Production and Facilities Don Meckley, Preparators Brad Martin, Stephen Hokanson, and Mark Leonhart, Manager of Technical Production Dennis O'Shea, and Senior Preparator Mykl Ruffino. Finally, we recognize the dedication of those who have organized Westermann programming at the MCA: Director of Education Wendy Woon and her staff members Suzanne Lampert and Julie Marie Lemon, Director of Performance Programs Peter Taub, and Associate Director of Performance Programs Yolanda Cursach. Former members of the MCA curatorial staff, including Richard Francis, Lucinda Barnes, and Sophia Shaw, capably established the broad scope of the Westermann projects. MCA Associate Curator Staci Boris also contributed to the early research of the Westermann catalogue raisonné, and MCA curatorial staff members Julie Rodrigues and Tricia Van Eck provided much

appreciated support. We are indebted to several MCA interns: Justin Christopherson, Lauren Douville, Ari Goldstein, Erika Morris, and Apsara di Quinzio. We are especially grateful for the faithful, trustworthy, and resourceful assistance of Ari Goldstein, who saw the projects through to completion.

We are grateful to Julie Klugman and Maria Grillo of the Grillo Group, Inc. for their beautiful design of the exhibition catalogue and catalogue raisonné, and we are indebted to Britt Salvesen for her sensitive editing of the catalogue raisonné text, a Herculean task that she undertook with quiet and diligent aplomb. We also appreciate the intelligent and handsome design that John Vinci contributed to the MCA's exhibition.

For additional research assistance we are grateful to the many others who have provided useful and often revelatory information. Among Westermann's family members, we thank: his late wife Joanna Beall Westermann, his nieces Lucinda Black, Joanna Beall Constantino, Emily Pac, Heidi Renner, and Mary Lu Renner-Lehman, his late brother-in-law Lester Beall, Jr., and his son Gregory Westermann and Gregory's wife Geri. We are enormously grateful to the following friends and colleagues of Westermann: Alice Adam, Terry Allen, John Ashbery, Robert Barnes, Bill Barrette, Billy Al Bengston, Richard Born, Roger Brouard, Robert Delford Brown, Jean Bush and her late husband Gerald Bush, Sara Canright, Billy Copley, Claire Copley, Theodora Copley, James Corcoran, Christopher Cordes, James Demetrion, Dominick DiMeo, Carl Ellstam, James Garrett Faulkner, Paula Gianini, Hermann Graff, Wanda Hansen, Barbara Haskell, Penny Hawks, Caspar Henselmann, James Hill, Walter Hopps, Robert Hudson, Ann Janss, Kasper König, Ellen Lanyon, Caroline Lee, Joel Leenaars, Jack Lemon, Lewis Manilow, John F. Miller, Jim Newman, Gladys Nilsson and Jim Nutt, Gerald Nordland, Errol and Kathy Ortiz, Lee Ostrander, Phil Pasquini, Peter Passuntino, Alan Press, Joel Press, Ken and Happy Price, Ed Ruscha, Franz Schulze, Marga Shubart, Robert Skaggs, Sam Tchakalian, William T. Wiley, and Mary Zecher. In addition, we thank the following: Rolf Achilles, James Aquino, Michael Asher, Miles Bellamy, Lindy Bergman, Rena Bransten, Charles Cowles, Jennifer Culvert, James S. DeSilva, Anita Duquette, Sheila Ferrari, Donna Fouks, Dr. Stephen Goddard, Roland Hanson and the John M. Flaxman Library, Glen Helm and the Navy Department Library, Richard Hollander, Jr., Ruth Horwich, Jay Jenson, David King, Blanche Koffler, Richard Koshalek, Robert Lehrman, Ethel Lemon, Karen Lennox, Tracy Lew, Judd Marmor, David McCarthy, Joan Adams Mondale, Myra Morgan, Ann Nathan, John Natsoulas, Tom Palazzolo, Lauren Panzo, Jenny Pompe, Clare Preston, Mary Robinson, Arnold Root, Jane Root, Kimerly Rorschach, John Scherer, Dan Schulman, David Sharpe, Raechell Smith, William Struve, Christina Tenaglia, the late Laila Twigg-Smith, and Mrs. Laura Lee Woods.

Finally, we are grateful to the lenders to the exhibition, and for the patience and encouragement of the collectors who welcomed us into their homes and who were as generous with their artworks as they were forthcoming about their sincere love for this man and his art.

Lynne Warren, *Curator*
Michael Rooks, *Assistant Curator*
Museum of Contemporary Art, Chicago

This volume is dedicated to the memory of
Joanna Beall Westermann, the Little Flower.

Lenders to the Exhibition

Alice Adam

George Adams Gallery, New York

Joe Adams and Lisette Baron

Jill Weinberg Adams and Tom Adams

Polly and Mark Addison

Terry Allen and Jo Harvey Allen

The Art Institute of Chicago

Mr. and Mrs. Mathew D. Ashe

John and Maxine Belger Family Foundation

Billy Al Bengston

Lindy Bergman

Marie Krane and Robert H. Bergman

John Bransten

The Henry and Gilda Buchbinder Family Collection

Jean W. Bush

Janice and Mickey Cartin

Douglas and Carol Cohen

Billy Copley and Patricia L. Brundage

Claire Copley and Alan Eisenberg

James Corcoran

CPLY Art Trust

Roy and Mary Cullen

Des Moines Art Center

Allan Frumkin

Jean Frumkin

Peter Frumkin

Stanley and Elyse Grinstein

Ann Goodman Hayes

Samuel and Ronnie Heyman

Hirshhorn Museum and Sculpture Garden, Smithsonian Institution, Washington, D.C.

Anne and William J. Hokin

Ruth P. Horwich

Indiana University Art Museum, Bloomington, Ind.

Ann Janss

David and Melani King

Barbara Klawans

Anstiss and Ronald Krueck

Barbara and Richard Lane

Robert Lehrman

Ethel Lemon

Sally Lillienthal

Dirk Lohan

Los Angeles County Museum of Art

Robert and Marlene McCauley

Michael F. Marmor

The Metropolitan Museum of Art, New York

Byron Meyer

Jerome H. and Linda Meyer

Mrs. Rachelle Schooler Miller

Bill and Teresa Moll

Museum Moderner Kunst Stiftung Ludwig Wien

The Museum of Modern Art, New York

The Nelson-Atkins Museum of Art, Kansas City, Mo.

Jim and Jeanne Newman

Collection Onnasch, Berlin

Lois and Lee Ostrander

John and Mary Pappajohn

Mr. Rupert Power

Alan and Dorothy Press

Martha Westermann Renner

Jane and Ruth Root

Ed Ruscha

SBC Communications, Inc.

George Schelling

Carole Selle

José and Lilliane Soriano

Spencer Museum of Art, Lawrence, Kans.

Marion Stroud-Swingle

Gail and Arden Sundheim

Sharon and Thurston Twigg-Smith

The University of Arizona Museum of Art, Tucson, Ariz.

Nina Van Rensselaer

Wadsworth Atheneum Museum of Art, Hartford, Conn.

Walker Art Center, Minneapolis, Minn.

Estate of Joanna Beall Westermann, Courtesy of Lennon, Weinberg, Inc.

Whitney Museum of American Art, New York

William T. Wiley

Mrs. Laura Lee Woods

Yale University Art Gallery, New Haven, Conn.

Sponsors

Support for this exhibition and associated publications is generously provided by Mary and Roy Cullen, The LLWW Foundation, Anstiss and Ronald Krueck, Henry and Gilda Buchbinder, Ruth P. Horwich, Susan and Lewis Manilow, Dorothy and Alan Press, The Kovler Family Foundation, the National Endowment for the Arts, Marie Krane Bergman and Robert H. Bergman, Carol and Douglas Cohen, The Judith Rothschild Foundation, Mrs. Edwin A. Bergman, Robert and Sylvie Fitzpatrick and Thurston and Sharon Twigg-Smith. The *H. C. Westermann Film Series* is made possible in part by a grant from the Illinois Humanities Council, the National Endowment for the Humanities, and the Illinois General Assembly. The Elizabeth Morse Charitable Trust is the generous sponsor of education programs for this exhibition.

April 7 Wed.

'Dear Martha Lu:

Hi honey — How are you. Guess I've owed you this letter for a long time — I'm a horrible correspondent aren't I? Well I hope your doing fine in school and at your job etc. I presume your still in school? Anyway doll I wish you well you know that — Whatever you do and if you ever need me for anything, let me know. Gee I'll be done in June — My how fast the time went — unreal how a persons tastes change as he becomes educated. When I started my aspirations were purely commercial then in my second year I majored in design which offered a little more aesthetics — then in my third year my interest extended on to the Fine Arts the highest forms of Art. Now when I look back back all the rest of my former aspirations were so superficial and unspiritual in content. I've discovered that a true piece of creative art is of a mans soul & character and is an integral part of mans relationship to God & the universe. When man strictly considers

2.

himself the great creator and pats himself on the back, he very much so limits himself. When I realized this beautiful principle some things were made quite clear and my work was enhanced by a power far beyond my own individual egotistical limitations. How limited is a completely mortal man! Do I make myself clear honey. Didn't mean to go off on a dissertation of my own personal art! which actually is of a very personal nature. My how a man is limited by depending on just his eyesight for answers. Doesn't it stand to reason that life and a being is so much below the surface of what the eye sees and the ear hears? Its amazing how this is the basis of creative art and exactly what is art if it isn't thus a creation? I've never written to any of the relatives of this revelation except Betty Bloom, she understands perfectly. I just wouldn't want to confuse them to the point of misinterpreting me more than they have. Your something special honey — I feel somehow free to discuss things with you that others

3.

would not understand. Perhaps it's your fine intellectual capacity. Anyway I am positive you would never make a mockery of this inner me I am disclosing. Do you know Martha when I was just a boy how I yearned to be an artist - I died a thousand deaths to be just an artist - Its my one lifelong dream and has always been. This I more or less kept secret for years. You don't know how I ate my heart out as a kid to draw and paint, somehow I knew it was my place in the sun. My dream is becoming a beautiful reality & Martha already I've been invited to exhibit quite a few times but this is not so important to me - Its hard to explain. Perhaps I've talked enough and probably sound vain & egotistical - These I've never divulged to anyone Why to you I don't really know - Things of this nature well up in a person and he will utterly explode unless he gets them off his chest at times. Please keep this in strict confidence with me Martha. Oh how I love to

4.

paint- Its really an experience, not only that but I've got something to say. I doubt very much though whether my work is possibly how you picture modern art even though it is modern in the true sense of the word. It is of a metaphysical nature Martha which perhaps may sound ridiculous but just have faith in me. Boy how I've declared myself - I suppose I may sound incoherent perhaps If I could talk to you I could clarify myself - I'm very poor at words. This isn't my medium, ha, ha. Well I just couldn't help myself this time Martha. I'll never blow like this again. Well honey take care of yourself and forgive me for completely exposing myself.

Love Always,
Cliff

The Devil's Handyman
Robert Storr

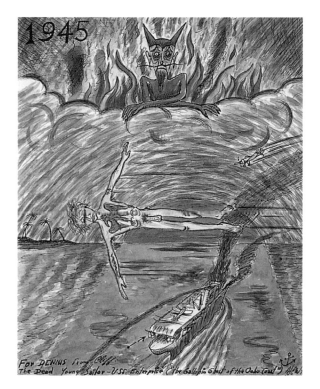

FIGURE 1
1945, 1978
Watercolor and ink on paper
13 5/8 x 11 in.
(34.6 x 27.9 cm)
Private collection, Chicago
Photograph © Museum of
Contemporary Art, Chicago

It seems to me that the grotesque is in almost all cases, composed of two elements, one ludicrous and one fearful; that, as one or the other of these elements prevails, the grotesque falls into two branches, sportive grotesque, and terrible grotesque; but that we cannot legitimately consider it under these two aspects because there are hardly any examples which do not in some degree combine both elements; there are so few grotesques so utterly playful as to be overcast with no shade of fearfulness, and few so fearful as absolutely to exclude all ideas of jest.

—John Ruskin
 The Stones of Venice

H. C. WESTERMANN IS ONE OF postwar art's great misfits. Emphasis should immediately be placed on "postwar." For generations increasingly remote from the events, it is World War II, America's last "good war," that is primarily at issue, though it is important to note that after serving in the Pacific during that global confrontation, Westermann signed up for a tour of duty in the Korean War (see fig. 4, p. 19), a murkier cause. He subsequently watched in disgust as his country marched into the quagmire of Vietnam, its third Asian conflict in a quarter century and a "bad war" by any measure. This trajectory entailed Westermann's increasing disillusionment with

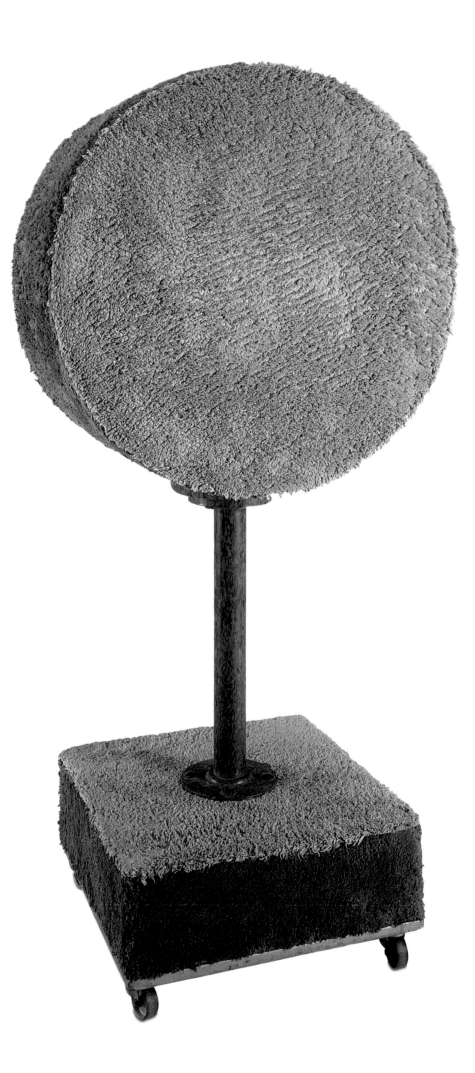

the use of moral righteousness and heroic virtue as alibis for carnage. Altogether his work is inconceivable without his firsthand knowledge of the ways in which reality is always more grotesque — in Ruskin's sense more horrible and more ridiculous — than anything invented in the studio.

Like Otto Dix, the German painter of social and physical decay, or Ivan Albright, the Chicago-based virtuoso of the macabre, both of whom saw action in World War I, Westermann emerged from his exposure to wholesale slaughter with no utopian dreams, but a few recurring nightmares. For artists of their kind and caliber, such knowledge provided the rawest of raw material for an anti-ideal of human folly and imperfection to which they aspired with all the aesthetic rigor of their idealistic counterparts who, in an almost symmetrical reaction to the catastrophes of their age, sought to give shape to pure, Platonic beauty. But in Westermann's case more than the others, the anger that informed this anti-ideal took the shape of high comedy.

The word "great" should also be underscored and its apparent hyperbole explained. In the last century, greatness has been a category usually reserved for modernism's primary form-givers — Brancusi, Matisse, Miró, and Picasso. No such claim for Westermann is being made here. Neither have I chosen the term to posthumously flatter him or inflate his art-world reputation any more than I would casually call someone a "revolutionary" when they never so much as upset an apple cart. Westermann did upset art-world apple carts, but still he was no revolutionary. If he is

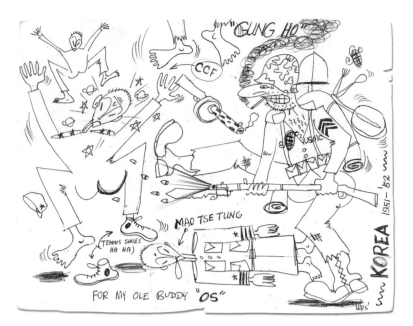

great, then, it is not *sui generis* inventiveness that makes him so, but rather his extraordinary knack for turning conventional art wisdom and the formal paradigms originated by others inside-out and backwards-to.

In this regard Westermann's affinities with dada are obvious. Although never a Duchampian, he was roughly a contemporary of Duchamp's principal American heirs, Jasper Johns and Robert Rauschenberg. They, of course, have become "old masters" of contemporary art, and if Westermann were alive today he would be, too. Achieving that status with tongue still in check has never been easy. Cleverness alone is insufficient. Now more than ever we are made aware by the sheer proliferation of contrarian stylists how hard it is to take examples of "sincere" expression and distort, lampoon, or otherwise reconfigure them in ways that definitively eclipse their sources. Many are called to the banner of anti-art, but few are chosen — and none from among those who underestimate the rules they transgress or the need to actually make something substantial out of their critical impulses.

Westermann thoroughly understood the traditions he reworked in his eccentric manner, and the strange things he fashioned are as distinct and affirmative as anything fashioned by those who hewed to the aesthetic straight-and-narrow. Not only did he succeed in establishing an independent position against the current, but the curious obstacles he placed in its way caused the mainstream to detour. You have to be "great" if you take on high modernism and win the respect of its most talented practitioners and intelligent defenders — but more on that later.

And "misfit"? From an art-historical perspective, this is undeniable for all the reasons mentioned above, but the irony is that in a strictly

FIGURE 4
Letter to Lee Ostrander, n.d.
Private collection

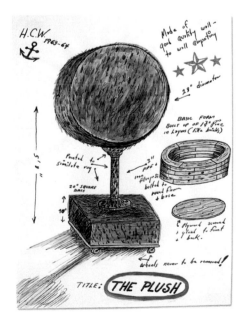

FIGURE 3
Untitled ("The Plush"), 1963. Ink and watercolor on paper, 11⁷/₈ x 8³/₄ in. (30.2 x 22.2 cm). From a letter to Allan Frumkin. Private collection, New York. Photograph by Adam Reich, New York, courtesy Allan Frumkin, Inc.

formal sense, no artist of his period worked harder at fitting things together. In his imagination Westermann seamlessly matched apparently incommensurable concepts; in the woodshop he was a painstaking master joiner. To the collage or assemblage sensibility that had generally thrived on patchwork improvisation, he brought the talents and labor-intensive methods of a cabinetmaker. No one working in this vein strived harder to give the anomalous forms and images that were their stock-in-trade the look of permanence. And in Westermann's meticulously constructed sculptures, it was more than a look. His art describes a world out of whack, a world teetering on the edge of total disintegration, yet his objects are all but indestructible. At a time during the 1950s and 1960s when many artists were exploiting the accidental and the ephemeral, tossing off paintings and sculptures of exquisite brittleness or poverty of means, Westermann applied himself to the task of crafting things that would last, offering up his oddball creations as if people blown about by epochal change and their own gusting appetites and delusions needed obdurate reminders of the absolute absurdity of their situation.

Cigar planted squarely in a rubber-faced grin, Westermann cultivated his reputation as a colorful character. By the time he turned his hand to his own work full-time in 1952 as one of the many in his generation who took a chance on art thanks to the G.I. Bill, Westermann had a roughneck résumé that could have been the envy of a young writer in the Hemingway mold—fellow veteran Norman Mailer, for example. However, Westermann's sardonic take on life more closely resembles that of two other ex-soldiers, Joseph Heller and Kurt Vonnegut. A former gandy dancer on the railroads and general roustabout in the timber industry, he had seen combat at sea, been busted to the ranks for drunken disobedience and promptly thereafter discharged, used his acrobatic skills as half of a two-man balancing act that toured the Far East for the U.S.O., married a showgirl in Shanghai, studied advertising, reenlisted, and finally ended up at The School of The Art Institute of Chicago, where, with time out for another war, he began his own creative life in earnest.

An over-achiever in the school of hard knocks, Westermann did not romanticize his experience but instead rendered it as burlesque, and this set him apart even within bohemian circles. Clearly, he relished the role of lone wolf. That he saw himself this way in various guises is evident from his visually and verbally riotous letters. To fellow artists Ed Flood and Sarah Canright, Westermann wrote, "Dear Ed and Sarah, Ever [*sic*] drawing I make is a self-portrait." These so-called self-portraits included graphic impersonations of a Halloween witch (the image on his letter to Flood and Canright), a muscle man, the Human Fly, Superman, a forest ranger, various versions of a grizzled cuss, and, most frequently, a dance-hall Romeo with patent leather hair and a Robert Taylor mustache.[1] None of these incarnations matched the stereotypes of the aesthetic old guard or the avant-garde milieu.

A man out of step with a cash-flush, gung-ho, culture-crazed America, Westermann's outlook nonetheless remained defiantly American, as if he were, in his wayward way, the last solid citizen

FIGURE 5
Letter to Allan Frumkin,
November 17, 1965
Ink on paper
10 1/2 x 7 1/4 in.
(26.7 x 18.4 cm)
Photograph by Adam Reich,
New York, courtesy Allan
Frumkin, Inc.

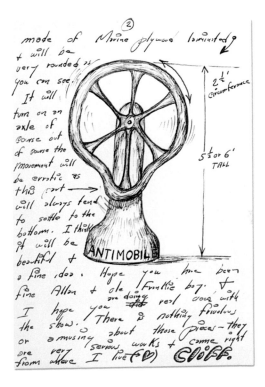

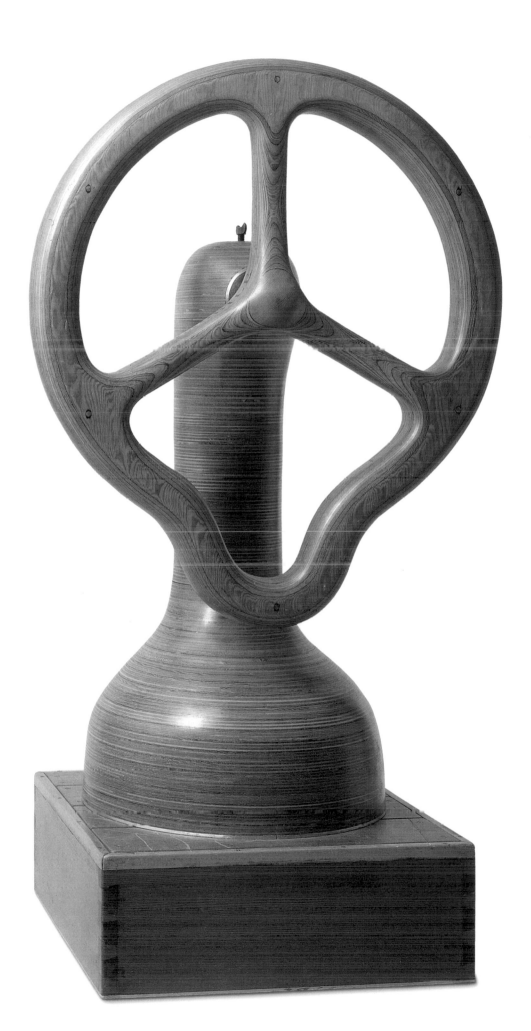

FIGURE 6
Antimobile, 1965
Douglas-fir marine plywood,
metal, and bicycle pedal
67¼ x 35½ x 27½ in.
(170.8 x 90.2 x 69.9 cm)
Whitney Museum of American
Art, New York, Purchase with
funds from the Howard and
Jean Lipman Foundation, Inc.,
and exchange (69.4 a–b)

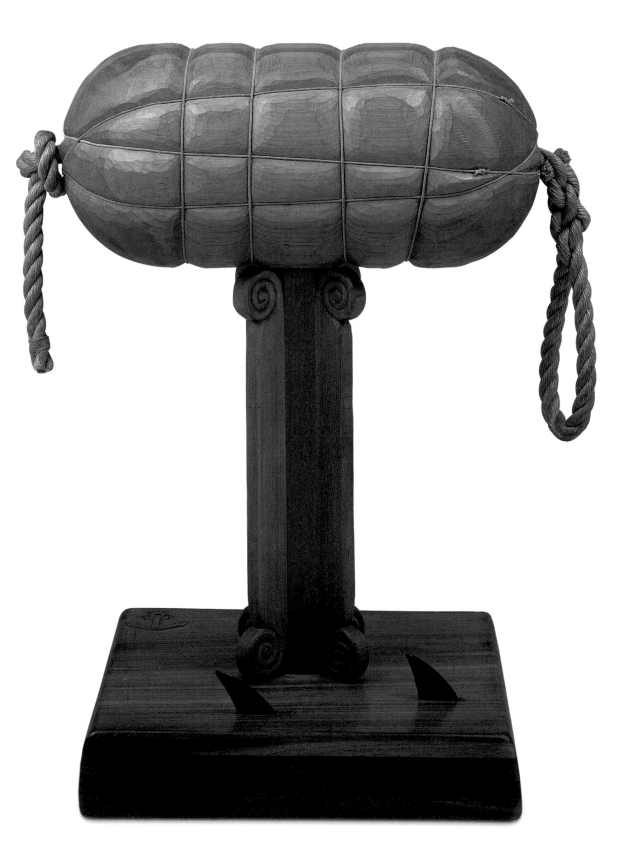

in a hell-bent nation. Sometimes the tenor of his wisecracking declarations of independence veered toward the sort of reactionary folksiness that gave midwestern artists a bad name in the 1930s, though Westermann's Chicago years were an episode in his life, not the essence of it. To Bruce and Doris Oxford he wrote, "You'd be surprised now how much I 'piss and moan' + rant + rave about just everything at this stage of the game. Ha, ha, ha, + that includes all clubs, bureaucracies, institutions, conventions, all governments, gallery dealers, professors, the whole mother fucking works. That's sort of terrible isn't it (+ oh yeh, all politicians). I guess I'm really some kind of fucking nut!"[2] Sometimes, indeed, his tirades have the ring of chauvinism. A letter to his dealer Allan Frumkin protests, "I don't like England (or France) in relationship to Art, etc. . . . I am an *American* artist + don't give one God damn about the international scene (which is pretty weak in general)."[3]

But Westermann was hardly a jingoistic know-nothing. His love of country was genuine and deep, and it was renewed by transcontinental car trips taken in the 1960s, when the "United" States was on the brink of coming unstuck. Those migrations were documented in letter-drawings and his *See America First* prints, whose principal motifs are not big-city sights but the empty spaces between — two-lane blacktop cutting through the desert past vintage signs, roadkill and road-side attractions, car wrecks and bleached bones, all of them metaphors of pioneer solitude in the age of V-8 engines. These scarred wastelands

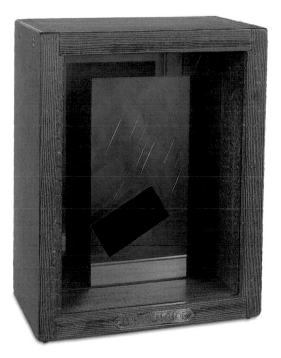

FIGURE 9
The Suicide, 1964
Douglas fir, plate-glass
mirror, enamel, brass
plate, and rubber bumpers
14 x 10 7/8 x 6 1/2 in.
(35.6 x 27.6 x 16.5 cm)
The Henry and Gilda
Buchbinder Family
Collection, Chicago

were also the nation's blasted heartland, and if Westermann's iconography was bleak, his rendering was vigorous and often gleefully obscene. His patriotism was for a place with room enough to get away from the air-conditioned nightmare of modernity. Far from treading the bitterly circular path cut by Thomas Hart Benton and the artistic America-firsters of the Depression, Westermann cut his own zigzag course across the landscape of American culture. To the extent that it resembles anyone else's, it is Jack Kerouac's minus Kerouac's "O Wow" epiphanies and leavened by a wild sense of humor akin to that of another Beat icon, Lord Buckley.

An element of nostalgia hovers around the edges of Westermann's nomadic imaginings. Formally, he was (like the pop artists) partial to dated commercial graphics and cornball wordplay the Americana of a vulgar republic. Thematically, this nostalgia centers on his romance with the sea. Westermann, on a pestilential dock in white tails tangoing by moonlight with his cantina sweetheart, is the vaudeville protagonist of this elegantly morbid reverie. The looming silhouette of a freighter usually completes the picture. To Herk van Tongeren, he explained, "I guess I always loved ships . . . I like the sea + feel at home there. But then I have seen 'Death Ships', many of them + I can't get them out of my lousy system. You know how it is! Well I still make those ships + I am a 48 year old fart. + they still aren't very good, but now I don't give a damn + they satisfy some kind of need there — But they are all death ships now."[4]

If the scenario of these drawings recalls countless movie versions of end-of-the-line eros

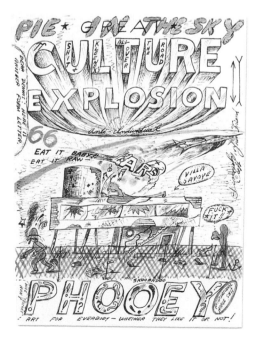

FIGURE 8
Great Culture Explosion, 1966. Ink and watercolor on paper.
13 1/2 x 9 7/8 in. (34.2 x 25 cm). Private collection, Chicago. Photograph
© Museum of Contemporary Art, Chicago.

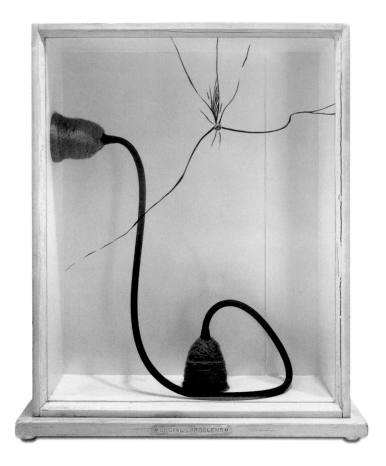

in the tropics, the reality entombed in these Death Ships is spelled out in Westermann's recollections of World War II. As a gunner on the aircraft carrier U.S.S. *Enterprise*, he felt the brunt of attacks by Japanese kamikaze planes, watched from his post while a sister ship—the *Franklin*—was reduced to a burning hull with her crew and passengers smoldering between decks. "To this," Westermann wrote another friend, speaking of the image in both his drawings and his sculpture, "I'd like to add the horrible SMELL OF DEATH but that's impossible dammit! of 2300 men" (see fig. 12).[5] Westermann's ambivalent feelings about the life of adventure toward which he leaned was fixated on this conflagration—and his gut response to it. Writing to a friend, he recalled, "After that I became a fucking coward & was ready to come home immediately, to hell with the war & all that crap about what 'we are fighting for. etc. ETC!' . . . Well anyway the Korean War came along & I wanted to see if I was still a coward—I was!"[6]

Although art could not convey the smell of death or of fear, the extreme physicality of Westermann's work—the strange tactility of his objects and the febrile line and color of his drawings—offers an equivalent intensity. One particularly unsettling drawing depicts "a good pal of mine" whose corpse the artist discovered on a pile of bodies "stacked like cordwood. . . . I recognized him immediately—he was naked + on his chest was a huge beautiful tatoo [*sic*] of an

eagle" (fig. 1, p. 17).[7] The unfortunate sailor reappears in Westermann's watercolor as a horizontally crucified Christ figure mimicking the flight of a fighter plane tearing across a sulfurous sky just above a rendering of the blazing *Enterprise* and just below a cartoon of the Devil in flames. In this case the easily identifiable *Enterprise* is captioned "the gallopin ghost"; in other variants an archetypal tramp steamer is labeled "Death ship, the ship of no port." Whatever the specifics, the vessels float in limbo with their cargo of the undead, as if they were boats launched across an oceanic River Styx doomed never to reach the opposite shore. For those condemned to wander eternally in this watery purgatory, Westermann's images are a symbolic resting place.

Westermann's own desire to put down roots is embodied in the numerous images of cabins in his work, though many, like the dilapidated, vulture-ridden one that adorns a "Welcome Home" letter to Flood and Canright and such sculptures as *Burning House* (1958; pl. 16), *Mad House* (1958; pl. 19), *Battle to the Death in the Ice House* (1971; fig. 17, p. 29), and the hermetically sealed *Snakehouse* (1976), are beset by sinister forces. The ultimate refuge Westermann designed was the house he built himself in Connecticut. Like Willem de Kooning's endlessly improvised studio-residence on Long Island, Westermann's Brookfield Center project was part fantasy dwelling, part busman's holiday, part *Gesamtkunstwerk*-in-progress (see essay by Michael Rooks). The ultimate irony is that although he managed to complete construction and oversee the remaining finish work, the artist never occupied it. Westermann fell ill in October 1981, just before he was to move in, and later died in a local hospital. In the end, fate cheated him out of a safe haven, as it had already cheated his comrades.

Westermann's antiheroic assessment of his own conduct in World War II and the Korean War was perfectly pitched to the skeptical mood of the Vietnam era.[8] Long before Americans in general—much less any appreciable number of two-time veterans—had turned against the policies of Presidents Johnson and Nixon, Westermann was making sick jokes out of the far sicker "seriousness" of the media and the military-industrial complex. The rage contained in the repulsive slapstick of his caricatures sealed the bond between him and a much younger generation. Images of comic savagery and rapine are common in his correspondence, along with newspaper clippings describing various kinds of mayhem. Perhaps the most extreme example is a 1966 letter to Allan

Frumkin. Above the overall caption "A Country Gone Nuts," Westermann worked out a fantasy inspired by a cut-out item from the *New York Times* headlined "Live TV Coverage of Vietnam Called Possible Within a Year." The blurb is accompanied by the sketch of a television screen showing the exploding body of a "grunt"; a snoring couch potato oblivious to the sound of broadcast gunfire; a couple hard at it in bed while the woman shouts, "Turn it up"; scattered dollar signs; and a speculative caption about the amount of breakfast cereal that can be sold during the commercials.[9]

Westermann the tough guy, Westermann the wise guy: these images shape the aura that hovers around the artist like smoke rings puffed between episodes of a preposterous story. The man telling the story and providing the pictorial or sculptural gags that illustrate it cuts a striking but deceptively easy-to-read profile. Add to this picture, however, images of a physically graceful man in shiny trunks doing handstands above his partner, or the older but still handsome workman bare-chested in his studio, carefully adjusting the bit of a manual drill. Or consider what his hands and tools created: dovetail joints of exquisite tolerances, laminated blocks of wood honed to the subtlest of curves and the smoothest of surfaces, elegantly marbled forms painted in delicate tints and shades, beautifully cast bronze and brass shapes, and crisply cut and sutured sheet-metal modules. The rough-and-ready Westermann is a variation on a character ubiquitous in postwar folklore, typified by a marginal machismo personified in different ways by writers like Mailer and Kerouac and by artists like David Smith and Jackson Pollock. Yet, behind the bluff mannerisms of all of them were varying degrees of uncertainty about how to be an artist in a country that had little use for art — except as cultural politics — and few role models for how a "man's man" could explore the aesthetic streak in his own nature. Virility and beauty were counterterms of Westermann's dilemma. The answer, in the alchemy of sublimation and dynamic inconsistency, was the inversion and fusion of opposites. Thus, coarseness paired with courtliness defined his temperament while simultaneous gross exaggeration and quirky elegance set the parameters of his work.[10]

Emblematic of these tensions, and of the sly refinements of Westermann's art overall, was his affinity for Elie Nadelman, the early modernist sculptor whose streamlined faceting of forms arguably anticipated aspects of Picasso's cubism, and whose playful variations of folk-art sculpture

set an all-time standard for faux-naif whimsy and sophistication. Westermann railed against force-fed high modernism in texts and drawings like the one that depicts Le Corbusier's Villa Savoye with broken glass and hurricane fence as a kind of urban renewal wreck. "Pie in the Sky Culture Explosion" reads the newsreel-like title above the cartoon; "Phooey" reads the caption emblazoned below it (fig. 8, p. 23). (But then Westermann's first sale was to the Bauhaus wizard of less-is-more, Mies van der Rohe.)[11] In Nadelman, however, Westermann found an antecedent he could wholeheartedly admire. Of course, Westermann's admiration came with a twist. *Homage to American Art (Dedicated to Elie Nadelman)* (1966; pl. 57) is a carefully assembled but ungainly composite consisting of a hand-hewn coal shovel handle — an aside to Marcel Duchamp's 1915 readymade *In Advance of a Broken Arm* — with a "big fir ball" at the end suspended from a gibbet-like armature to which is clamped a small lead version of the same anomalous tool.[12] In essence Westermann has appropriated the attributes of Nadelman's delicately carved and sanded cherry-wood sculptures of music-hall acrobats and performers and rendered those qualities in a massive and fundamentally absurd lumber object that swings like a pendulum. As odd as this formal translation of Nadelman is, Westermann was nothing but sincere in undertaking it. Writing to Frumkin on the completion of the piece, he said, "It turned real good I think — Very strange object, not facetious at all."[13] With a singular lightness of touch, Nadelman depicted people at play; imaginatively nimble but deliberately heavy-handed in his execution, Westermann played with form.

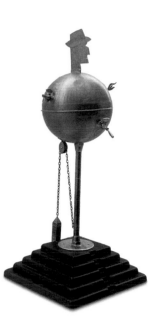

FIGURE 11
The Unaccountable, 1959
Gold-plated brass, pine, brass chain, U.S. penny, and enamel
27¼ x 12⅝ x 11⅝ in.
(69.2 x 32.1 x 29.5 cm)
Private collection, Los Angeles

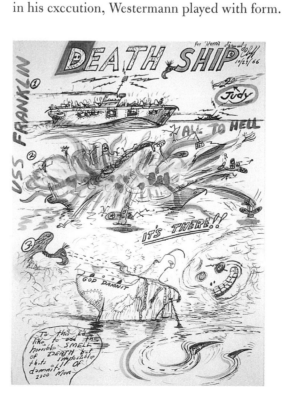

FIGURE 12
USS Franklin, 1966
Ink and watercolor on paper
13½ x 9⅞ in.
(34.3 x 25.1 cm)
Private collection, Chicago
Photograph courtesy Lennon, Weinberg, Inc., New York

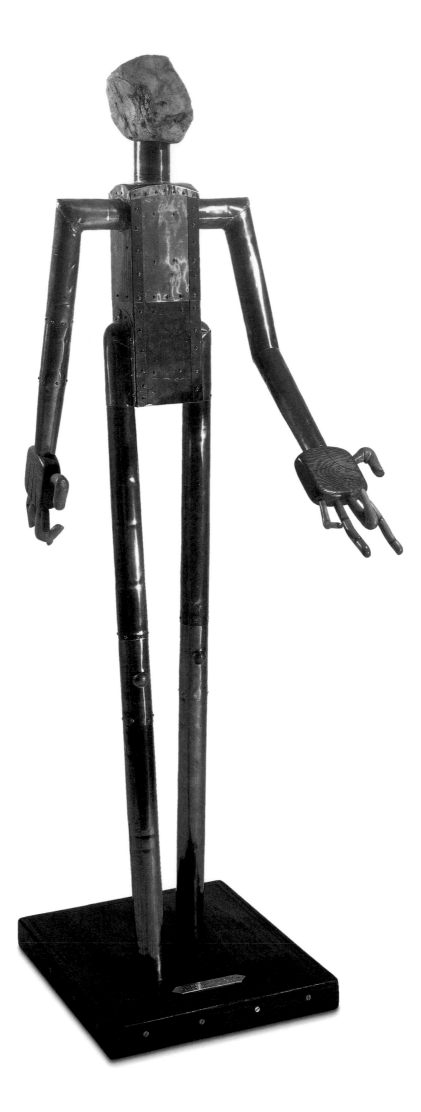

FIGURE 13

*The Man from the Torrid
Zone*, 1980
Sheet copper, Douglas fir,
aspen, teak, Connecticut field-
stone, oak, beech, and brass
64¼ x 18⅝ x 25¾ in.
(163.2 x 47.3 x 65.4 cm)
Alan and Dorothy Press
Collection, Chicago

Westermann's *Antimobile* (1965; fig. 6, p. 21) acknowledges another of his American precursors, Alexander Calder. Once again sculptural bulk salutes sculptural lightness, as Westermann tips his hat to the inventor of the mobile with an industrial-strength construction resembling an inert flywheel whose shape incidentally reminds one of the melting watch in Salvador Dali's *Persistence of Memory* (1931) and whose facture recapitulates the wooden prototypes for the molds from which, traditionally, steel machine tool parts are cast. And once again, despite all its obvious or probable sources, the final object looks like nothing we have ever seen before, an emphatically material witticism that results in an uncanny meta-image of utter self-containment and earth-bound helplessness, a machine that will not work, a body that cannot move. All in all, Westermann was a connoisseur of heft and solidity, of concentrations of wood, metal, and stone whose specific gravity one could feel in the muscle of one's forearms or back, even when, as in the case of such sight gags as *World's Strongest Glue* (1966) with its "cracking" armature, he traded on implausible illusion. Overbuilding was at the heart of his sculptural poetic, as if the statement of an idea required not so much the amplification of its symbolic content as a moral insistence upon its durability, like an awkward thought that just will not go away—and the longer it stays, the more matter-of-factly disarming and disquieting it becomes.

Then, of course, there is Westermann's relation to Joseph Cornell, one of the most European of American modernists in the same way that Nadelman became one of the most American of European modernists. Like Arshile Gorky, Cornell paraphrased French surrealism without an accent and then took it places that André Breton's original circle of artists had not yet explored. No less aware of what the Parisians had done than Cornell was, Westermann was a generation younger and in no hurry—and no position—to make contact with the movement's founders. Instead, he naturalized surrealism and translated its often effete vocabulary into a workmanlike vernacular. Thus, while Cornell's boxes are wistful, artfully dilapidated theaters of the subconscious, Westermann's are sturdy vitrines in which incongruous but always substantial objects are on display like specimens in a freak show. Many of Westermann's boxes are devoted to visual puns that recall those of René Magritte; as in Magritte's work, shameless wordplay in the titles Westermann gave his works is frequently a crucial element (such wordplay is just part of Westermann's

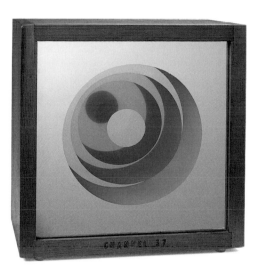

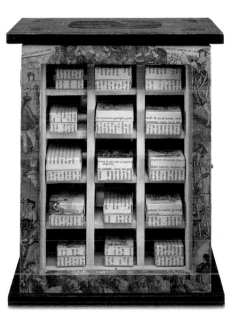

legacy to Chicago artists like Jim Nutt and Karl Wirsum). This is particularly true of Westermann's *Walnut Box* (1964; pl. 43), filled with, what else, walnuts; Untitled (1962; pl. 32), a woozy question mark; and *A Positive Thought* (1962; pl. 34), an exclamation point with an animated inflection. But the more abstract boxes such as *Eclipse*, *Rosebud* (p. 8), *The Suicide* (all 1963; see fig. 9, p. 23), and *Social Problems* (1964; fig. 10, p. 24) point in at least two other directions: back toward constructivism, as if rude funk were bear-hugging the puritanical Bauhaus despite the latter's attempts to resist the former's abrupt advances; and toward minimal and postminimal art, with which Westermann had no direct link.

It was Donald Judd who first made the connection. "With less knowledge than I should have," he wrote in his October 1963 review of the artist's show at the Allan Frumkin Gallery in New York, "I would guess that Westermann is one of the best artists around. . . . It is obvious that Surrealist sources could be found for many of Westermann's ideas. It is just as obvious that the objects are something new. I think the fact

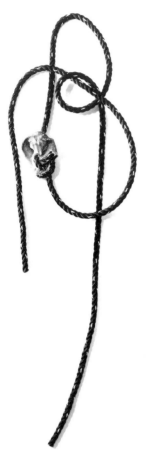

that they are objects has a lot to do with that. These are very much objects in their own right, direct though their meaning is recondite. . . . The pieces are very thorough."[14] The Westermann work that illustrated Judd's review—*Channel 37* (fig. 14, p. 27)—is a box abstraction, probably inspired by a TV test pattern but also reminiscent of Jasper John's target pictures or, in a more ironic way, of Kenneth Noland's paintings. It is remarkable that Judd, the most severe exponent of an emerging minimalist aesthetic, would extend himself to pay Westermann such a high compliment.

And Judd was not the only one of his generation to do so. A few years later, another young artist, this time on the West Coast, paid his respects in two works of his own that unmistakably allude to Westermann's *The Big Change* (1963; pl. 37). On this occasion the recognition came from Bruce Nauman, and the works in question were *Westermann's Ear* (1967; fig. 16) and an untitled 1967 drawing bearing the inscription "Square knot (H. C. Westermann)."

Meanwhile, Westermann's *Positive Thought* anticipates Richard Artschwager's punctuation-mark sculptures—such as *Chair Table* (1980)—just as Westermann's *The Plush* (1963; fig. 2, p. 18) foreshadows Artschwager's weird, quasi-domestic, quasi-abstract objects in synthetic, intensely tactile building materials such as Celotex, Formica, and rubberized hair, not to mention Artschwager's comparable obsession with craft and finish. Other parallels may readily be drawn between works such as Westermann's *Social Problems* and some of the reliefs Eva Hesse made while living in Germany in 1965, as well as her sculptures such as *Ingeminate* (1965), *Hang-Up* (1966), and later works in which connectivity and hostility are conveyed through the use of rubber tubing and other simultaneously appealing and repulsive types of conduits. Paul Thek's reliquaries likewise make one think of the more death-haunted of Westermann's boxes, while the cartoonish, sausagelike package of *A Piece from the Museum of Shattered Dreams* (1965; fig. 7, p. 22)—a wonderfully poignant idea for a museum, by the way—conjures up both Claes Oldenburg and Christo but returns what is soft, endearing, and forlorn in them to resolute, stoic hardness.

Locating Westermann in this corner of the art world means partially reclaiming him from two others. The first is regional, the second philosophical. To be sure, Westermann's primary artistic ties were to individuals and tendencies well outside the "mainstream," by which I mean the New York School of the 1950s and 1960s in all its principal dimensions. While the Midwest was Westermann's base of operations for around a decade, the twenty most productive years of his creative life were spent on the East Coast (depending on the calculations, the period of his real involvement with Chicago and its art culture dates from 1947, when he first entered The School of The Art Institute of Chicago, or 1952, when he returned from the Korean War and reenrolled at the S.A.I.C., to 1961, when he and his wife Joanna Beall moved to Brookfield Center). Meanwhile, many of his greatest enthusiasts among artists were on the West Coast—men like Nauman, Ed Ruscha, and William Wiley, even as others, such as the Paris– and New York–based painter and collector William Copley, were cosmopolitan figures. Although Westermann retained close contacts with his Chicago friends, notably the critic Dennis Adrian, he was in no sense a local artist, nor even a regional artist unless one takes literally Saul Steinberg's famous cartoon of New York City giving way at Riverside Drive to the Great Plains and Purple Mountains Majesty and thereby thinks of everything past the Hudson as a "region." (Incidentally, one suspects from their iconography, caprice, and linear snap that Steinberg's later drawings of the American scene were, to a considerable degree, influenced by Westermann's.) Thus, Westermann operated at a distance from all the art meccas— Brookfield Center's geographic, "center-of-what?" in-betweenness is emblematic of that—but kept in touch by letter or car with sympathetic spirits across the entire country. He was, in short, a national artist from "no place special."

The supposed philosophical orientation of Westermann's work is also largely a product of circumstantial associations raised to the level of ideological cliché. Westermann's introduction to the general public came with his inclusion in Peter Selz's 1959 Museum of Modern Art exhibition *New Images of Man*. A response to the predominance of New York School painting in general and the formalist readings of abstract expressionism in particular, Selz's show was a casting call for a mid-century humanist aesthetic. Its catalogue began with an epigraph by Goya and a prefatory note by the Protestant theologian Paul Tillich. The list of artists included was a tendentious and messy one. For example, Pollock and de Kooning were coopted for the cause as figurative painters (which they were, though not in the way Selz emphasized), and Dubuffet was usefully aligned with Leon Golub, whose work Dubuffet had significantly influenced, as was the case with a number of other Chicago artists who heard Dubuffet lecture at the Arts Club in 1951.

FIGURE 17
*Battle to the Death in the
Ice House*, 1971
Redwood, pine, vermillion,
fir plywood, brass, cast lead,
rope, pulley, and plate glass
32 x 28 x 22¼ in.
(81.3 x 71.1 x 56.5 cm)
Private collection,
Los Angeles

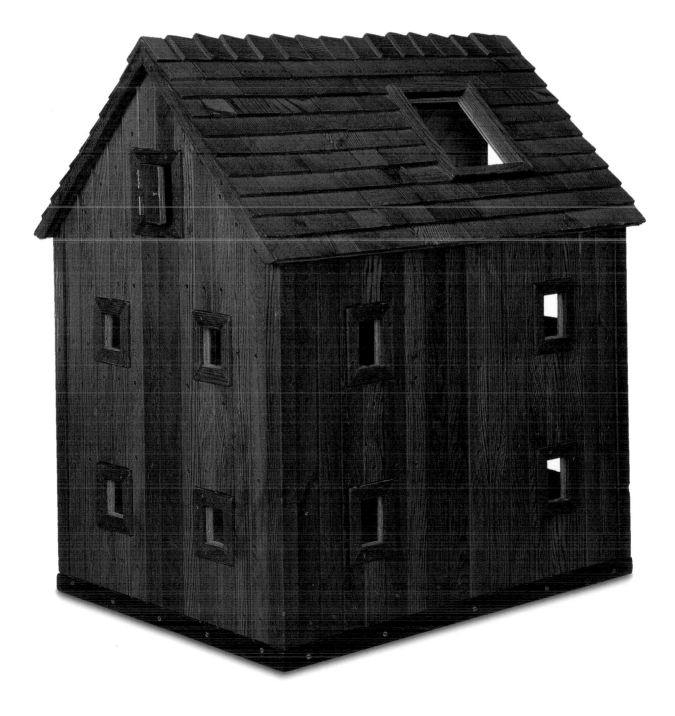

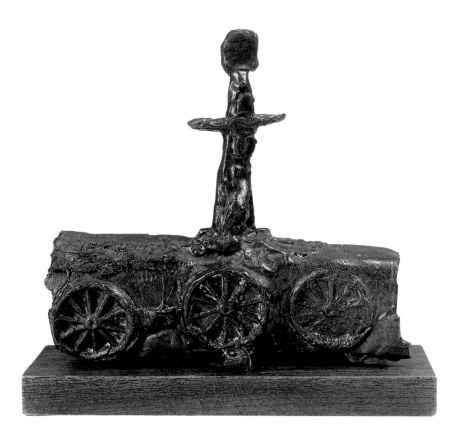

FIGURE 18
Eduardo Paolozzi
Man in a Motor Car, 1956
Cast bronze
The David and Alfred Smart
Museum of Art, The University
of Chicago; Gift of Mr. and
Mrs. Stanley M. Freehling
© 2001 Artists Rights Society
(ARS), New York/DACS,
London

Nevertheless, the exhibition acknowledged a variety of talents previously accorded little or no attention by major New York museums, and, as a newcomer, Westermann was one of these.

In keeping with his emphasis on postwar angst, Selz's selection of works included Westermann's *The Evil New War God (S.O.B.)* and *Memorial to the Idea of Man If He Was an Idea* (both 1958; pls. 23 and 22), and the brief essay he devoted to Westermann highlights the artist's service in World War II and the Korean War. Despite this rhetorical alignment with the other anxiety-ridden artists in the exhibition—Kenneth Armitage, Francis Bacon, César, Alberto Giacometti, Eduardo Paolozzi, Germaine Richier, Theodore Roszak, and Fritz Wotruba, to name just a few—Westermann sticks out like a clownish sore thumb among the predominantly dour or expressionist lot. Only Dubuffet matches him for humor, though the paintings chosen for the exhibition were among Dubuffet's more contained efforts, and—while his prescient pop-culture scrapbooks of the 1940s were not generally known at the time—only Paolozzi shared Westermann's taste for glaring vulgarity, though the sculptures shown on this occasion were not yet examples of Paolozzi full-blown machine-monsters. (It is noteworthy in this regard that Westermann's *The Silver Queen* and *Swingin' Red King* [1960 and 1961; pls. 28–29] anticipated rather than followed Paolozzi's most directly science fiction–influenced sculptures, even though Paolozzi identified the importance of 1940s and 1950s sci-fi film and magazine imagery as early as 1948,

and began to paraphrase Hollywood robot forms in his work by 1956.)

Made for an audience fixated on School of Paris art of the first half of the century and New York School art of the just-then-unfolding second half, *New Images of Man* was, in sum, a dissenting enterprise. It was an earnest one, as well. The most radical aesthetic component of the new humanism Selz proposed was not the return to the figure. Indeed, abstraction had yet to acquire the force of dogma it would have by the mid-1960s, and a mere turn in the cycle of figuration/abstraction had nothing inherently paradigm-shifting about it. In fact, quite the opposite was true, given the overt conservatism of so many of the artists represented, Giacometti and Bacon among them. Rather, what broke with conventional taste was the reemergence of the grotesque, a quality present in the work of a good half of the artists included in the exhibition, from Dubuffet and Paolozzi to de Kooning and, of course, Westermann.

At this juncture I am no longer using the word "grotesque" in its simple descriptive sense of bizarre or unsightly, but rather as a fundamental aesthetic category in which formal contradictions carried to extremes articulate and exaggerate clashes in consciousness. Moreover, I would qualify what was said at the outset about reality producing grotesque phenomena exceeding anything made in the studio by stating that this is true only in the sense that accidental distortions or juxtapositions surpass even the strangest of aesthetic contrivances in just the way that an actual sunset seen with the naked eye has greater optical intensity than a painted sunset does. Like beauty, the grotesque is a human invention, a way of synthesizing experience rather than a simple immersion in unmediated sensation, a category of mind rather than a self-evident and self-sustaining state of being. "There are no Grotesques in Nature," the seventeenth-century writer Thomas Brown claimed, and to the extent the grotesque consists of the purposeful forcing together of incommensurable things and the perceptions, thoughts, and emotions they trigger, Brown was right.[15]

At its lowest common denominator, the grotesque is an exercise in the obvious misalliance of images, styles, and materials undertaken for the sake of entertainment. Such were the original grotesques made for the grottoes of late imperial Rome—from which the term itself derives—as well as the majority of the scherzi and other manifestations of this whimsical impulse in the baroque, rococo, and romantic

periods. In the middle ground are the satirical grotesques that directly target social types, situations, or pieties. Beginning with Bernini, the history of caricature provides us with countless examples both elegant and egregious, bigoted or liberating. Goya's politically coded cartoons are the apogee of the genre, but at their most absurd and mysterious, his *Caprichos* and *Disparates* provoke even greater disorientation and set a more elevated standard of aesthetic ambition, one in which hubristic ingenuity presumes to outstrip the wonders and disparities of reality as we know it by conjuring wholly new, albeit imaginary, species. Insofar as we laugh at such novelties, an impossible-to-shake uneasiness accompanies the spasm that seizes us.

With Goya foremost in his mind, Charles Baudelaire, the nineteenth-century French poet and critic, framed the issue as the difference between the comic grotesque, a calculated distortion of what exists, and the true grotesque, a primary though necessarily flawed reinvention of the world. Moreover, he viewed the dichotomy as a quasi-religious contest between God-given perfection and diabolical but inspired imperfection. Baudelaire's basic equation clearly emerges as one stitches together passages from his essay "The Essence of Laughter." "The wise man laughs only with fear and trembling," he writes. "Laughter is Satanic; it is therefore profoundly human. . . . I refer of course to the laughter provoked by what is grotesque. Fabulous creations, beings for whose existence no explanation drawn from ordinary common sense is possible, often excite in us wild hilarity, excessive fits and swoonings of laughter. Evidently a distinction is called for here, as we are confronted with a higher form. From the artistic point of view, the comic is an imitation; the grotesque a creation. . . . I mean to say in this case, laughter is the expression of the idea of superiority, no longer of man over man, but of man over nature."[16]

It may seem a long way from Westermann to Baudelaire and back, especially given the artist's raucous contempt for arty types and fancy foreign things. Conceptually, however, the distance is short, and inasmuch as Selz quoted Goya's phrase "the sleep of reason produces monsters" on the opening page of his *New Images of Man* catalogue, the linkage is even more direct. However, it is neither Goya the proto-surrealist who counts here, though Westermann was openly indebted to the surrealists, nor Goya the passionate witness and patron saint of anguished liberalism, though Westermann's bloodbath caricatures are in their own way a catalogue of

the disasters of war. Rather it is the Baudelairian Goya who offers us the best perspective on Westermann's larger achievement, the Goya in whose work the tragic and the comic, the crude and the subtle are fused into images that do more than comment upon or toy with reality, but instead supplant it with an alternative aesthetic realm in which polarities are drawn together, not pushed apart, and the logic of categorical opposites is suspended by the seeming inevitability— and imperishability— of paradoxical constructs. Whether we have entered the Devil's workshop is perhaps another matter, but there is a markedly demonic quality to the things we discover, and, at very least, it would appear certain that we have left paradise, and the hope of it, in the distance. And if sculptures such as *The Unaccountable* (1959; fig. 11, p. 25), *Angry Young Machine* (1959; pl. 24), *Object under Pressure* (1960), *Control* (1968; fig. 20, p. 32), *Hutch the One Armed Astro-Turf Man with a Defense* (1976; pl. 101), *Female Figure* (1977; pl. 102), and *The Man from the Torrid Zone* (1980; fig. 13, p. 26) are indeed the new men and women of the age, then they are golems with little resemblance to Adam and Eve, even after the Fall. In any case, we are far from the vague consolations of 1950s humanism and close to the harder-edged thinking and questioning of the 1960s.

What Judd seems to have recognized in Westermann's work was the vital antithesis of his own puritan leanings but a complement to his striving for an art that was specific in its physical presence and independent of past— mostly European— stylistic solutions and compromises. What Nauman appears to have found in Westermann was a man who could twist the separate strands of human nature into unloosenable knots that correspond to the formal and psychological convolutions of his own multifarious production. Likewise, one can draw connections to the work of Artschwager, Hesse, Oldenburg, Thek, and a host of other 1960s artists not just on the level

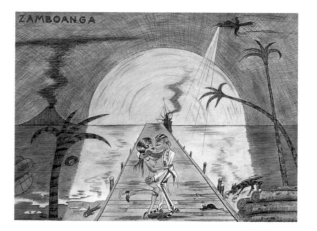

FIGURE 19
H. C. Westermann
Zamboanga, 1981
Ink and watercolor on paper
22 x 30½ in.
(55.9 x 77.5 cm)
Mrs. Laura Lee Woods,
Los Angeles
Photograph courtesy Lennon
Weinberg, Inc., New York

FIGURE 20

Control, 1968
Wood, plate glass, tar, chicken
feathers, sheet copper, brass,
and solder
$25^{1}/_{2}$ x $11^{3}/_{8}$ x $11^{3}/_{8}$ in.
(64.8 x 28.9 x 28.9 cm)
Alan and Dorothy Press
Collection, Chicago

of aesthetic similarities but on the level of spiritual resonance, if by spiritual one means a strictly unsentimental preoccupation with human need, anxiety, aspiration, and confusion. It is this kind of humanism, a disabused, self-mocking, prickly, I-dare-you-to-look, I-defy-you-to-look-without-laughing-or-wincing attitude toward our common condition that Westermann epitomized and shared to varying degrees with these contemporaries and near-contemporaries. And he shares it posthumously with many artists working today. Mike Kelley's shop-class deconstructions of the formalist ideal, Charles Ray's fastidious experiments in perceptual equilibrium and conceptual vertigo, and Tom Friedman's compulsively crafted sculptural enigmas are but a few examples of current work that, whether or not it shows Westermann's influence, responds to correlative impulses and circumstances.

Utopian modernism advocated the resolution of complex, conflicting truths in favor of the "irreducible" positive element. Valuing the negative in equal measure, the countertradition of modernism treats intractable conflict as its essential reality and takes truths of whatever kind, but especially those that assume too much— or much at all— about the inherent goodness of humankind, and subjects them to the crucible of humor. Westermann's drawings and sculptures come at

you "funny-ha-ha" and stay with you "funny-ouch." The joke, of course, is on us, men and women who might prefer to raise dignified memorials to our idea of ourselves— if only we were an idea and if only we possessed such dignity.

Westermann's ghost ships, casket boxes, and maimed, antic bodies— his World War II verging on World War III "Dance of Death"— rub our mortal noses in the incongruity of noble causes and their haphazardly cruel consequences. His images of freighters plunging from the sky like dive-bombers or overrun by the tire tracks of high-speed cars metaphorically brought the wars home, and, along with other menacing intrusions and signs of all-American anarchy, lent the domestic landscape a timely sense of impending disaster. We may have dodged the bullets after all— or for the time being, anyway— but the double whammy these gleefully calamitous symbols deliver leaves us in the double bind Ruskin described when he wrote, "There are so few grotesques so utterly playful as to be overcast with no shade of fearfulness, and few so fearful as absolutely to exclude all ideas of jest." Ruskin was a gentleman; Westermann, thank God, was not. But Westermann, the handiest of malcontents, understood this dynamic from the inside out and gave it unique idiomatic form. They don't quite make them like that anymore.

1. Bill Barrette, ed., *Letters from H. C. Westermann* (New York: Timken Publishers, 1988), p. 121.

2. Ibid., p. 109.

3. Ibid., p. 60.

4. Ibid. p. 149.

5. Ibid., p. 152.

6. Cited in Dennis Adrian, "Introduction," *H. C. Westermann*, exh. cat. (London: Serpentine Gallery, 1980), n. pag.

7. *Letters from H. C. Westermann* (note 1), p. 163.

8. Although Peter Saul did not see military service during the Vietnam era, his riotously ghastly treatment of the subject is in many ways comparable to Westermann's, and for many years the work of both

men was shown at the Allan Frumkin Gallery.

9. *Letters from H. C. Westermann* (note 1), p. 106.

10. One drawing-and-clipping combination brings this ambivalence home. Accompanying a Dix-like watercolor of a muscular, tattooed man in a woman's slip, hanging from a wall of a flophouse room, is a police report of a forty-one-year-old ex-seaman who stages his final exit in drag, leaving the note, "This is it. I've had it . . . Police Department please see I am buried in clothing laid out on bed (standard men's clothing— slacks, shirt, shoes). I am not queer. Just had a compulsion to wear this 'costume' to die in. Good-by, world. The next one can't likely be

much worse." If, as Westermann claimed, every one of his drawings was a self-portrait, then this one merits special consideration, not because Westermann was a closet transvestite, though in his drawings he did sport many theatrical costumes. Rather, by way of a surrogate offered up by a sensational newspaper item, Westermann drew attention to the clash between "masculine" and "feminine" attributes in a single individual, the former represented by the straight-talking sailor who writes the letter, the latter represented by the alter ego he achieved through artifice. See *Letters from H. C. Westermann* (note 1), pp. 102–03.

11. Ibid., p. 104.

12. See ibid., p. 68.

13. Ibid.

14. Donald Judd, *Complete Writings*, 1959–1975 (Nova Scotia: Press of the Nova Scotia College of Art and Design, and New York: New York University Press, 1975), p. 99.

15. See Geoffrey Galt Harpham, *On the Grotesque: Strategies of Contradiction in Art and Literature* (Princeton, N.J.: Princeton University Press, 1982), p. xix.

16. Charles Baudelaire, *Selected Writings on Art and Artists*, trans. P. E. Charvet (Cambridge: Cambridge University Press, 1972), pp. 141–51 passim.

H. C. Westermann's Sculptures, 1954–1981: Fragments of a Critical Introduction

Dennis Adrian

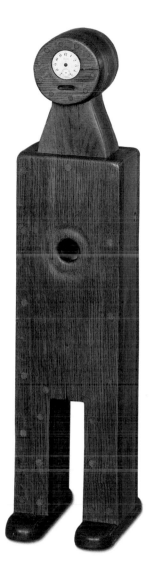

FIGURE 1
*Uncommitted Little Chicago
Child*, 1957
Oak, maple, metal clock face,
and paper découpage
29 ½ x 6 ⅝ x 8 in.
(74.9 x 16.8 x 20.3 cm)
Alan and Dorothy Press
Collection, Chicago

SO INTRICATE AND VARIED is H. C. Westermann's sculptural oeuvre that it both demands and defies analytical summary. Working across genres, in many media, in dialogue with an astonishing range of art and literature, and over the most eventful decades in America's history, Westermann may attract strictly comparative or chronological classification, but he is not fully explained by it.

Depending on the agendas of the critics involved, Westermann has been variously identified as a surrealist, a neo-dadaist, an heir to or competitor of Joseph Cornell, a down-home Yankee whittler whose personal concerns have gotten out of hand, a folk artist, an outsider artist, a minimalist, a pop artist, a social satirist, and quite a few other things. There is some truth in each of these associations, but none can adequately encompass all of his work, and — more importantly — none would have been comfortably adopted by the artist himself, whose worldview was far more expansive than any of these labels implies.

It is ultimately more rewarding, if also more challenging, to consider this worldview in its own right, as the basis from which recurrent concerns emerge. Westermann's character was grounded in an enduring honesty that had no choice but to address (sometimes with relish, sometimes in frustration) the paradoxes at the

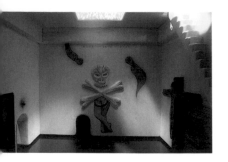 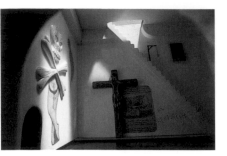

FIGURE 2
Mysterious Yellow Mausoleum,
1958
Douglas-fir plywood, pine,
tar, enamel, glass, antique
die-cast brass and cast-lead
doll head, metal, brass,
mirror, and paper découpage
48 1/8 x 19 3/8 x 27 5/8 in.
(124.8 x 49.2 x 70.2 cm)
Dr. Arthur Neumann,
San Francisco

Mysterious Yellow Mausoleum
(interior details)

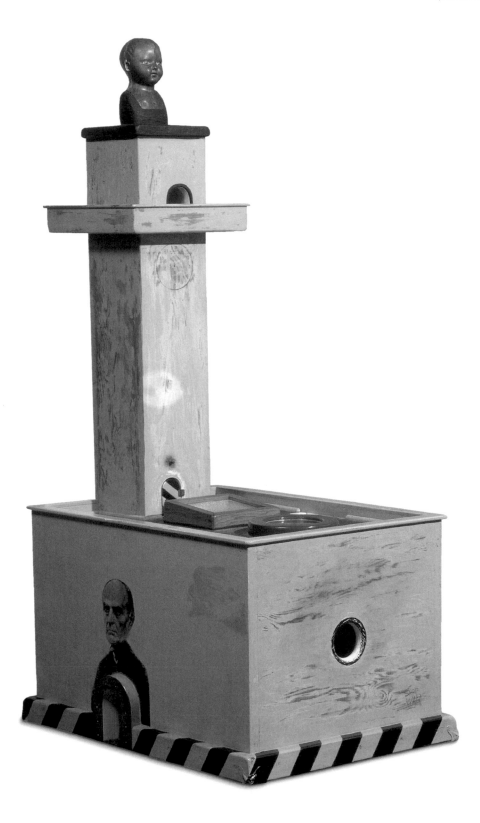

core of formalism and those at the core of humanism. This fertile dilemma played out over the course of Westermann's nearly thirty-year career, and a retrospective examination of his production yields thematic and material commonalities that may not have been intentional but nonetheless reflect his fundamental beliefs. It is important to remember that Westermann did not usually work in series of images or ideas. Instead, he seems to have had a number of stylistic and conceptual concerns that overlapped and that surfaced at intervals. This essay proposes the following categories that the artist employed repeatedly and inventively: figures, houses, Death Ships, boxes, tableaus, and machines. The terminology is deliberately irregular, some words suggesting content or subject, others pointing to medium, technique, or format. It is also important to note at the outset that an individual work may fit within more than one grouping, and that the nature and extent of the groupings evolved over time. In other words, the works define the categories, however sloppily, rather than the other way around.

The persistence of these categories within Westermann's work, as well as the fluidity of the boundaries between them, has to do with the artist's affinity for the paradoxical, which manifests itself in his techniques, sources, and— first and last—in his very character. His devotion to craft—principally woodworking but extending to work with metal, glass, and other materials—has something of a Shaker purity of heart and spirit about it. His dedication to certain methods of woodworking, such as joinery and lamination, and his appreciation of the beautiful and expressive nature of all kinds of wood link him to American craftsmen of an earlier era. Not only was Westermann ardently committed to preserving wood as a natural resource, he also did his part to maintain nearly lost skills and crafts, carrying on the traditions seen in eighteenth- and nineteenth-century American furniture, toys, builder's and shipwright's models, tools, patent models, and other sometimes anonymous but idiosyncratic objects. Yet this sensibility transcends vernacular allusion, as Westermann was able to make direct, simple objects that achieve great sophistication and subtlety.

Westermann's interactions with many different artistic traditions are only now beginning to be seen in their fullness: the breadth of his frames of reference was far more extensive than is suggested by the "Popeye the Sailor–Yankee whittler" stereotype that still has an unfortunate

currency in some quarters. His library holdings, ranging from Hermann Hesse's *Steppenwolf* to Colin Wilson's *The Outsider*, are particularly revealing here, as is his interest in film. Throughout his life he maintained an awareness of major films, including foreign films like Ingmar Bergman's *The Silence* and Marcel Carné's *Le Quai des Brumes*. But classical Hollywood cinema had the strongest impact. One of the great central products and expressions of American culture, film (along with some of his wartime experiences) is arguably the most influential aspect of the twentieth-century American experience in Westermann's thematic and emotional range. Not surprisingly, given Westermann's extensive military experience, war movies of different kinds, such as Stanley Kubrick's *Paths of Glory*, were prominent among his favorites.

Indeed, the experience of military life and combat left Westermann the person and the artist he was. It is probably not too much to say that during his hitches in the United States Marine Corps—in the Pacific theater of World War II (1942–46) and in the Korean War (1951–53)— Westermann's essential nature was bared, tested, smelted, and recast from the infernal crucible of war. These processes did not occur all at once or even rapidly. Westermann's character went through a long period of annealing during which the remarkable toughness and concentration of his nature came into being.

In some senses Westermann can be seen as the American "everyman." His persona also recalls certain icons of national culture, history, and legend. Like some of his protagonists, he was an odd amalgam of Herman Melville's cursed wanderers, Raymond Chandler's tough guys, and Walt Whitman's solitary individualists. In the service Westermann came to value friendship,

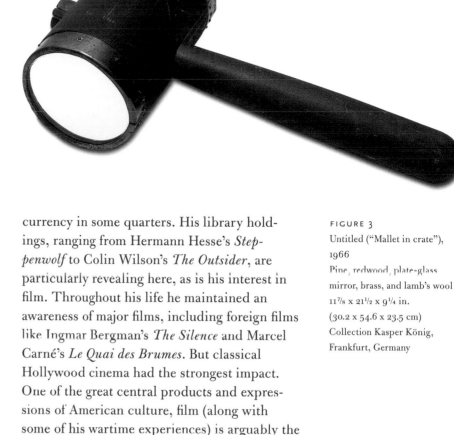

FIGURE 3
Untitled ("Mallet in crate"),
1966
Pine, redwood, plate-glass
mirror, brass, and lamb's wool
11⅞ x 21½ x 9¼ in.
(30.2 x 54.6 x 23.5 cm)
Collection Kasper König,
Frankfurt, Germany

FIGURE 4
Flying Thing (Male), 1958
Brass and glass
11³/₄ x 5¹/₈ x 4¹/₄ in.
(29.8 x 13 x 10.8 cm)
Lindy Bergman, Chicago

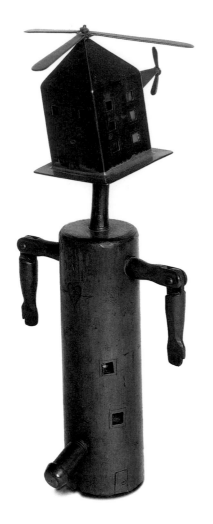

loyalty, and honesty. While there is the sense of the loner about his work—the artist was rigorously disciplined in his habits and eventually found city living unsuitable for them—he had an interesting and lively social life, maintaining personal contacts with other artists, friends, critics, dealers, and family. His hundreds of letters, many of them illustrated, detail the experiences crucial to his life and illuminate his ideas about art. In addition to an enhanced appreciation of the value of education, which he pursued with the help of his veteran's benefits during two periods at The School of The Art Institute of Chicago, Westermann had an intense regard for thoroughness and meticulousness in the execution of any project—priorities that his maternal grandfather, George Bloom, seems to have impressed upon him with his small boxes and other woodworking projects, some of which remain in the Westermann family.

The tempering of Westermann's extraordinary character, which started and gained momentum during his service in the marines and continued with his art-school experiences, culminated with his very happy marriage in 1959 to Joanna Beall, an artist he met in Chicago. Thanks to Beall's remarkably resilient character, exceptional artistic sensitivity, well-grounded common sense,

compassionate nature, and highly developed sense of humor and responsibility, the two achieved in their marriage a kind of Platonic wholeness of being. Westermann often remarked upon what he felt was an almost undeserved good fortune in having met and married Joanna Beall, and many who knew them were aware of the unusual intensity and depth of their relationship. Already by 1956–58 Westermann's work showed a remarkable force, innovativeness, and quality. But after Beall's appearance in his life, the work took on an increasing confidence and ambition, as if Westermann had become able to address transcendental emotions more profoundly and with a heightened sense of maturity.

By the time the Westermanns left Chicago for rural Brookfield Center, Connecticut, in 1962, most of the themes and directions of his subsequent production were present at least in some embryonic form. And artists, critics, scholars, and curators had begun to grasp that Westermann's art was, among many other things, a confrontation with the nature of reality both as human experience and as artistic exploration.[1]

Figures / *Personnages*

Given Westermann's essential humanism— his engagement with the human being as body, spirit, and mind—it is not surprising that the figure was one of his central and abiding preoccupations. Many of his figures, particularly the larger ones, address aspects of the Western sculptural tradition from antiquity through Auguste Rodin and into the twentieth-century vanguard: presentation of the figure scale, stasis versus motion, fragmentation. It is as if he wished to demonstrate that whatever other kinds of three-dimensional objects he produced, he understood sculpture in the older sense and could do it himself. The 1957 work *I Wonder If I Really Love Her?* (pl. 9) illustrates this well. Its form, the nude female torso from mid-thigh to just below the breasts, is traditional, as is its material, wood. It appears to be a solid and massive form; with its curving volumes indicating pregnancy it convincingly suggests that it safely contains another human entity. But, as we draw nearer to see the piece more completely, we find that its top is open, revealing that the figure is hollow and that the fetus within is not a three-dimensional volume but an image painted on a flat surface. Flatness is in fact inherent to the figure, which is made up of sheets of laminated plywood, its steplike layers drawing attention to its nature as a physical and artistic construct.

FIGURE 5
Oliver (The Outside Man), 1957
Pine, plywood, string,
and mirror
16 ³/₈ x 7 ³/₈ x 5 ⁷/₈ in.
(41.6 x 18.7 x 14.9 cm)
Robert Henry Adams Fine Art
and Ann Nathan Gallery,
Chicago

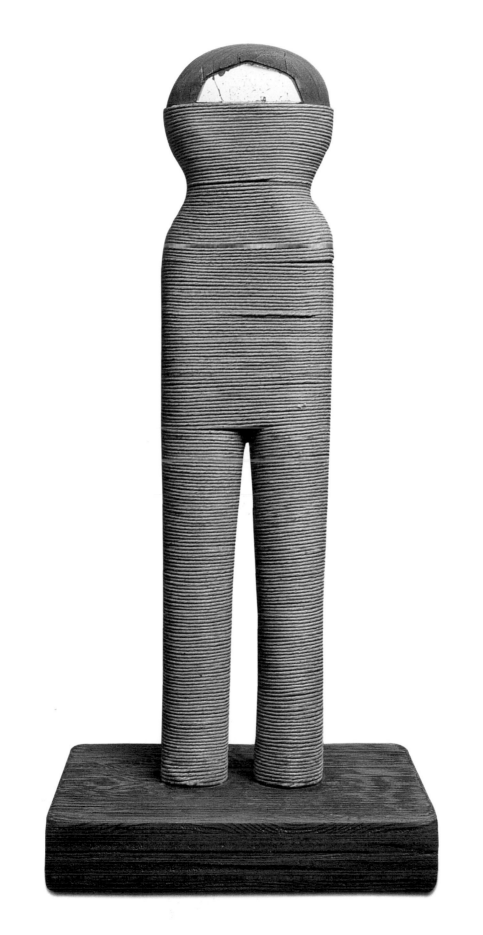

I Wonder If I Really Love Her? is a virtuosic manipulation, in form and material conforming to and confounding conventional expectations.

Westermann addressed and challenged the nature of figurative sculpture in other pieces, such as *Uncommitted Little Chicago Child* (1957; fig. 1, p. 35), composed of oak boards. Highly symmetrical and rigid, it scarcely suggests the organic and contradicts our sentimental expectations for the representation of children. But its stiffness directly correlates to its material—oak is one of the hardest of woods, associated with noble endurance and toughness. Thus Westermann allows us to see the subject, a child, in an unprecedentedly unyielding light and to view oak in a newly human way. Within the hollow interior of *Uncommitted Little Chicago Child*, we see the child's "heart," represented by a découpaged Victorian valentine image. This drop of mawkishness is the right seasoning for the harsh oak—the dash of sugar in the vinaigrette.

A *personnage* is a related form with some, but not entirely, human aspects or elements; it is a largely surrealist device employed frequently by Max Ernst, Matta, and Alberto Giacometti. Although Westermann did not necessarily have an affinity with these European modernists, he too found that the *personnage* served his expressive ends. *Angry Young Machine* (1959; pl. 24) (the title indicates that the piece may also fit in the category of machines) is an example of a figure that is more specifically a *personnage*, a construct whose general form is more or less analogous to human anatomy but whose individual parts do not correspond to human organs or features. The mechanical aspects of figures such as *The Silver Queen* and *Swingin' Red King* (1960 and 1961; pls. 28 and 29) suggest a process of dehumanization, on either the artist's or the viewer's part, that balances a tendency to anthropomorphize. These pieces are also interesting in that they are pendants, forming a male-female couple. When seen together, they

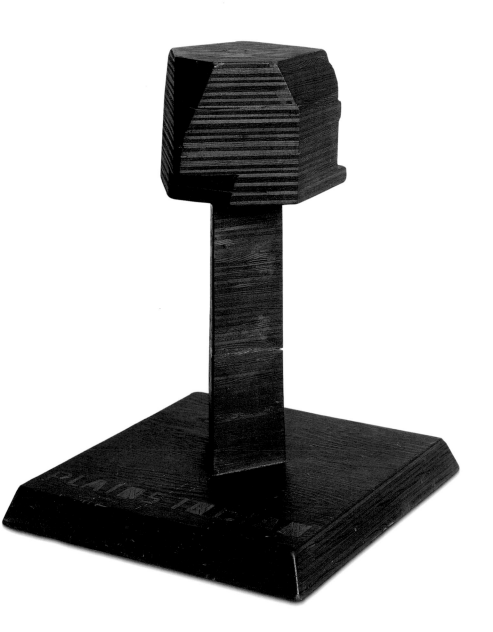

FIGURE 6
Plains Indian, 1957
Plywood
17 1/4 x 12 1/2 x 12 5/8 in.
(43.8 x 31.8 x 32 cm)
Errol and Kathy Ortiz,
Chicago

take on significations that each alone lacks, but the artist did not dictate their specific arrangement—perhaps acknowledging the element of hazard in human relationships.

The culminating work of Westermann's early figure pieces, notable for the depth and complexity of its imagery and meaning, is *Memorial to the Idea of Man If He Was an Idea* (1958; pl. 22). The title suggests that it is a reflection on what it is to be a human being. We may interpret the figure as male, due to its boxy proportions, wiry muscular arms, tattoos, and flat chest; moreover, the figures it contains—a headless baseball player made of metal and a wooden, armless trapeze artist—also read as male, certainly in the context of the late 1950s, when the work was made.[2] The imagery refers to Homer's *Odyssey*, specifically the episode of the cyclops Polyphemus, who trapped Ulysses and his men in a cave. After getting Polyphemus drunk and blinding him, the Greeks escape the cave by clinging to the fleecy bellies of the sheep that the cyclops is obliged to let out to pasture.[3] The blinded Polyphemus can only strike out aimlessly, like Westermann's headless baseball player; the Greeks hang upside down from the sheep, as the armless acrobat hangs from a trapeze in the work's interior.

Yet Westermann's *Memorial* is not strictly, or even primarily, illustrative. His inflection of the myth seems to turn on the concept of civilization and its contradictions. Ulysses and his men are "civilized" warriors who employ cunning and guile to defeat their "primitive" foe who, after all, is only defending his territory. The cyclops' single eye perhaps indicates that he can see things only from one point of view, but the more sophisticated, multidimensional perspective enjoyed by human beings brings with it existential anguish. (Monocular vision is a theme in several works of the late 1950s and early 1960s;

see also *Oliver [The Outside Man]*; fig. 5, p. 39.) The small painted figure on the reverse of the window in *Memorial*'s turreted head is surely trapped within the prison of dawning intelligence and awareness. Ultimately, Westermann proposes, each person must seek a balance between and among the different properties of human nature, while accepting the fundamental impossibility of defining humanity itself. As the title asks, is man a physical entity or an idea, or both? In what sense can he be memorialized, and for whom? These existential questions concerned Westermann throughout his life. His last work, *Jack of Diamonds* (1981; pl. 115), a life-sized wire-lath figure that contains nothing but whatever dust naturally accumulates inside it, is a poignant commentary on the fragility of the physical body. Its true contents, its heart and soul, are represented through their absence.

Houses / Architecture / Furniture

If the human figure is one of the central focuses of traditional sculpture, the house or building is quite rare as an autonomous sculptural form. For one thing, objects such as dollhouses, doghouses, and peep-show boxes—and objects that may take houselike form, such as thuribles, censers, and reliquaries—are generally regarded as peripheral to high art. For another, models constructed by architects, builders, carpenters, and contractors are considered solely in terms of their function; that is, subordinate to the full-scale object proposed. An exceptional form that manages to serve as both sculpture and architecture is the tomb or funerary monument: not inhabited in the usual sense, it often takes the form of a building and may in fact house something.

FIGURE 7
Untitled (for Caroline Lee),
c. 1956
Walnut, ebony, pine,
and bronze
9 1/4 x 13 1/2 x 9 1/2 in.
(23.5 x 34.3 x 24.1 cm)
Caroline Lee, Paris

FIGURE 8
A French House, 1979
Pine crate, ebony, and ink
15 1/2 x 12 5/8 x 10 3/4 in.
(39.4 x 32.1 x 27.3 cm)
Sharon and Thurston
Twigg-Smith,
Honolulu

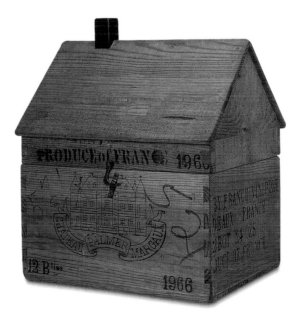

Westermann extended this notion of conflated forms to produce a number of fascinating sculptures that are architectural in a variety of ways. After initial experiments with relative abstraction or reduction—in terms of rounded solidity in *I'd Like to Live Here!* (1955), and through flat relief in *City* (1954) (see Lynne Warren essay, p. 56), two pieces that evoke an idea of a place perhaps more than a structure—he began literally to open up and fill his houses, inviting viewer engagement through his presentation of intriguing apertures and his embrace of disparate materials. In addition, he adopted the house as a motif, either on its own (in *Log Cabin* [1968] [see Michael Rooks essay, p. 75, or *A French House* [1979; fig. 8, p. 41], for example) or as a part of a larger context (in *Vent for a Chicken House* [1967] or *Yellow House and Death Ship* [1972]).

Extending the category even further are works related to other architectural forms, such as towers or monuments. For instance, *Plains Indian* (1957; fig. 6, p. 40), with its rough-edged plywood layers, recalls the stratifications of the Great Sphinx of Giza as well as a sphinx-shaped real-estate office that once stood in the Los Angeles neighborhood of Westermann's youth. There are also works related to the raw materials or basic components of building, such as *Little Egypt*, a free-standing post-and-lintel construction containing a door that opens and closes (1969; pl. 75), and *Scarf Joint* (1970).

Westermann's house sculptures are neither practical habitations nor miniaturized models for larger works. Their meaning often depends on a carefully established interaction between exterior and interior. Important early examples such as *The Old Eccentric's House* (1956–57;

fig. 9), *Mysteriously Abandoned New Home* (1958; pl. 17), and *Mysterious Yellow Mausoleum* (1958; fig. 2, p. 36) all have interior spaces that can be seen, at least partially, and that are important elements in the experience of these pieces.

This is also true of *Mad House* (1958; pl. 19), whose ambiguous message begins with its title: Is this house mad in the sense that it (like an asylum) contains mad occupants, and in what sense is the word "mad" used—angry or insane or both? Invested with human properties—an ear, a leg, a fist; the legs of a standing, headless female figure—the house also can be considered within the category of the *personnage*, evoking the human family or tribe. Specifically architectural features such as the steeple and windows suggest a church or a schoolhouse, which accommodate other kinds of human collectives. In any case, we are well beyond the simple notion of a dwelling and into a metaphysical consideration of the human mind. The work's enigmatic interior, glimpsed through small windows and doorways, is complex and intricate. Here, Westermann parallels ideas in Hermann Hesse's *Steppenwolf*; Hesse's statement about the complexity of the individual's psychosexual makeup has universal applications.

The appearance of the house form in Westermann's work is closely tied to events in his life. *Burning House* (1958; pl. 16), a gift that Westermann made for his soon-to-be wife Joanna Beall, belongs to his first engagement with the theme and suggests both his preoccupation with the theme of entrapment within one's own mind and his desire to settle down with his true love, then in the process of divorcing her first husband. *Dovetailed House* (1979; fig. 10), made twenty years later, heralded a return to the motif and speaks to another phase of his life, during

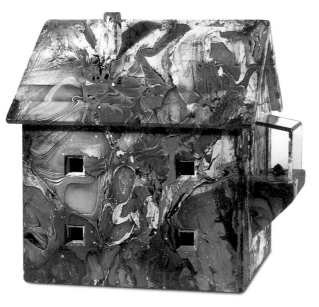

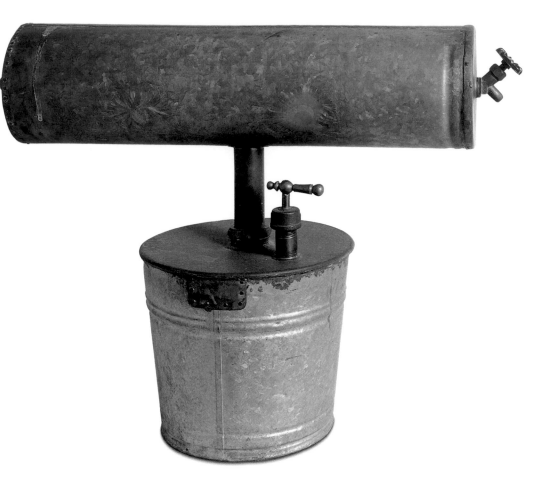

FIGURE 12
Steam Making Machine, 1966
Galvanized steel, galvanized
sheet metal, tin bucket,
pipe fittings, and copper plate
20 1/2 x 26 1/2 x 10 3/4 in.
(52.1 x 67.3 x 27.3 cm)
Private collection

which he was constructing a house for the couple
to share (see Michael Rooks essay). This mar-
bleized polychromed structure does not claim to
shut out all of life's unpleasantness — a cast-lead
rat scurries about inside — rather, it accepts
unpleasantness. In his mature years, Westermann
had come to equate the strength and beauty of a
dovetail joint, even if invisible, with the founda-
tion of a good home and a good life.

Death Ships

The category that is most enduring in Wester-
mann's work— in that it is literary and, in
many cases, literal— is that of the Death Ship.
Not all of the Death Ships are identified as
such by title, but they are always identifiable by
virtue of their forms and connotations. Like
recurring characters in an adventure tale, they
undergo various disasters: some are burned or
still hot; others are run over, dismasted, sinking,
listing; still others are adrift or abandoned.

Ships are extremely flexible carriers of mean-
ing. In various cultures, they have long served as
symbols for the human being's fate in the world
and as the means of delivery from one world to
another. Westermann drew upon a great tradition
of literary, artistic, and musical imagery when
devising his Death Ships: Frederick Marryat's

late gothic romance *The Phantom Ship* (1839),
B. Traven's novel *The Death Ship* (1934), Albert
Pinkham Ryder's painting *The Flying Dutchman*
(c. 1887), Winslow Homer's painting *The Gulf
Stream* (1899), and Richard Wagner's opera *The
Flying Dutchman* (1841), to name just a few.
Beginning in 1955, with *Derelict's Funeral*, and
continuing to 1980, with *Death Ship, Out of
San Pedro, Adrift*, the artist explored the theme
in all its diversity, from the allegory of the
"ship of fools," through the funerary boats of
the Egyptians and the Vikings, to vanished
or abandoned vessels of the twentieth century
such as the *Marie Celeste* and the *Mary Deere*.

Of course, Westermann had served aboard
ships in World War II, and these experiences
inevitably form a layer of iconography in his
Death Ships. The early emergence of the motif
in Westermann's sculptural output attests to
its importance, but for many years he seems to
have preferred to attach it to literary or pictorial
precedents rather than to his own vivid memo-
ries of the horrors of war. His earliest Death
Ships, made in the 1950s, are masted boats with
solitary figures aboard. By 1965 the ships began
representing steel-hulled or merchant marine
vessels, all abandoned, and their allusions were
more contemporary. *Death Ship Runover by*

a *'66 Lincoln Continental* (1966; pl. 53), a Death Ship drifting on a sea of money and encased within a vitrine, alludes to the shark-infested waters of the South Pacific Ocean, where Westermann had served, and the sea of dollars alludes to the more political and economic forces contributing to the Vietnam War, then being waged. The named ship in the later work *U.S.S. Franklin Arising from an Oil Slick Sea* (1976; fig. 11, p. 43) is a direct recollection of his encounter with the aircraft carrier, charred, burned, and damaged, but not yet sunk. Here harsh reality and horror predominate, so that the ship is not a toy or model but a frightening, toxic object, part of a narrative that cannot have a happy ending.

Boxes

The notions of utility and its negation are central to the box category of Westermann's work. Boxes can be containers or independent objects, and Westermann clearly enjoyed playing with this duality. Taken together his boxes form a large and varied category; many examples are connected in meaning, function, and material to works in other categories. The box, like the house, is a metaphysical construct, frequently suggesting entrapment, especially in early works (*A Soldier's Dream*, [1955; pl. 1], for example). A box may even contain another container, as in the group of boxed Death Ships. A coffin, of course, is a box, and a form that Westermann confronted and somewhat inventively altered in the pieces *A Human Condition* (1964; pl. 45) and *Coffin for a Crooked Man* (1979; pl. 108). Counterbalancing this pessimistic inflection, the artist also frequently adopted another conventional use of the box: as a container for a gift (Untitled [for Ann Davidow] [1956–57]; pl. 18). Even here, however, he sometimes injected a note of irony, as in *Untitled THIS IS TITLE* (1964; pl. 44), a somewhat sinister box dripping with blood-red paint and inscribed with the question, "Maybe this is a gift box???"

Although Westermann's boxes can be linked to those of Joseph Cornell, whose work Westermann saw at the Allan Frumkin Gallery in Chicago and in the collection of Mr. and Mrs. E. A. Bergman, also in Chicago, a more direct influence can be found in Westermann's own history: his grandfather George Bloom, a maker of heirloom boxes as well as of coffins. The suicide of his grandfather, never spoken of by the family, perhaps accounts for the deliberate hermeticism of a Westermann box such as *Secrets* (1964), a small walnut box whose lid is hinged on both sides.

Other examples are more playful, as if the artist wanted to celebrate rather than mourn his ancestor and the folk-art tradition he represented. One of Westermann's most ingenious plays upon the box form is *Imitation Knotty Pine* (1966; pl. 54). This box is eccentric in form—the front and back are parallelograms and the short ends are canted, so that it appears pushed out of shape from some angles but "drawn" in perspective from other points of view. It is also eccentric in material. Made of clear pine, it features shallow inlays of knots from knotty pine, a delicate operation that results in an ironic deception: it is knotty pine on the outside, but not on the inside. Just the opposite occurs in *Walnut Box*: it is made of walnut, is labeled as such, and contains walnuts. And *Ebony* (1968; fig. 13) is ebony by name but not by nature, as if the artist is sending up his own core belief that an object is what it is all the way through.

Beginning in the late 1960s, Westermann incorporated boxes into his work in the form of crates or cases meant both to protect pieces during shipping or storage and to serve as display bases that were undoubtedly superior in quality to the temporary, hastily constructed pedestals often found in museums and galleries (see Untitled ["Mallet in crate"] [1966; fig. 3, p. 37]). Of course, today Westermann's crate/pedestals are themselves often displayed on the very bases they were intended to replace, an irony that the artist might have enjoyed.

FIGURE 13
Ebony, 1968
Pine and brass
14⁵/₈ x 16 x 13 in.
(34.1 x 40.6 x 33 cm)
Private collection,
New York

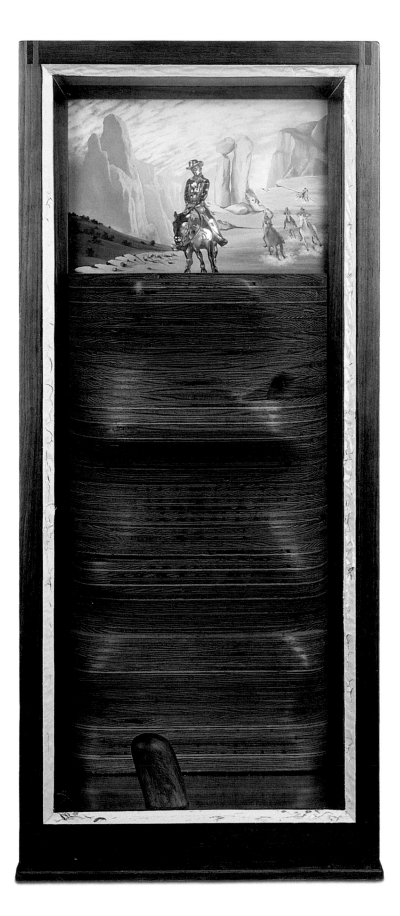

Tableaus / Vitrines

Westermann's tableaus bring together elements from all of the other categories, encompassing all of his themes and materials. Formally, there are a few basic types. Glazed boxes, with one side of clear glass, and vitrines, with more than one clear wall, are one type; platforms (unprotected by a glass cover or case) are another.

The fact of a platform helps to define a tableau as such, making narrative an issue. Westermann implied narrative both through the placement of objects on the base as well as through the nature of the objects themselves. They range from the mute mystery of *The Old Eccentric's House* (1956–57; fig. 9, p. 42), the first of the group of early houses as well as one of the most provocative of the early open tableaus, to the political commentary in *String & Paper Men* (1957; pl. 14). This last work recalls Giacometti in its arrangement of figures along the base; while the Italian artist's figures — with their attenuated bodies integrated into their bases — express the melancholy existentialism of the immediate postwar era, Westermann's figures, carved of wood, aggressively face (and possibly accuse) the viewer, as if challenging the racially segregated reality of the 1950s in America.

The many open tableaus of Westermann's early career give way to the glazed boxes or vitrine works that populate the 1960s and 1970s. The glazed boxes of the early 1960s, a relatively concentrated grouping exemplified by *The Last Ray of Hope* (1968; pl. 79) and *The Battle of Little Jack's Creek* (1969; pl. 72), provide a formal bridge to what might be called the vitrine tableaus, such as *A Family Tree* (1964) and the enigmatic *Control* (1968). Enclosure of the elements within a glass box transforms the implied narrative: whatever that narrative may say, it is held apart from the viewer and protected by its container, which inevitably calls to mind ideas of protection and preservation. The vitrines render their contents more precious and more mysterious, and it is instructive to compare later tableaus such as *Phantom in a Wooden Garden* (1970; pl. 77) with vitrine works like *A Close Call* (1965), which both feature *personnages* of one variety or another. The stick figure in *Phantom in a Wooden Garden* might seem to be merely passing through the tableau of elements; the figure in *A Close Call* is captured and pinned down, a specimen to be examined, caught in a glass box that has been penetrated by a wooden dagger. Of course the cracks in the piece are painted, further complicating the question of what exactly the glass is protecting: the fox-headed figure from the dagger, or the unknown dagger wielder? In this way Westermann deployed the vitrine itself as an essential component of the work's paradoxical meaning.

Machines / Tools

The "cracked" vitrine in *A Close Call* ironically draws attention to the inherent strength and structural reliability of Westermann's objects. Integrity of construction was one of his central preoccupations, and his choice of materials and of the implements and methods with which he shaped or combined them was always conscious. Instructions inscribed on pieces often give practical information about their handling, maintenance, or mounting, the assumption being that

FIGURE 15
Untitled ("Old Hammer Head with a Rosewood Handle"), 1970
Pine, rosewood, iron claw hammer, and suede
4¹⁄₂ x 16 x 6 in.
(11.4 x 40.6 x 15.2 cm)
Wichita Art Museum, Kansas, Gift of the Friends of the Wichita Art Museum, Inc. (1971.7)

FIGURE 16
Machine, 1977
Pine, sheet copper, aluminum alkyd enamel, oak, and sheet metal screws
23³⁄₄ x 36¹⁄₄ x 24 in.
(60.3 x 92.1 x 61 cm)
Private collection

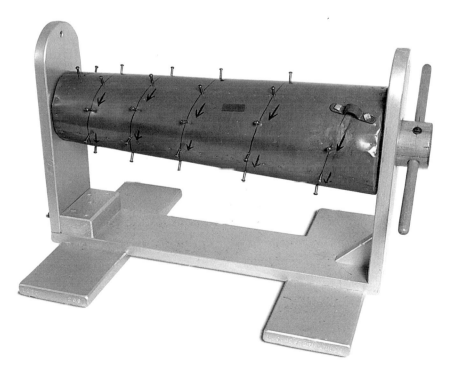

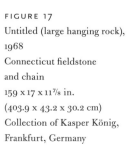

the owner will understand and respect the care that went into their making. On *Yellow House & Death Ship* (1972), for instance, Westermann punched the statement, "Walnut—& there isn't much left you know," and wrote the reminder, "Now when this piece is shipped I want these <u>same 2 screws</u> used to secure this lid—because they are the right size! Fragile / Do not drop!"

The machine, understood in its most basic sense as a construction of various parts, was a theme through which he could satisfy his obsessions with craftsmanship and physical activity—and, in many cases, indulge his love of paradox and punning. Functionality is often an issue in the machine/tool pieces, but rarely simply. In *Homage to American Art (Dedicated to Elie Nadelman)* (1966; pl. 57), for instance, a bentwood shovel handle ends unexpectedly in a ball of laminated redwood. It cannot be used to shovel anything nor can it stand upright: it can only exist on the hook that the artist devised for it. Westermann here acknowledged his affinity for Elie Nadelman with great subtlety: rather than literally quoting the Polish-American sculptor, he referred indirectly to Nadelman's unconventional use of materials and to his impeccable craftsmanship.

Even objects that Westermann seems to have developed for practical use—*Steam Making Machine* (1966; fig. 12, p. 44), used for bending laminated plywood; and *Machine* (1977; fig. 16, p. 47), built to bend copper pipe for the sculpture *The Wild Man from Borneo* (1977; pl. 105)—ended up as works of art themselves. This conceptual move also gives double meaning to implements such as *The Slob* (1965), *Nouveau Rat Trap* (1965; pl. 52), Untitled ("Old Hammer Head with a Rosewood Handle") (1970; fig. 15, p. 47), Untitled (California redwood) (1966; fig. 3, p. 37), *Negate* (1965; pl. 49), and the dust pan pieces. In other cases, Westermann made the opposite move: in Untitled (large hanging rock) (1968; fig. 17), he made a Connecticut fieldstone that might have served as a freestanding sculpture into a device of sorts, a pendulum that must be suspended from the ceiling.

FIGURE 17
Untitled (large hanging rock),
1968
Connecticut fieldstone
and chain
159 x 17 x 11⅞ in.
(403.9 x 43.2 x 30.2 cm)
Collection of Kasper König,
Frankfurt, Germany

The simultaneous ease and unease with which some of Westermann's machine sculptures occupy the spaces of art inevitably recalls both Marcel Duchamp and Alexander Calder. *Antimobile* (1965; see Robert Storr essay, p. 21), a descendant in some sense of Duchamp's *Bicycle Wheel* (1913), is clearly constructed to turn smoothly and heavily on its steel axis. It is also a demonstration of Calder in reverse: wood rather than metal; standing instead of hanging; volumetric, not planar. The wheel thus tempts the viewer to violate museum or gallery taboos and touch the art object, but turning it would only reveal its nonutility, just as in *Negate* our recognition of the tool forms, two carpenter's planes, coincides with our realization that they cannot function as such because they are connected face to face by a chain link. Here both emotional and intellectual elements enter into an example from a category that, unlike others in Westermann's oeuvre, begins from primarily material concerns and acquires conceptual significance rather than the reverse.

LIKE A CUSTOM HONORED more in the breach than in the observance, many of Westermann's works deliberately escape from the categories that would seem to define them so readily. At one level, a Westermann piece is almost always what it is, all the way through: his bronze casts are solid, not hollow; his joins are often glued, screwed, and doweled, not merely nailed; his houses are not models. Yet this straightforwardness is the point of departure for much more complicated interpretative approaches. Even a relatively unassuming piece such as *Flying Thing (Male)* (1958; fig. 4, p. 38) conflates two motifs, the house and the human figure, and perhaps some autobiographical episode such as Westermann's temporary separation from Joanna Beall while she awaited finalization of her divorce. An ambitious work such as *The Wild Man from Borneo* (1977; pl. 105) has aspects of nearly all the categories discussed above and recalls such pinball machines that inspired Joseph Cornell's *The Forgotten Game* (c. 1949), a work in the

Bergman Collection of Cornell boxes in The Art Institute of Chicago. It incorporates a life-sized head and an architectural tower; it is rigged to function as an interactive machine, for ball bearings can be dropped down a chute, through the mouth, and into a box; all these elements are affixed to a base that presents them as a tableau.

However odd, unexpected, or eccentric the forms, images, and ideas of Westermann's objects may be, they radiate a sense of completeness, giving the impression that nothing could be added or taken away and that the wholes are more than the sum of their parts. Westermann's intensely focused body of work is intimately bound up with his own experiences, but it is his ruthless examination of those experiences that makes it revelatory of larger human concerns. Full of references to art history, literature, film, music, history, sociology, and politics, to craft methods and mass production, it reverberates tellingly with the culture of which he was a product and observer. Hermetic and ironic, a Westermann object deals with elemental experiences and plain but harsh truths.

1. See bibliography: Kuh 1959, Schulze 1959–62, and Speyer 1956.

2. Westermann used the head of the baseball player in the interior of *Mad House* (MCA 36; plate 19).

3. *Odyssey*. Book IX.

"Right Where I Live": H. C. Westermann's American Experience

Lynne Warren

ARRIVING AT CHICAGO'S UNION STATION by train in August 1947, Horace Clifford Westermann, honorably discharged from the United States Marine Corps on July 13, 1946, was leaving a violent wartime world unimaginable to most Americans living today and entering a world, though peaceful and boundless with promise, that is almost equally hard to conceive (fig. 2, p. 52). Chicago in the late 1940s certainly could not have seemed an overwhelming place for this battle-hardened soldier. Born and raised in Los Angeles, Westermann had worked in the timber industry up and down the Pacific Coast, seen horrifying action in the South Pacific theater of World War II as a gunnery mate aboard the legendary aircraft carrier U.S.S. *Enterprise*, traveled to Japan and China as an acrobat in the U.S.O., and spent more than a few hours drunk and in the brig.[1] The only poetry found in Chicago, a city dedicated to industry and mercantilism, was that penned by Carl Sandburg, celebrating its slaughterhouses and criminal element.[2] A far cry from the golden land of make-believe in which Westermann had grown up, Chicago was a grim, dirty place (see figs. 3 and 4, p. 52); the Union Stockyards on the city's near Southwest Side sent their stench north on the wind, and the steel mills along the South Shore bellowed black smoke and an equally disagreeable smell. A relentless Democratic machine governed an astonishingly

FIGURE 1
Tension, 1967
Oak, pine, vermillion, paint, brass, and rubber bumpers
20 3/4 x 28 x 9 1/4 in.
(52.7 x 71.1 x 23.5 cm)
Los Angeles County Museum of Art, The Harry and Yvonne Lenart Fund

diverse populace that included immigrants from virtually every European country and numerous African Americans relocating from the South.

A married man twenty-five years of age, Westermann found lodging at 2246 West Division Street, on Chicago's West Side.[3] Located between the major north-south arteries Damen and Western Avenues, this apartment building was in the midst of a long-established, primarily central European, ethnic area that would be enervated by white flight and race riots in the late 1960s and early 1970s. Further west, slums stretched for miles and miles.

Westermann had come to the city to study advertising design at The School of The Art Institute of Chicago (S.A.I.C.), one of America's few art schools, which he had learned about from a fellow serviceman aboard the *Enterprise*.[4] The S.A.I.C., downtown on Michigan Avenue, would have been a good half-hour to forty-five minutes away by bus and a world apart from the rough life on West Division Street, so well described in the tough, lowlife prose of Nelson Algren's Chicago-based novels. If one judged by his exterior, Westermann—a hard drinker and smoker (of cigarettes, later cigars)—would have seemed a better fit with the working classes of the West Side than the sophisticates attending art school, but beneath his tattoo-adorned chest (including bluebirds that swooped over each nipple) he had a passionate, even tender, heart.

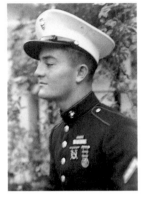

FIGURE 2
H. C. Westermann, c. 1945

FIGURE 3
View showing Polk and Clark Streets (northwest corner), Chicago, 1951. Courtesy Chicago Historical Society ICHi-13924; photograph by Tedward A. Dumetz, Jr.

He had grown up in a hardworking family in a city with little history beyond the stories and dreams spun by Hollywood. He had early shown artistic talent. At age sixteen, Cliff—as he was called by friends—submitted drawings of Snow White and the Seven Dwarfs, rendered after the recently released movie, to Disney Studios. The drawings were good enough to garner a job offer, which was rescinded when the studios discovered how young he was. He was handy, as well, and showed great initiative. At fifteen, in order to have his own room, he had built an addition onto his family's home with scavenged lumber.

A handsome man with a thick head of hair and a perfectly toned body, Westermann would

FIGURE 4
View from the Tribune Tower (looking south along Michigan Avenue; Art Institute of Chicago near center of image, abutting street), Chicago, 1946; Courtesy Chicago Historical Society ICHi-31800; photograph by Frank Stover.

find work as a model for sketching classes at the S.A.I.C. (see fig. 5). His great strength allowed him to work during the summer breaks for a moving company.[5] But things were difficult for Westermann, as they were for thousands of returning G.I.s. Housing and other basics were in short supply. The luxuries were few — a drink at the local bar, an occasional movie, a night out at a supper club. In the summers Westermann particularly liked to meet with friends at the North Avenue Beach House, a building on Lake Michigan in the shape of an ocean liner.

Historically, the S.A.I.C. had been a genteel place, where a mostly female student body drew from plaster casts and copied the museum's impressionist masterpieces in nearly deserted galleries. This changed dramatically in the post-war years. Filled with drive and the desire to overturn the dusty, antimodern traditions in which Chicago and especially the Art Institute were mired, students such as Leon Golub, Joseph Goto, Miyoko Ito, Ellen Lanyon, June Leaf, Claes Oldenburg, Irving Petlin, and Ray Yoshida experimented with bold abstraction or tortured figurative expressionism.[6] Like Westermann, many of these students were G.I.s who had seen bloody, violent action; because of their war service, they were older than the average undergraduate and were highly self-motivated. It must not be forgotten that for men of Westermann's generation, life as an artist was not only condemned as being effete, it was impractical. Artists, even successful ones, could barely make a living. For a married man expected to support his family, a choice of this career path would have been doubly frowned upon. And a year after relocating to Chicago, Westermann had another mouth to feed. His only child, Gregory, was born in 1948 (see fig. 7, p. 55).

Although he had enrolled in the S.A.I.C. to study commercial art, Westermann soon realized, as he passionately recalled in a 1958 letter to his sister Martha Renner, that he had fine-arts ambitions (see Michael Rooks essay, p. 65). He was only able to realize these ambitions several years later, after great personal upheaval. In 1949 Westermann's wife left him, citing his neglect of the family due to his artistic ambitions and taking their infant son. In August 1950, motivated by his deep sense of patriotism, Westermann re-enlisted in the Marine Corps to fight in the Korean War. This second military experience changed him profoundly. He became very close to a number of marines from his unit in Korea, and the death of some of these men haunted him for the rest of his life, especially that of Corporal Paul "Stick"

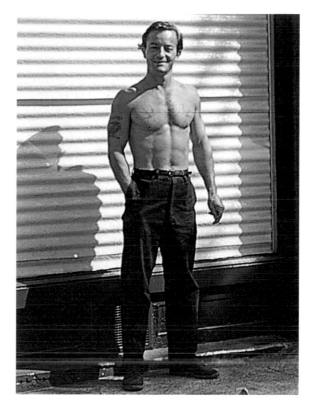

FIGURE 5
H. C. Westermann in Chicago, c. 1950s. Photograph by Phillip Fantl, Chicago, courtesy estate of Joanna Beall Westermann.

Flower. Westermann would later make a number of works in Flower's memory, including *Monument for a Dead Marine* (1957; fig. 8, p. 55). Although he had seen mass death and unimaginable horrors during World War II, in Korea these horrors struck him personally — perhaps in part because he could not fully believe in the cause at stake.

In March 1952 Westermann was discharged from the marines with the rank of sergeant.[7] Thus, five years after first arriving in Chicago, he returned and re-enrolled at the S.A.I.C., now to study painting. Along with his evolving convictions, a new life was opening up for him, a life in sync with the tenor of the times. America was flush with prosperity; television and modern advertising were hurrying along change. His divorce was finalized. Westermann still called Division Street home, but he now lived in the basement of a building on Division and Lake Shore Drive, in the heart of Chicago's wealthy Gold Coast district. The home of future legendary collector Morton G. Neumann was nearby; the S.A.I.C. was a brisk twenty-minute walk straight down North Michigan Avenue, past a handful of new galleries, including the Allan Frumkin Gallery, soon to become a central focus of Westermann's life. Earning a living by doing odd carpentry jobs and other handiwork, he was learning the woodworking skills that would shortly enable him to express his deepest feelings.

FIGURE 6
Death Ship of No Port, 1957
Pine, canvas, bronze, wire,
and paint
24¼ x 30½ x 3⅝ in.
(61.6 x 77.5 x 9.2 cm)
Museum of Contemporary
Art, Chicago, Gift of John F.
Miller (1995.121)

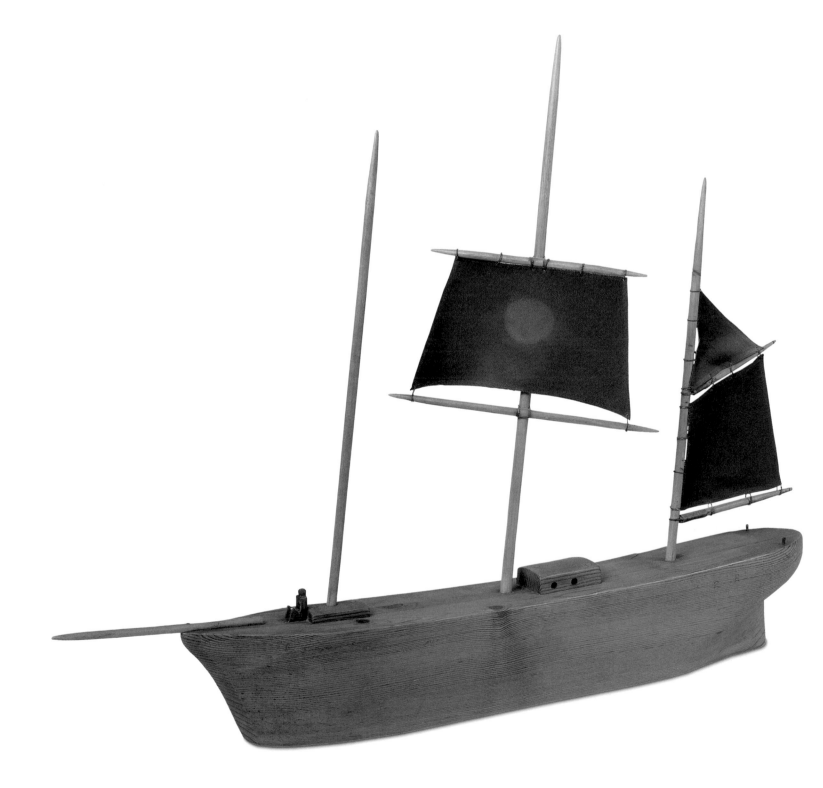

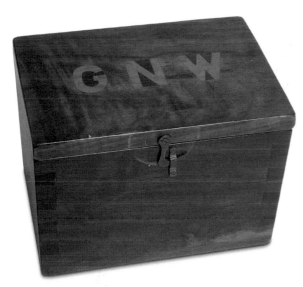

FIGURE 7
Untitled (for Gregory N.
Westermann), 1979
Vermillion, bird's eye maple,
and brass
7 3/8 x 9 7/8 x 6 7/8 in.
(18.7 x 25.1 x 17.5 cm)
Museum of Contemporary Art,
Chicago, Gift of Gregory N.
Westermann in memory of
H. C. Westermann (2000.18)

ONE CAN ONLY IMAGINE what might have happened if, aboard the U.S.S. *Enterprise,* Westermann had been advised by a shipmate to seek his artistic fortune at the Art Students League in New York. This hard-drinking man could very well have fallen in with fellow Californian Jackson Pollock, who in the late 1940s was already emerging as a major artist, and taken up the great struggle of abstract expressionist painting. After all, painting had been Westermann's first passion (see fig. 10, p. 56). He probably would have hovered around the periphery of the group of émigré artists—Willem de Kooning, Piet Mondrian, Hans Hofmann, and others—who had escaped the same conflict in Europe to which Westermann had given his youth and innocence in the Pacific. And one can imagine that Westermann would not have been very happy.

A plain-talking man who considered himself quite average, Westermann showed a corresponding disdain for pretension. The affectations of the New York art world would surely have grated on him. Although he had traveled widely during his wartime and U.S.O. service, Westermann never went to Europe. His treatment on the occasion of his first show in New York City, the famous *New Images of Man* exhibition held at The Museum of Modern Art in 1959, probably confirmed his suspicions about the art capital's elite. Of the

out-of-towners, Westermann was singled out for particularly scathing criticism by the leading critic of the day, John Canaday. Writing in the *New York Times,* Canaday characterized the Chicagoan as "a guest who arrived in a clown suit, forty years late for a costume party, to find a formal dinner in progress."[8] Needless to say, such overweening snobbishness would not have sat well with a man of Westermann's character.

In Chicago, Westermann stumbled across a paradoxical art scene — a group of passionate individualists who were forced into intense cooperation by the lack of exhibition venues. Chicago's legendary *Momentum* exhibitions, the first of which was held in 1948, were to New York's museums and galleries as the backyard shows portrayed in numerous Rooney-Garland movies were to Broadway theater. The "kids" got together and put on their own shows.[9] They met at parties and socialized at each other's apartments. There was no established way of doing things, no entrenched art network. Artists of the immediate postwar years in Chicago made it up as they went along. Westermann gladly helped out his fellow artists when a group of enthusiastic S.A.I.C. students organized a *Momentum* show in 1956, volunteering to design and construct the boards upon which the artworks were to be hung in the donated space in the College of Jewish Education. Yet it seems Westermann did most of this work alone, while the other participants focused on readying their own works and preparing the catalogue.[10] This willingness to help his fellow artists while always following his own path soon became a well-known aspect of Westermann's character.

If fate had led Westermann to New York, most likely he would have left very quickly, realizing it was not right for him — although given his perseverance and sense of loyalty, one can imagine him frustrated and unsuccessful as a third-rate abstract painter, suppressing his true nature in order to make a go of it and not let down his friends. If— to stretch the imagination even further—Westermann had in New York taken up carpentry and created wood sculptures similar to his early Chicago production, even greater scorn would have been heaped upon him.[11] For an artist unwilling to go along with the prevailing mode, Chicago was a refuge. Outside the ken of most New Yorkers of the day, Chicago was simply not taken very seriously.[12] The figurative, emotional expressions being made there, if known at all, were considered odd and out of step with the refined, formal aspirations of the New York art world.

FIGURE 8
Monument for a Dead Marine, 1957
Oak, walnut, ebony, and bronze
21 1/4 x 2 3/4 x 2 7/8 in.
(54 x 7 x 7.3 cm)
Private collection

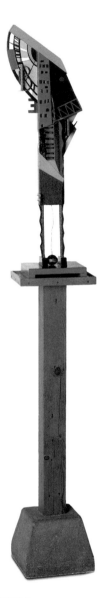

FIGURE 9

City, 1954
Wood, concrete, paint,
glass, lead, stained glass,
wire, and sandpaper
74¼ x 11 x 10¾ in.
(188.6 x 28 x 27.3 cm)
Museum of Contemporary Art,
Chicago, Gift of Stefan Edlis
(1986.59)

As David McCarthy has astutely pointed out, "So much of what we know about H. C. Westermann is wrapped up in myth that we tend to forget just how much he was a man of his place and time."[13] Westermann was indeed a typical American man of the World War II era—modest, hardworking, respectful of national values and ideals—who also happened to be a profoundly sensitive individual who was very good with his hands. Now, just after the turn of the twenty-first century, many in the contemporary art world have little notion of World War II aside from mythic images gleaned from movies such as *Stalag 17* (1953) or *Sands of Iwo Jima* (1949). And even though many who shaped contemporary art in the 1950s and 1960s had served in the military, the art they created elided this experience and concerned itself largely with formal advances. Even those movements that explored the social fabric of America, such as pop art, were not primarily perceived as doing so at the time of their emergence.

Yet the reality of the postwar era was that millions of American men and women had served in the war; countless more had suffered through shortages, rationing, and, worst of all, the loss of their spouses, parents, children, and siblings. The country then reaped the benefits of World War II: rapid industrialization and specialization, explosive consumerism, and suburbanization that irrevocably changed the landscape. The "real" America was not to be seen in the esoteric color-field paintings of Mark Rothko or Ad Reinhardt, but in the Coca-Cola bottle and the Chevrolet car of suburban life. In the 1950s America was concerned with the cold war and McCarthyism and the evaporation of agrarian life and its values, not with eternal truths revealed by deep meditations on paint on canvas.

While it might seem logical that an artist who had witnessed the darkest manifestations of humanity in modern history's most hideous rupture would be compelled to make solid, beautifully put-together objects, as Westermann did, his was in fact an eccentric response. While the European émigré artists exorcised the unspeakable tragedy and dislocation of their experience by suppressing narrative in reductivist paintings, American artists tended—like the country at large—to bury narrative in a heap of things. It was as if one could forget the horrors of the war by pursuing the American dream of material comfort and security through conspicuous consumption. Many of Westermann's contemporaries, such as Robert Rauschenberg (see fig. 12, p. 58), Andy Warhol, Pollock, and Jasper Johns in New

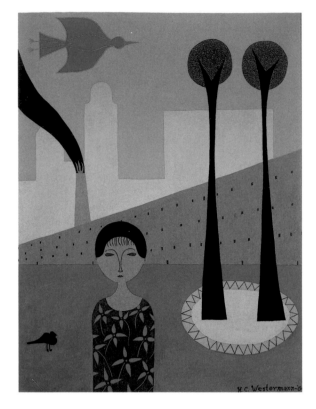

FIGURE 10

Untitled, 1954. Oil on canvas. 39½ x 29½ in. (100.3 x 74.9 cm). Museum of Contemporary Art, Chicago, Gift of Herbert K. Reis in memory of his sister Jory Graham (1983.77).

York, or Ed Kienholz and Ed Ruscha on the West Coast, made highly ephemeral objects with the most untested of means: assemblages of materials most people would rightly call junk, canvases covered with house paint or transfers from newspapers, and collages of items likely to yellow and discolor culled from the "mass culture," as it was then commonly called. Art critics mistook much of this activity as "experimentation" when in fact it was a flat-out race to escape the brutal realities of the age; along with the millions who had died, so the old ways of life had been destroyed. American life was no longer centered on the farm or small town.[14] The nuclear genie had escaped from its bottle, and a future—that of total global annihilation—even more terrifying than the immediate past was a distinct possibility. In urban centers the nascent civil rights movement drew attention to discriminatory Jim Crow laws, and in general, change was in the air.

In the late 1950s and early 1960s, Westermann made work after work dealing with just these issues. *Brinkmanship* (1959; pl. 21) addresses the American cold-war policy of the title. *Machine for Calculating Risks* (1962; pl. 36) refers to the so-called Doomsday Clock devised by editors of *The Bulletin of the Atomic Scientists,* which symbolically showed how close the U.S. and U.S.S.R. were to nuclear war. *Trophy for a Gasoline Apollo*

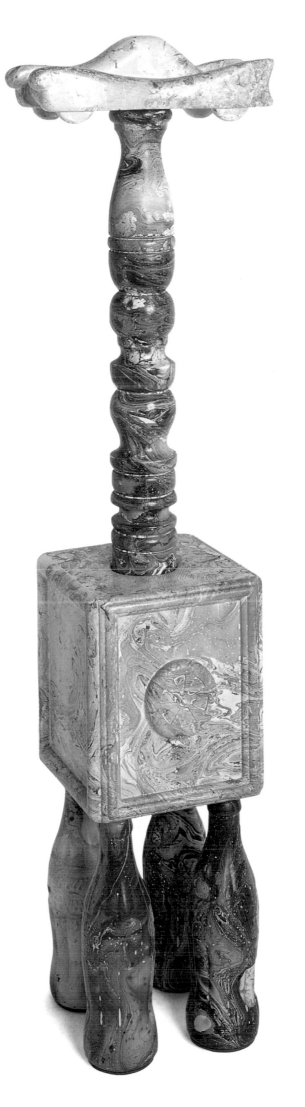

FIGURE 11
Trophy for a Gasoline Apollo,
1961
Wood, Hydrostone, enamel,
and plastic bumpers
$32^{3}/_{8}$ x $8^{1}/_{2}$ x $6^{1}/_{4}$ in.
(82.2 x 21.6 x 15.9 cm)
Jane Root and Ruth Root

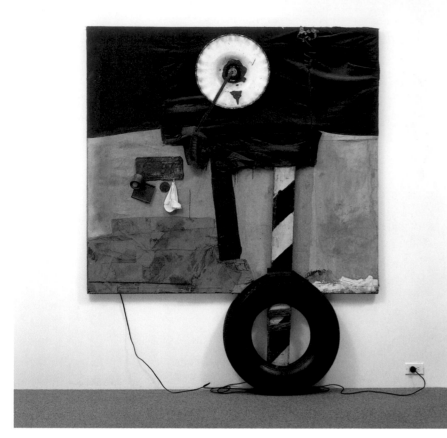

(fig. 11, p. 57) and *The Pillar of Truth* (1962; pl. 30) speak to the dark side of American consumerism. *White for Purity* (fig. 15, p. 60) deals with racism. Somehow, Westermann resisted the collective desire to flee from these realities; almost unique among his peers, out of his "average" American experience he wrested a solitary American art career.

MUCH HAS BEEN WRITTEN about Westermann as an outsider, from knowledgeable, first-hand accounts of his passionate individualism to fourth-hand notions that he was some sort of folk artist. Although by no stretch of the imagination was Westermann a folk artist, he was clearly an outsider in the club that was the contemporary art scene of the 1950s through 1970s. It was a matter of his personality, an uncommon combination of the respectful little boy who always washed behind his ears and combed his hair in order to please his mother but who, at the same time, could hold his own with the most uncouth of his peers. The art world, despite its claim of supporting iconoclastic individuality, demands a certain conformity—in terms of aspiration, thought, personal habits—of which Westermann was simply incapable. He did conform to a gentleman's code seemingly gleaned from dusty adventure stories and hard-boiled movies and fused with the very real sense of fellowship forged in war—all in all a rather old-fashioned and sentimental attitude. He surely would not

have felt such a strong need to prove that he was not a "phony" if he had taken up a profession, say law enforcement or engineering, that is not burdened by lofty aspirations or avant-garde sensibilities. Westermann was not pursued by the demons that commonly torment artists, that is, he did not fret that he wasn't as good as he could be, or understood as he wished to be, or as successful as he should be. Rather, Westermann's insecurity seems to have stemmed from the conflict between his perception of himself as "just an average Joe" and the prevailing attitudes about his chosen profession, which in its very essence sets the practitioner apart from the mainstream of humanity.

Thus, by virtue of his profession and the way it was perceived during the postwar years, Westermann was, so to speak, a double outsider, pursuing a lonely course at a distance from the aesthetic fashions emanating from New York. (A good number of his works made in Chicago in fact overtly deal with the theme of the outsider.) But in an essential way, Westermann's genius as an artist is that he was "just an average Joe." He worked intuitively in an age when theory and planning directed artmaking; he made things to please himself rather than to fit in with fashionable movements or the current critical thinking. In doing so, he created a body of work strangely unburdened by the weight of art history that so much of modern and contemporary art seeks—and ironically fails—to escape. At the same time, and paradoxically, Westermann's work taps into this and continues the deeply humanistic traditions of Western art, so much so that one can approach it with little or no art-historical knowledge and still appreciate it deeply.

ONE CAN CONCLUDE that Westermann brought these qualities with him to Chicago rather than discovering them there. In fact, his residence in the city as a mature artist was only

five years in duration (1957 through 1961). Chicago did not breed into or elicit from Westermann any particular type of artmaking as it surely did with other, less formed personalities. His love of the vernacular probably sprang from his childhood in the great city of vernacular, Los Angeles, with its mass entertainment industry and its kitschy architecture (fig. 13). In many ways Westermann was as much an outsider to the Chicago tradition of tortured figurative expressionism as he was to the emotionally restrained formalism associated with New York. Westermann's oft-cited influence on the development of the Hairy Who artists (including Jim Nutt, Gladys Nilsson, and Karl Wirsum) is overstated; after all, Westermann left Chicago in 1961, before many of these artists had even entered the S.A.I.C. Although his sculptures were regularly shown in the mid-1960s at Allan Frumkin Gallery, his boisterous graphic imagery—which would seem to have been an inspiration to these artists—was not very well known, for the illustrated letters he sent to friends were not widely exhibited or published until much later and his first print series, *See America First,* was not completed until 1968.[15] If he inspired anything in Chicago, it was an appreciation of and reverence for craftsmanship, qualities that knit together the disparate artists of the city.

Westermann's Chicago experience was thus essential to him less as an artist than as a typical man of his generation. Although he returned from war to become an artist, he did so to a "real" city, not to a rarefied art capital. Poet Bruce Oxford, who was Westermann's landlord at 222 West North Avenue in the late 1950s, recalled his discussions with his friend about Chicago,

> a city indifferent to its artists, careless of its own architectural heritage, a street-brawler of a city with more vigor than style, a sprawl of ethnic enclaves rather than a melting pot— but, nevertheless, a fertile matrix for tough creative mavericks. I remember Cliff telling me that he thought his home city was beautiful, but too seductive to work in. I also remember walking down Michigan Boulevard [Avenue] with Cliff, both of us cursing the city roundly. We cursed the unabashed midwestern parochialism, the raw commercialism that bulldozed and wrecking-balled indiscriminately whatever stood in its path. But, at the same time we were stimulated by the impersonal, amoral vigor.[16]

Yet, unlike the typical Chicago artist of this era, Westermann was extraordinarily successful.

Not only was he given one-person shows while still a student,[17] he had considerable success in selling his work—his first collector was the great architect Ludwig Mies van der Rohe, who purchased the bas-relief *Butterfly* (fig. 17, p. 61) in 1957. The emerging generation of great postwar Chicago collectors—Joseph Randall Shapiro, Lewis Manilow, Mr. and Mrs. E. A. Bergman, Morton G. Neumann—all acquired a number of Westermann's early masterpieces, which joined works by Francis Bacon, Salvador Dali, and Max Ernst (in Shapiro's collection); Joseph Cornell (in the Bergmans'); Jean Dubuffet (in Manilow's), and Joan Miró and Pablo Picasso (in Neumann's). The Chicago art world needed no reassurances that Westermann was a worthwhile artist; like Westermann, these collectors followed their own interests and went their own way, collecting surrealism and other styles considered unappealing in New York. Westermann's work was acquired by major museums, an accomplishment that was almost unprecedented for a young artist in Chicago. The Art Institute of Chicago attempted to purchase *The Evil New*

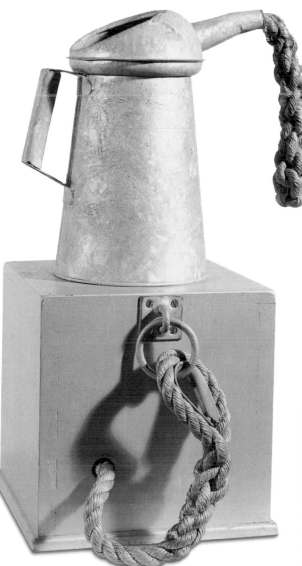

FIGURE 14
Untitled (oil can), 1962
Pine, hemp rope, galvanized
sheet metal, aluminum alkyd
enamel, and metal
22¼ x 13⅛ x 12¼ in.
(56.5 x 33.3 x 31.1 cm)
Whitney Museum of American
Art, New York, Purchase,
with funds from Charles
Cowles (70.70)

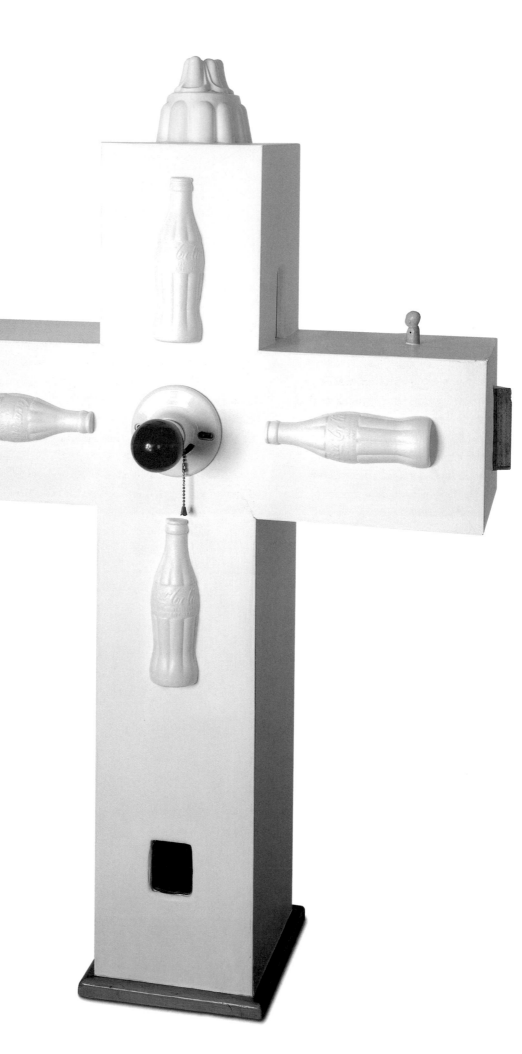

FIGURE 15
White for Purity, 1959
Wood, paint, Hydrostone,
antique pudding mold, porce-
lain, light bulb, mirror, glass
prism, and die-cast metal doll
45 ⁵/₈ x 31 ⁷/₈ x 15 ³/₄ in.
(115.9 x 81 x 40 cm)
The Henry and Gilda
Buchbinder Family Collection,
Chicago

War God (S.O.B.) (1958; pl. 23) on the occasion of its first exhibition there, but it had already been acquired by a private collector. Lewis Manilow donated the 1958 work *Mysteriously Abandoned New Home* (pl. 17) to the A.I.C. in 1962.

Broad and flat, Chicago is not hemmed in by mountains and the sea as is Westermann's native Los Angeles. Often described as the prototypical American city, Chicago was the perfect spiritual jumping-off point for Westermann's cross-country trips, during which he literally "[saw] the U.S.A. in [his] Chevrolet," as the advertising slogan directed.[18] These journeys revealed to him the quintessential America—for which he, in his youth, had risked his life without hesitation or reflection, feeding him and inspiring him in ways that life in New York or tours of Europe never could have.

Chicago did provide Westermann one of his most valuable assets as a man and an artist. It was there that he met Joanna Beall, a native of the city (fig. 16). Her refinement and natural elegance may have seemed an odd fit with the "old salt" persona that Westermann cultivated. In fact, though, it was a perfect match. Westermann's love for Joanna seemed like that in a nineteenth-century novel, passionate, yearning, and romantic. Joanna, herself an artist and daughter of the famous graphic designer Lester Beall, Sr., became a sophisticated partner in Westermann's artistic quest, inspiring numerous works (the odd spiral form found in such works as *Ash Relief* [1965; pl. 48] was Joanna's signature motif).

FIGURE 16
Joanna Beall Westermann and H. C. Westermann, 1967. Photo courtesy estate of Joanna Beall Westermann.

She also contributed to the works *Cliff* (1970; see Dennis Adrian essay, p. 46) and *A New Piece of Land* (1973).

In 1961 Westermann, now happily married to Joanna, left Chicago. There were cross-country travels and a brief residence in San Francisco before the couple finally settled in Brookfield Center, Connecticut, where Westermann spent the last two decades of his life in a rustic, rural setting (see Michael Rooks essay). Thus it is rather by default that Westermann is usually thought of as a Chicago artist—an accident of history resulting from New York's blindness to distinctions among things that come from outside coupled with Chicago's tendency to claim artists long after they have left the city.

In recent years many have convincingly argued that Westermann's influence on the West Coast

FIGURE 17
Butterfly, 1957
Cotton rope, plywood, and nails
18½ x 25¾ x 1⅜ in.
(47 x 65.4 x 3.5 cm)
Dirk Lohan, Chicago

"I Made a Deal with God": H. C. Westermann's House and Studio

Michael Rooks

THE HOUSE H. C. WESTERMANN BUILT on the wooded and rocky slopes of Brookfield Center, Connecticut,[1] is in many ways a manifestation of the philosophy he shared with his wife Joanna Beall Westermann. This philosophy could be summed up by the words inspired by visionary author Kahlil Gibran that Westermann inscribed on his sculpture *A Family Tree* (1964): "Work is visual love."[2] Westermann applied every discipline he practiced as an artist in the details of the house; every conviction he had compelled its meticulous realization. In 1958 he wrote to his sister Martha: "I would most certainly prefer to die than to do one, just one, piece that I didn't pour everything conceivable within me, into. And this I mean right from my heart. Art is not to be cheated or bargained with as are business practices & art is pretty brutal when it is not respected or the improper insight is shown . . . in a sense each piece is a reassurance of my own inner self."[3]

Westermann's house and art are the result of his uncompromising principles — the work regimen of an ox; a particular brand of spirituality independent of religion; and a nature-loving philosophy of life. The nature that surrounded him in Brookfield Center was the essence of his art: "If we ask ourselves what has been common to all men in all parts of the world for all times, we will have the answer we are looking for. The

FIGURE 1
H. C. Westermann at work
on his house and studio
in Brookfield Center, Conn.,
c. 1971.

common factor must be <u>NATURE</u>. Man cannot completely control the forces of nature, but from all time he has been controlled by them, and the perfect design of the universe with its balance of seasons and evolution of life must inevitably influence each generation of man. Thus it is in nature that we find the fundamental origin of the principles of design."[4]

The sturdiness of Westermann's work, sometimes disproportionate to its size or its apparent function, seems to express his pursuit of the meaning of truth. By insisting on solidity, on substantiating the very materiality of the things he used, Westermann sought to make truth physical—something you could hold in your hands or top-load with 2,000 pounds of pressure.

The house is in some respects Westermann's greatest work of art because it represents the actual union of life and art for which he strove figuratively or metaphorically in his sculptures, and because it embodies this impossible quest for truth. In Donald Judd's residence and studio on Mercer and Spring streets in New York City, the artist's presence resonates in the clean, spare geometry of the architecture that he preserved and modified. Within the cast iron–clad building, you feel as though you inhabit Judd's sculpture.[5] Likewise, Westermann's house is very much "a Westermann" and, for that matter, is signed and dated.

WESTERMANN'S WIFE AND TRUE LOVE, Joanna, designed the house.[6] The words "true love" are by no means an exaggeration—they describe the extraordinary relationship the Westermanns shared. By all accounts, their love was boundless, and the solitude they sought in the woods of Connecticut afforded them the opportunity to enjoy each other's company in every respect. Their self-imposed isolation only strengthened their faith in one another. It also provided a sanctuary from the New York art world where Cliff (as Westermann was known) and Joanna could live and work without interruption. In Connecticut they found escape from the trappings and social obligations of urban life (quite different from the artist-colonized Hamptons), under conditions that encouraged asceticism, reflection, and hard work.[7]

THE PROPERTY WAS BEQUEATHED to the Westermanns in 1969 by Joanna's father, Lester Beall, Sr., a renowned graphic designer who had moved his studio from New York City to rural Connecticut in 1951, dubbing the property Dumbarton Farm. (Beall died of cancer on June 20, 1969.) The Westermanns lived in a small cottage on Obtuse Road to the east of the Bealls' house and across the road south of the parcel of land they eventually inherited (see fig. 4, p. 67).[8] They lived there for about three years, from

FIGURE 2
Gatepost to Westermann property

FIGURE 3
Westermann house and studio, 1998. Photograph by William Taylor, Princeton, N.J.

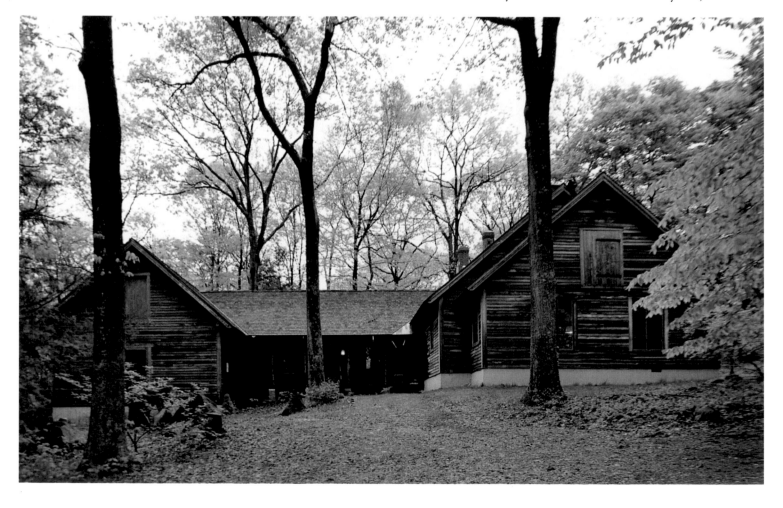

1961 to 1964, before moving to San Francisco in August 1964, perhaps to put some distance between themselves and Joanna's parents. Several factors, including the poor health of Lester Beall, Sr., led them to return to the cottage at Dumbarton Farm in October 1965.

In December 1966 Westermann was among the first to receive a grant from the newly created National Endowment for the Arts. He used the $5,000 award to purchase a truck and hauling equipment, which came into heavy use the following summer, when Joanna's studio was built several hundred feet to the south of where Westermann would eventually build his studio and the house. With the assistance of a pair of local carpenters, the Westermanns worked on the studio the entire summer. In this space Joanna would paint, sculpt, and keep up her training as an acrobat (she had joined an acrobatic troupe called "The 3 Renowns" in November 1966 and toured Canada with them until an injury required her to bring this short career to a close).

Westermann designed and built the chimney for Joanna's studio, which swells at the base to a width of eight feet (see "Chronology," 1967). For the sweeping curve of the base, he drew each brick to scale and shaped each by hand: "I carved each brick—216 of them—as you know bricks are only rectangular."[9] By October the chimney was twenty-five feet tall, topped by a cast-concrete cap and covered by a five-hundred-pound marble slab. Five cartoonish mushrooms cast in concrete rested on top of the marble. Westermann incorporated irregularly shaped fieldstones from the surrounding property into the masonry, foreshadowing his use of similar stones in sculptures such as Untitled ("This Great Rock Was Buried Once for a Million Years") (1968; pl. 70). Westermann also included hand-ornamented bricks; he carved his signature anchor on the face of one. In another, a dedication to his wife, he carved a heart.

This was the beginning of Westermann's great preoccupation. With the building of Joanna's studio, he reopened an avenue of interest and activity he had put aside when he left Chicago in 1961. There, Westermann had worked as a carpenter, handyman, and building superintendent, taking great pride in every job that came his way. He was continually disappointed by his clients' apparent disregard for details, on which he no doubt lavished much time: "I tried carpentry in Chicago, I tried it, and it wasn't enough; it just left me hung up horribly . . . you know, just unsatisfied—it just wasn't enough, God damn it! It drove me crazy. I used to do these jobs and I loved 'em . . . you know,

FIGURE 4
Cottage on Dumbarton Farm
where the Westermanns lived

and people, they don't really give a damn about that."[10]

Westermann's experience as a carpenter facilitated an exchange of ideas between his practical work and his art, rupturing conventional notions of art-making that he had acquired in school and resulting in an innovative body of work that included early masterworks such as *He-Whore* (1957; pl. 8), *Mad House* (1958; pl. 19), and *Memorial to the Idea of Man If He Was an Idea* (1958; pl. 22). Likewise, the building of the house and his studio between 1969 and 1981 inspired a prolific twelve-year dialogue.

BEFORE HER FATHER'S DEATH in June 1969, Joanna had drawn up plans for the Westermanns' future home. They were sketches of room scenarios rather than architectural drawings, roughly equivalent to floor plans and elevations, but they were nevertheless adhered to with practically no deviation until the house was completed in 1981. The Westermanns had initially hoped to complete the house within a year: "The spot back in the woods is heavenly & about a quarter-mile from the road. Maybe next year or so you could visit & we will have accommodations ?"[11]

According to Joanna's designs, the house consists of a large rectangle divided into six principal spaces: the kitchen, guest bedroom, living room, master bedroom, bathroom, and laundry. Westermann designed his studio adjacent to the house, with a breezeway connecting the two structures (see fig. 7, p. 70).

Cliff and Joanna cleared the property in April 1969, felling more than sixty-five trees—ash, hemlock, hickory, and oak—that they milled locally and cured for later use in the

FIGURE 5
Foundation of Westermann house
under construction, c. 1969

house. They planned to build the foundation, install the septic tank, and put in the main electrical line for the house before winter, but were delayed when Joanna contracted mononucleosis and was restricted to bed for most of the fall. However, by November they finished paving the winding eight-hundred-foot drive with soil and lined it with boulders from the excavation of the foundation, which they managed to finish before winter (see fig. 5). Westermann made certain the foundation was solid; the floor is five inches of concrete on a twelve-inch bed of gravel, and the walls are solid cast concrete. He made the walls ten inches thick, one inch thicker than the standard. Work would continue in the spring.

The year Westermann completed the foundation—"'70"—is cast on a pier wall (the fireplace footing) in the basement. Westermann made this solid concrete pier (with beveled edges) to support a massive living-room chimney as well as the interstices of the two principal walls of the house.[12] After laying two-by-ten-inch boards for the floor joists, he commenced work on the framing of the house (see fig. 9, p. 71). That summer, with local carpenters, Westermann built the entire frame — bolting and nailing every structural timber together. By late August the roof was covered with cedar shingles, painted with wood preservative and capped, and the sides of the house were sheathed with one-half-inch plywood.

After the exterior walls were built, Cliff and Joanna built the beams and posts that supported ceiling joists in the living room and bedroom. Since these would be exposed elements, Westermann chose hemlock — abundant on their

property — for its warm hue, and especially because it was a wood Joanna favored. Unfortunately, the hemlock trees they felled on the property were not large enough, so Westermann purchased six-by-eight-inch hemlock beams from New Hampshire. Beams of this width were available only in eight-foot lengths, so he bolted several together end-to-end with scarf joints (see figs. 10–11, p. 72). This permitted one continuous beam to run the full twenty-four-foot length of the living-room ceiling, creating a subtle visual continuity between the essentially open spaces of the kitchen and living room.

Westermann also finished a stairway connecting the ground level with the attic. For this space he used redwood and Douglas fir, woods whose range of reds and ochres lend the compartment a remarkable depth of color. A hand-winch bolted to the wall raises or lowers the attic door by a steel cable — its clatter resonates in the narrow stairwell like the weighing of an anchor must sound in the hold of a ship. Inlaid on the front of the fourth stair from the bottom in a dark exotic wood is an image of stairs shown in elevation: "I just finished building the stairway up to the attic from the living room (redwood & Douglas fir) & it was quite involved & took me weeks. I suppose we'll move in next year."[13]

The framing and sheathing of the house and the shingling of the roof added up to a tremendous amount of work for Cliff and Joanna, even with hired tradesmen. Nevertheless, Westermann's work on the house did not stifle his art making. On the contrary, he hadn't produced more sculptures since 1966: "I never worked so hard in my life as I am now — days on the house & nights on new pieces. Oddly enough I have made some new things & they are pretty good or at least I'm excited with them."[14] Because of the work regimen that summer, there was a symbiosis between Westermann's art and his house. The scarf joints he devised out of necessity in the house inspired the sculpture *Scarf Joint* (1970; fig. 13, p. 73), and another work, *Large Dovetail Joint* (1970), was certainly inspired by the joining of weighty roof beams and corner posts.[15] *Phantom in a Wooden Garden* (1970; pl. 77) seems to reflect Westermann's daytime occupation as a carpenter, surrounded by a forest of wooden studs, joists, and beams.

Cliff and Joanna began building the frame of his studio in July 1970 and returned to it the following spring. Unlike the house, it does not have a basement; rather, it rests on a system of cast-concrete piers buried about four feet into the ground. They treated the framing lumber

with wood preservative to protect it from the elements and soaked every structural joint with creosote for protection from wood-burrowing insects (see fig. 15, p. 74). Considering the stress to which the studio frame might be subjected, Westermann bolted and nailed every structural timber together, including the wall studs. These were bolted to the three-by-ten-inch floor and ceiling joists (see fig. 14, p. 74). Every corner post was joined with mortises and tenons: "Anyway it's a strong shop — it might burn down but it won't blow away heh, hch, heh!!!"[16]

For a lintel above the front door of the studio, Westermann used a salvaged section of a tar-blackened railroad tie. Its prominent placement at the entrance of his studio seems to have significance beyond its weather-worn beauty and conspicuous strength. Perhaps Westermann chose the railroad tie as a symbol of his heritage, for when he was nearly four years old his grandfather George Bloom, a carpenter and cabinetmaker, committed suicide on the railroad tracks in Medicine Lodge, Kansas.[17] Westermann no doubt retained vivid memories of his grandfather, and of his tragic end. Trains and suicide are subjects that recur frequently in Westermann's oeuvre.

Compared with the previous year, work on the house and studio progressed at a considerably slower rate in 1971, perhaps because Cliff and Joanna were now working alone. The tradesmen they had hired to frame out the house were efficient and adept, but their work added significantly to the cost of the house: "These two carpenters are very good & very fast & as expensive as a shrink but they are putting it together well."[18] The high cost of construction, which had reached nearly $40,000 at this early stage, was also due to the quality of materials on which Westermann insisted, such as three-by-ten-inch boards for joists in the studio (rather than two-by-fours), heartwood beams for cornerposts and weight-bearing timbers, heavy steel hardware to bind the frame together, expensive decorative woods for exposed elements, and cedar cladding and shingles. The cost was also inflated by the extensive labor required to meet Cliff's standards of craftsmanship.

"H. C. WESTERMANN 1971" is carved in relief on the front exterior rafter of Westermann's studio (see fig. 16, p. 74).[19] With the house already sealed up and shingled, Westermann concentrated on finishing the frame of the studio before winter. By the end of November 1971, he had

FIGURE 6
H. C. Westermann's studio, 1998. Photograph by William Taylor, Princeton, N.J.

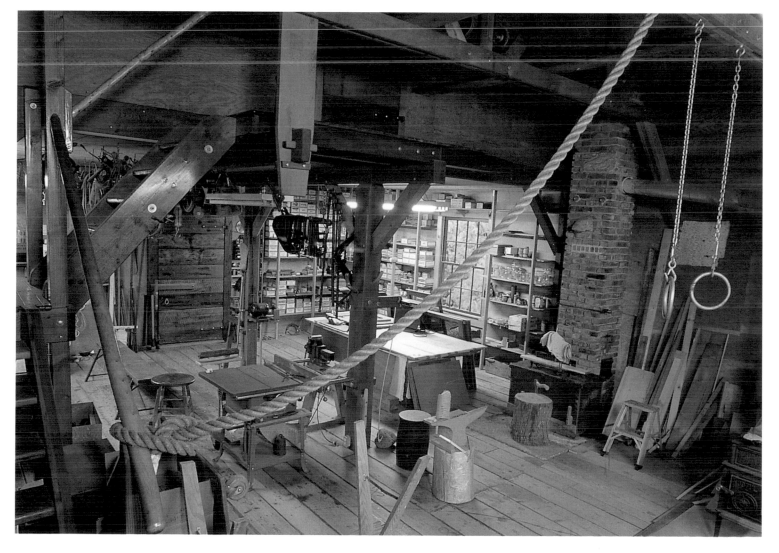

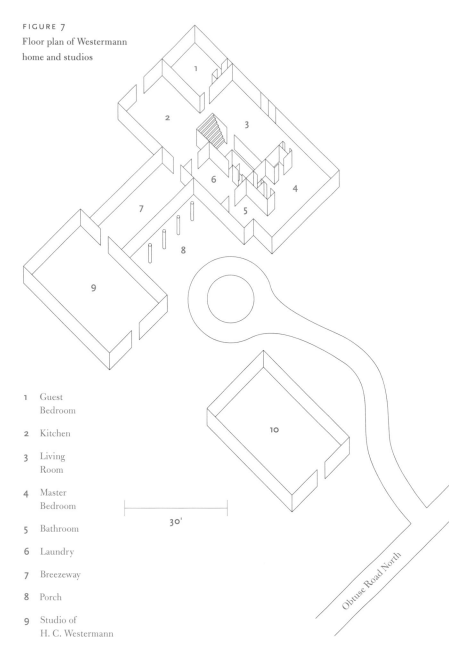

30'

Obtuse Road North

shingled the roof, sheathed the sides with ply-wood, and clad them with cedar. One sculpture from that year, *Battle to the Death in the Ice House* (1971; see Robert Storr essay, p. 29), is a send-up of his efforts to finish the studio before the bitter cold of winter set in: "I'm finally shingling the place now & one morning last week I stepped outside to go up & work on the place (at dawn) & I thought Jesus its cold. Well I went up & about 9:30 came down for breakfast & turned the radio on – well it was 16° & I guess you know . . ."[20]

Besides the work on the house and studio, 1971 was a busy year for Westermann, with three solo exhibitions, visiting-artist stints in San Francisco and in Urbana, Illinois, and an enticing offer to make a large public sculpture.

In February the Chicago suburb of Highland Park, Illinois, requested a proposal for a public sculpture by Westermann. Funds for the project were made available partially through the National Council on the Arts with additional funds raised by the Highland Park Art Commission.[21] Westermann accepted the offer and flew to Chicago in March. He was impressed by a beautifully preserved nineteenth-century log cabin that had recently been moved to the site in front of the city hall and across from the railroad depot. This log cabin recalled his earlier sculpture, *The Log Cabin* (1968; fig. 17, p. 75), which seems to have been inspired by the building of Joanna's studio and chimney. As remembered by Walter Hopps, Westermann wanted to make a mate for the beautiful old cabin in keeping with his tendency to pair sculptures, such as *The Silver Queen* (1960; pl. 28) and *Swingin' Red King* (1961; pl. 29).[22] He eventually suggested bringing in a huge boulder from Brookfield Center with a plaque explaining its origin.[23] The idea was not to the liking of the Highland Park Arts Commission, and Westermann never submitted a maquette.

The log cabin, perhaps one of the oldest American symbols, is a theme that recurs in Westermann works such as *W.W. I General, W.W. II General & W.W. III General* (1962) and *Come Off It "Jackie"* (1967), as well as *The Log Cabin*. As a symbol that conveys the modest, pious, and hardworking lifestyle of the nineteenth-century American frontiersman, the log cabin had special significance for Westermann—his palpable Americanness was of a generation that still valued these qualities.[24] His modesty and work ethic are well known, but less conspicuous was his non-religious piety, which seems to have rested on a faith in the capacity of humanity to overcome its own limitations: "I have a terrific amount of hope for the future . . . a man doesn't build something that's gonna last for a thousand years if he doesn't have hope or optimism . . . I can't live without hope."[25] Westermann gave the provisional title "I Made a Deal with God" to a drawing for *The*

FIGURE 8
Front door of studio with relief carving of a handsaw overhead

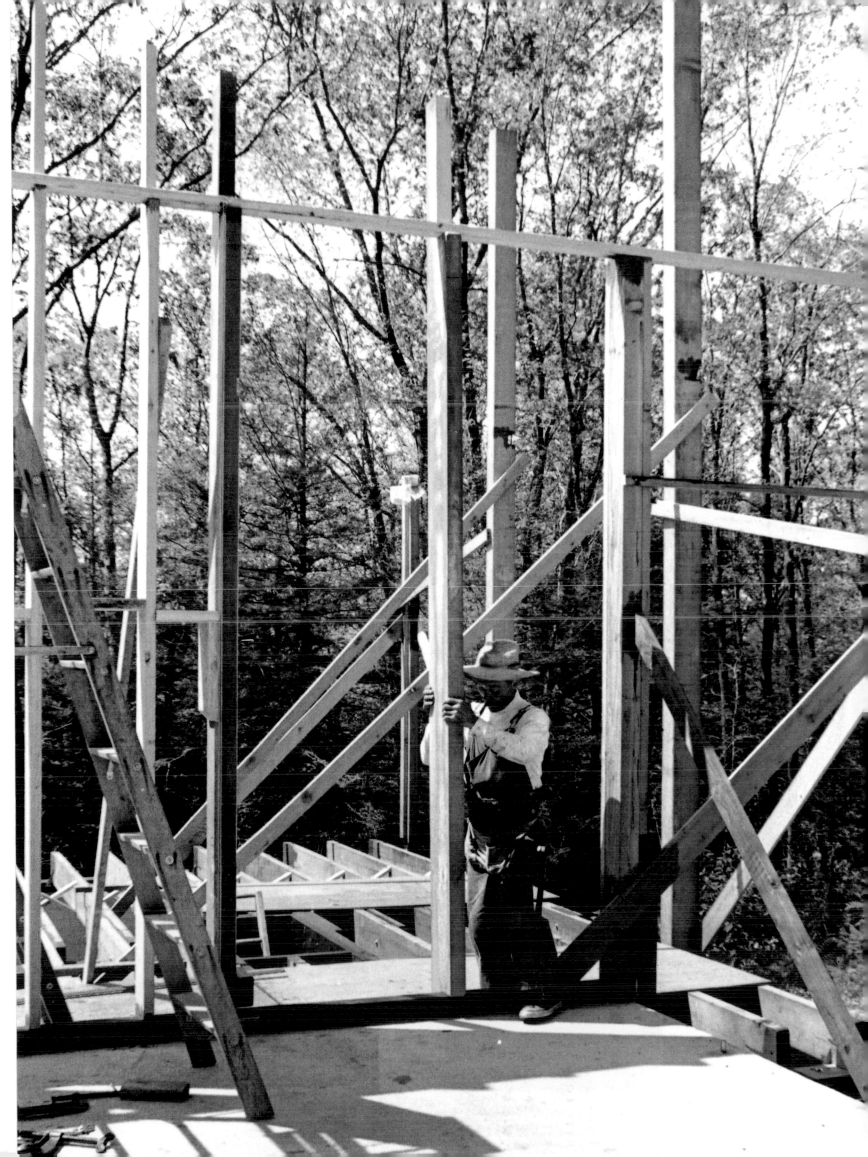

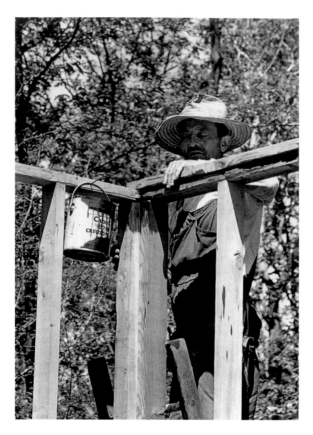

1976 even though the house was still unfinished. Remaining work included installation of the heating and plumbing. This stage of construction can be traced in sculptures made contemporaneously such as *Billy Penn* (1976; fig. 23, p. 78), a full-size figure made from "Billy Penn" stove pipe used in the house.

In February 1978 Westermann had a heart attack brought on by shoveling snow and ice after two blizzards that month. Doctors discovered that one of his kidneys had failed many years before, but they decided not to remove it because of Westermann's weak heart. They speculated that were it not for his habitual exercise, Westermann would have died many years earlier.

Since his days as a teenager on Santa Monica Beach (later known as Muscle Beach), Westermann kept up a demanding exercise routine, and he religiously recorded every repetition of each exercise. His studio was a place to maintain that practice. It was part of a daily ritual that also included feeding birds, raccoons, and other animals that might wander into the clearing outside the large picture window at the rear of the studio. A plain-laid hemp rope for climbing and a pair of gymnast's rings still hang from the studio rafters. Another exercise device in the form of a hand-winch is bolted onto the side of a post: a large fieldstone is hoisted from the floor by a connecting rope as it is wound around the crankshaft. Westermann also cast a pair of weights that probably doubled as handlebars for doing push-ups.[30] These objects reveal the seamlessness between his daily life and his art—the stone echoes his earlier sculpture Untitled (large hanging rock) (1968), and the weights are unembellished aluminum castings of the sculpture *A Bronze Sculpture Which Might Be Moved Frequently* (1966).

believe the shoddiness of the damned thing."[28] Westermann had been actively involved with local environmental groups since he was hospitalized in 1974. He and Joanna donated sixteen acres of open land to the town of Brookfield as a nature preserve and in January 1976 became involved with a local environmental group called Preserve Obtuse Wetlands.[29]

Their privacy in Brookfield Center was diminishing with every new house built in the area. It was most likely their desire for privacy and seclusion that led them to refuse a feature story proposed by *Progressive Architecture* in

Several other major events that year eclipsed work on the house — the opening of Westermann's second career retrospective, at the Whitney Museum of American Art; the end of his twenty-year affiliation with the Allan Frumkin Gallery; and the beginning of his affiliation with Xavier Fourcade, Inc. in New York. Westermann resumed work on the house in the summer of 1979 with the help of artist and master carpenter Roger Brouard. Brouard was seeking a place to live and work outside the city during the summer months. However, before Westermann allowed Brouard to stay, he gave him a test — he had to climb to the top of the rope in the studio hand-over-hand without using his legs. Brouard passed this test, after which Westermann climbed the rope — extending each of his legs at a right angle to his torso.

Brouard's first assignment was to reinforce the exterior frame of the house by bolting two-by-six-inch studs to the existing two-by-four studs. He was then asked to build a closet door in the guest bedroom. He completed it expeditiously, and Westermann promptly made a branding iron with Brouard's initials used to

sign the latch plate on the door. Later that summer Westermann and Brouard clad the gabled ends of the house with cedar clapboards. They attached each board to the side of the house with galvanized nails into predrilled holes. This allowed the wood siding to expand or contract, moving along the shank of the nail, with the changing humidity and temperature. Westermann installed copper flashing extending out from below the boards and sills to prevent termites and other insects from burrowing into the wood. Likewise, he installed copper flashing around window sashes and as drip-caps above doorways. He had a peculiar aversion to sharp edges and so rounded the corners of every cedar board in the siding (this peculiarity is evident in nearly every detail of the house and studio, including the foundation, as well as in his sculpture). In the evenings Westermann and Brouard worked in the studio on their own respective projects.

In the summer of 1980, Brouard returned to Brookfield Center with a minor handicap — he had lost the index finger on his left hand in an accident on a carpentry job in the city. Undaunted, he and Westermann helped

FIGURE 17
The Log Cabin, 1968
Maple, beech, pine, redwood, walnut, leather, glass, enamel, and paper découpage
18¼ x 18¾ x 14¼ in.
(46.4 x 47.6 x 36.2 cm)
Byron Meyer, San Francisco

contractors rough-in the remaining electrical and plumbing parts in the house, which consisted entirely of copper, brass, and bronze pipes and fittings: "We got the rough plumbing in & I told the plumber (& he's a good one) that we did not want one inch of that goddamned plastic pipe. So it's all copper and brass including the waste system."[31] They also finished framing doorways and windows in the kitchen, bedrooms, and bathroom. Each door frame was joined with dovetails and with mortise-and-tenon joints, and the windows were installed with extra-wide sill-horns to accommodate the three-quarter-by-six-inch redwood frames. Among the many noteworthy details, a pierced heart for Joanna is inlaid above the door leading to the basement (see fig. 24, p. 78).[32] Westermann gave Brouard the nickname "The White Tornado": "I never mentioned 'the White Tornado'? Well he is a pal of ours, for 10 years now. He is a sculptor who lives in N.Y. but is never home. He is a fantastic carpenter, who is in much demand."[33]

Westermann's sculpture *The Man from the Torrid Zone* (1980; see Robert Storr essay, p. 26), a full-size figure made with copper sheet and a boulder for a head, mirrors their work on plumbing that year. Westermann expressed his fondness for Brouard by modeling the sculpture after him — only the second portrait sculpture that Westermann made. The solidity of the stone head and the integrity of the copper used

FIGURE 18
H. C. Westermann's house and studio, c. 1972

for the body represent the integrity of character that Westermann perceived in his friend — it is also missing a digit on the left hand.

The following year Westermann and Brouard tended to the final details of the house while hired tradesmen applied plaster to the walls and ceilings. That April Westermann had already installed built-in bookcases in the master bedroom and wire lath on the walls over which plaster would be applied. He and Brouard laid the floor using massive oak boards that Westermann had milled and cured in 1969. Each one, some as wide as seventeen inches and as long as fifteen feet, were ship-lapped — that is, the ends of each board were notched to connect with one another.[34] In the course of the installation, Westermann depleted the entire brass screw supply in the area. He always used slotted screws, never Phillips head, as Brouard recalled: "Slotted screws are easier to strip and harder to put in. When Phillips

FIGURE 19
East side of porch showing window frame inscribed with Joanna's name

FIGURE 20
Porch in front of breezeway connecting the house and studio, 1998. Photograph by William Taylor, Princeton, N.J.

FIGURE 21 (OPPOSITE)
Storage area in studio, 1998. Photograph by William Taylor, Princeton, N.J.

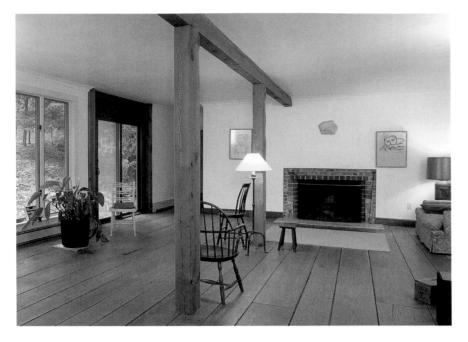

FIGURE 22
Living room, 1998. Photograph by William Taylor, Princeton, N.J.

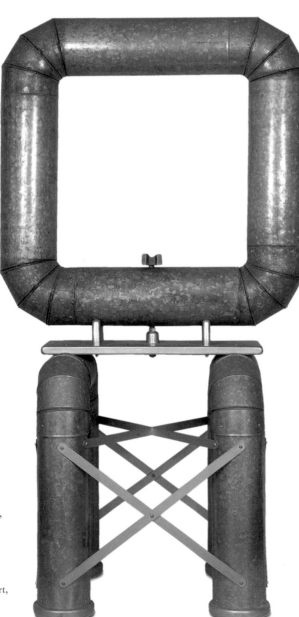

FIGURE 23
Billy Penn, 1976
Galvanized sheet metal, steel,
pine, bronze, and aluminum
alkyd enamel
79¼ x 42½ x 29⅝ in.
(201.3 x 108 x 75.3 cm)
Museum of Contemporary Art,
Chicago, Gift of Alan and
Dorothy Press

head screws first came out they represented a new era of craftsmanship . . . it wasn't like the slow, tried-and-true tradition of taking your time and doing something right. Phillips head screws represented a speedy installation—you could pull them in with an electric drill. Each slotted screw was turned by hand with a brace and bit. This is how Cliff wanted it."[35]

The final task on the house was the plaster. Westermann was adamant that the walls and ceilings be covered with old-fashioned plaster-over-wire lath rather than drywall. Even the cornice around the periphery of the ceiling was plaster—an especially difficult and time-consuming detail: "The plasterers told me that they hadn't done a complete cornice job in a house for 35 years nor a 3 coat plaster job."[36] The three coats of plaster consisted of a bottom "scratch" coat providing a surface with tooth to receive subsequent layers, a middle "brown" coat consisting mainly of sand as a foundation, and a final smooth "white" coat given its lustrous color from marble dust or gypsum plaster. Westermann's last sculpture, *Jack of Diamonds* (1981; pl. 115), a full-size figure made from wire lath, reflects his enthusiasm for the finished plasterwork and the exciting prospect of finally moving into the house. The house—more than a decade-long obsession—was finally completed.

On October 28, 1981, Westermann had his first solo exhibition at the Xavier Fourcade, Inc. Three days later he had another heart attack and died of heart failure on November 3, never occupying the home that had taken him twelve years to build and which he had finished just two months before.[37] Joanna lived alone in the house until she died of lung cancer in January 1997.

H. C. WESTERMANN UNDERTOOK THE TASK of building his house and studio as he would the making of an artwork, building by hand and with simple means a monument to his art, to Joanna, and to his faith in the goodness of life and nature: it was a labor of love.

FIGURE 24
Inlay above cellar door at rear of kitchen. Photograph by William Taylor, Princeton, N.J.

1. Brookfield Center was the name of the rural area just outside the township of Brookfield, Connecticut. "Center" was dropped from the name in 1987.

2. Kahlil Gibran, *The Prophet*. New York: Alfred A. Knopf, 1921 (first English edition). The quote actually reads "Work is love made visible."

3. H. C. Westermann to Martha Westermann Renner, September 20, 1958.

4. From H. C. Westermann's sketchbook, c. 1949–50.

5. As a critic for *Arts Magazine*, Donald Judd wrote two favorable reviews of Westermann's work. Judd owned the Westermann work titled *2063 AD* (1963; MCA 80).

6. "JOANNA BEALL, ARCHITECT" is inlaid above the window on the proper left side of the porch of the house.

7. Joanna Beall Westermann was an accomplished painter. Westermann incorporated her paintings in his sculptures *Cliff* (1970; MCA 206) and *A New Piece of Land* (1973; MCA 242).

8. The Westermanns moved to Brookfield Center from Chicago in 1961.

9. H. C. Westermann to Martha Westermann Renner, September 10, 1967.

10. From an unpublished interview with H. C. Westermann by Martin Friedman and Dennis Adrian, July 18, 1966.

11. H. C. Westermann to Mike Renner and Martha Westermann Renner, April 18, 1969.

12. A smaller pier, three feet square (also with beveled edges), was cast for the kitchen's stove and chimney.

13. H. C. Westermann to Mike Renner and Martha Westermann Renner, October 11, 1970.

14. Ibid.

15. Two other works related to the framing of the house and studio, *Yellow Construction* (1970; MCA 204) and Untitled Construction (1970; MCA 205), both deal with the support and distribution of masses and weights.

16. H. C. Westermann to Ruth Marchant, November 14, 1971.

17. As a toddler Westermann had prized a small toy ladder that his grandfather made for him and had watched him at work on a courtyard building complex in Los Angeles (see "Chronology," 1925).

18. H. C. Westermann to Ruth Marchant, July 11, 1970.

19. Other details of the studio exterior include a narrow face fashioned into a beam used for hoisting heavy weight into the studio loft and a handsaw carved in relief on the exterior cornice molding above the front door.

20. H. C. Westermann to Ruth Marchant, November 14, 1971.

21. Members of the local commission included art critic Franz Schulze and art collector Mrs. Edwin Hokin, while members of the National Council included the art historian Walter Hopps (currently Founding Director and Consulting Curator at the Menil Collection) and Richard Koshalek (currently President and CEO, the Art Center College of Design, Pasadena, California).

22. Walter Hopps in a telephone interview with the author, March 2000.

23. Westermann later considered proposing boulders with jack-o'-lantern faces cut into them — monumental versions of the three "Jack" sculptures that he made that year.

24. The log cabin, the typical dwelling of the American frontier during the westward expansion of the United States in the second half of the eighteenth century, became a symbol for Manifest Destiny. It was also adopted as a political symbol by the Republican Party in the 1850s.

25. From an unpublished interview with H. C. Westermann by Martin Friedman and Dennis Adrian, July 18, 1966.

26. During this time Westermann built a chimney and acquired a cast-iron wood-burning stove for heat, sheathed the interior walls and ceiling with half-inch plywood, and laid the floor with two-by-ten-inch fir planks screwed into a sub-floor of half-inch plywood.

27. H. C. Westermann to Carl Bloom, October 25, 1965: "'I'm Goin' Home' is a quote from a San Quentin inmate just before he jumped to his death from the water tower. It got right to me — right where I live!"

28. H. C. Westermann to Ruth Marchant, November 14, 1971.

29. Obtuse Road, one of the main thoroughfares in Brookfield Center, led directly to Dumbarton Farm and the Westermanns' property. Westermann protested the development of land near Obtuse Road North at a hearing of the Connecticut Inland-Wetlands Commission: "I know that area very well, and it is absolutely beautiful. There are still a few deer in there and many other forms of wildlife, beautiful trees, rocks. It is just about the last open space area in this town of any consequence." (*H. C. Westermann Papers*, 3170:63)

30. Independent researcher David McCarthy, based at Rhodes College in Memphis, Tennessee, has been investigating Westermann's obsession with physical fitness and body art — the multiple tattoos that covered Westermann's torso and limbs. The possible significance of Charles Atlas's method of "dynamic tension" on Westermann's exercise regimen has been discussed by McCarthy, who has demonstrated the possible use of these weights for exercise.

31. H. C. Westermann to Ruth Marchant, August 1, 1980.

32. "WALNUT" is punched into the top of the frame of the attic door, along with an anchor carved in relief.

33. H. C. Westermann to Mike Renner and Martha Westermann Renner, August 27, 1980.

34. The ship-lapping of the floorboards as well as the use of brass screws call upon traditions in shipbuilding with which Westermann was familiar. He had attempted filling the gaps between floorboards in his studio with oakum and tar, another shipbuilding technique, but he abandoned this process because the removal of excess tar from the floorboards proved nearly impossible.

35. From an interview with Roger Brouard by the author, June 12, 2000.

36. H. C. Westermann to Mike Renner and Martha Westermann Renner, October 27, 1981.

37. Westermann may have lived in the house with Joanna to "get the feel" of it during the last month of his life, although it was not furnished at that time.

Plates

1

A Soldier's Dream, 1955
Maple, stained glass, brass,
and string
29¼ x 15 x 11½ in.
(74.3 x 38.1 x 29.2 cm)
Sharon and Thurston
Twigg-Smith, Honolulu

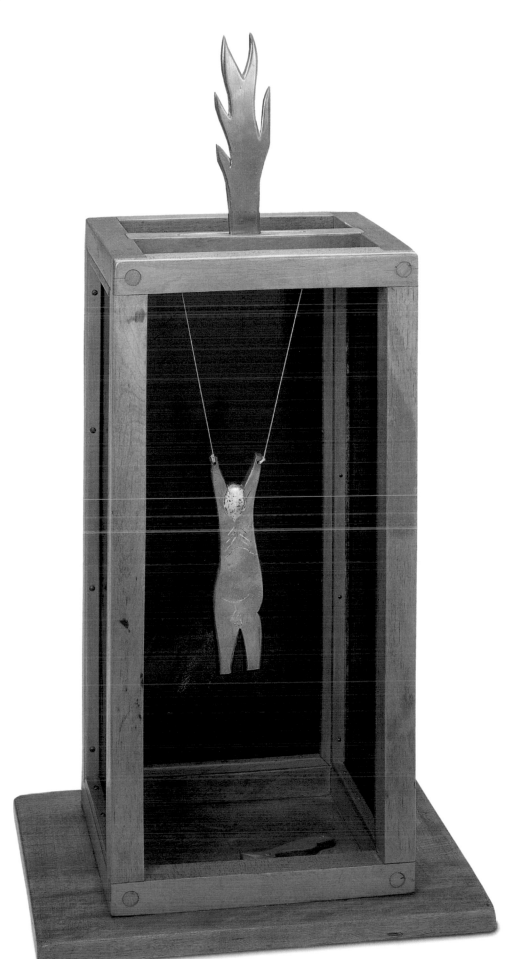

2
Confined Murderer, 1955
Ebony and bronze
12 x 5 x 4¼ in.
(30.5 x 12.7 x 10.8 cm)
Private collection,
New York

3
I'd Like to Live Here!, 1955
Maple
15⁷⁄₈ x 7⁵⁄₈ x 7⁷⁄₈ in.
(40.3 x 19.4 x 20 cm)
Lindy Bergman, Chicago

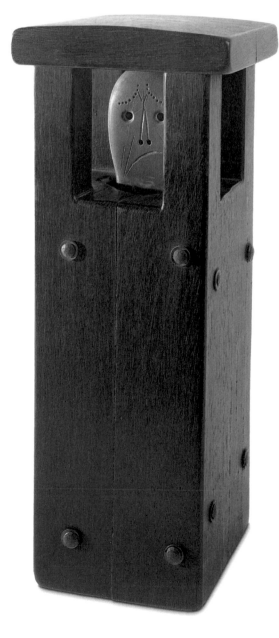

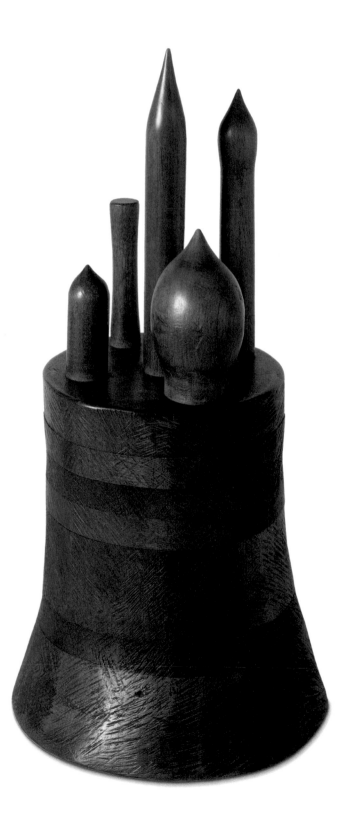

4
The Dead Burying the Dead, 1956
Brass, pine, bronze, lead, mahogany, and enamel
6¼ x 17 x 10 in.
(15.9 x 43.2 x 25.4 cm)
Museum Moderner Kunst Stiftung Ludwig Wien

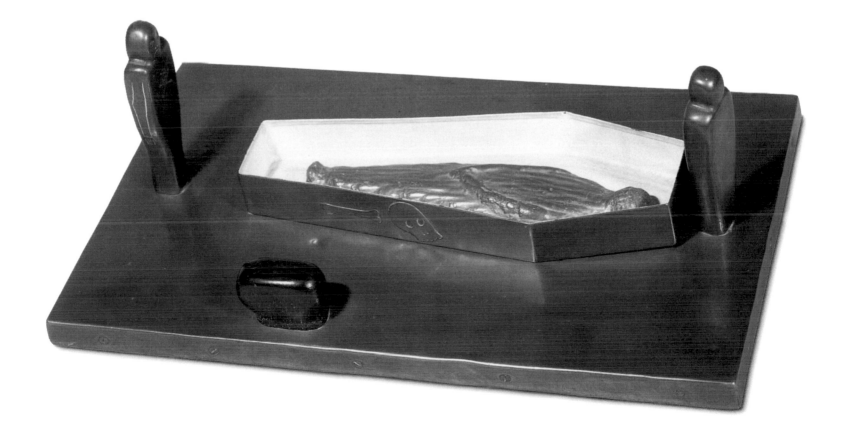

5
Eye of God, 1955–56
Oak, brass, lead, and glass
10 ³/₄ x 14 ³/₄ x 4 in.
(27.3 x 37.5 x 10.2 cm)
John and Maxine Belger Family
Foundation, Kansas City, Mo.

6
Dismasted Ship, 1956
Walnut and bronze
7 ³/₈ x 21 ¹/₈ x 3 ¹/₄ in.
(18.7 x 53.7 x 8.3 cm)
Gail and Arden Sundheim,
Palatine, Ill.

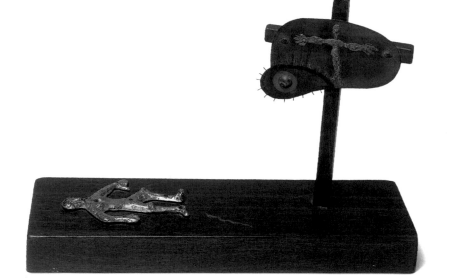

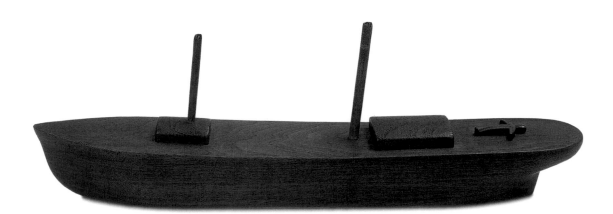

7
Great Mother Womb, 1957
Plywood, pine, glass, bronze,
iron, steel, and brass screws
74 ⅝ x 26 x 26 in.
(189.5 x 66 x 66 cm)
Michael F. Marmor,
Stanford, Calif.

7a–b
Great Mother Womb
(interior details)

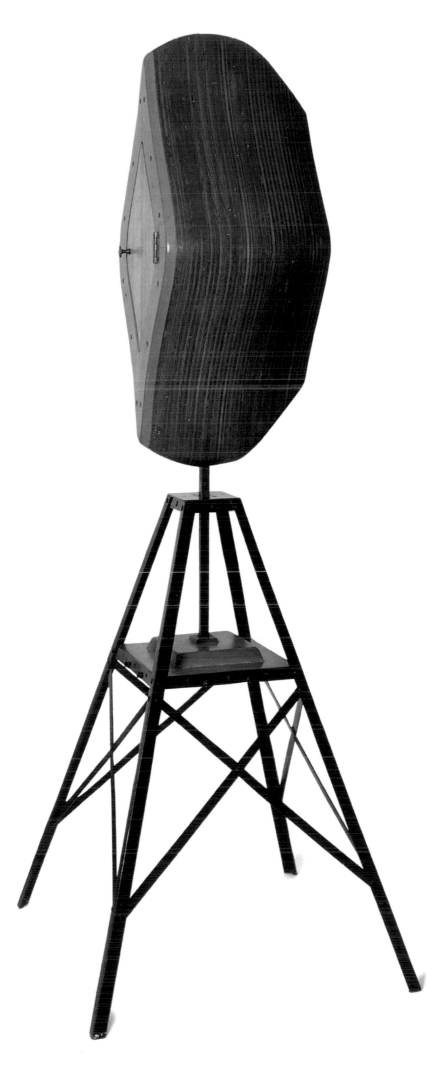

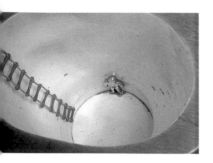

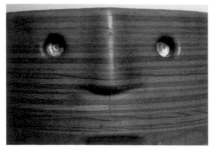

8
He-Whore, 1957
Plywood, vermillion, oak,
maple, walnut, fir, birch,
mirror, paint, chromium-plated
brass, paint, cork, rope, and
U.S. dimes
$23^{1}/_{2}$ x $11^{1}/_{2}$ x 20 in.
(59.7 x 29.2 x 50.8 cm)
Museum of Contemporary Art,
Chicago, Gift of Susan and
Lewis Manilow (1993.35)

8 a – b
He-Whore (interior and
exterior detail)

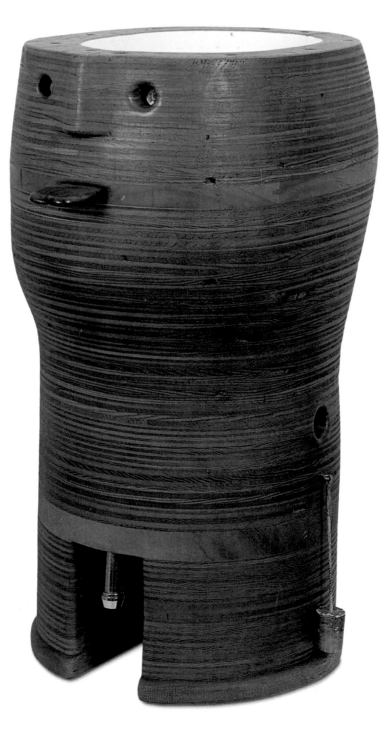

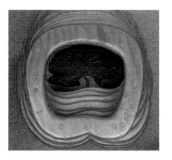

9
I Wonder If I Really Love Her?
1957
Plywood, varnish, paint,
and graphite
21 x 19½ x 22 in.
(53.3 x 49.5 x 55.9 cm)
The Henry and Gilda
Buchbinder Family
Collection, Chicago

9a
I Wonder If I Really Love Her?
(interior detail)

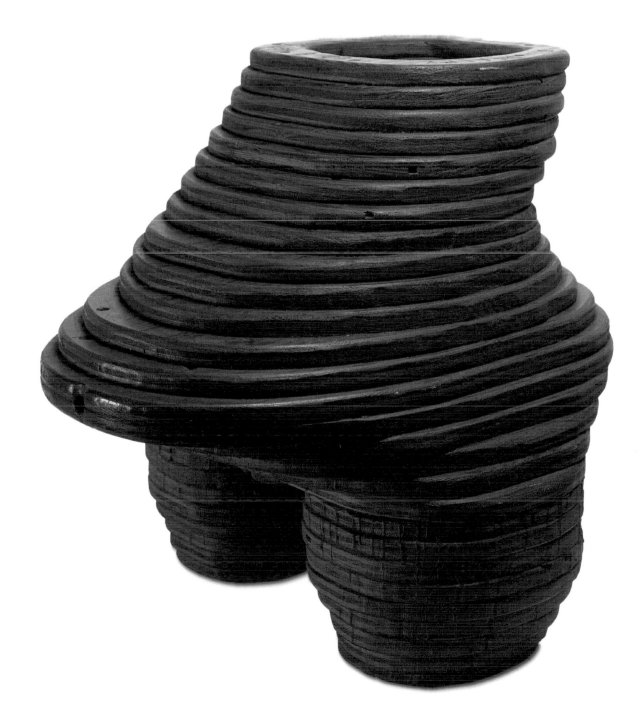

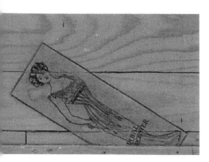

10
Mother, 1957
Pine, plywood, mirror, paper
découpage, and graphite
30 ³/₄ x 16 ⁵/₈ x 9 ⁷/₈ in.
(78.1 x 42.4 x 25.1 cm)
Sally Lilienthal,
San Francisco

10a
Mother (detail)

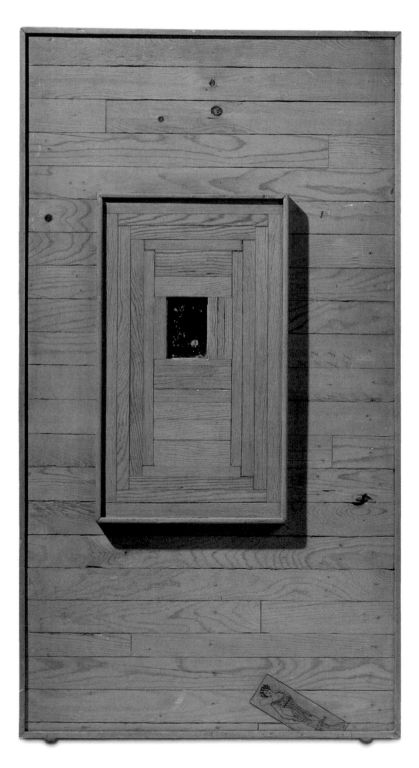

11

*Monument for a Dead
Marine*, 1957
Oak, walnut, ebony, and bronze
21¼ x 2¾ x 2⅞ in.
(54 x 7 x 7.3 cm)
Private collection

12

Untitled (for Lee and Lois
Ostrander), 1957
White pine, maple, amaranth
(purpleheart), ebony, brass,
commercially printed post-
cards, and decorative paper
9 x 11⅞ x 8⅞ in.
(22.9 x 30.2 x 22.5 cm)
Private collection

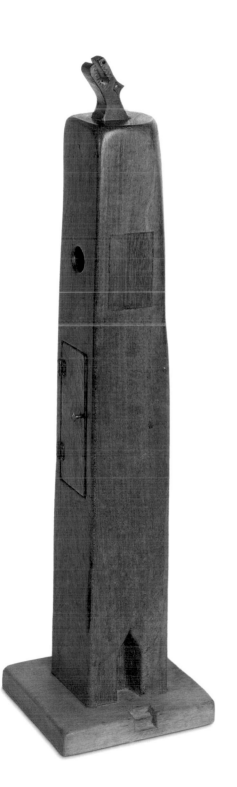

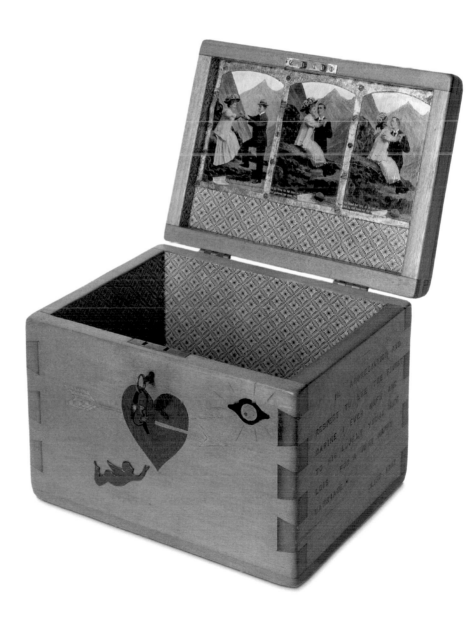

Essentially this is a very unusual physician, effecting a wonderful cure of a horribly diseased (suffering) young man. And yet this is a composite of other things including some sentimental "slobbery."

• • • • •

Dovetail construction — oil-base + shellac finish — Pine wood box.

13
Untitled ("Unusual Physician"),
1957
Pine, metal, aluminum alkyd
enamel, postcard, and varnish
8½ x 12 x 9¼ in.
(21.6 x 30.5 x 23.5 cm)
Collection of Janice and
Mickey Cartin

13 a – b
Untitled ("Unusual Physician")
(interior and exterior details)

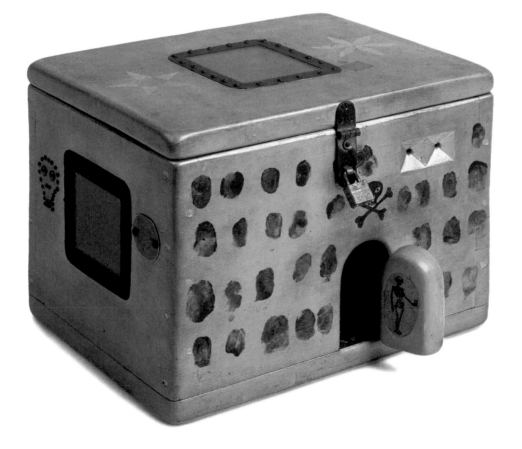

14

String & Paper Men, 1957
Walnut, redwood, string,
paper découpage, and paint
10 ⁵/₈ x 26 ¹/₈ x 6 ¹/₂ in.
(27 x 66.4 x 16.5 cm)
Jerome H. and Linda Meyer,
Chicago

15

*Two Acrobats and a Fleeing
Man*, 1957
Fir, pine, and lead
12 x 20 ¹/₄ x 1 ¹/₂ in.
(30.5 x 51.4 x 3.8 cm)
Museum of Contemporary Art,
Chicago, Gift of Susan and
Lewis Manilow (1984.6)

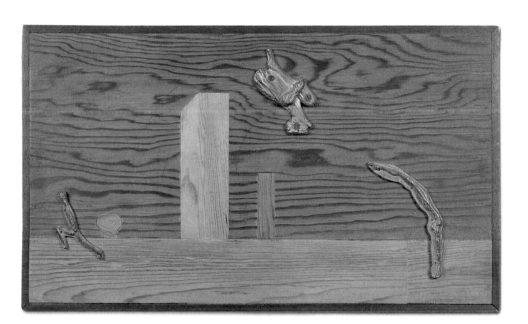

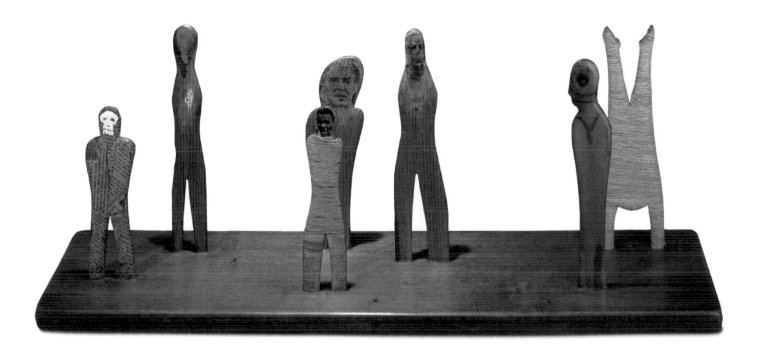

Burning House, 1958
Pine, brass bell, tin, glass,
rope, and enamel
42 ¼ x 11 ¾ x 15 ¾ in.
(107.3 x 29.8 x 40 cm)
Private collection, Courtesy
Lennon, Weinberg, Inc.,
New York

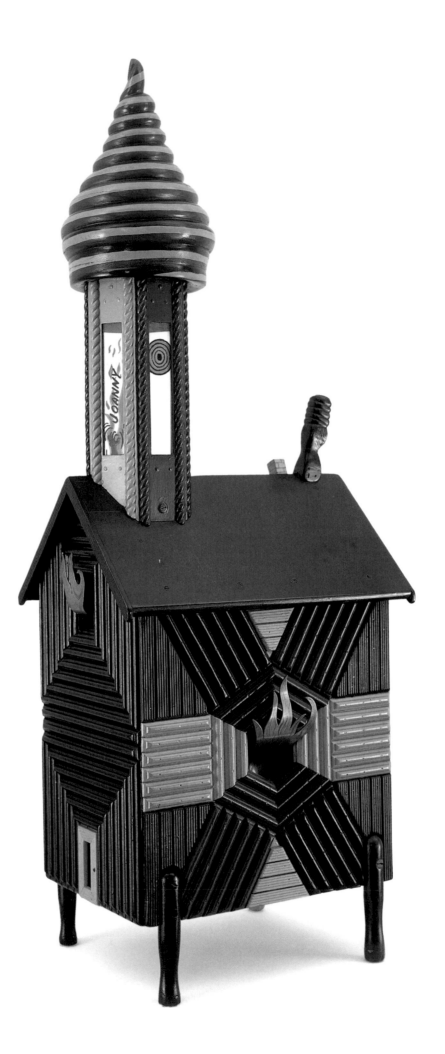

17
*Mysteriously Abandoned
New Home*, 1958
Pine, birch, vermillion, red-
wood, glass, paint, and wheels
50⅛ x 24⅞ x 24⅞ in.
(127.4 x 63.2 x 63.2 cm)
The Art Institute of Chicago,
Gift of Lewis Manilow
(1962.905)

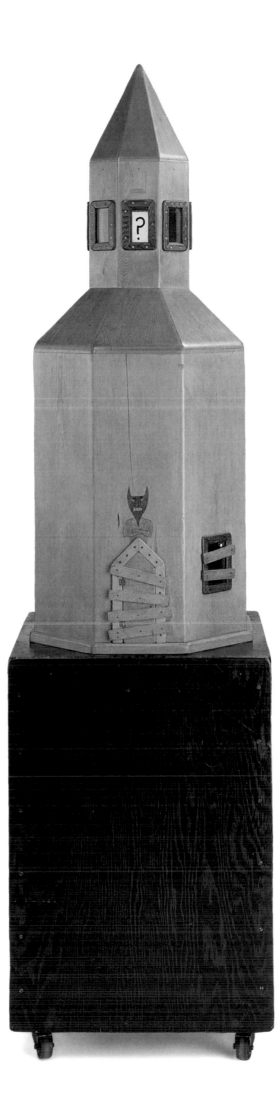

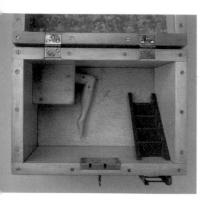

18
Untitled (for Ann Davidow),
1956–57
Wood, galvanized sheet
metal, paint, and glass
9 x 8 x 11 in.
(22.9 x 20.3 x 27.9 cm)
Ann Goodman Hayes,
Boulder, Colo.

18a
Untitled (for Ann Davidow)
(interior detail)

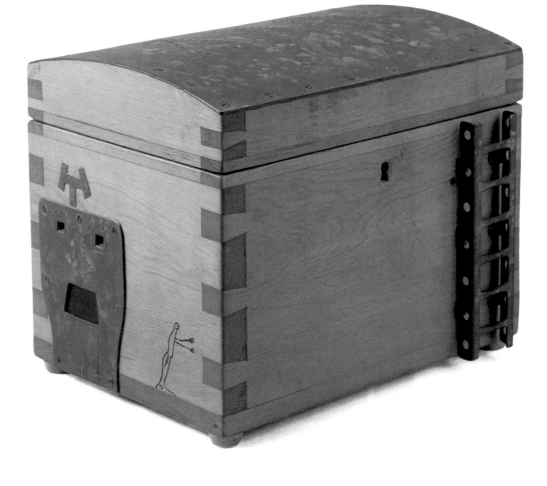

19
Mad House, 1958
Pine, plywood, glass, brass,
galvanized sheet metal,
enamel, tin toy, lead soldier,
paper découpage, mirror,
and U.S. penny
38⅛ x 17½ x 21 in.
(96.8 x 44.5 x 53.3 cm)
Museum of Contemporary Art,
Chicago, Gift of Joseph and
Jory Shapiro (1978.5)

19a
Mad House (detail)

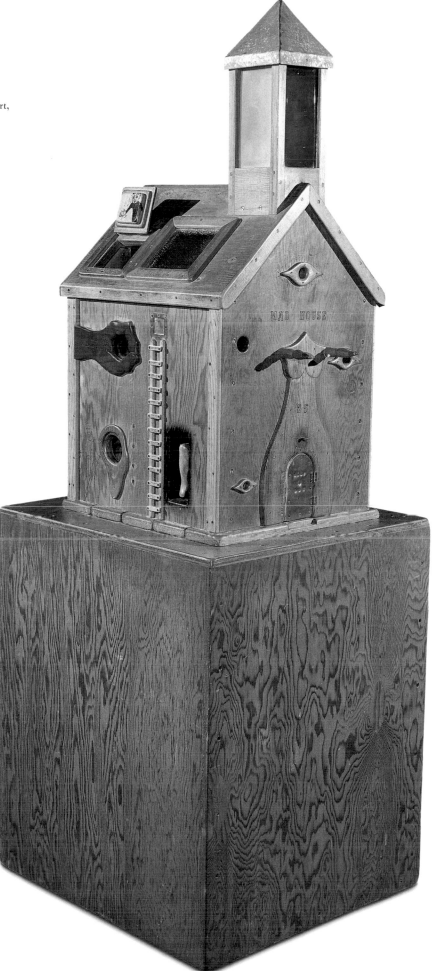

Untitled ("Castle Box"),
c. 1956
Plywood, pine, brass, bronze,
rope, paint, brass padlock, and
paper découpage
15 x 10¼ x 8 in.
(38.1 x 26 x 20.3 cm)
Private collection, New York

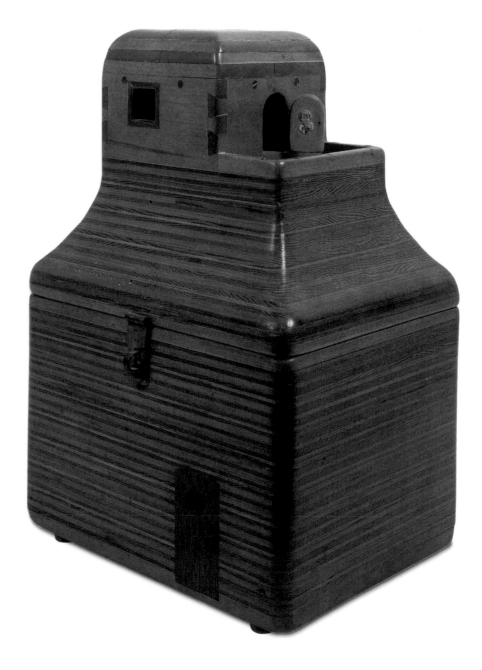

21

Brinkmanship, 1959
Plywood, electroplated metal,
bottle cap, and string
23¼ x 24 x 19⅜ in.
(59 x 61 x 49.2 cm)
Hirshhorn Museum and
Sculpture Garden, Smithsonian
Institution. Gift of Allan
Frumkin, 1984.

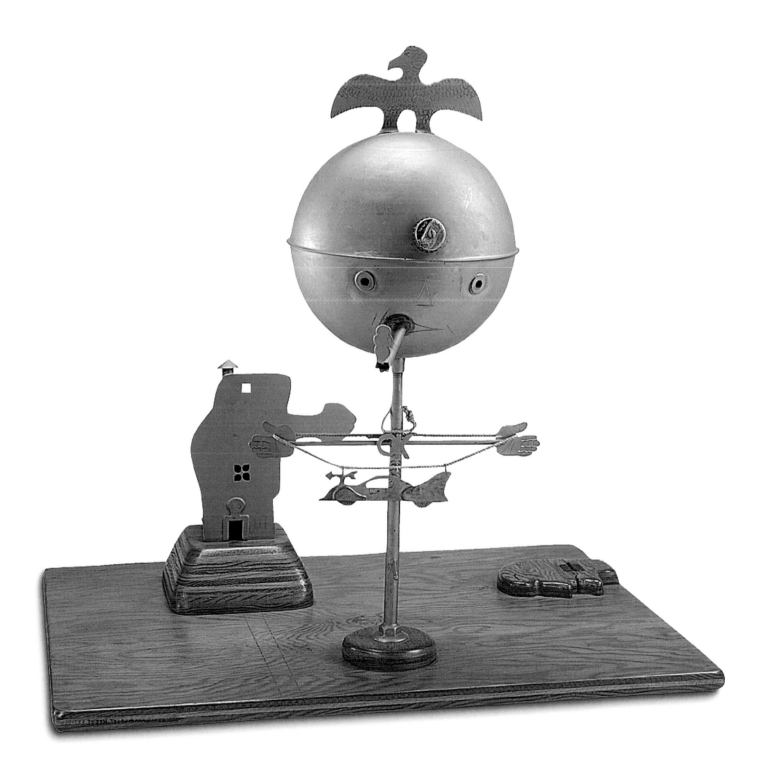

22
*Memorial to the Idea of Man
If He Was an Idea*, 1958
Pine, bottle caps, cast-tin toys,
glass, metal, brass, ebony,
and enamel
56 1/2 x 38 x 14 1/4 in.
(143.5 x 96.5 x 36.2 cm)
Museum of Contemporary Art,
Chicago, Gift of Susan
and Lewis Manilow (1993.34)

22a
*Memorial to the Idea of Man
If He Was an Idea*
(alternate view)

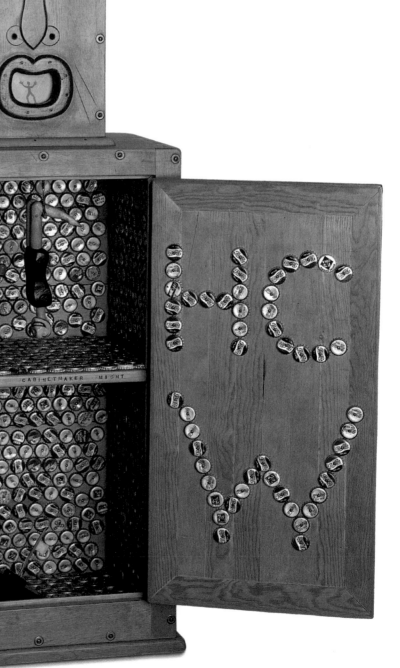

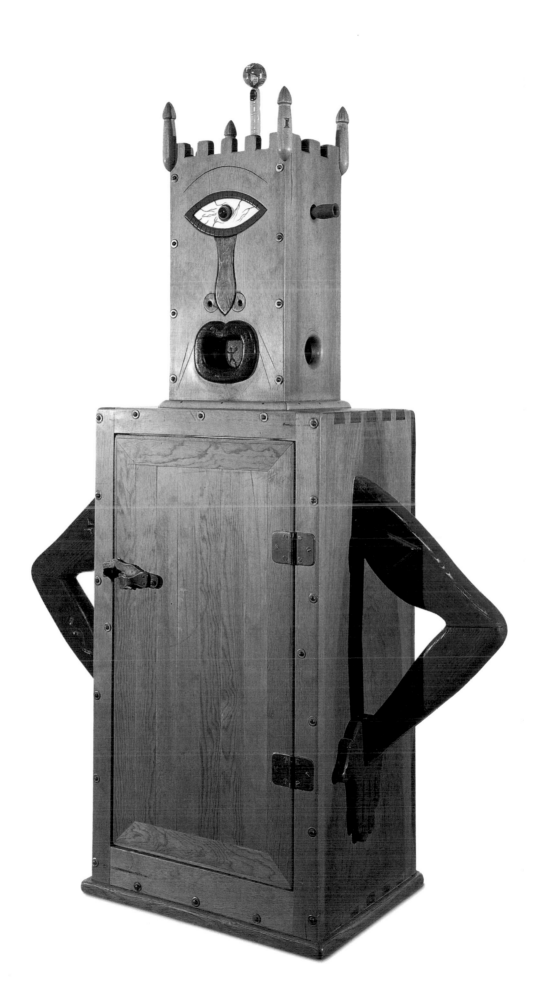

23

The Evil New War God
(S.O.B.), 1958
Partially chromium-
plated brass
16 ³/₄ x 9 ¹/₂ x 10 ³/₈ in.
(42.5 x 24.1 x 26.4 cm)
Whitney Museum of American
Art, New York, Gift of
Howard and Jean Lipman
(97.113.10)

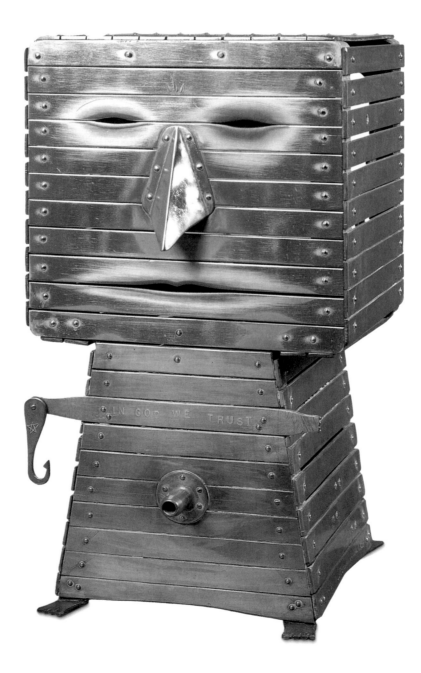

24
Angry Young Machine, 1959
Pine, plywood, galvanized iron
pipe and fittings, faucet handle,
cast-lead soldier, aluminum
alkyd enamel, and wheels
89 ¾ x 26 ⅞ x 28 ¼ in.
(228 x 68.3 x 71.8 cm)
The Art Institute of Chicago,
Restricted gift of Mr. and
Mrs. E. A. Bergman (1975.132)

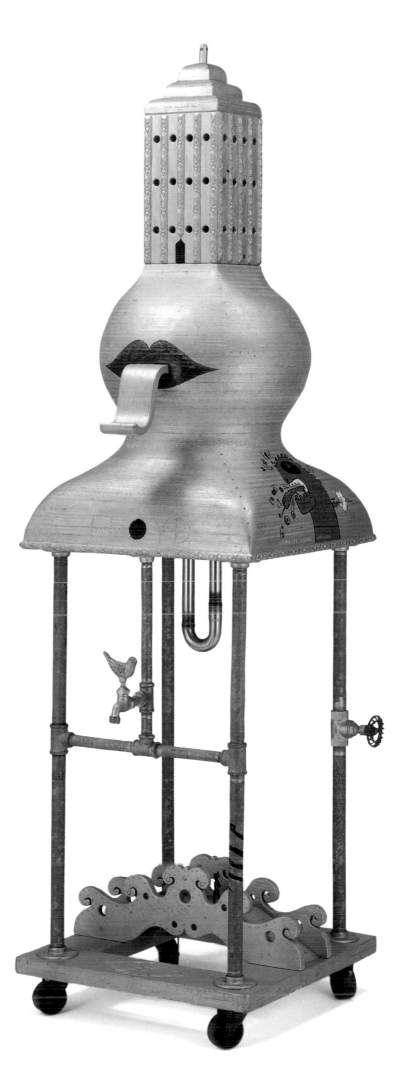

25
Untitled ("J & C Box"), 1959
Pine, brass, glass, mirror,
and enamel
16¼ x 13 x 10 in.
(41.3 x 33 x 25.4 cm)
Private collection, Courtesy
Lennon, Weinberg, Inc.,
New York

26
Monument to Martha, 1960
Pine, Colonial Casque pine
molding, plywood, mirror,
tin, cast-metal soldier, plastic
decal, and paper découpage
47 x 19 x 19 in.
(119.4 x 48.3 x 48.3 cm)
Martha Westermann Renner,
Atherton, Calif.

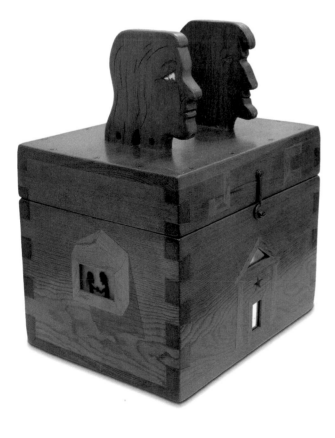

27
The Hands, 1961
Cast aluminum, wood,
linoleum, paint, chromium-
plated pipe, and metal
43 ³/₄ x 21 ³/₈ x 21 ³/₈ in.
(111.1 x 54.3 x 54.3 cm)
The Nelson-Atkins Museum
of Art, Kansas City, Mo.,
Gift of Mr. and Mrs.
Richard M. Hollander (F73-36)

The Silver Queen, 1960
Pine, plywood, pine molding,
galvanized metal weather
vent, iron fittings, enamel, and
aluminum alkyd enamel
79 ³/₄ x 20 ⁷/₈ x 21 ¹/₈ in.
(202.6 x 52.9 x 53.7 cm)
Private collection, London

29
Swingin' Red King, 1961
Pine, pine molding,
plywood, and enamel
83 ¾ x 29 ¼ x 25 in.
(212.7 x 74.3 x 63.5 cm)
Private collection, London

30

The Pillar of Truth, 1962
Red oak, pine, walnut,
enamel, cast aluminum,
and metal spring
24 5/8 x 7 1/2 x 8 in.
(62.5 x 19.1 x 20.3 cm)
Allan Frumkin, Inc.

31

Hard of Hearing Object, 1961
Iron pipes with fittings,
wood, aluminum alkyd enamel,
galvanized sheet metal, metal
screen, and steel bolt with nut
24 1/2 x 12 1/4 x 12 3/4 in.
(62.2 x 31.1 x 32.4 cm)
Allan Frumkin, Inc.

32
Untitled (question mark), 1962
Plywood and enamel
40 x 23 x 23 in.
(101.6 x 58.4 x 58.4 cm)
The Henry and Gilda
Buchbinder Family
Collection, Chicago

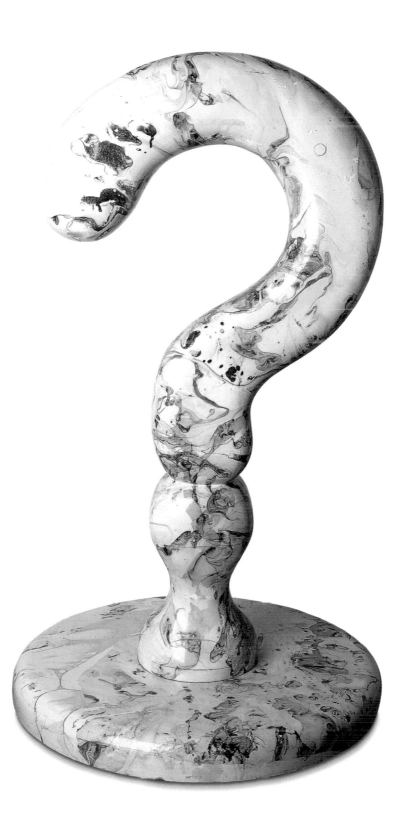

33
A Small Negative Thought, 1962
Douglas fir and metal bolts
28¼ x 16½ x 16 in.
(71.8 x 41.9 x 40.6 cm)
Wadsworth Atheneum,
Hartford, Conn.,
Purchased through a gift of the
Athena Fund (1964.143)

34
A Positive Thought, 1962
Douglas fir, iron pipe, and
metal bolts
30 x 12½ x 11⅜ in.
(76.2 x 31.8 x 28.9 cm)
Private collection,
Courtesy Lennon Weinberg,
Inc., New York

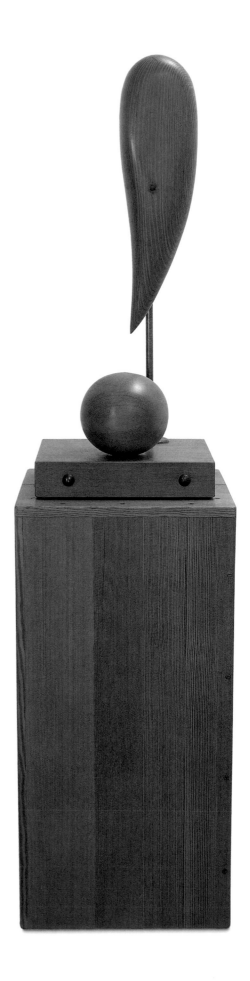

35
Exotic Garden, 1962
Pine, plywood, enamel,
and mirror
26 ³/₈ x 32 x 22 in.
(67 x 81.3 x 55.9 cm)
The Henry and
Gilda Buchbinder Family
Collection, Chicago

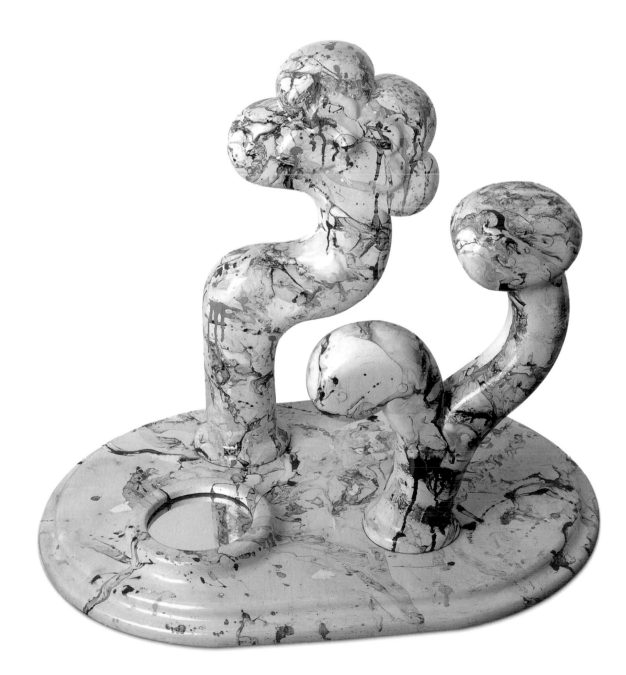

*Machine for Calculating
Risks*, 1962
Wood, linoleum, metal, glass,
bowling trophy, reflector,
clockworks, aluminum alkyd
enamel, antique acanthus leaf
feet, plastic decal, and paint
$24^{1}/_{4}$ x 10 x 9 in.
(61.6 x 25.4 x 22.9 cm)
Billy Al Bengston, Los Angeles

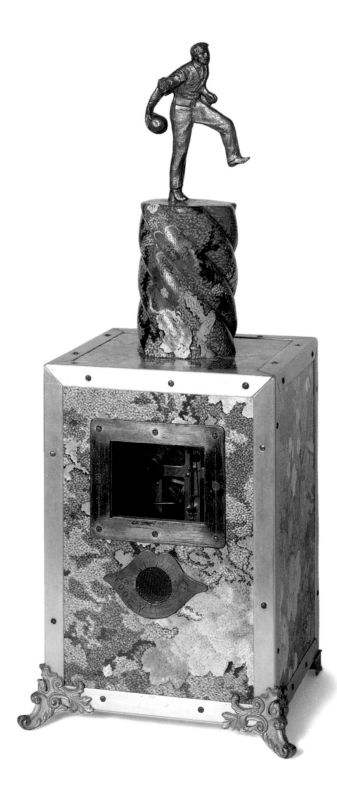

37
The Big Change, 1963
Douglas-fir marine plywood,
Masonite, and ink
75 ³/₈ x 20 ¹/₄ x 20 ¹/₄ in.
(191.5 x 51.4 x 51.4 cm)
Billy Copley and Patricia L.
Brundage, New York

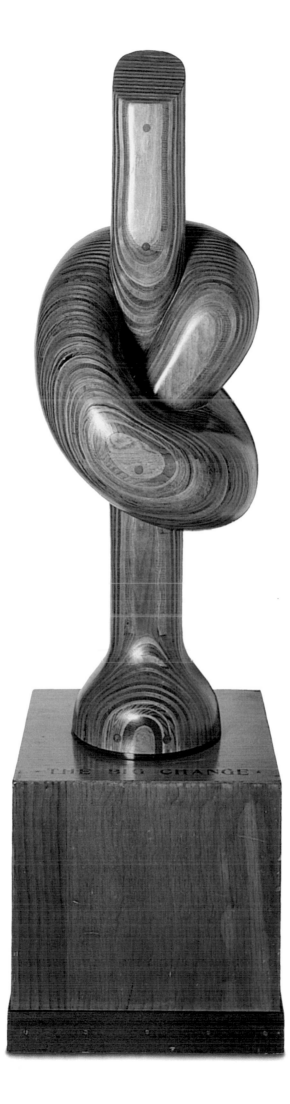

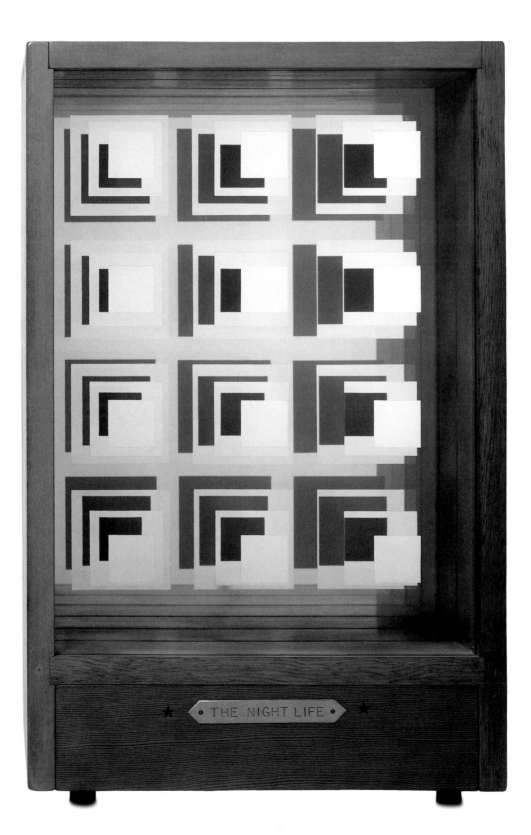

39
The Dream World, 1963
Douglas fir, plate-glass mirror,
ink, and rubber bumpers
14 1/8 x 13 3/4 x 6 5/8 in.
(35.9 x 34.9 x 16.8 cm)
Private collection

40
Clean Air, 1964
Walnut, plate glass, putty, brass
plate, and rubber bumpers
15 3/4 x 22 1/4 x 14 5/8 in.
(40 x 56.5 x 37.1 cm)
Collection of Samuel and
Ronnie Heyman

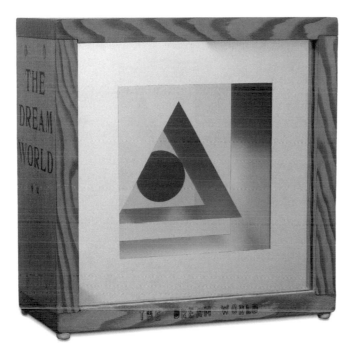

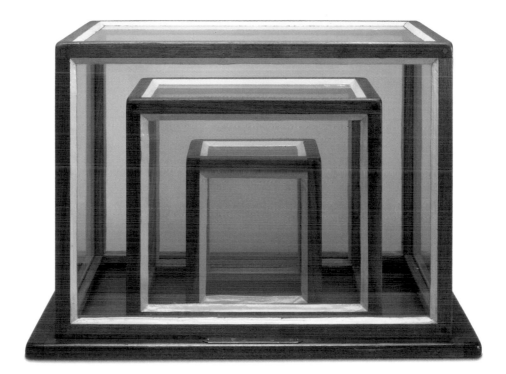

41
Aluminated, 1964
Marine plywood, Masonite,
aluminum alkyd enamel,
reflectors, enamel, mirror,
and rubber bumpers
18 ¾ x 21 ¾ x 22 in.
(47.6 x 55.2 x 55.9 cm)
Jim and Jeanne Newman,
San Francisco

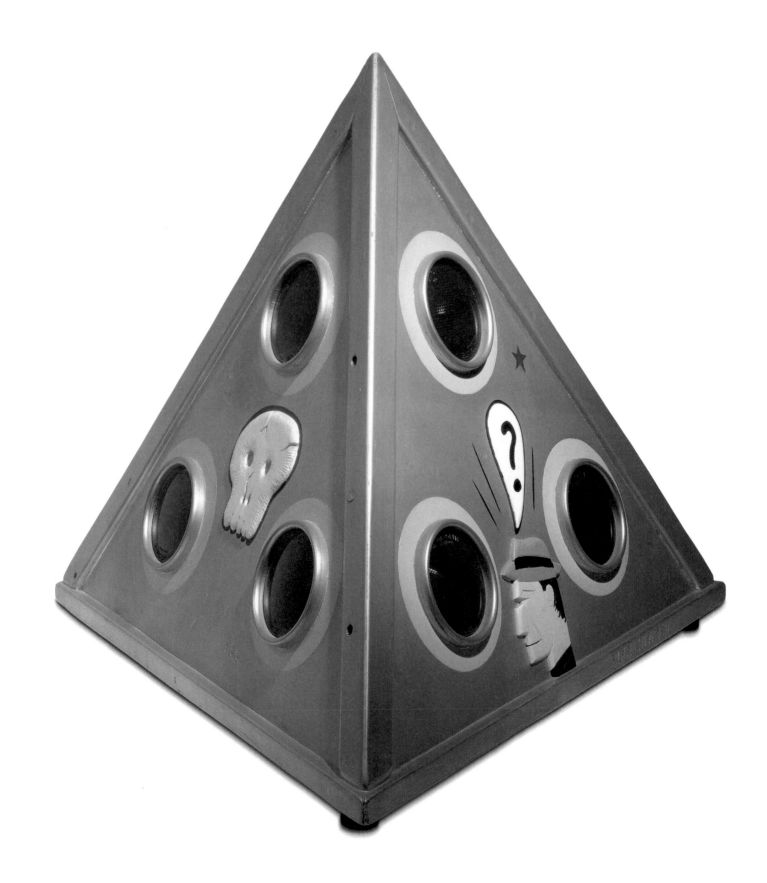

42
Plywood Box, 1964
Fir plywood, brass key, brass
chain, and rubber bumpers
$9^{1}/_{2}$ x $12^{7}/_{8}$ x $12^{1}/_{2}$ in.
(24.1 x 32.7 x 31.8 cm)
Sharon and Thurston
Twigg-Smith, Honolulu

43
Walnut Box, 1964
Walnut, walnuts, plate glass,
and brass chain
$10^{3}/_{8}$ x $13^{3}/_{8}$ x 11 in.
(26.4 x 34 x 28 cm)
Private collection, Chicago

43a
Walnut Box (open)

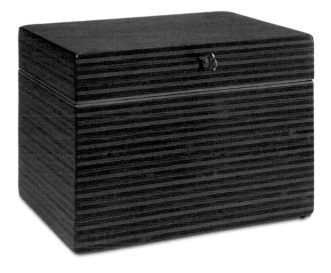

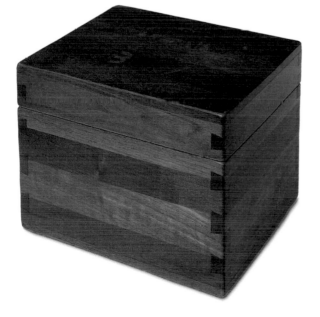

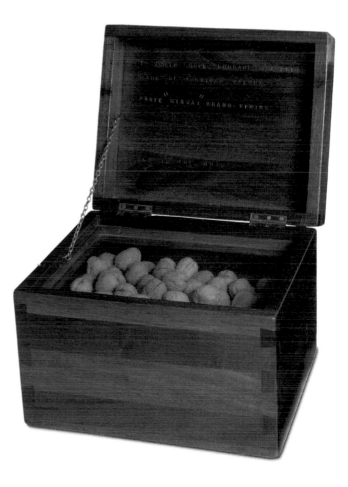

44
Untitled THIS IS TITLE, 1964
Mahogany, vermillion,
hemlock, and wood stain
70¹⁄₄ x 17³⁄₄ x 27¹⁄₄ in.
(178.4 x 45.1 x 69.2 cm)
Anne and William J. Hokin,
Chicago

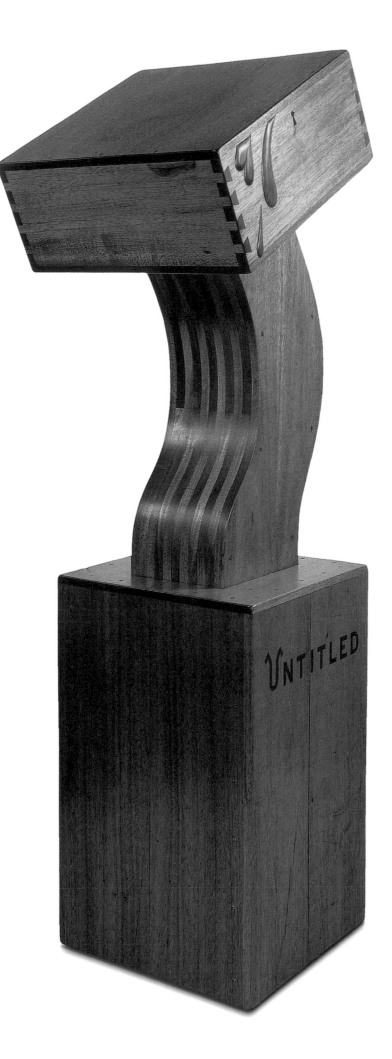

45
A Human Condition, 1964
Pine, Masonite, brass,
glass doorknob, and ink
37 7/8 x 24 x 13 in.
(96.2 x 61 x 33 cm)
Private collection, Courtesy
Lennon, Weinberg, Inc.,
New York

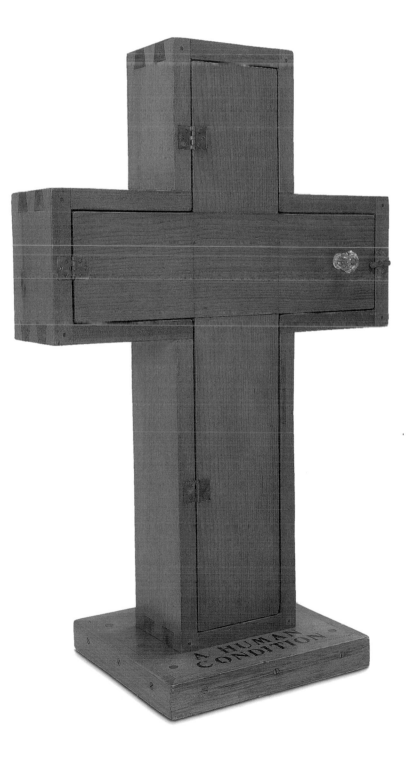

46

1.2.3., 1965
Honduras mahogany
Three panels, each
30 x 19 ³/₄ x 1 in.
(76.2 x 50.2 x 2.5 cm)
Ann Janss, Los Angeles

47
Korea, 1965
Pine, glass, rope, brass,
and found objects
34¹/₂ x 16¹/₈ x 8³/₈ in.
(87.6 x 41 x 21.3 cm)
Private collection, Courtesy
Lennon, Weinberg, Inc.,
New York

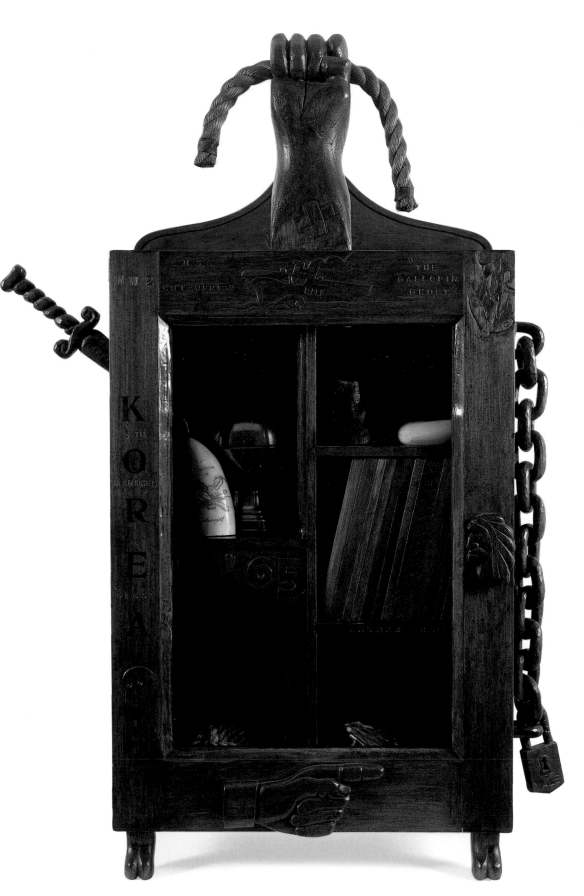

48
Ash Relief, 1965
Ash and brass hinges
28 x 15⅛ x 8¾ in.
(71.1 x 38.4 x 22.2 cm)
Anstiss and Ronald Krueck,
Chicago

49
Negate, 1965
Maple
8⅛ x 28⅛ x 3¾ in.
(20.8 x 71.4 x 9.5 cm)
Jerome H. and Linda
Meyer, Chicago

50
Suicide Tower, 1965
Mahogany, brass, ebony,
postcards, and metal
43 ¾ x 15 ¼ x 13 ⅞ in.
(111.1 x 38.7 x 35.2 cm)
Robert Lehrman,
Washington, D.C.

51
Untitled, 1965
Fir plywood, ash, plate glass,
ebony, photograph, paper
découpage, silk flowers,
rubber bumpers, and ink
28 x 20 x 9 ¾ in.
(71 x 50.8 x 24.8 cm)
Claire Copley and Alan
Eisenberg, New York

52
Nouveau Rat Trap, 1965
Birch plywood, rosewood,
metal, and rubber bumpers
13 x 34 x 7 ¾ in.
(33 x 86.4 x 19.7 cm)
Sharon and Thurston
Twigg-Smith, Honolulu

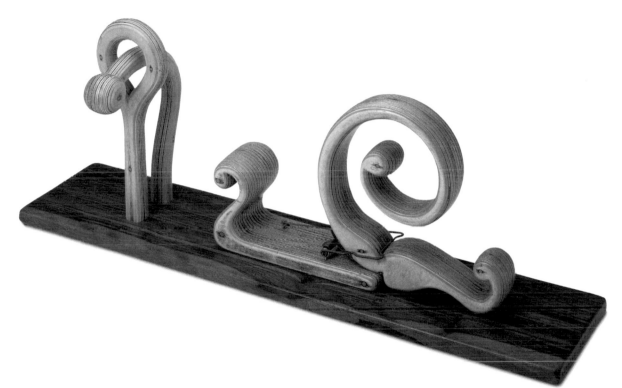

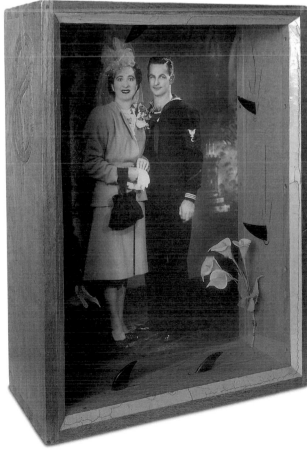

53
Death Ship Runover by a '66
Lincoln Continental, 1966
Pine, plate glass, ebony,
U.S. dollar bills, putty, brass,
and ink
15 ⁵/₈ x 32¹/₂ x 11³/₄ in.
(39.7 x 82.6 x 29.8 cm)
Ann Janss, Los Angeles

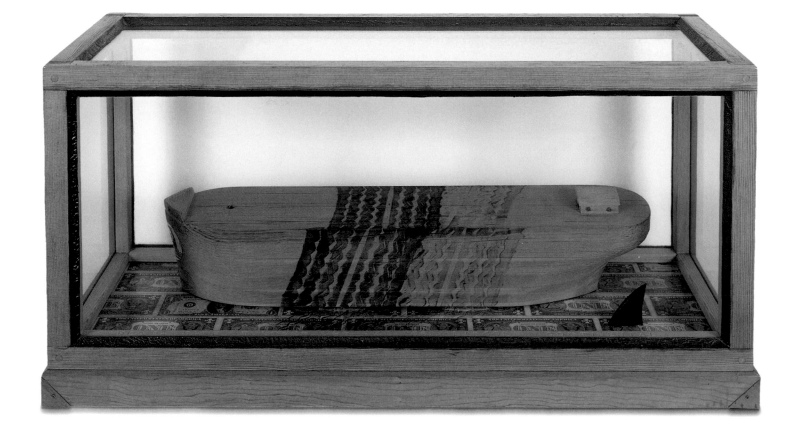

54
Imitation Knotty Pine, 1966
Pine, knotty pine, and brass
12¹/₂ x 20 ³/₄ x 13 in.
(31.8 x 52.7 x 33 cm)
Sharon and Thurston
Twigg-Smith, Honolulu

55
Le Keeque (after Jockomedy),
1966
Chromium-plated solid
cast bronze
36 x 19 x 9 in.
(91.4 x 48.3 x 22.9 cm)
Ann Janss, Los Angeles

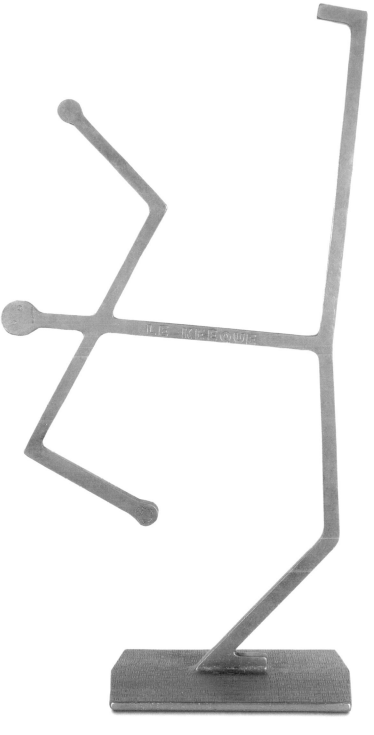

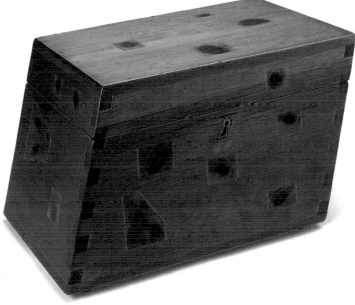

56
Westermann's Table, 1966
Douglas-fir plywood, Masonite,
leather-bound books, bolt,
brass nut, paint, and graphite
44 x 23 x 23¹⁄₂ in.
(111.8 x 58.4 x 59.7 cm)
Alan and Dorothy Press
Collection, Chicago

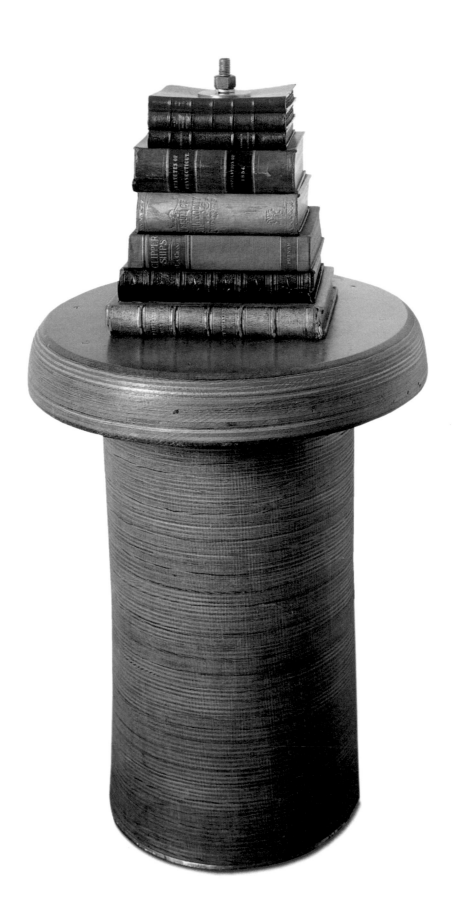

57
Homage to American Art (Dedicated to Elie Nadelman), 1966
Douglas fir, ash, cast lead, and antique shovel handle
48¼ x 18 x 18¼ in.
(122.6 x 45.7 x 46.4 cm)
Alan and Dorothy Press
Collection, Chicago

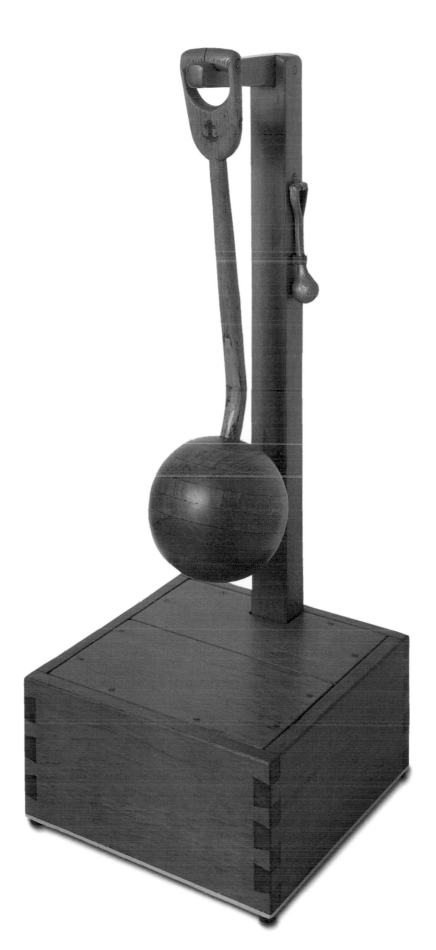

58
March or Die, 1966
Pine, redwood, leather, ebony,
metal, felt, and ink
30 ³/₄ x 20 x 10 ³/₈ in.
(78.1 x 50.8 x 26.4 cm)
Jim and Jeanne Newman,
San Francisco

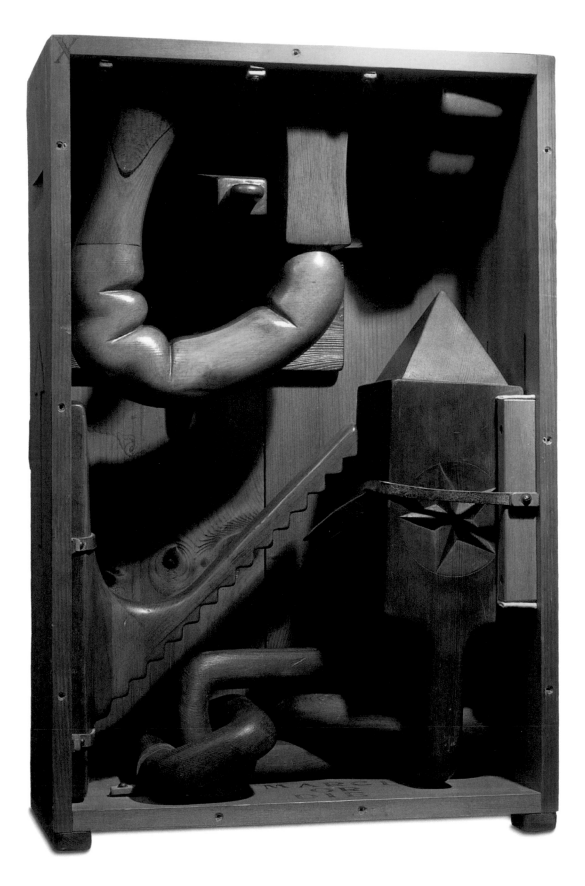

59
The Rape of "Cracker Jack,"
1967
Maple, hemp rope with
electrical tape, brass chain,
rubber bumpers, and ink
11 3/8 x 30 1/4 x 9 1/4 in.
(28.9 x 76.8 x 23.5 cm)
The Grinstein Family,
Los Angeles

60
Death of Cracker Jack, 1967
Pyrex jar, oak, mahogany,
brass, lead, cast copper, dried
roots, linoleum, and ink
18 3/4 x 12 1/2 x 12 1/2 in.
(47.6 x 31.8 x 31.8 cm)
Mrs. Rachelle Schooler Miller,
Chicago

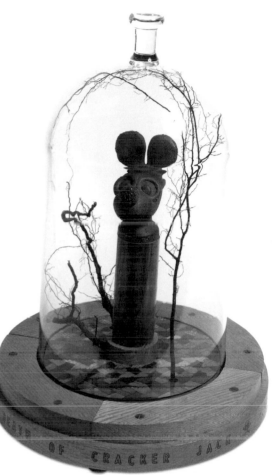

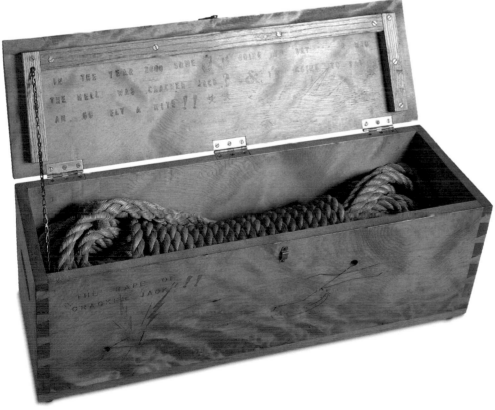

61
Lily Bolero, 1967
Pine, plate glass, enamel, and
cast lead
18 ³/₄ x 9 ¹/₄ x 8 in.
(47.6 x 23.5 x 20.3 cm)
Private collection, Courtesy
Lennon, Weinberg, Inc.,
New York

62
Lightning, 1967
Beech, pine, plate-glass mirror,
brass, rubber bumpers. and ink
15 ³/₄ x 26 ¹/₈ x 10 in.
(40 x 66.4 x 25.4 cm)
Museum Moderner Kunst
Stiftung Ludwig Wien

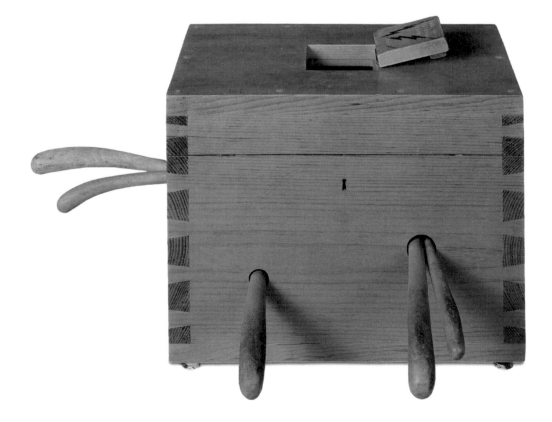

63
Untitled (Death Ship), 1967
Pine, U.S. dollar bills,
shellac, plastic decals, brass
tacks, and graphite
5 ⁵⁄₈ x 18¹⁄₂ x 3⁷⁄₈ in.
(14.3 x 47 x 9.8 cm)
Collection Carol Selle,
New York

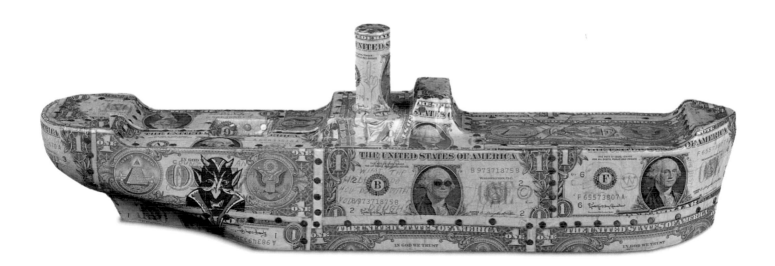

64
*Nothing Is to Be Done for
William T. Wiley*, 1967
Pine, oak, and ink
44 x 28 x 2 in.
(111.8 x 71.1 x 5.1 cm)
William T. Wiley, Woodacre,
Calif.

65
Walnut Log, 1969
Walnut, black friction tape
(replaced), and ink
8 x 17¼ x 6 in.
(20.3 x 43.8 x 15.2 cm)
William T. Wiley, Woodacre,
Calif.

65a
Walnut Log (closed)

66

*No Man Stands So Straight
As When He Stoops to Help
a Boy*, 1968
Bird's-eye maple, cast bronze,
cast lead, brass, stainless steel,
copper, iron, paint, nuts and
bolts, rubber bumpers, and ink
15 x 22½ x 9½ in.
(38.1 x 57.2 x 24.1 cm)
Ed Ruscha, Los Angeles

67

*Death Ship of No Port with
a Shifted Cargo*, 1968
Redwood, ebony, amaranth
(purpleheart), goatskin, brass,
pine, and rubber bumpers
9⅞ x 16⅞ x 6½ in.
(25.1 x 42.9 x 16.5 cm)
Robert Lehrman,
Washington, D.C.

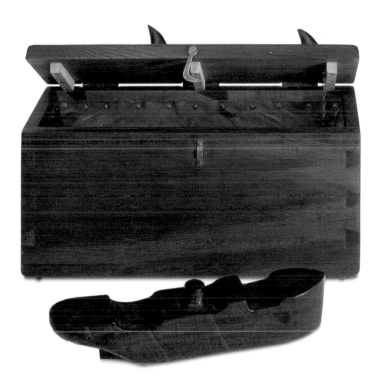

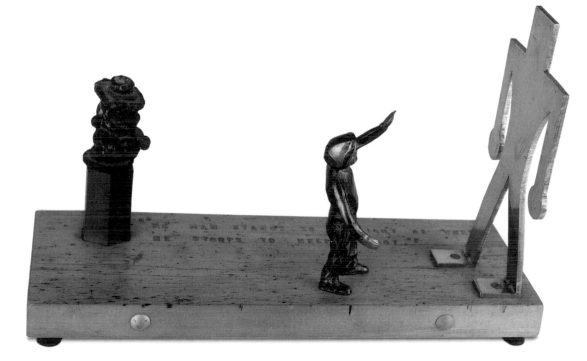

68

Red Rock Canyon, 1968
Mahogany, plate glass, hand-
tinted photograph, lead,
enamel, wood, bird's nest,
string, putty, and rubber
bumpers
27 ³/₄ x 10 ¹/₄ x 10 ¹/₄ in.
(70.5 x 26 x 26 cm)
Sharon and Thurston
Twigg-Smith, Honolulu

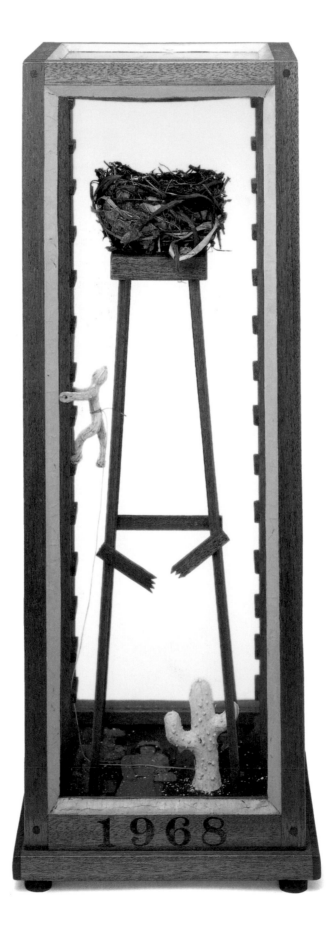

69
Wet Flower, 1968
Wood, glass, Connecticut
stone, linoleum, dried roots,
putty, and varnish
29 x 18 x 14 in.
(73.7 x 45.7 x 35.6 cm)
Alan and Dorothy Press
Collection, Chicago

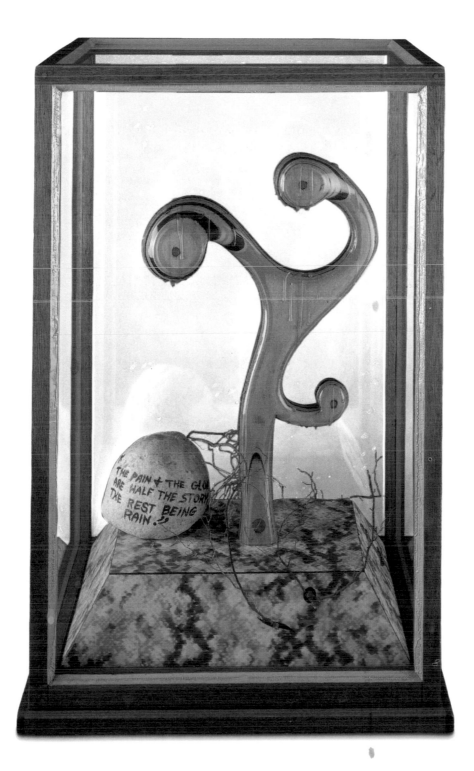

70
Untitled ("This Great
Rock Was Buried Once for a
Million Years"), 1968
Connecticut fieldstone, wood,
paint, galvanized metal chain,
and aluminum plate
8 ³/₈ x 24 x 9 ³/₄ in.
(21.3 x 61 x 24.8 cm)
Sharon and Thurston
Twigg-Smith, Honolulu

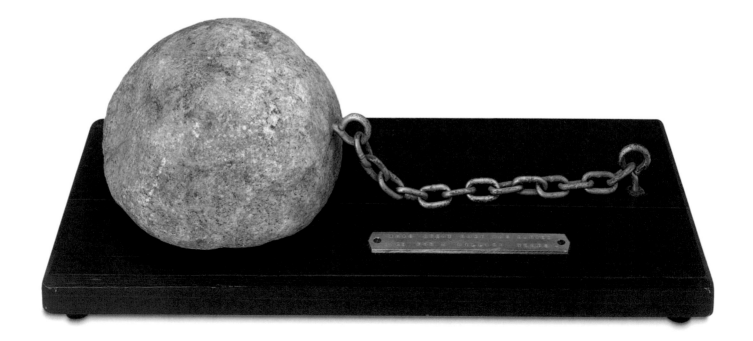

71
Temporary Repair of a Damaged
& Ill-Fated Spacecraft
on a Hostile Planet, 1969
Pine, vermillion, plate glass,
bubinga, saplings, lead, post-
card, copper, Statue of Liberty
statuette, and putty
$24^{1}/_{2}$ x $25^{1}/_{8}$ x $13^{1}/_{2}$ in.
(62.2 x 63.8 x 34.3 cm)
The Metropolitan Museum
of Art, New York,
Gift of Allan Frumkin, 1987
(1987.464)

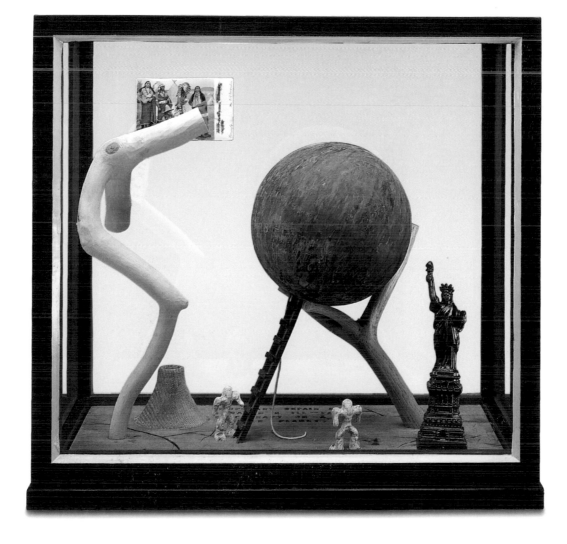

72

*The Battle of Little Jack's
Creek*, 1969
Pine, mahogany, plate glass,
tin beer cans, map of Roxbury,
Connecticut, chrome hood
ornament, watercolor on paper,
plate-glass mirror, plastic doll,
golf balls, galvanized sheet
metal, paper découpage, paint,
putty, and ink
30 ³/₄ x 24 ¹/₂ x 16 ³/₄ in.
(85.7 x 62.2 x 42.5 cm)
The Museum of Modern Art,
New York, Fractional gift of
Robert and Laura Lee Woods
(312.92)

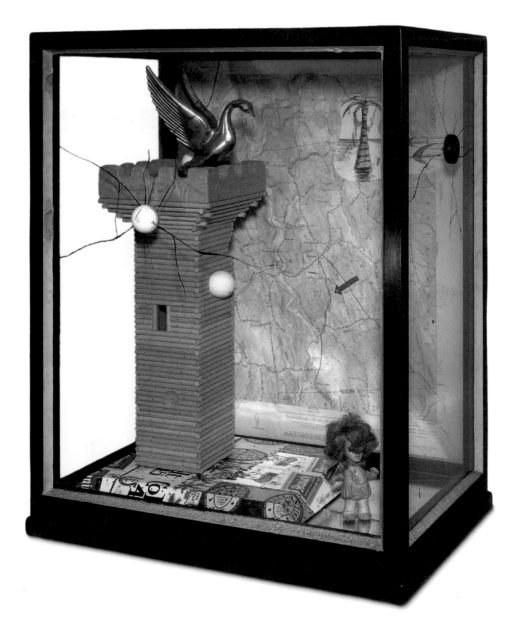

73
*Abandoned Death Ship
of No Port with a List,* 1969
Basswood, walnut, and
brass plate
11 x 39 x 12 in.
(27.9 x 99.1 x 30.5 cm)
Collection Onnasch, Berlin

74
*Abandoned & Listing Death
Ship,* 1969
Redwood, zebrawood, cast
metal toy, hand-tinted
postcards, pine, brass chain,
and brass plate
11 x 30½ x 8⅛ in.
(27.9 x 77.5 x 20.6 cm)
The Henry and Gilda
Buchbinder Family
Collection, Chicago

75
Little Egypt, 1969
Douglas fir, pine, oak,
and bronze
68½ x 32⅜ x 31⅛ in.
(174 x 82.2 x 79.1 cm)
Alan and Dorothy Press
Collection, Chicago

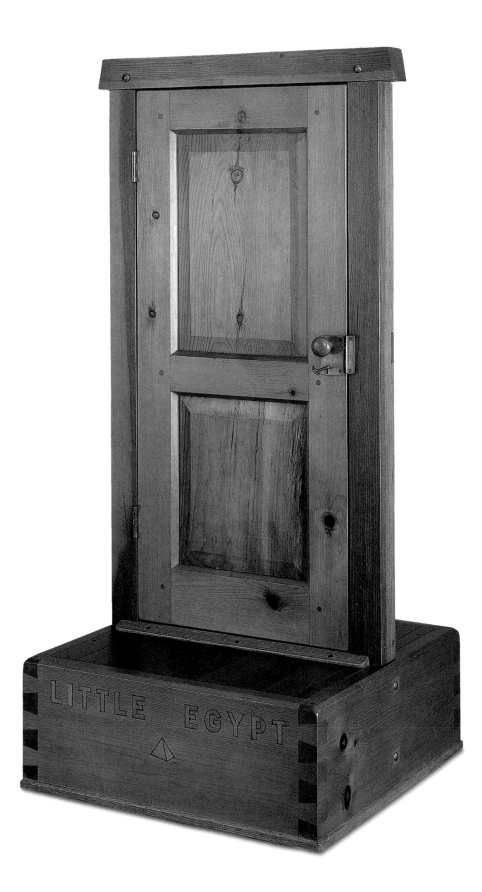

76
The Deerslayer, 1969
Galvanized iron pipe and
fittings, metal wood, and
 antler
82$\frac{1}{2}$ x 28 x 47$\frac{1}{4}$ in.
(209.6 x 71.1 x 120 cm)
Mr. and Mrs. Matthew D. Ashe,
Sausalito, Calif.

77
Phantom in a Wooden Garden, 1970
Douglas fir, pine, redwood, vermillion, and ink
27 ⁷/₈ x 36 ¹/₂ x 18 ⁵/₈ in.
(70.8 x 92.7 x 47.3 cm)
Purchased with funds from the Coffin Fine Arts Trust, Nathan Emory Coffin, collection of the Des Moines Art Center, Iowa (1976.89)

78
It's a Heavy Mother, 1969
Paldao, rosewood, vermillion, oak, kindling wood, galvanized iron, and brass
15 ³/₄ x 24 x 10 ⁷/₈ in.
(40 x 61 x 27.6 cm)
Sharon and Thurston Twigg-Smith, Honolulu

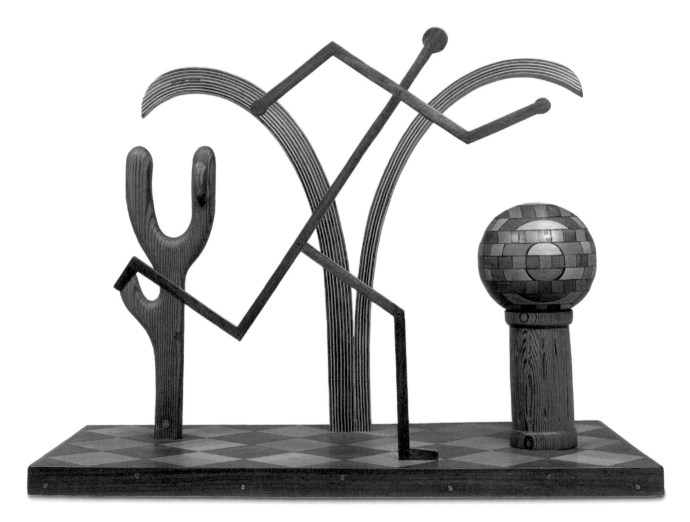

79
The Last Ray of Hope, 1968
Pine, plate glass, leather
boots, linoleum, galvanized
sheet metal, and brass
17 ½ x 25 x 15 ¼ in.
44.5 x 63.5 x 38.3 cm
Private collection, New York

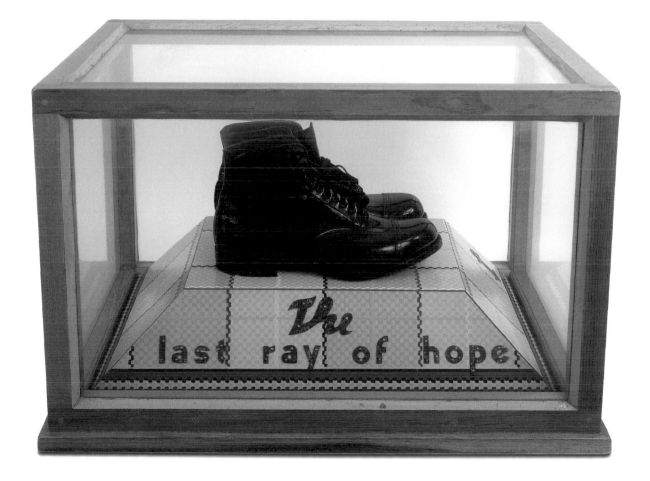

80
The Electric Flower, 1971
Plate glass, cast lead,
vermillion, putty, wire,
and solder
19 ³/₈ x 8 ¹/₄ x 8 ¹/₄ in.
(49.2 x 21 x 21 cm)
John and Mary Pappajohn,
Des Moines, Iowa

81
*Object from a Dying
Planet*, 1971
Connecticut fieldstone, walnut,
"difu" wood, and pigskin
19 ⁷/₈ x 12 ¹/₄ x 9 in.
(50.5 x 31.1 x 22.9 cm)
Anstiss and Ronald Krueck,
Chicago

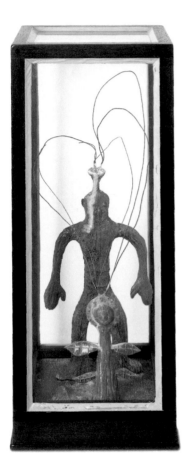

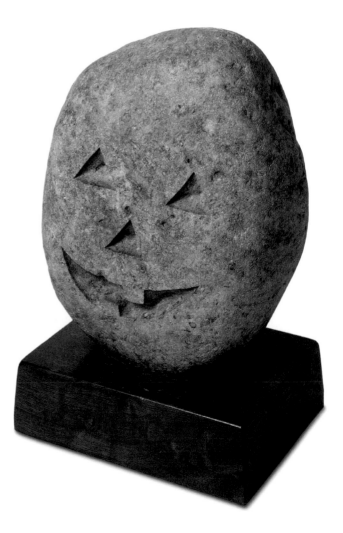

82
30 Dust Pans, 1972
Plywood, oak, various
woods, galvanized
sheet metal, and brass
46 x 45 x 32 ¾ in.
(116.8 x 114.3 x 83.2 cm)
Various collections,
United States

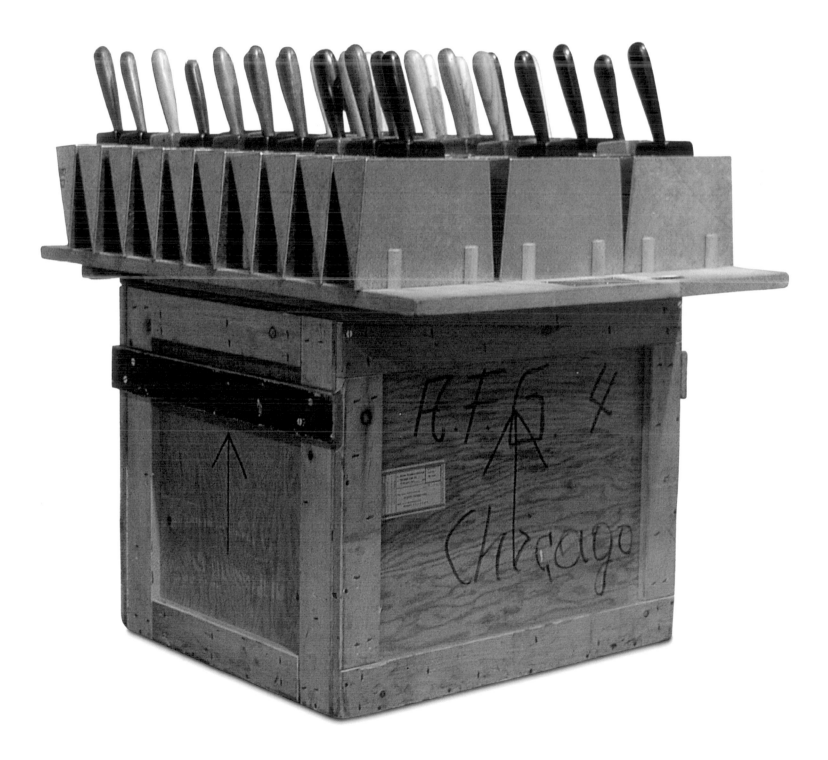

83
*American Death Ship on
the Equator*, 1972
Plate glass, copper, amaranth
(purpleheart), pine, plywood,
solder, putty, and brass
14¹⁄₈ x 36¹⁄₂ x 12⁷⁄₈ in.
(35.9 x 92.7 x 32.7 cm)
The Henry and Gilda
Buchbinder Family
Collection, Chicago

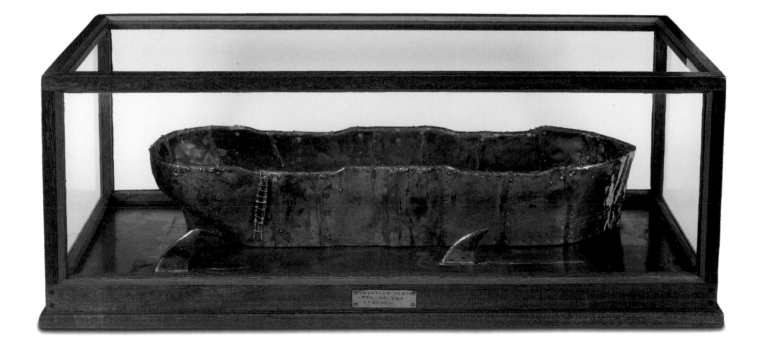

84
The Diver, 1972
Paldao, ebony, walnut, ply-
wood, bronze, mirror,
aluminum alkyd enamel,
and felt
38 5/8 x 27 1/4 x 15 1/2 in.
(98.1 x 69.2 x 39.5 cm)
The Henry and Gilda
Buchbinder Family
Collection, Chicago

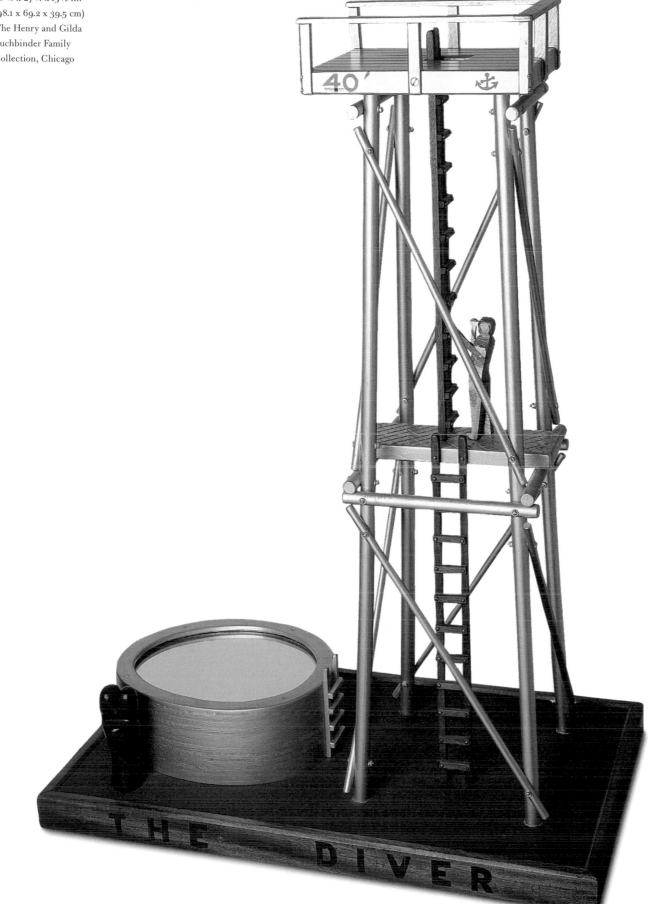

85

The Pig House, 1972
Copper screen, pine, enamel,
wire, cast rubber pig, "difu"
wood, and solder
48 1/2 x 37 3/4 x 17 3/4 in.
(123.2 x 95.9 x 45.1 cm)
The University of Arizona
Museum of Art; Museum
Purchase with funds provided
by the Edward J. Gallagher,
Jr., Memorial Fund

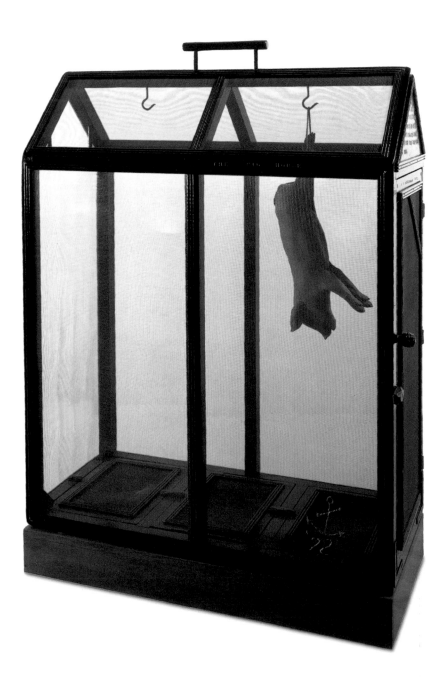

86
The Airline Pilot, 1973
Copper screen and solder
27 ³/₈ x 26 ³/₄ x 21¹/₈ in.
(69.5 x 67.9 x 53.7 cm)
Alan and Dorothy Press
Collection, Chicago

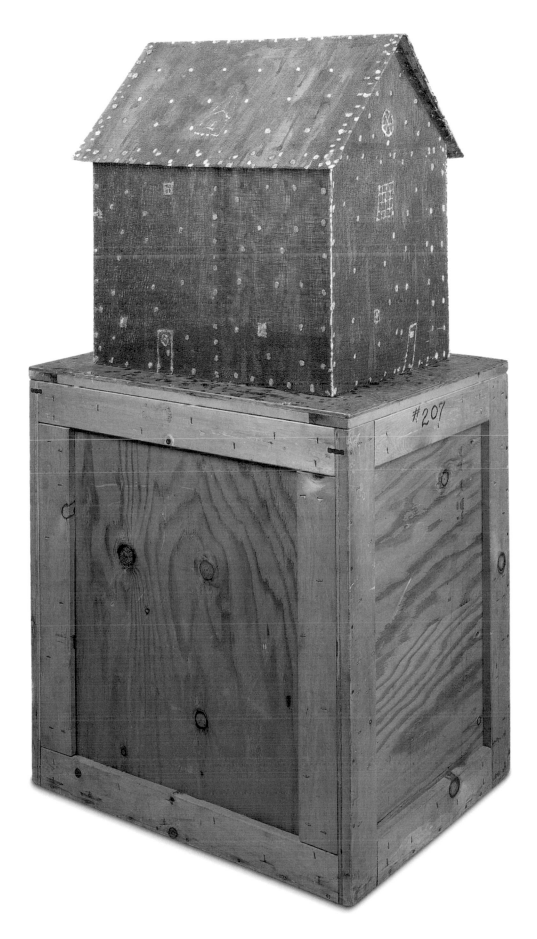

87
Untitled ("Walnut Death Ship
in a Chestnut Box"), 1974
Chestnut, walnut, zebrawood,
galvanized sheet metal, copper,
and ebony
17 7/8 x 24 7/8 x 8 1/2 in.
(45.4 x 63.2 x 21.6 cm)
Private collection, New York

88
Untitled ("Sardine Box"), 1973
Pine, tin sardine can, purple-
heart (amaranth), Douglas fir,
and brass chain
13 x 22 3/8 x 12 1/8 in.
(33 x 56.8 x 30.8 cm)
Private collection, Courtesy
Lennon, Weinberg, Inc.,
New York

88a
Untitled ("Sardine Box")
(interior detail)

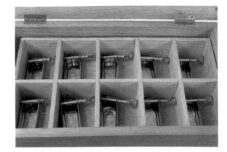

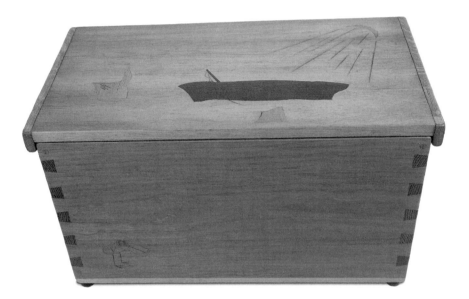

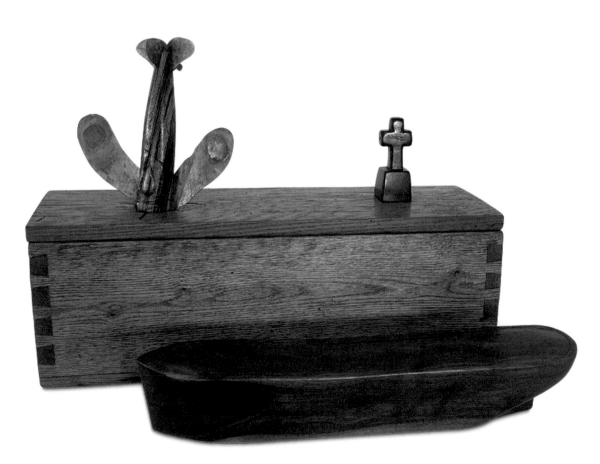

89
Untitled (for Ed Janss), 1973
Pine, ebony, vermillion,
brass wing-screws, wing nut,
steel bolt, washer, plastic
bumpers, and ink
19¹⁄₈ x 36 x 2¹⁄₂ in.
(48.6 x 91.4 x 6.4 cm)
Ann Janss, Los Angeles

89a
Untitled (for Ed Janss),
alternate view

90
*Im Goin' Home on the
Midnight Train*, 1974
Purpleheart (amaranth),
hickory, zebrawood, ebony,
brass, steel, pine, and ink
5¹⁄₂ x 23 x 7³⁄₄ in.
(14 x 58.4 x 19.7 cm)
CPLY Art Trust, New York

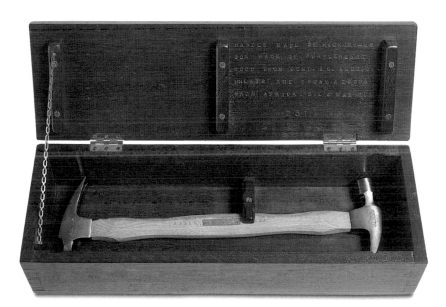

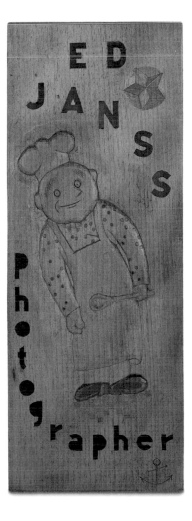

97
Soldier, 1976
Wood, granadillo (cocobolo),
purpleheart (amaranth), maple,
and brass
35 x 25 x 24 in.
(88.9 x 63.5 x 61 cm)
Barbara and Richard S. Lane,
New York

98
Fools Gold, 1976
Wood, plate glass, copper,
bronze, pocket watch, cast lead,
aluminum alkyd enamel, and
brass plate
50¼ x 13 x 11⅜ in.
(127.6 x 33 x 28.9 cm)
John and Mary Pappajohn,
Des Moines, Iowa

99
Pine Construction, 1976
Pine and brass plate
22¹/₂ x 12 x 12¹/₄ in.
(57.2 x 30.5 x 31.1 cm)
Mary and Roy Cullen, Houston

100
*Machine Dedicated to
Spike Jones*, 1976
Pine, oak, birch, leather,
vermillion, granadillo
(cocobolo), amaranth (purple-
heart), brass, and ink
38 x 28³/₄ x 20¹/₂ in.
(96.5 x 73 x 52.1 cm)
Jean W. Bush, San Francisco

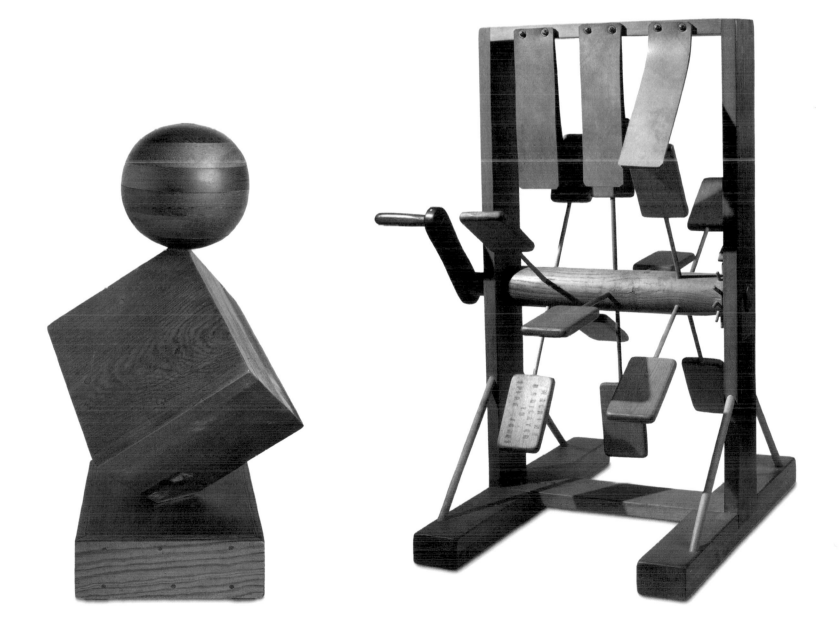

107
Big Leaguer, 1978
Pine, wood, walnut, oak,
calfskin, enamel, and brass
8¼ x 36¼ x 22 in.
(21 x 92.1 x 55.9 cm)
Douglas and Carol Cohen,
Highland Park, Ill.

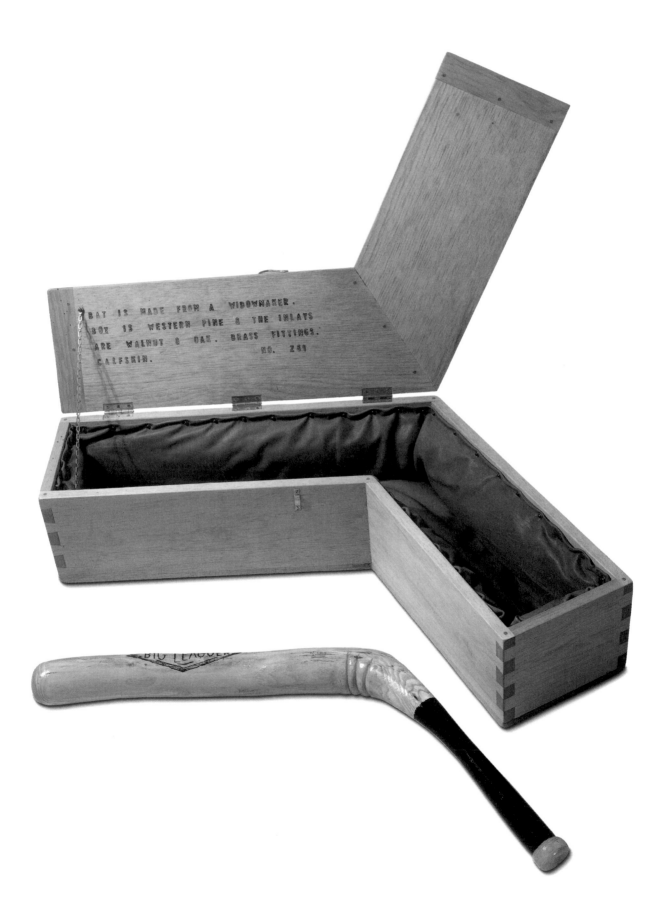

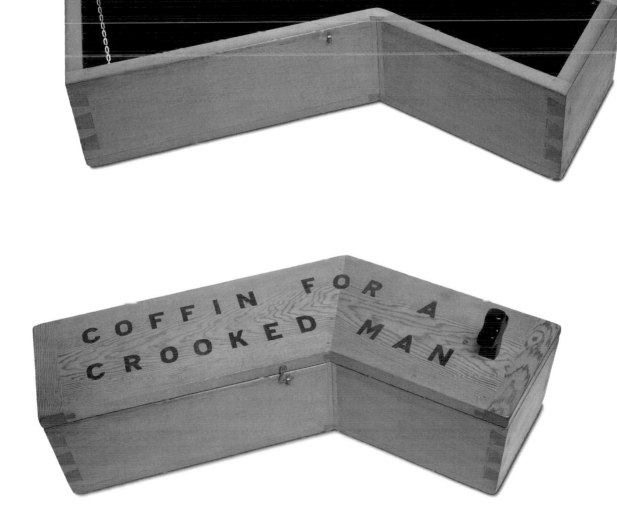

108
Coffin for a Crooked Man, 1979
Pine, pigskin, vermillion,
granadillo (cocobolo),
and brass
13¼ x 40⅝ x 18 in.
(33.6 x 103.2 x 45.7 cm)
The Henry and Gilda
Buchbinder Family
Collection, Chicago

108a
Coffin for a Crooked Man
(closed)

111
They Couldn't Put "Humpty
Dumpty" Back Together Again,
1980
Walnut, Macassar ebony,
vermillion, and brass
54¼ x 52¼ x 13⅞ in.
(137.8 x 132.7 x 35.2 cm)
Sharon and Thurston
Twigg-Smith, Honolulu

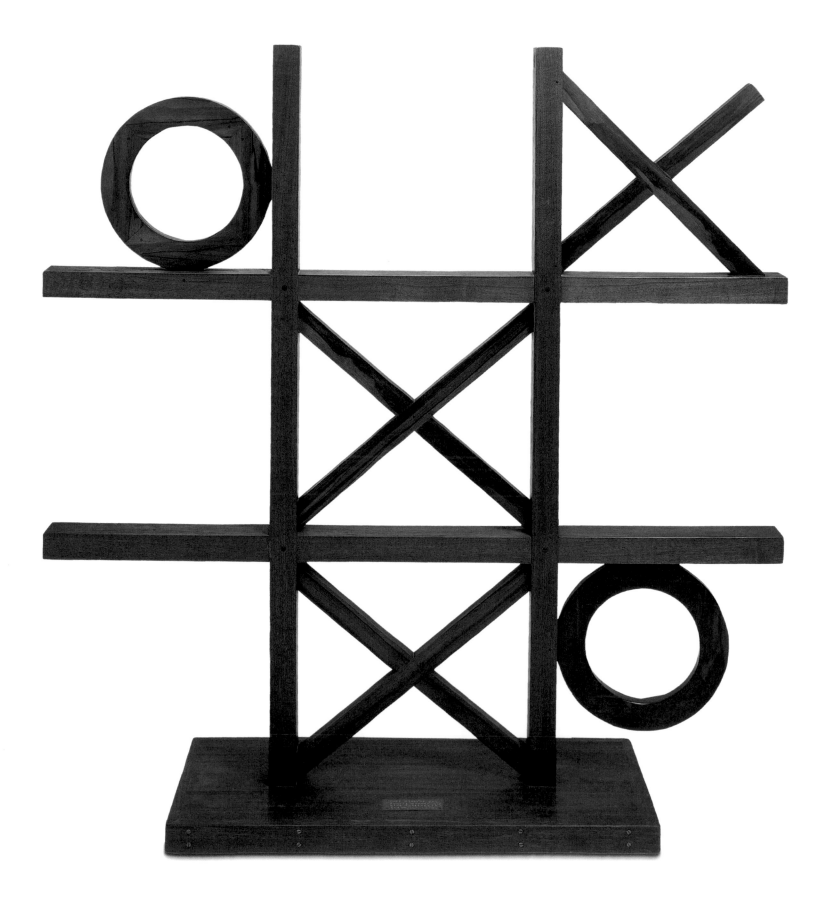

112
The Tin Woodman of Oz, 1981
Wood, bird's-eye maple,
Douglas fir, and Masonite
20 7/8 x 9 1/8 x 12 5/8 in.
(53 x 23.2 x 32.1 cm)
The Henry and Gilda
Buchbinder Family
Collection, Chicago

113
Untitled (ice chest with
Pearl beer), 1979
Purpleheart (amaranth), six-
pack of Pearl beer, Honduras
mahogany, ash, vermillion,
granadillo (cocobolo), ivory,
and maple
7 1/2 x 10 1/2 x 7 1/2 in.
(19 x 26.7 x 19 cm)
Terry Allen and Jo Harvey
Allen, Santa Fe, N.Mex.

114
*Death Ship, Out of San Pedro,
Adrift*, 1980
Ebony, brass, copper,
and solder
7 x 23 7/8 x 6 1/2 in.
(17.6 x 60.6 x 16.4 cm)
Alan and Dorothy Press
Collection, Chicago

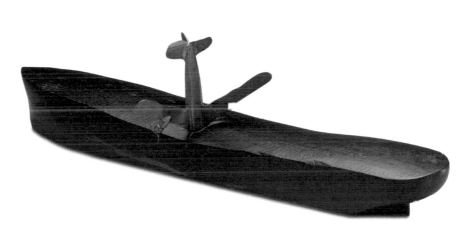

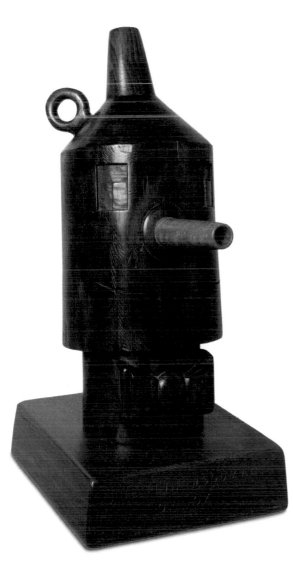

115

Jack of Diamonds, 1981
Galvanized wire lath,
galvanized sheet metal, galva-
nized corner beading,
oak, pine, and vermilion
79 ³/₄ x 36 ³/₄ x 23 ⁵/₈ in.
(202.6 x 93.3 x 60 cm)
Alan and Dorothy Press
Collection, Chicago

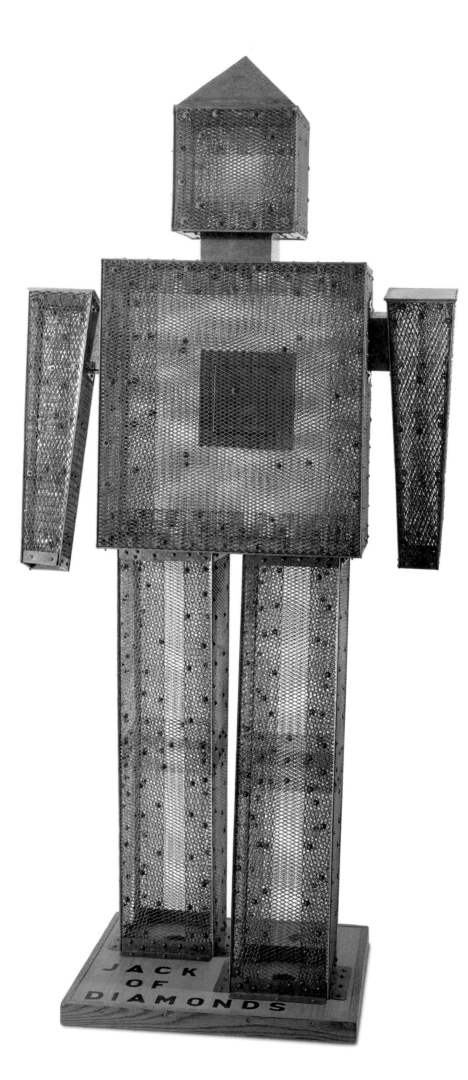

Chronology

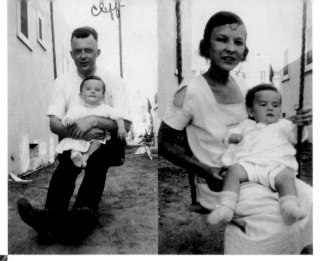

1923 H. C. Westermann, Sr.,
and H. C. Westermann, Jr.

1923 Florita Lynd Westermann
and H. C. Westermann

MAY 1923 H. C. Westermann

c. 1923 H. C. Westermann

c. 1924 Westermann family home at 401 Norwich Dr.,
Los Angeles

1922

DECEMBER 11
Horace Clifford Westermann, Jr., is born to
Florita Lynd Bloom
(from Kansas) and
Horace Clifford Westermann, Sr. (from Pennsylvania), in Los Angeles
at Angelus Hospital.
(The artist is hereinafter
referred to as "HCW.")
The family lives in a
courtyard apartment
building built and
owned by the Bloom
family on Kingsley Ave.

DECEMBER 20
14 Russian republics
form the Union of Soviet
Socialist Republics
(U.S.S.R.).

1924

Westermanns move to
new home at 401 Norwich Dr., Los Angeles.

MARCH 19
HCW is severely burned
when his rocking chair
falls onto a gas heater.

1926

Construction on U.S.
101 in California (one
of the original U.S.
highways) completed.

JULY 24
George Bloom, HCW's
maternal grandfather
(who shares his birthday), travels by train to
Medicine Lodge, Kans.
(where his daughter
Florita was born), and
commits suicide by
shooting himself on the
railroad tracks.

1927

Abe Saperstein, an
entrepreneur and
basketball fan, forms
the country's first allblack professional
basketball team, the

Harlem Globetrotters,
based in Chicago.

OCTOBER 6
The first motion picture
with full sound, *The
Jazz Singer*, starring
Al Jolson, is released.

OCTOBER 13
HCW becomes a
member of the National
Society of the Children of the American
Revolution.

1928

HCW enters Rosewood
Elementary School,
Los Angeles.

1929

OCTOBER 29
New York Stock
Exchange experiences a
surge of panic selling;
combined with an earlier sell-off the previous
Thursday, called Black
Thursday, this leads to

the collapse of the
stock market.

NOVEMBER 4
The Lyric Opera Company in Chicago opens
its inaugural season with
Verdi's *Aida*; HCW's
mother keeps a newspaper story on the opera
house in her scrapbook.

NOVEMBER 16
HCW's first "baby"
tooth is pulled by
H. C. Westermann, Sr.

1932

JULY 30
Opening ceremonies
for the Los Angeles
Olympics; Westermann
family attends.

AUGUST 14
Death of HCW's greatgrandfather George
Henry Corn; Corn lived
in Georgia during
the Civil War and was
conscripted into
the Confederate Army;

he refused to fight
against the Union and
deserted "in order to
escape having to fight
against the old flag
which my grandfather
had helped to save
as a symbol of our glorious nation." Corn's
grandfather fought in
the Revolutionary War.

1934

HCW enters Hubert
Howe Bancroft Junior
High School, Los
Angeles (will graduate
on June 25, 1937).

1935

AUGUST 17
Birth of Joanna Beall
to Dorothy Miller
and Lester Beall, Sr.,
in Chicago.

MARCH 26, 1924 LeNore Westermann and H. C. Westermann bandaged after fall onto heater

C. 1930 The Igloo ice cream shop, 4302 West Pico Blvd., Los Angeles

1936

JULY 17
Spanish Civil War begins.

OCTOBER 3
The aircraft carrier U.S.S. *Enterprise* is launched.

1937

MAY 6
The German zeppelin *Hindenburg* explodes before docking in Lakehurst, N.J.

JULY
Japan launches full-scale invasion of China.

AUGUST
HCW enters Fairfax High School, Los Angeles (will graduate June 28, 1940).

DECEMBER 21
Walt Disney's *Snow White and the Seven Dwarfs*, the first feature-length animated film, is released.

1938

HCW builds an addition to the garage of the family home using lumber and bricks, much of which he has salvaged and scavenged. The addition had a concrete slab floor, built-in bookcases flanking a brick fireplace, a pitched roof, and exercise rings hanging from the ceiling.

HCW submits drawings of "Snow White and the Seven Dwarfs" to Disney Studios and is offered a job, but the offer is rescinded when Disney discovers his young age; begins frequenting Santa Monica beach (later known as "Muscle Beach").

MARCH 13
German remilitarization and annexation (Die Anschluss) of Austria.

1939

Pablo Picasso's painting *Guernica* is placed on loan to The Museum of Modern Art (MoMA), New York.

SEPTEMBER 1–17
Hitler invades Poland.

1940

JUNE 28
HCW enrolls at Los Angeles City College; studies liberal arts.

1941

DECEMBER 7
Japan attacks U.S. naval base at Pearl Harbor, Hawaii; planes from the U.S.S. *Enterprise* are the only American aircraft to operate during the attack.

DECEMBER 8
U.S. declares war on Japan.

DECEMBER 8
HCW's mother, Florita Westermann, is admitted to Olive View Sanatorium in the San Fernando Valley, Calif., to be treated for tuberculosis.

1942

HCW is given an appointment to the Naval Academy at Annapolis, effective in June, due in part to a recommendation from his uncle Jay Marchant, an executive at Metro Goldwyn Mayer; attends Meade Preparatory School in Los Angeles; quits Meade and moves to northern California to work for a logging railroad as a "gandy dancer" (rail repairman).

MAY 19
Florita Westermann dies at Olive View Sanatorium; HCW is unaware of mother's death.

MAY 25
HCW begins employment at Simpson Logging Company in Shelton, Wash.

JUNE 4–6
U.S.S. *Enterprise* participates in the Battle of Midway.

JULY
HCW enlists in the U.S. Marine Corps (U.S.M.C.); recruiting officer contacts H. C. Westermann, Sr., for permission to enlist HCW, who is underage; HCW's father asks the recruiter to relay to HCW the news of his mother's death.

JULY 3
HCW terminates his employment at Simpson Logging Company.

C. 1936 C. 1939
H. C. Westermann H. C. Westermann

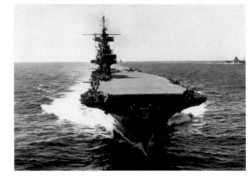

JUNE 28, 1940 H. C. Westermann and family at his graduation from Fairfax
High School, Los Angeles

C. 1941–45 The aircraft carrier U.S.S. *Enterprise*
in the South Pacific. ©CORBIS.

JULY 14
HCW begins active ser-
vice in the U.S.M.C.;
receives basic training at
Camp Pendleton, Calif.;
is assigned to sea school
(had hoped to become a
paratrooper) in Seattle.

NOVEMBER 4
HCW is stationed to
the cleanup of the
U.S.S. *West Virginia*,
recently refloated
after being sunk during
the Japanese attack
on Pearl Harbor.

NOVEMBER 12–15
U.S.S. *Enterprise* par-
ticipates in the Battle of
Guadalcanal, one of the
Solomon Islands occu-
pied by the Japanese.

1943

HCW deliberately fails
inspection on the
U.S.S. *West Virginia*
in order to volunteer
for duty aboard the
U.S.S. *Enterprise*.

JANUARY
H. C. Westermann, Sr.,
marries Georgia Burd
Farmer in Yuma, Ariz.

MAY 8–JULY 14
U.S.S. *Enterprise* is
under repair in the
Pearl Harbor Navy Yard.

JUNE 29
General Dwight D.
Eisenhower dispatches a
cablegram requesting
a shipment of three mil-
lion bottles of Coca-
Cola for the troops in
Europe.

AUGUST 13
HCW qualifies as expert
rifleman.

SEPTEMBER 4
HCW is stationed
aboard the U.S.S.
Enterprise as private,
first class (line);
serves as anti-aircraft
machine-gun crewman.

NOVEMBER 19–21
U.S.S. *Enterprise* par-
ticipates in the occupa-
tion of the Gilbert
Islands, a group of atolls

in the central Pacific
belonging to the British,
formerly occupied by
the Japanese.

DECEMBER 4
U.S.S. *Enterprise* par-
ticipates in the raid on
Kwajalein Atoll, one
of the Marshall Islands
occupied by the
Japanese.

1944

FEBRUARY 16–17
U.S.S. *Enterprise* par-
ticipates in the raid
on the Truk Islands, in
the west Pacific, the
site of a major Japanese
naval base.

JUNE 6
D-Day landings take
place on the Normandy
coast.

JUNE 19–20
U.S.S. *Enterprise* par-
ticipates in the Battle
of the Philippine Sea.

JUNE 22
President Franklin D.
Roosevelt's Service-
men's Readjustment Act
of 1944 — popularly
known as the G.I. Bill—
is signed into law.

1945

JANUARY 1
New Year's Day broad-
cast on WBBM radio,
Chicago, by Gil Martyn
reports a kamikaze
attack on the U.S.S.
Enterprise.

JANUARY 12–16
U.S.S. *Enterprise* par-
ticipates in strikes on
French Indochina, Hong
Kong, and Canton.

JANUARY 20–22
U.S.S. *Enterprise* par-
ticipates in strikes on
Formosa and Okinawa.

JANUARY 22
KKOY radio, Phoenix,
airs a broadcast about
the U.S.M.C.; HCW is
mentioned in the report.

FEBRUARY 16–17
U.S.S. *Enterprise*
participates in the first
strikes on Tokyo.

FEBRUARY 19–MARCH 9
U.S.S. *Enterprise* par-
ticipates in operations
in support of the occu-
pation of Iwo Jima.

MARCH 4
HCW is temporarily
promoted to corporal.

MARCH 18–21
U.S.S. *Enterprise* par-
ticipates in strikes
on Kyushu and Shikoku.

MARCH 19
U.S.S. *Franklin* suffers
a Japanese fighter attack;
press report released
by the U.S.S. *Enterprise*
(May 20): "More than
One Thousand mem-
bers of the crew of the
Aircraft Carrier
Franklin were killed or
wounded March 19th
when a Japanese dive
bomber scored two
direct hits that set off
the ship's entire load

944	FORMOSA RAID	
944	OCCUPATION of LEYTE ISLAND	2
944	BATTLE of the PHILIPPINE SEA No 2	3
944	PHILIPPINE ISLANDS RAIDS	6
	TOTALS	**52**

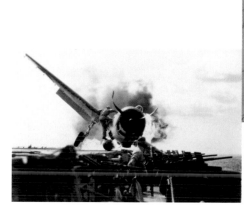

of explosives and turned the flat top into a float-ing hell"; more than 800 men are rescued along with the ship; the *Enterprise* escorts the *Franklin* from the com-bat area; *Enterprise* participates in action in the Marshall, Mariana, Philippine, and Ryukyu Islands.

APRIL 12
Death of President Roosevelt; Vice-President Harry S. Truman takes office.

MAY 8
The unconditional sur-render of Germany, signed the day before at Rheims, in northeast France, is ratified in Berlin; V-E Day is pro-claimed, announcing the end of the war in Europe.

MAY 14
U.S.S. *Enterprise* is attacked by a kamikaze plane; HCW shoots the

plane as it approaches, deflecting it from mid-ship to the stern; HCW writes: "We didn't know it then, but we were shooting at the first of the suicide planes. It came out of the sun and bore down on us, and we stood there sweating it out until finally our shells tore a wing off. Then the plane swerved at the last minute and went down" (*H. C. Westermann Papers*, 3170:13); the strike kills 14 men and wounds 34 others; in the same attack, the U.S.S. *Franklin* and the U.S.S. *Belleau Wood* are hit by kamikaze planes; the *Franklin* is severely damaged and loses many men.

JUNE 7
U.S.S. *Enterprise* arrives at Puget Sound Navy Yard in Bremer-ton, Wash., where it undergoes repairs.

JUNE 8
HCW put into brig for fighting on first night of leave.

JULY 11
HCW receives a U.S.M.C. good-conduct citation.

JULY 16
The U.S. explodes its first atomic bomb at Alamogordo, New Mexico.

JULY 26
HCW meets Elizabeth Marie Case Flanagan in Bremerton; they marry soon thereafter in Seattle.

JULY 30
The U.S.S. *Indianapolis* is sunk by a Japanese submarine; of the 1,196 men on board, about 900 survive the initial attack, but only 317 sur-vive after spending five days in shark-infested waters.

AUGUST 2
Meeting of the Allied powers to partition Germany.

AUGUST 6
U.S. B-29 bomber *Enola Gay* drops the first atomic bomb on Hiroshima, Japan.

AUGUST 9
A second U.S. atomic bomb obliterates Nagasaki, Japan.

AUGUST 11
American and Soviet planners divide the Korean peninsula into occupation zones north and south of the 38th parallel.

AUGUST 14
Japan agrees to uncondi-tional surrender; placed under the rule of Gen-eral Douglas MacArthur.

SEPTEMBER 2
Japan formally signs its surrender aboard the U.S.S. *Missouri* in Tokyo Bay; President Truman proclaims V-J Day.

SEPTEMBER 21
HCW's marriage to Flanagan is annulled.

U.S.S. *Enterprise* participates in the occupation of Japan.

1946

The U.S. Mint issues the Roosevelt dime.

MARCH 5
British prime minister Winston Churchill delivers the "Sinews of Peace" speech, better known as the "Iron Curtain" speech, at Westminster College, Fulton, Mo.

JUNE 8
HCW returns to the U.S. after two-and-a-half years at sea; is court-martialed for drunken-ness, fighting, and leaving his post while on duty; is reduced in rank to private and confined to the ship without pay.

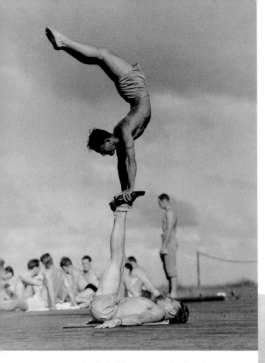

c. 1946 H. C. Westermann (top) and acrobatic partner on deck of the U.S.S. *Enterprise*

1946 H. C. Westermann, *Sudden Kamikaze Attack,* ink on paper, 13 x 10⅛ in. (33 x 25.7 cm), Martha Westermann Renner, Atherton, Calif.

c. 1946 H. C. Westermann (right) and acrobatic partner on deck of the U.S.S. *Enterprise*

JULY 13

HCW is honorably discharged from U.S. Naval Base, San Pedro Island, Calif., after four years of service; applies to The School of The Art Institute of Chicago (S.A.I.C.), but entry is deferred because the G.I. Bill quota for 1946 has been met; develops hand-balancing act called "Wayne and Westermann" with Wayne Uttley.

NOVEMBER 19

"Wayne and Westermann" sign a contract with Vinnicof Theatres to perform three shows at the New Strand Theater, 255 West Pike, Long Beach, Calif.; they will be paid $60 for each performance.

DECEMBER

After auditioning for the U.S.O., Westermann and Uttley begin a tour of Japan and China.

DECEMBER 28

Death of Polish-American sculptor Elie Nadelman.

1947

HCW meets actress, dancer, and singer June Jeanette LaFord (whose stage name is Penny Parker) while performing with her in Shanghai; HCW marries LaFord; moves to Chicago (2246 W. Division St.); works as a life-drawing model at the S.A.I.C. in the evenings and on Saturdays; also works for a moving company during the summers between 1947 and 1950.

JANUARY 23

The Art Institute of Chicago (A.I.C.) opens the exhibition *American Rooms in Miniature by Mrs. James Ward Thorne.*

FEBRUARY 26

Georgia Westermann, HCW's stepmother, sends a $20 deposit to the S.A.I.C. to reserve a space for his enrollment in school.

APRIL 1

HCW is accepted for day school at the S.A.I.C. to study graphic and applied arts.

JUNE

The Bulletin of Atomic Scientists debuts the "Doomsday Clock" on the cover; the clock's hands are set at seven minutes to midnight to symbolize the danger of nuclear war.

JUNE 5

The A.I.C.'s *51st Annual Chicago and Vicinity Exhibition* opens; student work is banned from exhibition; students organize the landmark series of exhibitions called *Momentum.*

JULY 1–8

A U.F.O. allegedly crashes in Roswell, N.M., spurring reported U.F.O. sightings across the U.S.; after debris is examined, it is determined to be from weather balloons, giving rise to the popular belief in a cover-up conspiracy at Roswell.

SEPTEMBER

HCW begins full-time studies at the S.A.I.C.

Beginning of the "red scare": investigations into communist infiltration of organized labor, the federal government, and Hollywood begin; directly questioned about their membership in the Communist Party are the infamous Hollywood Ten.

OCTOBER 14

Pilot Chuck Yeager breaks the sound barrier at Edwards Air Force Base, Calif.

NOVEMBER 6

The A.I.C.'s *58th Annual American Exhibition of Painting and Sculpture,* devoted to abstract and surrealist American art, opens.

1948

JUNE

The U.S.S.R. imposes a blockade on land routes into West Berlin; President Truman sends atomic-capable B-29 bombers to England and initiates an airlift to West Berlin that lasts for almost a year.

JUNE 3

Boston-born sculptor and World War II veteran Korczak Ziolkowski accepts commission from Lakota native Americans to carve a monument to Crazy Horse in the Black Hills of South Dakota; the proposed monument is the world's largest carving.

AUGUST 1947 H. C. Westermann, sisters LeNore and Martha, and H. C. Westermann, Sr.

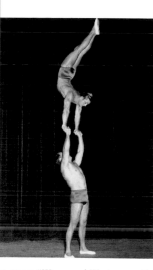

C. 1947 "Wayne and Westermann," H. C. Westermann (top) and Wayne Uttley, in performance

1947 H. C. Westermann in Pasadena, Calif.

c. 1947 H. C. Westermann in China on U.S.O. tour

AUGUST 17

Birth of Gregory Nathaniel Westermann, HCW's son.

OCTOBER

HCW's sister Martha enlists in the Women's Army Corps (W.A.C.) in Phoenix.

NOVEMBER

Truman is elected to a second term as president of the U.S.

1949

HCW and LaFord separate; LaFord moves to Florida with a friend, taking Gregory with her.

APRIL

The North Atlantic Treaty Organization (NATO) is created, in part to give the West a preponderance of power over the U.S.S.R.

MAY

President Truman's Berlin Airlift forces the U.S.S.R. to lift its blockade of West Berlin.

OCTOBER 20

The A.I.C. opens the exhibition *20th-Century Art from the Louise and Walter Arensberg Collection*, noted for its unparalleled collection of works by Marcel Duchamp; HCW visits the exhibition frequently until it closes on December 18.

1950

The Contemporary Art Workshop is founded in Chicago by Leon Golub and Cosmo Campoli, among others.

FEBRUARY

China and the U.S.S.R. recognize the insurgent government of Ho Chi Minh in French Indochina (Vietnam, Laos, and Cambodia); the U.S. recognizes the puppet regime of Bao Dai, selected by the French government.

JUNE 25

North Korea invades South Korea; Korean War begins.

JUNE 27

NATO Security Council requests member nations to furnish assistance to South Korea; President Truman orders air and naval forces to Korea under General Douglas MacArthur.

JUNE 30

President Truman orders ground forces to Korea, calling the military intervention a "police action."

JULY 17–AUGUST 11

Julius and Ethel Rosenberg are arrested on espionage charges.

AUGUST 19

HCW re-enlists in the U.S.M.C. as an infantry private, Chicago.

OCTOBER

Martha Westermann, a corporal in the W.A.C.,

is stationed at Yokohama, Japan, where she works as a personnel pay clerk.

NOVEMBER

Chinese troops cross into North Korea and drive American forces back to the 38th parallel.

DECEMBER 16

Truman declares a state of National Emergency.

DECEMBER 16

HCW's period of active duty begins.

1951

APRIL 11

President Truman fires General MacArthur, who has openly criticized his administration, and replaces him with General Matthew Ridgway.

APRIL 14

HCW begins service in Korea; participates in operations in South and central Korea with the Third Battalion, Fifth Regiment, First Division of the U.S.M.C.

JULY 17

U.S. Air Force reports new wave of U.F.O. sightings—more than 60 reports in two weeks.

SEPTEMBER 21

20-year-old Corporal Jack A. Davenport of Kansas City, Mo., is killed as he covers a hand grenade with his body near Songnaedong, Korea, saving a fellow marine; Davenport, who served with HCW's unit, is posthumously awarded the Congressional Medal of Honor.

DECEMBER 10

HCW is temporarily promoted to corporal.

DECEMBER 20
French artist Jean Dubuffet gives an influential lecture titled "Anticultural Positions" at the Arts Club of Chicago in conjunction with an exhibition of his work.

1952

Robert Rauschenberg, Merce Cunningham, and John Cage collaborate at Black Mountain College, N.C.; Allan Frumkin Gallery opens in Chicago.

LaFord files for divorce from HCW, making no claim for alimony or child support.

JANUARY 27
HCW leaves Korea and is sent to Japan.

MARCH 1
HCW is discharged from the marines with the rank of sergeant (promoted retroactively on April 4), with Korean Service Medal (1 star) and U.N. Ribbon; returns to Chicago; is transferred to Class III U.S.M.C. Reserves and assigned to the Ninth Marine Corps Reserve District, Chicago.

APRIL
Death of HCW's comrade, Corporal Paul "Stick" Flower, in Korea.

JULY
Martha Westermann discharged from army at Fort Ord, Calif.

JULY 7
Presbyterian minister Norman Vincent Peale's best-seller *The Power of Positive Thinking* is published.

FALL
HCW re-enrolls at the S.A.I.C. in the Fine Arts program; begins painting; lives in the basement at 25 E. Division St.; renovates the building in return for room and board and acquires woodworking skills; earns money through various handyman jobs in the neighborhood.

SEPTEMBER 15
HCW and LaFord divorce; court determines that HCW must pay $5 per week in child support.

SEPTEMBER 30
HCW's friend and former marine squad leader, Sergeant Lee Ostrander, is discharged.

OCTOBER 3
Bing Crosby Enterprises makes the first video recording on high-definition magnetic tape at one-third the cost of photographic processes.

NOVEMBER
The U.S. explodes the first hydrogen bomb in Eniwetok atoll in the Marshall Islands; the *Bulletin of Atomic Scientists'* "Doomsday Clock" is changed to two minutes to midnight; Dwight D. Eisenhower is elected president of the U.S.

1953

The 414 Art Workshop and Gallery is founded in Chicago by Shirley and Doc Walters, managed by John Miller and Eugene Bennett.

MARCH 5
Stalin dies after a stroke; power in the U.S.S.R. falls to Georgi Malenkov, Nikolai Bulganin, and Nikita Khrushchev.

JUNE 19
Julius and Ethel Rosenberg are executed in the electric chair.

JULY
End of the Korean War, which claimed the lives of more than 30,000 American soldiers and more than 1,000,000 Korean and Chinese soldiers.

NOVEMBER 3
RCA transmits the first color television broadcast from Burbank, Calif.

DECEMBER
First issue of *Playboy* magazine is published; Marilyn Monroe is Miss December.

1954

HCW solo exhibition *Paintings by H. C. Westermann* opens at the National College of Education, Wilmette, Ill.; HCW graduates from S.A.I.C. with a B.F.A.; builds first sculpture, *The City* (MCA 1).

U.S. Congress adds the words "under God" to the Pledge of Allegiance and "In God We Trust" to U.S. paper currency. The Chicago Bridge and Iron Company constructs first spheroid water tank in Elmhurst, Ill.; this type of large

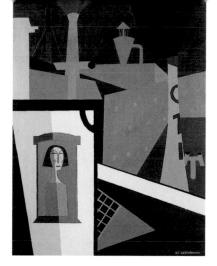

c. 1954 H. C. Westermann, Untitled, oil on canvas, 42 x 32 x in. (106.7 x 81.9 cm), Museum of Contemporary Art, Chicago, Gift of Mrs. E. A. Bergman (1991.76)

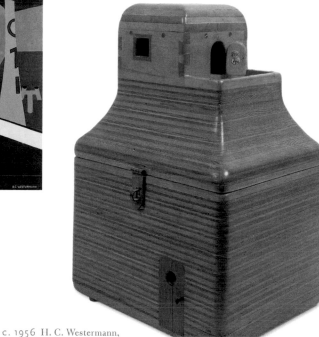

c. 1956 H. C. Westermann, Untitled ("Castle Box") (MCA 12), plywood, pine, brass, bronze, rope, paint, brasspadlock, and paper découpage, 15 x 10¼ x 8 in. (38.1 x 26 x 20.3 cm), Private collection, New York

c. 1958 H. C. Westermann in Chicago. Photograph by Phillip Fantl, Chicago. Courtesy the Estate of Joanna Beall Westermann.

metallic silver water tank, shaped like a mushroom cloud, is replicated all over the country.

DECEMBER
Senator Joseph McCarthy conducts hearings against U.S. army officers on television; is censured by the Senate.

1955

Ed Kienholz is given first solo exhibition at Von's Café Galleria, Los Angeles.

FEBRUARY
Khrushchev ousts his colleagues and assumes absolute control in the U.S.S.R.

APRIL 5
Richard J. Daley is elected mayor of Chicago.

MAY
U.S. Supreme Court rules that states must

end segregation in their public school systems.

JULY 17
Disneyland, "The Magic Kingdom," opens in Anaheim, Calif.

DECEMBER 1
Rosa Parks, an African American seamstress in Montgomery, Ala., is arrested for refusing to give up her bus seat to a white passenger, marking the beginning of the modern civil rights movement in the U.S.

1956

HCW solo exhibition *Sculpture by H. C. Westermann* opens at the Rockford College Art Gallery, Rockford, Ill.; HCW helps with the carpentry and installation of the exhibition and shows work in *Momentum*; meets art dealer Allan Frumkin through sculptor Caroline Lee, an employee

of the Allan Frumkin Gallery who served as the chairman of *Momentum*; exhibits work for the first time at the Allan Frumkin Gallery in a group exhibition. Joanna Beall marries Gaylord T. Meech.

The passage of the Interstate Highway Act is championed by President Eisenhower; the U.S. Highway shield comes into use.

MARCH 8
HCW work is included in the A.I.C.'s *59th Annual Exhibition: Artists of Chicago and Vicinity.*

APRIL 21
Martha Westermann marries Mike Renner in San Marino, Calif.

NOVEMBER
Eisenhower is elected to a second term as president of the U.S.

1957

The Leo Castelli Gallery opens in New York; hit records include Elvis Presley's "All Shook Up" and "Jailhouse Rock."

JANUARY 7
Life magazine begins series of articles titled "The Age of Psychology in the U.S."

MAY 5
First major presentation of HCW's sculpture, a two-man show with painter Ivan Mischo, opens at the 414 Art Workshop and Gallery.

JUNE
Painter Irving Petlin introduces Joanna Beall, newly separated from her husband, to HCW.

JUNE 10
Architect Ludwig Mies van der Rohe purchases HCW's *Butterfly* (MCA 26) for $100.

OCTOBER 4
The U.S.S.R. launches the basketball-sized satellite *Sputnik I*; White House Chief of Staff Sherman Adams dismisses *Sputnik I* as an "outer space basketball game."

NOVEMBER 3
The U.S.S.R. launches *Sputnik II*, a much larger satellite carrying a dog into orbit around the earth.

1958

HCW is given first solo exhibition at the Allan Frumkin Gallery, Chicago: *H. C. Westermann: Recent Work.*

Billy Al Bengston is given first solo exhibition at the Ferus Gallery, Los Angeles; Robert Rauschenberg exhibits "combine" paintings at the Leo Castelli Gallery, New York; cartoon television series *Popeye*

1952–59 Apartment building of H. C. Westermann, 1952–59. Sigmund J. Osty (architect), 25–29 East Division Street, Chicago. Chicago Historical Society (note HCW rocketship attached to cornice)

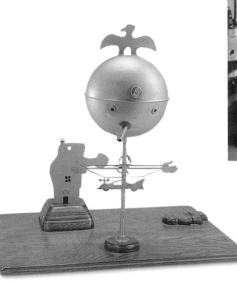

c. 1961 H. C. Westermann in his Chicago studio with *Swingin' Red King* (MCA 56) and *The Silver Queen* (MCA 49)

1959 H. C. Westermann, *Brinkmanship* (MCA 40), Plywood, electroplated copper, bottle cap, and string, 23¹⁄₄ x 24 x 19³⁄₈ in. (59 x 61 x 49.2 cm), Hirshhorn Museum and Sculpture Garden, Smithsonian Institution, Washington, D.C.

c. 1960 H. C. Westermann in his Chicago studio

the Sailor premieres; Skidmore, Owings and Merrill finish the Inland Steel Building, located three blocks west of the A.I.C. at Dearborn and Monroe streets; in Rising City, Neb., Cliff Hillegass launches book series called *Cliff's Notes:* readers' guides to 16 plays by Shakespeare with black and yellow covers.

JANUARY 1
The U.S. launches the satellite *Explorer I.*

FEBRUARY 12
HCW notes in his exercise ledger three repetitions of carrying a large stone up and down the stairs at 25 E. Division St.

JUNE 10
Joanna Beall leaves Chicago for Reno, Nev., to take up temporary residence (six weeks) in order to get a divorce from Meech.

AUGUST 18
HCW is honorably discharged from U.S.M.C. Reserves.

1959

Allan Kaprow's *18 Happenings in Six Parts* opens at Reuben Gallery, New York; the U.S.S. *Enterprise* is scrapped; Khrushchev visits the U.S. for a summit meeting with President Eisenhower at Camp David, Md.; Bertrand Goldberg designs Marina City, a pair of circular towers in Chicago.

JANUARY
U.S.-backed Cuban regime of Fulgencio Batista falls to the communist revolution led by Fidel Castro.

JANUARY 3
Alaska becomes the 49th state in the U.S.

FEBRUARY 24
HCW and Beall travel to the Yucatan, Mexico.

MARCH 11
Art in America publisher Howard Lipman purchases Westermann's *The Evil New War God (S.O.B.)* (MCA 33) from the Allan Frumkin Gallery.

MARCH 31
HCW and Beall marry in Chicago; they move to 222 W. North Ave.; both work as janitors to earn a living; buildings that they maintain include 37 E. Elm and 21 E. Division.

APRIL 10
HCW's *The Evil New War God (S.O.B.)* is selected for inclusion in *New Images of Man*, curated by Peter Selz at MoMA, opening on September 30; other Chicagoans included are Leon Golub and Cosmo Campoli of "Monster

Roster"; HCW becomes associated with "Monster Roster."

MAY 13
The A.I.C.'s *62nd Annual Exhibition, Artists of Chicago and Vicinity* opens; *The Evil New War God (S.O.B.)* is included and wins the Mr. and Mrs. Seymour Oppenheimer Purchase Prize; A.I.C. approaches Lipman requesting to purchase the work; Lipman declines.

MAY 24
John Foster Dulles, President Eisenhower's secretary of state, dies after resigning from office; his controversial stance that the U.S. must be prepared to "go to the brink" of war in opposition to communist aggression was called "brinkmanship."

AUGUST 21
Hawaii becomes the 50th state in the U.S.

DECEMBER 2
The A.I.C.'s *63rd American Exhibition: Paintings, Sculpture* opens; includes work by HCW.

1960

U.S. U-2 spy plane is shot down over U.S.S.R.; Civil Rights Act of 1960 provides federal referees to safeguard the rights of black voters; Claes Oldenburg's first solo exhibition, *The Street*, opens at the Judson Gallery, Judson Memorial Church, New York; 90 percent of all homes in the U.S. include at least one television.

HCW wins a New Talent Award given by *Art in America* magazine.

JUNE 30
The Belgian Congo attains independence from Belgium; Patrice Lumumba becomes

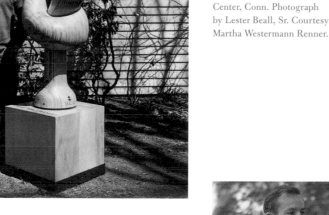

1963 H. C. Westermann with *The Big Change* (MCA 73) on the Beall estate, Brookfield Center, Conn. Photograph by Lester Beall, Sr. Courtesy Martha Westermann Renner.

1962 From left to right, top row: H. C. Westermann, Lester Beall, Sr., Dorothy Beall, Lester Beall, Jr.; bottom row: Joanna Beall Westermann, Mrs. Lester Beall, Jr., Alison Beall, Joanna Beall

c. 1960 H. C. Westermann and Joanna Beall Westermann

1962 H. C. Westermann and Joanna Beall Westermann

the first prime minister of the Congo, favored by the U.S.S.R.; he is later overthrown by U.S.-supported Mobutu Sese Seko and Joseph Kasavubu; he is arrested in September by former aide Joseph Désiré Mobutu.

JULY
HCW frequently seen wearing a t-shirt with the slogan "Free Patrice Lumumba" printed on its front.

SEPTEMBER 24
The new nuclear-powered U.S.S. *Enterprise* (CVN 65) is christened.

DECEMBER 22
Fire starts in the evening at a coffeehouse below Westermanns' apartment at 222 W. North Ave., severely damaging the building and their apartment.

1961

Peter Saul is given first solo exhibition at the Allan Stone Gallery, New York.

JANUARY 17
CIA operatives assassinate imprisoned Congolese prime minister Lumumba.

JANUARY 21
John F. Kennedy is sworn in as president of the U.S.

APRIL 12
Soviet astronaut Yuri Gagarin orbits the earth, becoming the first man in space.

APRIL 17
The U.S. government supports the Bay of Pigs invasion of Cuba by approximately 1,500 Cuban exiles; all but 150 escape death or capture.

MAY
HCW receives $5,000 grant from the National Council on the Arts; Joanna leaves Chicago for an extended stay at her parents' home in Brookfield Center, Conn.

JULY
Westermanns move to the Beall estate, Dumbarton Farm, in Brookfield Center, Conn.

AUGUST 13
The East German government begins construction of the Berlin Wall, intended to halt the flow of refugees from East Berlin to West Berlin.

OCTOBER 2
HCW's work included in the MoMA exhibition *The Art of Assemblage.*

NOVEMBER
U.S. sends 15,000 "military advisers" to help South Vietnam in its struggle against the North.

DECEMBER
HCW has operation for testicular cancer at New York Presbyterian Hospital; undergoes 25 betatron ray therapies throughout the first half of 1962.

1962

Roy Lichtenstein exhibits paintings of cartoon images at the Leo Castelli Gallery, New York; Andy Warhol exhibits Campbell's Soup paintings at the Ferus Gallery, Los Angeles; American forces in Vietnam begin to defoliate vast tracts of forests with chemical toxins such as Agent Orange; Rachel Carson publishes *Silent Spring*,

a denunciation of the indiscriminate use of the insecticide DDT and other toxins that pollute the environment.

JANUARY 16
HCW work is included in group exhibition at the Galerie du Dragon, Paris, *Huit Artistes de Chicago: Barnes, Campoli, Cohen, June Leaf, Golub, Petlin, Rosofsky, Westermann.*

FEBRUARY 20
John Glenn becomes the first American astronaut in space.

JUNE
Death of Jay Marchant, HCW's uncle.

JULY–SEPTEMBER
HCW completes sculptures *Where the Angels Fear to Tread* (MCA 64), Untitled (question mark) (MCA 65), and *W.W. I General, W.W. II General & W.W. III General* (MCA 66).

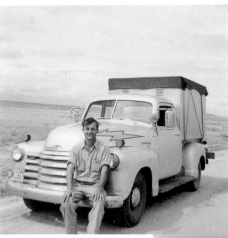

1964 H. C. Westermann seated on the front bumper of the "bat-mobile"

SEPTEMBER 1964 The Westermanns' "bat-mobile" set up in the San Joaquin Valley, Calif.

1964 H. C. Westermann, *Aluminated* (MCA 87), marine plywood, Masonite, aluminum alkyd enamel, reflectors, enamel, mirror, and rubber bumpers, 18 ³/₄ x 21 ³/₄ x 22 in. (47.6 x 55.2 x 55.9 cm), Jim and Jeanne Newman, San Francisco

JULY 10
First live television broadcast using Telstar communications satellite.

OCTOBER 15
Cuban Missile Crisis begins; thermonuclear war between the U.S. and the U.S.S.R. is a possibility.

OCTOBER 28
Cuban Missile Crisis ends; U.S.S.R. is forced to remove missiles and manned bombers from Cuba.

NOVEMBER–DECEMBER
HCW completes sculptures *A Small Negative Thaught* (MCA 67) and *A Positive Thought* (MCA 68).

DECEMBER 3
HCW's first solo exhibition at the Dilexi Gallery, Los Angeles, opens; founded by Walter Hopps and James

Newman, the Dilexi Gallery introduces Westermann's work to young artists on the West Coast.

1963

Ed Ruscha is given first solo exhibition at the Ferus Gallery, Los Angeles.

JANUARY
In the margins of his exercise ledger, HCW notes "still smoking."

JANUARY–JUNE
HCW completes sculptures *A Rope Tree* (MCA 72), *The Big Change* (MCA 73), *The Sonic Boom* (MCA 74), *Bullseye* (MCA 75), *The Dream World* (MCA 76), *L.B.* (MCA 77), *Channel 37* (MCA 78), and *The Mystery* (MCA 79).

JULY 20
Total solar eclipse visible in North America.

AUGUST
HCW completes sculpture *2063 AD* (MCA 80).

AUGUST 28
Civil rights leaders organize the "March on Washington"; more than 300,000 people fill the Mall, facing the Lincoln Memorial; Martin Luther King, Jr., delivers his "I Have a Dream" speech.

SEPTEMBER
HCW completes sculptures *Eclipse #1* (MCA 81), *Eclipse #2* (MCA 82), and *The Night Life* (MCA 84).

SEPTEMBER 12
H. C. Westermann, Sr., dies of angina in Pasadena, Calif., leaving his son and two daughters $1 each.

OCTOBER
HCW completes *Rosebud* (MCA 85).

Westermanns visit St. Louis, Mo., for two weeks while HCW is guest instructor (to architecture students) at Washington University; en route back to Connecticut, they drive south through Cairo, Ill., and into Kentucky, spending three days in Kentucky before heading into West Virginia, Washington, D.C., then finally Brookfield Center, Conn.

NOVEMBER 22
President Kennedy is assassinated in Dallas; Vice-President Lyndon B. Johnson takes the Oath of Office aboard Air Force One; Lee Harvey Oswald is arrested for the murder.

NOVEMBER 24
While Oswald is being transferred through the basement of the Dallas police station, he is shot and killed by nightclub owner Jack Ruby.

1964

The U.S. Mint issues the Kennedy half-dollar.

HCW's childhood home, 401 Norwich Dr., Los Angeles, is demolished to make way for a freeway.

JANUARY–FEBRUARY
HCW completes memorial to John F. Kennedy titled *Aluminated* (MCA 87), along with *Ben* (MCA 88), *A Family Tree* (MCA 89), *The Suicide* (MCA 90), and *Social Problems* (MCA 91).

JANUARY 29
Stanley Kubrick's film *Dr. Strangelove* is released.

FEBRUARY 7
The Beatles arrive at Kennedy Airport in New York to begin U.S. tour.

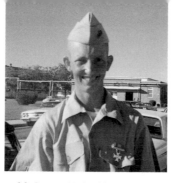

1966 Gregory Nathaniel Westermann at Camp Lejeune, N.C.

1959–67 Bertrand Goldberg Associates (architect), Marina City towers, Chicago, ca. 1965. HB-23215-A5, Photo courtesy Chicago Historical Society.

SEPTEMBER 1965 American soldiers arriving in Qui Nhon, South Vietnam. © Bettmann/CORBIS.

1966 H. C. Westermann practicing an acrobatic routine in Brookfield Center, Conn.

1966 Joanna Beall Westermann practicing acrobatic routine in Brookfield Center, Conn.

FEBRUARY 28
The A.I.C.'s *67th Annual American Exhibition* opens, featuring work by HCW; he receives Campana Memorial Prize for *The Big Change* (MCA 73).

MARCH
HCW completes sculptures *Beginning of a Brand New City* (MCA 92) and *28 Years Bad Luck* (MCA 93).

MARCH 27
Westermanns see the Ringling Brothers Circus in New York.

APRIL–MAY
HCW completes sculptures *Clean Air* (MCA 94), *Walnut Box* (MCA 95), *Secrets* (MCA 96), *Plywood Box* (MCA 97), and *A Human Condition* (MCA 98).

JUNE 20
Westermanns purchase a 1949 Chevrolet pickup truck; HCW paints it

with aluminum paint and decorates the hood with orange thunderbolts; HCW also builds a plywood cabin in the bed of the truck to be used for sleeping; mounts a cast-lead "batman" sculpture on the hood as an ornament (MCA 99) and names the truck the "bat-mobile."

JUNE 24
HCW is included as a pop artist in the *New Realism* exhibition, organized by the Akademie der Künste, Berlin.

JULY 2
President Johnson signs the Civil Rights Act.

AUGUST 23–SEPTEMBER 17
Westermanns drive across the country to San Francisco in the "batmobile"; there, they settle into a small apartment at 1254 Taylor St. and produce many drawings and illustrated

letters; their trip will inspire HCW's 1968 series of prints *See America First.*

OCTOBER 14
Khrushchev is deposed by the Soviet Politburo, led by Leonid Brezhnev and Aleksei Kosygin.

NOVEMBER
Johnson is elected to a second term as president of the U.S.

DECEMBER 25
HCW completes *Untitled THIS IS TITLE* (MCA 101).

1965

JANUARY 4
In his State of the Union Address, President Johnson outlines his vision of the "Great Society."

JANUARY 11
F.D.A. officials foresee 125,000 deaths associated with smoking for 1965.

FEBRUARY 21
Malcolm X is assassinated in Harlem.

AUGUST 11–15
20,000 National Guardsmen are sent to Los Angeles during race riots in Watts neighborhood; in 5 days of rioting, 33 people die.

OCTOBER
Westermanns return to Brookfield Center, Conn., from San Francisco; move in with Joanna's parents.

DECEMBER
The Los Angeles County Museum of Art (LACMA) places a hold on HCW sculpture *Untitled THIS IS TITLE* (MCA 101); they do not purchase work.

DECEMBER 29
The James Bond film *Thunderball* is released.

1966

President Johnson creates the National Endowment for the Arts (NEA) and the National Endowment for the Humanities (NEH).

APRIL
Brezhnev becomes General Secretary of the Communist Party in the U.S.S.R.

APRIL 28
HCW writes to his sister Martha that he is experimenting with bronze and has completed two bronze sculptures.

MAY
HCW's son, Gregory, visits the Westermanns in Brookfield Center, Conn., before entering the U.S.M.C.

JULY 18
HCW is interviewed by Chicago critic Dennis Adrian and Martin

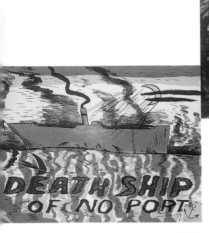

1967 H. C. Westermann, *Death Ship of No Port,* three-color lithograph, 18 x 24 in. (61 x 45.7 cm), Adrian/Born 12 B. Photograph courtesy Lennon, Weinberg, Inc., New York.

SUMMER 1967 H. C. Westermann at work on Joanna's studio chimney

1969 H. C. Westermann retrospective exhibition, Museum of Contemporary Art, Chicago

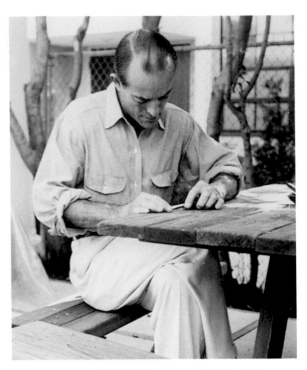

1968 H. C. Westermann at the Tamarind Lithography Workshop, © Center for Southwest Research, General Library, University of New Mexico, Albuquerque, N.M.

Friedman, director of the Walker Art Center, Minneapolis, at the Lowell Hotel in New York.

OCTOBER 4
HCW solo exhibition opens at the Kansas City Art Institute, Kansas City, Mo.

OCTOBER 5
HCW receives his first formal commission, from the Kansas City Art Institute, to make a series of lithographs.

OCTOBER 28
HCW's letter to the editor of *Life* magazine, criticizing Ian Fleming, author of James Bond series, for helping to "render sex and death a little more impersonal," is published.

NOVEMBER
Joanna joins a Montreal-based acrobatic act called the "3 Renowns"; tours Canada with the act through end of month.

NOVEMBER 12
Editor Marcia Tucker asks HCW to donate a work to a sale benefiting the magazine *East Side Review* (Tucker and HCW had met previously at the home of Noma Copley); Westermann sends a check as a donation along with an illustrated letter to Tucker.

NOVEMBER 20
Hommage à Pablo Picasso opens at the Grand Palais, Paris, setting off what *New York Times* critic John Canaday calls a "Paris culture explosion."

DECEMBER 18
Michelangelo Antonioni's film *Blowup* is released in the U.S.

DECEMBER 23
HCW receives $5,000 award from the National Foundation on the Arts and the Humanities.

1967

Gabriel García Márquez's novel *Cien años de soledad* (first English translation, *One Hundred Years of Solitude,* 1970) is published.

HCW work is included in the LACMA exhibition *American Sculpture of the Sixties.*

FEBRUARY
HCW sends postcard of the KCMO-TV tower in Kansas City, Mo., to Lester and Dorothy Beall; at that time the KCMO tower was the tallest self-supported tower in the U.S.

FEBRUARY 15
HCW begins his first lithographs at the Kansas City Art Institute, working with master printer Jack Lemon.

MARCH–APRIL
Lance Corporal G. N. Westermann 230 82 61, U.S.M.C.— HCW's

son, Gregory— is sent to Vietnam.

JUNE 1
Beatles release the album *Sgt. Pepper's Lonely Hearts Club Band*; HCW is among the many artists and celebrities featured on the cover designed by British artist Peter Blake.

JULY 23
Race riots in Detroit.

AUGUST
The appointment of Thurgood Marshall, the first African American associate justice of the Supreme Court, is confirmed by the U.S. Senate.

AUGUST 8
HCW begins building chimney for Joanna's studio.

OCTOBER
Six acres of Westermann family property in Muskogee, Okla., are sold; HCW's aunt Ruth

Marchant, a real-estate broker, sends HCW a share of the proceeds, which total $700.

OCTOBER 10
Chimney for Joanna's studio reaches height of 20 feet; 5 more feet, and a 400-pound cast concrete cap, will complete chimney.

1968

JANUARY 30
Tet Offensive begins in Vietnam; the U.S. Embassy in Saigon, along with other population centers in Vietnam, is attacked by Vietcong commandos during Tet, the Vietnamese New Year.

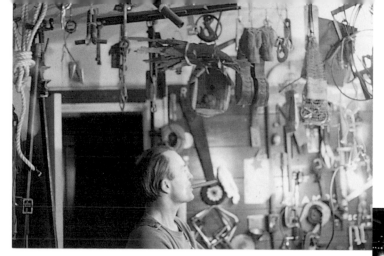

c. 1968 H. C. Westermann in his shop in the Westermann's Dumbarton Farm cabin, Brookfield Center, Conn.

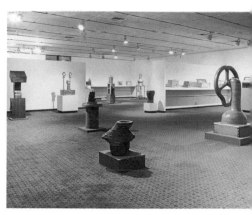

1968 Installation view, H. C. Westermann retrospective, Los Angeles County Museum of Art

AUGUST 1968 Delegates at the Chicago Democratic National Convention protesting the Vietnam War. ©Bettmann/CORBIS.

MARCH

HCW visits collector Charles Jules in New York and waxes his works *Antimobile* (MCA 132) and *Uncommitted Little Chicago Child* (MCA 30) in Jules's collection (*H. C. Westermann Papers*, 3170: 458–59).

MARCH 21

HCW's son, Gregory, writes HCW from Vietnam during his second tour of duty; reports that half of his battalion (the 26th Marines) has been killed and that his regiment has received the Presidential Unit Citation; Gregory himself is wounded.

APRIL 4

Martin Luther King, Jr., is assassinated at the Lorraine Motel in Memphis, Tenn; riots erupt in New York, Detroit, Washington, D.C., and other cities.

JUNE 5

Robert Kennedy is assassinated in California by Sirhan Sirhan.

AUGUST 28

Antiwar protestors disrupt the Democratic National Convention in Chicago.

AUGUST–SEPTEMBER

Gregory Westermann returns to the U.S. from Vietnam; awarded the Purple Heart.

SEPTEMBER 3

HCW begins an eight-week fellowship at the Tamarind Lithography Workshop, Los Angeles, where he produces *See America First*, a series of 17 prints; stays at the Ravenswood Hotel at 570 N. Rossmore Ave.; HCW mentions in a letter to Joanna from Tamarind that their friends Bruce and Doris Oxford want to move back to Australia and that they "don't like the U.S.A."

SEPTEMBER 23

Betty Asher of LACMA takes HCW to see the Gamble House (1908), designed by Greene and Greene, in Pasadena, Calif.; HCW writes enthusiastically to Joanna about the house on September 27.

OCTOBER 1

Having heard nothing from his son, HCW writes to the U.S. Department of Navy requesting information on his whereabouts; the navy's response of October 16, furnishing name, rank, serial number, and location, is signed "C. H. Doom."

OCTOBER 28

HCW begins building 24 custom wooden boxes for each editioned set of *See America First* at his uncle Carl Bloom's workshop (edition size of suite is 20).

NOVEMBER

Richard Nixon is elected president of the U.S.

NOVEMBER 11

HCW writes letter to Joanna with a drawing of a soldier playing taps with "So long 'Stick'. . ." in the top margin.

NOVEMBER 26

HCW retrospective exhibition opens at LACMA; travels to the Museum of Contemporary Art (MCA), Chicago (January 29–March 2, 1969).

1969

MARCH

After his retrospective exhibition is dispersed, HCW makes alterations to *Object under Pressure* (MCA 51) and repairs *A Rope Tree* (MCA 72).

APRIL

Westermanns begin construction of a new home and studio by

felling trees in a wooded lot promised to them by Lester Beall, Sr.; by October they fell over 65 trees.

JUNE 17

HCW is offered a teaching job at the University of California, Berkeley; he declines.

JUNE 20

Death of Lester Beall, Sr.; Beall leaves the Westermanns a parcel of land adjacent to the Beall home, Dumbarton Farm, in Brookfield Center, Conn.

JULY 14

The film *Easy Rider*, directed by Dennis Hopper, is released.

JULY 20

Neil Armstrong becomes the first man to walk on the moon during the *Apollo 11* mission.

1968 H. C. Westermann
and brother-in-law
Mike Renner

1970s H. C. Westermann and house with
plywood sheathing, Brookfield Center, Conn.

1970 H. C. Westermann,
*Walker in a Black Circular
Wheel* (MCA 211), enamel,
wood, metal, and sapling,
37 7/8 x 37 7/8 x 9 3/8 in. (96.2 x
96.2 x 23.8 cm), Private col-
lection, Los Angeles

1970 H. C. Westermann with
neighbor Nick Vaccaro, Jr.,
Brookfield Center, Conn.

AUGUST
Westermanns mill lum-
ber from their lot and
season it on their prop-
erty, intending to use
it later for their house.

AUGUST 15–17
Woodstock rock
concert.

AUGUST 17
Death of architect Mies
van der Rohe in Chicago.

OCTOBER
Westermanns obtain
building permit from
Brookfield Township;
Joanna is sick for six
weeks with mononu-
cleosis.

OCTOBER 9
Actress Sharon Tate and
four others are murdered
in Los Angeles by group
led by Charles Manson.

NOVEMBER
Concrete foundation of
Westermanns' house is
poured; HCW unearths
large rocks and places
them alongside driveway.

1970

JANUARY 4
HCW solo exhibition
*H. C. Westermann
Drawings* opens at the
Galerie Thomas
Borgmann, Cologne,
Germany.

APRIL 10
Samuel Wagstaff (owner
of *The Plush* [MCA 86]),
of the Detroit Institute
of Arts, proposes an
artist-film project to
HCW; he declines.

APRIL 19–MAY 3
HCW is a guest instruc-
tor at the San Francisco
Art Institute.

MAY 4
Students protest the
Vietnam War at Kent
State University, Ohio;
four students are killed
by National Guardsmen.

SUMMER
Westermanns begin
building frames of house
and studio; HCW fin-
ishes frame of house;

shingles roof with cedar
shingles; sheathes sides
with plywood.

SEPTEMBER 11
Actor Chester Morris,
one of HCW's favorites,
dies from a barbiturate
overdose.

OCTOBER 11
HCW writes to his sis-
ter Martha that he
and Joanna have spent
$30,000–40,000 on the
house thus far, doing
most of the work them-
selves; HCW finishes
stairway from living
room to attic using Dou-
glas fir and redwood;
HCW works on house
during the day and in
his studio (cottage) dur-
ing the evenings.

1971

FEBRUARY 22
HCW is asked to submit
a proposal for a large
public commission in
Highland Park, Ill.;
he accepts.

MARCH
Westermanns travel to
Highland Park, Ill.,
to examine site for a
proposed public sculp-
ture by HCW; site has
old log cabin nearby for
which HCW proposes
building a mate; also
proposes mounumental
jack-o'-lanterns; project
committee does not
accept either proposal;
no sculpture is pro-
duced.

MARCH 7–12
HCW is a visiting artist
at the University of
Illinois, Urbana.

APRIL 6
HCW solo exhibition
opens at the University
Art Museum, Berkeley,
Calif.

APRIL 29
U.S. Command in
Saigon reports that the
total American death
toll in Indochina is
45,019.

JUNE 5
U.S. Command in
Saigon reports weekly
American death toll of
19 servicemen — the
lowest weekly total since
October 1965.

SEPTEMBER
HCW finishes framing
of studio; framing of
building is held together
almost entirely with
nuts and bolts instead
of nails.

OCTOBER
HCW discusses with
Frumkin the possibility
of obtaining a public
commission for a large
Jack sculpture.

NOVEMBER 24
HCW finishes shingling
roof of studio; sheathes
sides with plywood,
and clads them with
cedar siding.

1972

HCW is diagnosed with
hypertension.

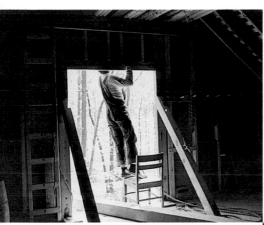

1970 H. C. Westermann working on roof of the house, Brookfield Center, Conn.

c. 1971 Gable of Westermann's studio with pulley block and sheave, Brookfield Center, Conn.

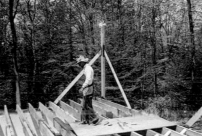

c. 1971 H. C. Westermann building frame of studio, Brookfield Center, Conn.

1972 H. C. Westermann, Moore College of Art poster, Philadelphia.

Louis Sullivan's Chicago Stock Exchange is demolished; photographer Richard Nichol is killed photographing the ruins.

JANUARY
HCW prints *6 Lithographs* with Jack Lemon at Landfall Press, Chicago (then located at 63 W. Ontario St.).

APRIL 11
HCW visits the Wright Brothers' Museum while visiting North Carolina.

JUNE 17
Break-in at the Democratic National Committee headquarters at the Watergate Hotel, Washington, D.C.

JUNE 30
HCW work is included in *Documenta 5* in Kassel, Germany.

JULY 10
Senator George S. McGovern wins the Democratic Party's

presidential nomination at the party's national convention in Miami.

SEPTEMBER 11
Death of *Popeye* filmmaker Max Fleischer from heart failure.

OCTOBER 27–NOVEMBER 21
HCW solo exhibition held at Moore College of Art, Philadelphia.

NOVEMBER
Richard M. Nixon is re-elected president of the U.S.

NOVEMBER 3
HCW solo exhibition opens at the Galerie Rudolf Zwirner, Cologne, Germany.

DECEMBER 26
Death of former president Harry S. Truman.

1973

JANUARY
Joanna calls HCW's second wife, June La Ford, to get Gregory's

address; June explains that she is still angry about HCW's remark that "giving money to [LaFord] is like giving oats to a dead horse."

JANUARY 10
HCW work is included in the 1973 *Biennial* at the Whitney Museum of American Art, New York.

JANUARY 19
Death of actor J. Carrol Naish from emphysema.

JANUARY 22
The U.S. Supreme Court issues the Roe *v.* Wade ruling, which gives women the right to terminate pregnancy.

Death of former president Lyndon B. Johnson.

JANUARY 22
HCW solo exhibition opens at the Galerie Neuendorf, Hamburg, Germany.

MARCH 13
Westermanns take up guest teaching positions

at the University of Colorado, Boulder.

MAY 16
HCW donates a drawing to a charity auction held by Sotheby's, New York, for the Pan-American Development Foundation; donated works are exhibited at the United Nations Building on June 5.

JUNE 5
HCW is invited by Herbert Distel to contribute to his artwork called the *Schubladenmuseum*, a cabinet of small works by international artists; he declines.

OCTOBER 5
HCW work is included in the 12th São Paulo *Bienal*; is awarded a $2,500 prize; Stephen Prokopoff, who organized the American Pavilion (and will later be director of the MCA, Chicago), receives inquiries about HCW from galleries in

Austria, Germany, and England; the American entry from São Paulo tours the U.S. as *Made in Chicago*.

OCTOBER 16
U.S. decision to assist Israel in repelling Arab forces during the Arab invasion of Israel on October 6, 1973, prompts the Organization of the Petroleum Exporting Countries (OPEC) to halt the flow of oil to the U.S.; oil embargo lasts until March 18, 1974, resulting in long gas lines and rationing.

NOVEMBER
Westermanns join Ed and Ann Janss, Penny Little, and Billy Al Bengston on a boat trip to Baja, Mexico; HCW reluctantly learns to scuba dive, despite his dislike of the water; the group witnesses the Kohoutek Comet in the evening.

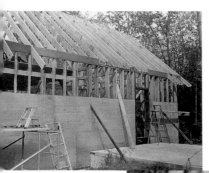

c. 1970 Frame of Westermann's studio, Brookfield Center, Conn.

NOVEMBER 1973 H. C. Westermann and Joanna Beall Westermann in Baja, Mexico

NOVEMBER 1973
H. C. Westermann (foreground) and Billy Al Bengston in Baja, Mexico

c. 1972 H. C. Westermann working on frame of breezeway connecting house and studio, Brookfield Center, Conn.

1974

JANUARY
HCW falls ill and undergoes three weeks of testing at Columbia Presbyterian Hospital, New York; contacts Arthur Harris at the Brookfield Nature Conservancy to offer help and support to wetlands conservancy.

FEBRUARY
HCW is unable to work due to the depressive effects of heart medication; writes to Senator Lowell Weicker, Jr., to express his opinions on Nixon's impeachment; Weicker returns HCW's letter on March 7, declining to comment as he may serve as a judge during the impeachment proceedings.

FEBRUARY 14
Patty Hearst is kidnapped by the Symbionese Liberation Army.

MARCH 19
HCW's first solo exhibition at the James Corcoran Gallery, Los Angeles, opens.

AUGUST 9
President Nixon resigns.

1975

HCW donates 16 acres of open land to town of Brookfield, Conn; artist/singer Terry Allen releases album titled *Juarez*.

JANUARY 6
HCW finishes the window casings on studio.

MARCH
HCW finishes workbench, shelves, and cabinets in studio and begins to install his shop.

MAY 7
HCW takes another boat trip with Ed and Ann Janss, Billy Al Bengston, and Penny

Little, to La Paz; Joanna declines.

SUMMER
HCW works for the first time in his newly built studio.

JUNE
HCW begins the *Connecticut Ballroom* series of woodcuts.

JUNE 20
Steven Spielberg's film *Jaws* is released.

AUGUST
HCW offers to make a drawing for the waiting room of the Cardiovascular Center at New York Hospital; the center accepts his offer; HCW sends a woodcut (*H. C. Westermann Papers*, 3171:422).

DECEMBER
Westermanns begin refurbishing HCW's former studio in the cottage where they are living while construction on their house proceeds.

1976

The Allan Frumkin Gallery moves from 41 E. Madison Ave. to 50 W. Madison Ave., New York.

JANUARY
As part of environmental group called POW (Preserve Obtuse Wetlands), the Westermanns attend a meeting of the Inland-Wetlands Commission to protest the development of land near Obtuse Road North in Brookfield, Conn.; HCW states: "I know that area very well, and it is absolutely beautiful. There are still a few deer in there and many other forms of wildlife, beautiful trees, rocks. It is just about the last open space area in this town of any consequence" (*H. C. Westermann Papers*, 3170:63).

JANUARY 6
HCW on jury duty in Bridgeport, Conn., and "considers it a privilege"; prints sixth woodcut in the *Connecticut Ballroom* series.

MARCH 16
Whitney Museum of American Art's exhibition *200 Years of American Sculpture* opens; HCW is represented in the exhibition by *Antimobile* (1965–66; MCA 132) and *American Death Ship on the Equator* (1972; MCA 234).

MARCH 29
HCW is solicited by *Progressive Architecture* to feature his Brookfield Center, Conn., home in the magazine; he declines.

MAY 11
HCW is offered a one-year residency for 1978 at the Deutscher Akademischer Austauschdienst (DAAD), Berlin, by Jan van der

1975 H. C. Westermann, *The Connecticut Ballroom Suite*, 1975, *Arctic Death Ship*, three-color woodcut, 24 x 30 in. (61 x 76.2 cm), Adrian/Born 22 c, Photograph courtesy Lennon, Weinberg, Inc., New York.

DECEMBER 11, 1973 H. C. Westermann, sister Martha Westermann Renner, and brother-in-law Mike Renner on Westermann's birthday, Atherton, Calif.

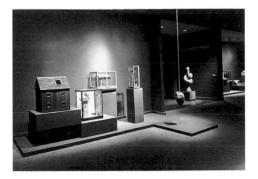

1978 Installation view, H. C. Westermann retrospective, Whitney Museum of American Art, New York

Marck, director of Dartmouth College Galleries and Collections, a member of the DAAD jury, and former director of the MCA; he declines.

JULY 4
The U.S. celebrates its bicentennial.

JULY 18
HCW work is included in the 1976 Venice *Biennale*.

OCTOBER 27
HCW goes to Hartford Art School at the University of Hartford, West Hartford, Conn., as a visiting artist for the day.

NOVEMBER
Jimmy Carter is elected president of the U.S.

NOVEMBER 18
Death of surrealist artist Man Ray in Paris.

DECEMBER 18
In a letter to his sister Martha, HCW discusses his admiration for the

Watts Towers in Los Angeles, designed by Simon Rodia.

1977

FEBRUARY 2
Due to a natural-gas shortage, President Carter proclaims a National Emergency.

FEBRUARY 15
HCW work is included in the 1977 *Biennial* at the Whitney Museum of American Art, New York.

MARCH 19
Frumkin purchases HCW's *30 Dust Pans* (MCA 227) and confirms an agreement with HCW to sell the dust pans individually, giving right of first refusal to past supporters and collectors of his work.

APRIL–MAY
HCW builds oak bumpers for his new Jeep truck and bolts a

metal figure of Buster Brown to the hood.

MAY 17
HCW is contacted by the NEA's Coordinator of Works of Art in Public Places to confirm his interest in executing a large public sculpture in Madison, Wis.; some members of the panel are concerned about the permanence of the work if the artist were to use wood (*H. C. Westermann Papers*, 3171:659).

MAY 25
George Lucas's science-fiction film *Star Wars* is released.

MAY 26
George Willig, "The Human Fly," scales the World Trade Center in New York.

AUGUST
Terry Allen invites HCW to be a visiting artist at California State University, Fresno; he declines.

AUGUST 16
Death of Elvis Presley at Graceland, his home in Memphis, Tenn.

SEPTEMBER 26
HCW is offered a commission for a major public work by the Madison Art Center, Madison, Wis.; he declines.

OCTOBER 1
President Carter inaugurates the U.S. Department of Energy in response to the gas crisis.

OCTOBER 9
NASA tests the prototype space shuttle *Enterprise*.

NOVEMBER 1
HCW is asked for a videotaped interview for the S.A.I.C.'s Video Data Bank; he declines.

1978

HCW ends his association with the Allan Frumkin Gallery.

JANUARY 14
Death of Carl Bloom, HCW's uncle.

FEBRUARY–MARCH
A blizzard blankets Brookfield Center, Conn., in snow and ice; Westermanns spend two weeks digging out from the first storm in early February when another hits on February 20; HCW admitted to New York Hospital after suffering worsened hypertension and high blood pressure; while in hospital, suffers a heart attack; doctors plan to remove a dead kidney after convalescence from heart attack but determine that his heart is too weak to undergo surgery; doctors say that his habitual exercise has saved his life.

MAY 17
HCW retrospective exhibition opens at the Whitney Museum of American Art (see "Solo

c. 1976 H. C. Westermann working in his newly finished studio, Brookfield Center, Conn.

c. 1975 H. C. Westermann, Brookfield Center, Conn.

1979 H. C. Westermann, Untitled (brass HCW profile) (MCA 307), brass, 2⅝ x 2 x ⅛ in. (6.7 x 4.9 x .5 cm), Private collection

c. 1980 H. C. Westermann on the porch of his house, Brookfield Center, Conn.

Exhibitions," p. 196, for other venues); HCW receives "fan mail" from Ed Ruscha, William Wiley, Ray Johnson, Allen Jones, David Sharpe, Xavier Fourcade, Grace Glueck, Mike Nevelson, and Deborah Butterfield, among others.

JULY 5
HCW visits Xavier Fourcade, Inc., at 36 East 57th St., New York.

JULY 6
Fourcade writes to HCW expressing his interest in Westermann's work and to discuss representing HCW in future.

JULY 7
Democratic Congressman Robert F. Drinan of Connecticut writes HCW to thank him for participating in his election campaign; major

issues in Drinan's campaign were nuclear disarmament, the phasing out of world hunger, and international human rights; Drinan adds that he is "working hard for the artists."

JULY 9
Ray Johnson sends two collaborative mailart works to HCW (*H. C. Westermann Papers*, 3171:876–78); HCW adds to and returns mail-art.

JULY 17
Johnson thanks HCW for his contribution to mail-art, which also includes contributions from Chuck Close, Marcia Tucker, and James Rosenquist; asks permission to offset reprint.

JULY 21
Johnson sends HCW three "political pieces."

JULY 25
The world's first "test-tube" baby, Louise Brown, is born.

NOVEMBER
HCW is represented by Xavier Fourcade, Inc., in New York.

NOVEMBER 10
HCW is invited to be a visiting artist at The School of Art at Yale University, New Haven, Conn., between January and April 1979; he declines.

NOVEMBER 18
American cult leader Jim Jones leads mass suicide of more than 900 members of the People's Temple in Jonestown, Guyana.

DECEMBER 22
Thomas Armstrong, director of the Whitney Museum of American Art, invites HCW to design note cards,

folded stationery, or pads of stationery with envelopes to be sold in the museum shop; he declines.

1979

JANUARY 29
The American Society for the Prevention of Cruelty to Animals (ASPCA) solicits HCW for the donation of a work of art to be included in a benefit auction.

FEBRUARY 6
HCW is included in the *1979 Biennial* at the Whitney Museum of American Art, New York.

MARCH 28
The worst nuclear accident in U.S. history occurs at the Three Mile Island nuclear reactor, Harrisburg, Pa.

MAY
Students at the Northwest Intermediate School in Salt Lake City hold an annual art exhibit and dedicate it to HCW for the second consecutive year.

MAY 20
The S.A.I.C. grants HCW an honorary doctor of fine arts degree.

MAY 21
HCW donates a print from the *Connecticut Ballroom* series of woodcuts to the ASPCA auction.

JULY 4
HCW attends a minireunion in Austin, Tex., of men who served aboard the U.S.S. *Enterprise* in World War II.

AUGUST
HCW is contacted by Helge Westermann, from Christchurch, New Zealand (she had read

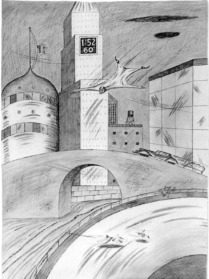

1981 H. C. Westermann, *1:52, 60° A.D. 2000*, ink and watercolor on paper, 30½ x 22 in. (77.5 x 55.9 cm), Private collection, Kansas City, Mo. Photo courtesy Lennon, Weinberg, Inc., New York.

SEPTEMBER 1981 H. C. Westermann and Joanna Beall Westermann in his studio, Brookfield Center, Conn. Photograph © Bobbe Wolf, Chicago.

SEPTEMBER 1981 H. C. Westermann in his studio, Brookfield Center, Conn. Photograph © Bobbe Wolf, Chicago.

1981 Installation view, H. C. Westermann exhibition, Xavier Fourcade, Inc., New York

about his work in the local newspaper); they are not related.

AUGUST 21
Dr. David Case from the Cardiovascular Center writes to HCW that he is happy with the artist's improving medical condition.

OCTOBER 3
HCW work is included in the 15th São Paulo *Bienal*.

NOVEMBER 4
Mob of thousands storms the U.S. embassy in Tehran, Iran, taking 66 people hostage; the Iran hostage crisis lasts more than a year.

DECEMBER
Westermanns purchase a small house (HCW calls it a "doll house") in Marfa, Tex.

DECEMBER 3
HCW speaks before a zoning board of appeals in favor of allowing pinball machines to be installed at the Brookfield Village Store because they provide teenagers in town with something to amuse themselves; according to a local newspaper article, the "amusement machines" were illegally installed at the store; HCW states: "It's not doing a bit of harm and it is benefiting the community."

1980

MAY 1
Joan Mondale invites HCW to a dinner with Vice-President Walter Mondale in honor of the artists whose works are on display in the vice-president's residence; Westermanns attend.

MAY 18
Mount St. Helens, in Washington State, erupts.

JULY 4–6
Information is solicited for another U.S.S. *Enterprise* reunion, planned to occur in Denver.

AUGUST 5
Joan Mondale writes HCW to thank him for his letters and for lending *Secrets* (MCA 96) to the vice president's house.

OCTOBER 27
HCW is invited to be a visiting artist for a weekend at Skowhegan School of Painting and Sculpture, Skowhegan, Maine; he declines.

NOVEMBER 4
Ronald Reagan is elected president of the U.S.; HCW writes to his sister Martha on

November 27 (Thanksgiving): "Nancy Reagan says she hates cigars, mustaches & vulgarity—that lets me out . . . Ha, ha, ha. How are we going to cope with those two idiots?"

DECEMBER 10
HCW work is included in group exhibition *Who Chicago?: An Exhibition of Contemporary Imagists* at the Camden Arts Centre, London.

1981

Picasso's *Guernica* is returned to Spain.

JANUARY 20
American hostages in Iran are released minutes after President Carter leaves office.

JULY 30
HCW completes final sculpture, *Jack of Diamonds* (MCA 323).

OCTOBER 15
HCW invited to speak at the Rhode Island School of Design, Providence; he declines.

OCTOBER 28
HCW's first solo exhibition at Xavier Fourcade, Inc., New York, opens.

OCTOBER 31
HCW suffers another heart attack.

NOVEMBER 3
Death of HCW.

1997

JANUARY 12
Death of Joanna Beall Westermann from lung cancer.

Exhibition Checklist

◎ *Chicago showing only.*
○ *Tour only.*
◖ *Partial tour only.*

SCULPTURES AND OBJECTS

City, 1954 ◎
Wood, concrete, paint,
glass, lead, stained glass, wire,
and sandpaper
74¼ x 11 x 10¾ in.
(188.6 x 27.9 x 27.3 cm)
Museum of Contemporary Art,
Chicago, Gift of Stefan Edlis
(1986.59)
MCA 1

Confined Murderer, 1955 ◎
Ebony and bronze
12 x 5 x 4¼ in.
(30.5 x 12.7 x 10.8 cm)
Private collection, New York
MCA 6

I'd Like to Live Here!, 1955
Maple
15⅞ x 7⅝ x 7⅞ in.
(40.3 x 19.4 x 20 cm)
Lindy Bergman, Chicago
MCA 2

A Soldier's Dream, 1955
Maple, stained glass, brass,
and string
29¼ x 15 x 11½ in.
(74.3 x 38.1 x 29.2 cm)
Sharon and Thurston Twigg-
Smith, Honolulu
MCA 5

Eye of God, 1955–56
Oak, brass, lead, and glass
10¾ x 14¾ x 4 in.
(27.3 x 37.5 x 10.2 cm)
John and Maxine Belger Family
Foundation, Kansas City, Mo.
MCA 7

*The Dead Burying
the Dead*, 1956
Brass, pine, bronze, lead,
mahogany, and enamel
6¼ x 17 x 10 in.
(15.9 x 43.2 x 25.4 cm)
Museum Moderner Kunst
Stiftung Ludwig Wien
MCA 9

Dismasted Ship, 1956 ◎
Walnut and bronze
7⅜ x 21⅛ x 3¼ in.
(18.7 x 53.7 x 8.3 cm)
Gail and Arden Sundheim,
Palatine, Ill.
MCA 10

Untitled ("Castle Box"),
c. 1956
Plywood, pine, brass, bronze,
rope, paint, brass padlock, and
paper découpage
15 x 10¼ x 8 in.
(38.1 x 26 x 20.3 cm)
Private collection, New York
MCA 12

Untitled (for Ann Davidow),
1956–57
Wood, galvanized sheet metal,
paint, and glass
9 x 8 x 11 in.
(22.9 x 20.3 x 27.9 cm)
Ann Goodman Hayes,
Boulder, Colo.
MCA 13

Butterfly, 1957 ◎
Cotton rope, plywood,
and nails
18½ x 25¾ x 1⅜ in.
(47 x 65.4 x 3.5 cm)
Dirk Lohan, Chicago
MCA 26

Death Ship of No Port, 1957
Pine, canvas, bronze, wire,
and paint
24¼ x 30½ x 3⅝ in.
(61.6 x 77.5 x 9.2 cm)
Museum of Contemporary Art,
Chicago, Gift of John F. Miller
(1995.121)
MCA 29

Great Mother Womb, 1957
Plywood, pine, glass, bronze,
iron, steel, and brass screws
74⅝ x 26 x 26 in.
(189.5 x 66 x 66 cm)
Michael F. Marmor, Stanford,
Calif.
MCA 16

He-Whore, 1957
Plywood, vermillion,
oak, maple, walnut, fir, birch,
mirror, paint, chromium-
plated brass, cork, rope, and
U.S. dimes
23½ x 11½ x 20 in.
(59.7 x 29.2 x 50.8 cm)
Museum of Contemporary Art,
Chicago, Gift of Susan and
Lewis Manilow (1993.35)
MCA 20

*I Wonder If I Really
Love Her?*, 1957
Plywood, varnish, paint,
and graphite
21 x 19½ x 22 in.
(53.3 x 49.5 x 55.9 cm)
The Henry and Gilda
Buchbinder Family
Collection, Chicago
MCA 21

*Monument for a Dead
Marine*, 1957
Oak, walnut, ebony,
and bronze
21¼ x 2¾ x 2⅞ in.
(54 x 7 x 7.3 cm)
Private collection
MCA 24

Mother, 1957
Pine, plywood, mirror, paper
découpage, and graphite
30¾ x 16¾ x 9⅞ in.
(78.1 x 42.2 x 25.1 cm)
Sally Lilienthal, San Francisco
MCA 19

String & Paper Men, 1957
Walnut, redwood, string,
paper découpage, and paint
10⅝ x 26⅛ x 6½ in.
(27 x 66.4 x 16.5 cm)
Jerome H. and Linda Meyer,
Chicago
MCA 18

*Two Acrobats and
a Fleeing Man*, 1957 ◎
Fir, pine, and lead
12 x 20¼ x 1½ in.
(30.5 x 51.4 x 3.8 cm)
Museum of Contemporary Art,
Chicago, Gift of Susan and
Lewis Manilow (1984.6)
MCA 27

*Untitled (for Lee and Lois
Ostrander)*, 1957
White pine, maple, amaranth
(purpleheart), ebony, brass,
postcards, and decorative paper
9 x 11⅞ x 8⅞ in.
(22.9 x 30.2 x 22.5 cm)
Private collection
MCA 25

*Untitled ("Unusual
Physician")*, 1957
Pine, metal, aluminum alkyd
enamel, postcard, and varnish
8½ x 12 x 9¼ in.
(21.6 x 30.5 x 23.5 cm)
Collection of Janice and
Mickey Cartin
MCA 32

Burning House, 1958
Pine, cast brass bell, tin,
glass, rope, and enamel
42¼ x 11¾ x 15¾ in.
(107.3 x 29.8 x 40 cm)
Private collection, Courtesy
Lennon, Weinberg, Inc.,
New York
MCA 34

The Evil New War God
(S.O.B.), 1958
Partially chromium-
plated brass
16 3/4 x 9 1/2 x 10 3/8 in.
(42.5 x 24.1 x 26.4 cm)
Whitney Museum of American
Art, New York, Gift of Howard
and Jean Lipman (97.113.10)
MCA 33

Mad House, 1958
Pine, plywood, glass,
brass, galvanized sheet metal,
enamel, tin toy, lead soldier,
paper découpage, mirror, and
U.S. penny
38 1/8 x 17 1/2 x 21 in.
(96.8 x 44.5 x 53.3 cm)
Museum of Contemporary Art,
Chicago, Gift of Joseph
and Jory Shapiro (1978.5)
MCA 36

*Memorial to the Idea of Man
If He Was an Idea*, 1958
Pine, bottle caps, cast-tin toys,
glass, metal, brass, ebony,
and enamel
56 1/2 x 38 x 14 1/4 in.
(143.5 x 96.5 x 36.2 cm)
Museum of Contemporary Art,
Chicago, Gift of Susan
and Lewis Manilow (1993.34)
MCA 38

*Mysteriously Abandoned
New Home*, 1958
Pine, birch, vermillion, red-
wood, glass, paint, and wheels
50 1/8 x 24 7/8 x 24 7/8 in.
(127.4 x 63.2 x 63.2 cm)
The Art Institute of Chicago,
Gift of Lewis Manilow
(1962.905)
MCA 37

Angry Young Machine, 1959
Pine, plywood, galvanized
iron pipe and fittings,
faucet handle, cast-lead
soldier, aluminum alkyd
enamel, and wheels
89 3/4 x 26 7/8 x 28 1/4 in.
(228 x 68.3 x 71.8 cm)
The Art Institute of Chicago,
Restricted gift of Mr.
and Mrs. E. A. Bergman
(1975.132)
MCA 44

Brinkmanship, 1959
Plywood, electroplated metal,
bottle cap, and string
23 1/4 x 24 x 19 3/8 in.
(59.1 x 70 x 49.2 cm)
Hirshhorn Museum and Sculp-
ture Garden, Smithsonian
Institution, Gift of Allan
Frumkin, 1984
MCA 40

Untitled ("J & C Box"), 1959
Pine, brass, glass, mirror,
and enamel
16 1/4 x 13 x 10 in.
(41.3 x 33 x 25.4 cm)
Private collection, Courtesy
Lennon, Weinberg, Inc.,
New York
MCA 46

Monument to Martha, 1960
Pine, Colonial Casque pine
molding, plywood, mirror, tin,
cast-metal soldier, plastic
decal, and paper découpage
47 x 19 x 19 in.
(119.4 x 48.3 x 48.3 cm)
Martha Westermann Renner,
Atherton, Calif.
MCA 48

The Silver Queen, 1960
Pine, plywood, pine molding,
galvanized metal weather
vent, iron fittings, enamel, and
aluminum alkyd enamel
79 3/4 x 20 7/8 x 21 1/8 in.
(202.6 x 52.9 x 53.7 cm)
Private collection, London
MCA 49

The Hands, 1961
Cast aluminum, wood,
linoleum, paint, chromium-
plated pipe, and metal
43 3/4 x 21 3/8 x 21 3/8 in.
(111.1 x 54.3 x 54.3 cm)
The Nelson-Atkins Museum
of Art, Kansas City, Mo.,
Gift of Mr. and Mrs. Richard
M. Hollander (F 73-36)
MCA 52

Hard of Hearing Object, 1961
Iron pipes with fittings,
wood, aluminum alkyd enamel,
galvanized sheet metal, metal
screen, and steel bolt with nut
24 1/2 x 12 1/4 x 12 3/4 in.
(62.2 x 31.1 x 32.4 cm)
Allan Frumkin, Inc.
MCA 55

Swingin' Red King, 1961
Pine, pine molding, plywood,
and enamel
83 3/4 x 29 1/4 x 25 in.
(212.7 x 74.3 x 63.5 cm)
Private collection, London
MCA 56

*Trophy for a Gasoline
Apollo*, 1961
Wood, Hydrostone, enamel,
and plastic bumpers
32 3/8 x 8 1/2 x 6 1/4 in.
(82.2 x 21.6 x 15.9 cm)
Jane Root and Ruth Root
MCA 53

*Machine for Calculating
Risks*, 1962
Wood, linoleum, metal, glass,
bowling trophy, reflector,
clockworks, aluminum alkyd
enamel, antique acanthus
leaf feet, plastic decal, and paint
24 1/4 x 10 x 9 in.
(61.6 x 25.4 x 22.9 cm)
Billy Al Bengston, Los Angeles
MCA 62

The Pillar of Truth, 1962
Red oak, pine, walnut,
enamel, cast aluminum, and
metal spring
24 5/8 x 7 1/2 x 8 in.
(62.5 x 19.1 x 20.3 cm)
Allan Frumkin, Inc.
MCA 60

A Positive Thought, 1962 ◎
Douglas fir, iron pipe, and
metal bolts
30 x 12 1/2 x 11 3/8 in.
(76.2 x 31.8 x 28.9 cm)
Private collection, Courtesy
Lennon, Weinberg, Inc.,
New York
MCA 68

A Small Negative Thought,
1962 ◎
Douglas fir and metal bolts
28 1/4 x 16 1/2 x 16 in.
(71.8 x 41.9 x 40.6 cm)
Wadsworth Atheneum,
Hartford, Conn.,
Purchased through a gift of
the Athena Fund (1964.143)
MCA 67

Untitled (question mark),
1962 ◎
Plywood and enamel
40 x 23 x 23 in.
(101.6 x 58.4 x 58.4 cm)
The Henry and Gilda
Buchbinder Family
Collection, Chicago
MCA 65

Untitled (oil can), 1962
Pine, hemp rope, galvanized
sheet metal, aluminum
alkyd enamel, and metal
22 1/4 x 13 1/8 x 22 1/4 in.
(56.5 x 33.3 x 31.1 cm)
Whitney Museum of American
Art, New York, Purchase, with
funds from Charles Cowles
MCA 69

Exotic Garden, 1962 ○
Pine, plywood, enamel,
and mirror
26 3/8 x 32 x 22 in.
(67 x 81.3 x 55.9 cm)
The Henry and Gilda
Buchbinder Family
Collection, Chicago
MCA 63

The Big Change, 1963
Douglas-fir marine plywood,
Masonite, and ink
75 3/8 x 20 1/4 x 20 1/4 in.
(191.5 x 51.4 x 51.4 cm)
Billy Copley and
Patricia L. Brundage, New York
MCA 73

The Dream World, 1963 ◓
(IL, DC)
Douglas fir, plate-glass mirror,
ink, and rubber bumpers
14 1/8 x 13 3/4 x 6 5/8 in.
(35.9 x 34.9 x 16.8 cm)
Private collection
MCA 76

The Night Life, 1963
Plate-glass mirror, fir,
Masonite, brass plate,
rubber bumpers, and ink
28 3/8 x 17 7/8 x 9 3/4 in.
(72.1 x 45.4 x 24.8 cm)
Private collection,
Los Angeles
MCA 84

Rosebud, 1963
Douglas fir, plate-glass mirror,
brass, rubber bumpers, and ink
24 1/4 x 19 3/4 x 9 1/4 in.
(61.6 x 50.2 x 23.5 cm)
Museum of Contemporary
Art, Chicago, Partial gift
of Ruth P. Horwich
MCA 85

Aluminated, 1964
Marine plywood, Masonite,
aluminum alkyd enamel,
reflectors, enamel, mirror,
and rubber bumpers
18 3/4 x 21 3/4 x 22 in.
(47.6 x 55.2 x 55.9 cm)
Jim and Jeanne Newman,
San Francisco
MCA 87

Clean Air, 1964
Walnut, plate glass, putty, brass
plate, and rubber bumpers
15 3/4 x 22 1/4 x 14 5/8 in.
(40 x 56.5 x 37.1 cm)
Collection of Samuel and
Ronnie Heyman
MCA 94

A Human Condition, 1964
Pine, Masonite, brass, glass
doorknob, and ink
37 7/8 x 24 x 13 in.
(96.2 x 61 x 33 cm)
Private collection, Courtesy
Lennon, Weinberg, Inc.,
New York
MCA 98

Plywood Box, 1964
Fir plywood, brass key, brass
chain, and rubber bumpers
9 1/2 x 12 7/8 x 12 1/2 in.
(24.1 x 32.7 x 31.8 cm)
Sharon and Thurston Twigg-
Smith, Honolulu
MCA 97

Untitled THIS IS TITLE, 1964
Mahogany, vermillion, hem-
lock, and wood stain
70 1/4 x 17 3/4 x 27 1/4 in.
(178.4 x 45.1 x 69.2 cm)
Anne and William J. Hokin,
Chicago
MCA 101

Walnut Box, 1964
Walnut, walnuts, plate glass,
and brass chain
10 3/8 x 13 3/8 x 11 in.
(26.4 x 34 x 28 cm)
Private collection, Chicago
MCA 95

1.2.3., 1965 ◎
Honduras mahogany
Three panels, each
30 x 19 1/4 x 1 in.
(76.2 x 50.2 x 2.5 cm)
Ann Janss, Los Angeles
MCA 127

Antimobile, 1965
Douglas fir, marine plywood,
metal bicycle pedal,
and steel bolt with wing nut
67 1/4 x 35 1/2 x 27 1/2 in.
(170.8 x 90.2 x 69.9 cm)
Whitney Museum of American
Art, New York, Purchase with
funds from the Howard and
Jean Lipman Foundation, Inc.,
and exchange (69.4a–b)
MCA 132

Ash Relief, 1965 ◎
Ash and brass hinges
28 x 15⅛ x 8¾ in.
(71.1 x 38.4 x 22.2 cm)
Anstiss and Ronald Krueck,
Chicago
MCA 121

Korea, 1965
Pine, glass, rope, brass, and
found objects
34½ x 16⅛ x 8⅜ in.
(87.6 x 41 x 21.3 cm)
Private collection, Courtesy
Lennon, Weinberg, Inc.,
New York
MCA 110

A Little Black Cage, 1965
Walnut, copper screen, twine,
enamel, brass screws, metal,
rubber bumpers, and tar
15 x 11½ x 12⅝ in.
(38.1 x 29.2 x 32.1 cm)
Robert Lehrman,
Washington, D.C.
MCA 106

Negate, 1965
Maple
8⅛ x 28⅛ x 3¾ in.
(20.8 x 71.4 x 9.5 cm)
Jerome H. and Linda Meyer,
Chicago
MCA 105

Nouveau Rat Trap, 1965
Birch plywood, rosewood,
metal, and rubber bumpers
13 x 34 x 7¾ in.
(33 x 86.4 x 19.7 cm)
Sharon and Thurston Twigg-
Smith, Honolulu
MCA 115

*A Piece from the Museum of
Shattered Dreams*, 1965
Cedar, pine, ebony, rope,
and twine
29⅛ x 24¼ x 15½ in.
(74 x 61.3 x 39.4 cm)
Walker Art Center, Minneap-
olis, Gift of the T. B. Walker
Foundation, 1966 (66.45)
MCA 113

Suicide Tower, 1965 ◉
(IL, DC)
Mahogany, brass, ebony,
postcards, and metal
43¾ x 15¼ x 13⅞ in.
(111.1 x 38.7 x 35.2 cm)
Robert Lehrman,
Washington, D.C.
MCA 108

Untitled, 1965 ◎
Fir plywood, ash, plate glass,
ebony, photograph, paper
découpage, silk flowers, rubber
bumpers, and ink
28 x 20 x 9¾ in.
(71 x 50.8 x 24.8 cm)
Claire Copley and Alan
Eisenberg, New York
MCA 116

*Death Ship Runover by a '66
Lincoln Continental*, 1966
Pine, plate glass, ebony, U.S.
dollar bills, putty, brass,
and ink
15⅝ x 32½ x 11¾ in.
(39.7 x 82.6 x 29.8 cm)
Ann Janss, Los Angeles
MCA 159

*Homage to American Art (Ded-
icated to Elie Nadelman)*, 1966
Douglas fir, ash, cast lead,
and antique shovel handle
48¼ x 18 x 18¼ in.
(122.6 x 45.7 x 46.4 cm)
Alan and Dorothy Press
Collection, Chicago
MCA 153

Imitation Knotty Pine, 1966
Pine, knotty pine, and brass
12½ x 20¾ x 13 in.
(31.8 x 52.7 x 33 cm)
Sharon and Thurston Twigg-
Smith, Honolulu
MCA 157

Jockstrap, 1966
Chromium-plated solid
cast bronze
26⅜ x 35¼ x 7¾ in.
(67.3 x 89.5 x 19.7 cm)
Anstiss and Ronald Krueck,
Chicago
MCA 142

Le Keeque (after Jockomedy),
1966
Chromium-plated solid
cast bronze
36 x 19 x 9 in.
(91.4 x 48.3 x 22.9 cm)
Ann Janss, Los Angeles
MCA 151

March or Die, 1966
Pine, redwood, leather, ebony,
metal, felt, and ink
30¾ x 20 x 10⅜ in.
(78.1 x 50.8 x 26.4 cm)
Jim and Jeanne Newman,
San Francisco
MCA 156

Westermann's Table, 1966
Douglas-fir plywood,
Masonite, leather-bound
books, bolt, brass nut, paint,
and graphite
44 x 23 x 23½ in.
(111.8 x 58.4 x 59.7 cm)
Alan and Dorothy Press
Collection, Chicago
MCA 160

Death of Cracker Jack, 1967 ◎
Pyrex jar, oak, mahogany,
brass, lead, cast copper, dried
roots, linoleum, and ink
18¾ x 12½ x 12½ in.
(47.6 x 31.8 x 31.8 cm)
Mrs. Rachelle Schooler Miller,
Chicago
MCA 165

Lily Bolero, 1967 ◎
Pine, plate glass, enamel,
and cast lead
18¾ x 9¼ x 8 in.
(47.6 x 23.5 x 20.3 cm)
Private collection, Courtesy
Lennon, Weinberg, Inc.,
New York
MCA 163

*Nothing Is to Be Done for
William T. Wiley*, 1967
Pine, oak, and ink
44 x 28 x 2 in.
(111.8 x 71.1 x 5.1 cm)
William T. Wiley,
Woodacre, Calif.
MCA 167

*The Rape of "Cracker
Jack,"* 1967
Maple, hemp rope with
electrical tape, brass chain,
rubber bumpers, and ink
11⅜ x 30¼ x 9¼ in.
(28.9 x 76.8 x 23.5 cm)
The Grinstein Family,
Los Angeles
MCA 164

Tension, 1967
Oak, pine, vermillion, enamel,
brass, and rubber bumpers
21 x 28 x 9¼ in.
(53.3 x 71.1 x 23.5 cm)
Los Angeles County Museum
of Art, The Harry and
Yvonne Lenart Fund
MCA 162

Lightning, 1967
Beech, pine, plate-glass
mirror, brass, rubber
bumpers, and ink
15¾ x 26⅛ x 10 in.
(40 x 66.4 x 25.4 cm)
Museum Moderner Kunst
Stiftung Ludwig Wien
MCA 166

Untitled (Death Ship), 1967
Pine, U.S. dollar bills,
shellac, plastic decal, brass
tacks, and graphite
5⅝ x 18½ x 3⅞ in.
(14.3 x 47 x 9.8 cm)
Collection Carol Selle,
New York
MCA 170

*Death Ship of No Port
with a Shifted Cargo*, 1968 ◉
(IL, DC)
Redwood, ebony, amaranth
(purpleheart), goatskin, brass,
pine, and rubber bumpers
9⅞ x 16⅞ x 6½ in.
(25.1 x 42.9 x 16.5 cm)
Robert Lehrman,
Washington, D.C.
MCA 178

The Log Cabin, 1968
Maple, beech, pine, redwood,
walnut, leather, glass, enamel,
and paper découpage
18¼ x 18¾ x 14¼ in.
(46.4 x 47.6 x 36.2 cm)
Byron Meyer, San Francisco
MCA 177

The Last Ray of Hope, 1968
Pine, plate glass, leather boots,
linoleum, galvanized sheet
metal, and brass
17½ x 25 x 15¼
(44.4 x 63.5 x 38.7 cm)
Private collection, New York
MCA 180

*No Man Stands So Straight
As When He Stoops to Help
a Boy*, 1968 ◎
Bird's-eye maple, cast bronze,
cast lead, brass, stainless steel,
copper, iron, paint, nuts and
bolts, rubber bumpers, and ink
15 x 22½ x 9½ in.
(38.1 x 57.2 x 24.1 cm)
Ed Ruscha, Los Angeles
MCA 183

Red Rock Canyon, 1968
Mahogany, plate glass, hand-
tinted photograph, lead,
enamel, wood, bird's nest,
string, putty, and rubber
bumpers
27¾ x 10¼ x 10¼ in.
(70.5 x 26 x 26 cm)
Sharon and Thurston Twigg-
Smith, Honolulu
MCA 184

Untitled ("This Great Rock
Was Buried Once for a Million
Years"), 1968
Connecticut fieldstone, wood,
paint, galvanized metal chain,
and aluminum plate
8⅜ x 24 x 9¾
(21.3 x 61 x 24.8 cm)
Sharon and Thurston Twigg-
Smith, Honolulu
MCA 185

Wet Flower, 1968
Wood, glass, Connecticut
fieldstone, linoleum, dried
roots, putty, and varnish
29 x 18 x 14 in.
(73.7 x 45.7 x 35.6 cm)
Alan and Dorothy Press
Collection, Chicago
MCA 181

*Abandoned & Listing
Death Ship*, 1969 ◎
Redwood, zebrawood, cast
metal toy, hand-tinted
postcards, pine, brass chain,
and brass plate
11 x 30½ x 8⅛ in.
(27.9 x 77.5 x 20.6 cm)
The Henry and Gilda
Buchbinder Family
Collection, Chicago
MCA 196

*Abandoned Death Ship
of No Port with a List*, 1969 ○
Basswood, walnut, and
brass plate
11 x 39 x 12 in.
(27.9 x 99.1 x 30.5 cm)
Collection Onnasch, Berlin
MCA 197

Walnut Log, 1969
Walnut, black friction tape
(replaced), and ink
8 x 17¼ x 6 in.
(20.3 x 43.8 x 15.2 cm)
William T. Wiley,
Woodacre, Calif.
MCA 193

The Battle of Little Jack's Creek, 1969
Pine, mahogany, plate glass, tin beer cans, map of Roxbury, Connecticut, chrome hood ornament, watercolor on paper, plate-glass mirror, plastic doll, golf balls, galvanized sheet metal, paper découpage, paint, putty, and ink
30 3/4 x 24 1/2 x 16 3/4 in.
(85.7 x 62.2 x 42.5 cm)
The Museum of Modern Art, New York, Fractional gift of Robert and Laura Lee Woods [312.92]
MCA 191

Death Ship of No Port with a List, 1969 ○
Redwood, pine, leather, brass, rope, and brass plate
11 x 38 7/8 x 11 7/8 in.
(27.9 x 98.7 x 30.2 cm)
Billy Copley, New York
MCA 198

The Deerslayer, 1969
Galvanized iron pipe and fittings, metal, wood, and deer antler
82 1/2 x 28 x 47 1/4 in.
(209.6 x 71.1 x 120 cm)
Mr. and Mrs. Matthew D. Ashe, Sausalito, Calif.
MCA 189

It's a Heavy Mother, 1969 ⊛
Paldao, rosewood, vermillion, oak, kindling wood, galvanized iron, and brass
15 3/4 x 24 x 10 7/8 in.
(40 x 61 x 27.6 cm)
Sharon and Thurston Twigg-Smith, Honolulu
MCA 199

Little Egypt, 1969
Douglas fir, pine, oak, and bronze
68 1/2 x 32 3/8 x 31 1/8 in.
(174 x 82.2 x 79.1 cm)
Alan and Dorothy Press Collection, Chicago
MCA 200

Temporary Repair of a Damaged & Ill-Fated Spacecraft on a Hostile Planet, 1969
Pine, vermillion, plate glass, bubinga, saplings, lead, postcard, copper, Statue of Liberty statuette, and putty
24 1/2 x 25 1/8 x 13 1/2 in.
(62.2 x 63.8 x 34.3 cm)
The Metropolitan Museum of Art, New York, Gift of Allan Frumkin, 1987 (1987.464)
MCA 201

Cliff, 1970
Douglas-fir plywood, plate glass, vermillion, chromium-plated figure (hood ornament), oil painting by Joanna Beall Westermann, mirror, and putty
37 3/8 x 16 3/8 x 16 1/2 in.
(94.9 x 41.6 x 41.9 cm)
Indiana University Art Museum, Bloomington, Ind. (70.79)
MCA 206

Phantom in a Wooden Garden, 1970
Douglas fir, pine, redwood, vermillion, and ink
27 7/8 x 36 1/2 x 18 5/8 in.
(70.8 x 92.7 x 47.3 cm)
Purchased with funds from the Coffin Fine Arts Trust, Nathan Emory Coffin, Collection of the Des Moines Art Center (1976.89)
MCA 202

Battle to the Death in the Icehouse, 1971
Redwood, pine, vermillion, fir plywood, brass, cast lead, rope, pulley, and plate glass
32 x 28 x 22 1/4 in.
(81.3 x 71.1 x 56.5 cm)
Private collection, Los Angeles
MCA 225

The Electric Flower, 1971 ◎
Plate glass, cast lead, vermillion, putty, wire, and solder
19 3/8 x 8 1/4 x 8 1/4 in.
(49.2 x 21 x 21 cm)
John and Mary Pappajohn, Des Moines, Iowa
MCA 226

Object from a Dying Planet, 1971 ◎
Connecticut fieldstone, walnut, "difu" wood, and pigskin
19 7/8 x 12 1/4 x 9 in.
(50.5 x 31.1 x 22.9 cm)
Anstiss and Ronald Krueck, Chicago
MCA 223

30 Dust Pans, 1972
Plywood, oak, various woods, galvanized sheet metal, and brass
46 x 45 x 32 3/4 in.
(116.8 x 114.3 x 83.2 cm)
Various collections, United States (see below)
MCA 227

30 Dust Pans (base), 1972
Plywood, oak, pine, brass
46 x 45 x 32 3/4 in.
(116.8 x 114.3 x 83.2 cm)
Courtesy George Adams Gallery, New York
MCA 227

Dust Pan 30/2, 1972
Galvanized sheet metal, Douglas fir, and brass
3 5/8 x 11 1/2 x 15 1/4 in.
(9.2 x 29.2 x 38.7 cm)
Private collection, Courtesy George Adams Gallery, New York
MCA 227.2

Dust Pan 30/3, 1972
Galvanized sheet metal, walnut, and brass
3 5/8 x 11 1/2 x 15 1/4 in.
(9.2 x 29.2 x 38.7 cm)
Joe Adams and Lisette Baron, New York
MCA 227.3

Dust Pan 30/4, 1972
Galvanized sheet metal, bubinga, and brass
5 1/2 x 11 1/2 x 15 1/4 in.
(14 x 29.2 x 38.7 cm)
Ethel Lemon, Lewisville, Tex.
MCA 227.4

Dust Pan 30/5, 1972
Galvanized sheet metal, cherry, and brass
5 1/2 x 11 1/2 x 15 1/4 in.
(14 x 29.2 x 38.7 cm)
Ruth P. Horwich, Chicago
MCA 227.5

Dust Pan 30/6, 1972
Galvanized sheet metal, lignum vitae, and brass
3 5/8 x 11 1/2 x 15 1/4 in.
(9.2 x 29.2 x 38.7 cm)
Private collection, Chicago
MCA 227.6

Dust Pan 30/7, 1972
Galvanized sheet metal, hemlock, and brass
3 5/8 x 11 1/2 x 15 1/4 in.
(9.2 x 29.2 x 38.7 cm)
George Schelling, St. Louis
MCA 227.7

Dust Pan 30/8, 1972
Galvanized sheet metal, rosewood, and brass
5 3/4 x 11 5/8 x 16 3/4 in.
(14.6 x 29.5 x 42.5 cm)
Mrs. Laura Lee Woods, Los Angeles
MCA 227.8

Dust Pan 30/9, 1972
Galvanized sheet metal, willow, and brass
3 5/8 x 11 1/2 x 15 1/4 in.
(9.2 x 29.2 x 38.7 cm)
Collection of Marion Stroud-Swingle, Northeast Harbor, Maine
MCA 227.9

Dust Pan 30/10, 1972
Galvanized sheet metal, vermillion, and brass
5 3/8 x 11 1/2 x 15 3/8 in.
(13.7 x 29.2 x 39.1 cm)
Private collection, New York
MCA 227.10

Dust Pan 30/11, 1972
Galvanized sheet metal, oak, and brass
3 5/8 x 11 1/2 x 15 1/4 in.
(9.2 x 29.2 x 38.7 cm)
David and Melani King, Point Richmond, Calif.
MCA 227.11

Dust Pan 30/12, 1972
Galvanized sheet metal, walnut, and brass
5 3/8 x 11 1/2 x 15 5/8 in.
(13.7 x 29.2 x 39.7 cm)
Allan Frumkin, Inc.
MCA 227.12

Dust Pan 30/13, 1972
Galvanized sheet metal, maple, and brass
5 3/8 x 11 1/2 x 15 3/4 in.
(13.7 x 29.2 x 40 cm)
Private collection, New York
MCA 227.13

Dust Pan 30/14, 1972
Galvanized sheet metal, walnut, and brass
4 7/8 x 11 1/2 x 15 1/4 in.
(12.4 x 29.2 x 38.7 cm)
Private collection, New York
MCA 227.14

Dust Pan 30/15, 1972
Galvanized sheet metal, oak, and brass
5 3/8 x 11 1/2 x 15 5/8 in.
(13.7 x 29.2 x 39.7 cm)
Allan Frumkin, Inc.
MCA 227.15

Dust Pan 30/16, 1972
Galvanized sheet metal, bubinga, ebony, and brass
3 5/8 x 11 1/2 x 15 1/4 in.
(9.2 x 29.2 x 38.7 cm)
Alice Adam, Chicago
MCA 227.16

Dust Pan 30/17, 1972
Galvanized sheet metal, lignum vitae, and brass
3 5/8 x 11 1/2 x 15 1/4 in.
(9.2 x 29.2 x 38.7 cm)
Sharon and Thurston Twigg-Smith, Honolulu
MCA 227.17

Dust Pan 30/18, 1972
Galvanized sheet metal, amaranth (purpleheart), and brass
3 5/8 x 11 1/2 x 15 1/4 in.
(9.2 x 29.2 x 38.7 cm)
Courtesy George Adams Gallery, New York
MCA 227.18

Dust Pan 30/19, 1972
Galvanized sheet metal, ash, and brass
5 3/8 x 11 1/2 x 15 1/2 in.
(13.7 x 29.2 x 39.4 cm)
Private collection, New York
MCA 227.19

Dust Pan, 30/20, 1972
Galvanized sheet metal, rosewood, and brass
3 1/2 x 11 1/2 x 15 1/4 in.
(8.9 x 29.2 x 38.7 cm)
Robert and Marlene McCauley, Rockford, Ill.
MCA 227.20

Dust Pan 30/21, 1972
Galvanized sheet metal, oak, and brass
4 7/8 x 11 1/2 x 15 5/8 in.
(12.4 x 29.2 x 39.7 cm)
Private collection, New York
MCA 227.21

Dust Pan 30/22, 1972
Galvanized sheet metal, "difu" wood, amaranth (purpleheart), and brass
5 3/8 x 11 1/2 x 15 1/4 in.
(13.7 x 29.2 x 38.7 cm)
Private collection, New York
MCA 227.22

Dust Pan 30/23, 1972
Galvanized sheet metal, oak, and brass
5 3/8 x 11 1/2 x 15 5/8 in.
(13.7 x 29.2 x 39.7 cm)
Private collection, New York
MCA 227.23

Dust Pan 30/24, 1972
Galvanized sheet metal, rosewood, and brass
5 1/2 x 11 1/2 x 16 in.
(14 x 29.2 x 40.6 cm)
Private collection, New York
MCA 227.24

Dust Pan 30/25, 1972
Galvanized sheet metal,
ash, and brass
5 x 11¹⁄₂ x 15¹⁄₄ in.
(12.7 x 29.2 x 38.7 cm)
Nina Van Rensselaer,
San Francisco
MCA 227.25

Dust Pan 30/26, 1972
Galvanized sheet metal,
ash, and brass
5³⁄₈ x 11¹⁄₂ x 15⁵⁄₈ in.
(13.7 x 29.2 x 39.7 cm)
Allan Frumkin, Inc.
MCA 227.26

Dust Pan 30/27, 1972
Galvanized sheet metal,
rosewood, and brass
5³⁄₈ x 11¹⁄₂ x 15 in.
(13.7 x 29.2 x 38.1 cm)
Allan Frumkin, Inc.
MCA 227.27

Dust Pan 30/28, 1972
Galvanized sheet metal,
avocado wood, amaranth
(purpleheart), and brass
5 x 11¹⁄₂ x 15⁵⁄₈ in.
(12.7 x 29.2 x 39.7 cm)
Private collection, New York
MCA 227.28

Dust Pan 30/29, 1972
Galvanized sheet metal, "difu"
wood, wenge, and brass
5¹⁄₂ x 11¹⁄₂ x 15 in.
(14 x 29.2 x 38.1 cm)
The Henry and Gilda
Buchbinder Family
Collection, Chicago
MCA 227.29

Dust Pan 30/30, 1972
Galvanized sheet metal,
walnut, and brass
5¹⁄₂ x 10¹⁄₂ x 15¹⁄₂ in.
(14 x 26.7 x 39.4 cm)
Mr. and Mrs. Matthew D.
Ashe, Sausalito, Calif.
MCA 227.30

*American Death Ship on
the Equator*, 1972 ◎
Plate glass, copper, amaranth
(purpleheart), pine, plywood,
solder, putty, and brass
14¹⁄₈ x 36¹⁄₂ x 12⁷⁄₈ in.
(35.9 x 92.7 x 32.7 cm)
The Henry and Gilda
Buchbinder Family
Collection, Chicago
MCA 234

The Dancing Teacher, 1972 ○
Plate glass, copper screen,
Douglas fir, and solder
21 x 28 x 17³⁄₈ in.
(53.3 x 71.1 x 44.4 cm)
Courtesy SBC Communica-
tions, Inc., San Antonio, Tex.
MCA 232

The Diver, 1972 ◎
Paldao, ebony, walnut,
plywood, bronze, mirror,
aluminum alkyd enamel,
and felt
38⁵⁄₈ x 27¹⁄₄ x 15⁵⁄₈ in.
(98.1 x 69.2 x 39.7 cm)
The Henry and Gilda
Buchbinder Family
Collection, Chicago
MCA 231

The Pig House, 1972
Copper screen, pine, enamel,
wire, cast rubber pig, "difu"
wood, and solder
48¹⁄₂ x 37³⁄₄ x 17³⁄₄ in.
(123.2 x 95.9 x 45.1 cm)
The University of Arizona
Museum of Art; Museum Pur-
chase with funds provided
by the Edward J. Gallagher, Jr.,
Memorial Fund
MCA 233

The Airline Pilot, 1973 ◎
Copper screen and solder
27³⁄₈ x 26³⁄₄ x 21¹⁄₈ in.
(69.5 x 67.9 x 53.7 cm)
Alan and Dorothy Press
Collection, Chicago
MCA 240

Untitled (for Ed Janss), 1973
Pine, ebony, vermillion, brass
wing-screws, wing nut, steel
bolt, washer, plastic bumpers,
and ink
19¹⁄₈ x 36 x 2¹⁄₂ in.
(48.6 x 91.4 x 6.4 cm)
Ann Janss, Los Angeles
MCA 241

Untitled ("Sardine Box"), 1973
Pine, tin sardine cans, purple-
heart (amaranth), Douglas fir,
and brass chain
13 x 22³⁄₈ x 12¹⁄₈ in.
(33 x 56.8 x 30.8 cm)
Private collection, Courtesy
Lennon, Weinberg, Inc.,
New York
MCA 243

The Death Ship, 1974
Wood, plate glass, tar, tin,
and brass
18¹⁄₄ x 39¹⁄₄ x 15¹⁄₈ in.
(46.4 x 99.7 x 38.4 cm)
John and Mary Pappajohn,
Des Moines, Iowa
MCA 249

*Im Goin' Home on the
Midnight Train*, 1974 ◎
Purpleheart (amaranth),
hickory, zebrawood, ebony,
brass, steel, pine, and ink
5¹⁄₂ x 23 x 7³⁄₄ in.
(14 x 58.4 x 19.7 cm)
CPLY Art Trust, New York
MCA 255

U.F.O. Landing in Africa, 1974
Zebrawood, plate glass, cop-
per, rosewood, redwood, tin
coffee can, solder, Bances
cigar band, putty, and leather
bumpers
13³⁄₄ x 17 x 12⁷⁄₈ in.
(34.9 x 43.2 x 32.7 cm)
Sharon and Thurston Twigg-
Smith, Honolulu
MCA 258

Untitled ("Walnut Death Ship
in a Chestnut Box"), 1974 ◎
Chestnut, walnut, zebrawood,
galvanized sheet metal, copper,
and ebony
17⁷⁄₈ x 24⁷⁄₈ x 8¹⁄₂ in.
(45.4 x 63.2 x 21.6 cm)
Private collection, New York
MCA 253

Untitled ("The Plane
Truth"), 1975 ◎
Pine, vermillion, and hand
plane
6³⁄₈ x 10¹⁄₂ x 5¹⁄₂ in.
(16.2 x 26.7 x 14 cm)
Claire Copley and Alan
Eisenberg, New York
MCA 263

Billy Penn, 1976
Galvanized sheet metal, steel,
pine, bronze, and aluminum
alkyd enamel
79¹⁄₄ x 42¹⁄₂ x 29⁵⁄₈ in.
(201.3 x 107.9 x 75.2 cm)
Museum of Contemporary Art,
Chicago, Gift of Alan and
Dorothy Press
MCA 266

*Bird's-Eye Maple Snake
House*, 1976 ◎
Bird's-eye maple and brass
15⁵⁄₈ x 13¹⁄₄ x 11⁵⁄₈ in.
(39.7 x 33.7 x 29.5 cm)
Barbara Klawans,
Munster, Ind.
MCA 269

Bronze Man 2, 1976
Blistered mahogany, bird's-eye
maple, zebrawood, vermillion,
rosewood, white oak, bubinga,
amaranth (purpleheart),
bronze, maple, and string
24¹⁄₈ x 27¹⁄₂ x 11⁷⁄₈ in.
(61.3 x 69.9 x 30.2 cm)
Mark and Polly Addison,
Boulder, Colo.
MCA 278

Eds Varnish, 1976
Pine, three one-quart cans of
"Man O' War Ultra Spar
Marine Varnish," bird's-eye
maple, brass, and ink
9⁷⁄₈ x 18¹⁄₂ x 8¹⁄₂ in.
(25.1 x 47 x 21.6 cm)
Ed Ruscha, Los Angeles
MCA 272

Fools Gold, 1976
Wood, plate glass, copper,
bronze, pocket watch, cast
lead, aluminum alkyd enamel,
and brass plate
50¹⁄₄ x 13 x 11³⁄₈ in.
(127.6 x 33 x 28.9 cm)
John and Mary Pappajohn,
Des Moines, Iowa
MCA 276

*Hutch the One-Armed
Astro-Turf Man
with a Defense*, 1976 ◎
AstroTurf, pine, aspen, ash,
chestnut, and saplings
75 x 28³⁄₄ x 21¹⁄₂ in.
(190.5 x 73 x 54.6 cm)
Alan and Dorothy Press
Collection, Chicago
MCA 271

*Machine Dedicated to
Spike Jones*, 1976
Pine, oak, birch, leather, ver-
million, granadillo (cocobolo),
amaranth (purpleheart), brass,
and ink
38 x 28³⁄₄ x 20¹⁄₂ in.
(96.5 x 73 x 52.1 cm)
Jean W. Bush, San Francisco
MCA 273

Pine Construction, 1976
Pine and brass plate
22¹⁄₂ x 12 x 12¹⁄₄ in.
(57.2 x 30.5 x 31.1 cm)
Mary and Roy Cullen,
Houston
MCA 270

Soldier, 1976
Wood, granadillo (cocobolo),
purpleheart (amaranth), maple,
and brass
35 x 25 x 24 in.
(88.9 x 63.5 x 61 cm)
Barbara and Richard S. Lane,
New York
MCA 267

Female Figure, 1977
Southern pine, aspen,
hemlock, Douglas fir, beech
saplings, oak, plate glass,
watercolor on paper, and
photograph
79³⁄₄ x 24¹⁄₈ x 31¹⁄₄ in.
(202.6 x 61.3 x 79.4 cm)
Claire Copley and Alan
Eisenberg, New York
MCA 280

The Second Shotgun, 1977
Pine, bird's-eye maple, ebony,
granadillo (cocobolo), galva-
nized sheet metal, cotton rope,
newspaper, brass chain, ink,
and leather bumpers
20³⁄₄ x 45⁷⁄₈ x 20³⁄₄ in.
(52.7 x 116.5 x 52.7 cm)
Robert Lehrman,
Washington, D.C.
MCA 283

Untitled (for Richard M.
Hollander), 1977
Pine, postcard, photograph,
newspaper, and woodcut print
3³⁄₄ x 9 x 5¹⁄₄ in.
(9.5 x 22.9 x 13.3 cm)
Spencer Museum of Art,
Lawrence, Kans., Gift
of Richard M. Hollander
(82.67 a–e)
MCA 289

*The Wild Man from
Borneo*, 1977 ◎
Douglas fir, plywood, southern
pine, granadillo (cocobolo),
copper, steel ball bearings, and
brass bell
45 x 37⁵⁄₈ x 14¹⁄₂ in.
(114.3 x 95.7 x 36.8 cm)
The Henry and Gilda
Buchbinder Family
Collection, Chicago
MCA 290

Big Leaguer, 1978 ◎
Pine, wood, walnut, oak, calf-
skin, enamel, and brass
8¹⁄₄ x 36¹⁄₄ x 22 in.
(21 x 92.1 x 55.9 cm)
Douglas and Carol Cohen,
Highland Park, Ill.
MCA 297

A Blimp-Wood Carving, 1978
Wood
6 7/8 x 17 3/4 x 5 1/8 in.
(17.5 x 45.1 x 13 cm)
Barbara Klawans,
Munster, Ind.
MCA 295

Coffin for a Crooked Man, 1979
Pine, pigskin, vermillion,
granadillo (cocobolo),
and brass
13 1/4 x 40 5/8 x 18 in.
(33.6 x 103.2 x 45.7 cm)
The Henry and Gilda
Buchbinder Family
Collection, Chicago
MCA 298

The One-Eyed Poet, 1979
Blistered mahogany, Macassar
ebony, maple, plywood,
and pine
65 1/8 x 60 x 14 1/2 in.
(165.4 x 152.4 x 36.8 cm)
Yale University Art Gallery,
New Haven, Conn.,
Gift of Susan Morse Hilles
(1984-75.27)
MCA 300

Untitled (for Gregory N.
Westermann), 1979 ◎
Vermillion, bird's eye maple,
and brass
7 3/8 x 9 7/8 x 6 7/8 in.
(18.7 x 25.1 x 17.5 cm)
Museum of Contemporary
Art, Gift of Gregory N. Wes-
termann in memory of H. C.
Westermann (2000.18)
MCA 314

Untitled (ice chest with
Pearl beer), 1979
Honduras mahogany, six-pack
of Pearl beer, ash, maple, pur-
pleheart (amaranth), vermil-
lion, granadillo (cocobolo),
and ivory
7 1/2 x 10 1/2 x 7 1/2 in.
(19 x 26.7 x 19 cm)
Terry Allen and Jo Harvey
Allen, Santa Fe, N.M.
MCA 302

Texas Cactus, 1979-80 ◎
Douglas-fir plywood, sugar
pine, enamel, Masonite,
and sapling
56 5/8 x 20 1/2 x 23 5/8 in.
(143.8 x 52.1 x 60 cm)
Alan and Dorothy Press
Collection, Chicago
MCA 315

*Death Ship, Out of San Pedro,
Adrift*, 1980 ◎
Ebony, brass, copper,
and solder
7 x 23 7/8 x 6 1/2 in.
(17.8 x 60.6 x 16.5 cm)
Alan and Dorothy Press
Collection, Chicago
MCA 319

*The Man from the Torrid
Zone*, 1980 ◎
Sheet copper, Douglas fir,
aspen, teak, Connecticut field-
stone, oak, beech, and brass
64 1/4 x 18 5/8 x 25 3/4 in.
(163.2 x 47.3 x 65.4 cm)
Alan and Dorothy Press
Collection, Chicago
MCA 320

*They Couldn't Put "Humpty
Dumpty" Back Together Again*,
1980
Walnut, Macassar ebony,
vermillion, and brass
54 1/4 x 52 1/4 x 13 7/8 in.
(137.8 x 132.7 x 35.2 cm)
Sharon and Thurston Twigg-
Smith, Honolulu
MCA 321

Jack of Diamonds, 1981
Galvanized wire lath, galva-
nized sheet metal, galvanized
corner beading, oak, pine, and
vermillion
79 3/4 x 36 3/4 x 23 5/8 in.
(202.6 x 93.3 x 60.2 cm)
Alan and Dorothy Press
Collection, Chicago
MCA 323

The Tin Woodman of Oz, 1981
Wood, bird's-eye maple,
Douglas fir, and Masonite
20 7/8 x 9 1/8 x 12 5/8 in.
(53 x 23.2 x 32.1 cm)
The Henry and Gilda
Buchbinder Family
Collection, Chicago
MCA 322

WORKS ON PAPER

Sketchbook #4, c. 1958-60
Hardbound
Graphite and ink on paper
14 x 11 in.
(35.6 x 27.9 cm)
Private collection, Courtesy
Lennon, Weinberg, Inc.,
New York

Sketchbook #5, c. 1962
Hardbound
Graphite, ink, and watercolor
on paper
14 x 11 in.
(35.6 x 27.9 cm)
Private collection, Courtesy
Lennon, Weinberg, Inc.,
New York

Sketchbook #6, c. 1962
Hardbound
Graphite and ink on paper
14 x 11 in.
(35.6 x 27.9 cm)
Private collection, Courtesy
Lennon, Weinberg, Inc.,
New York

Sketchbook #7, c. 1962-64
Hardbound
Graphite and ink on paper
14 x 11 in.
(35.6 x 27.9 cm)
Private collection, Courtesy
Lennon, Weinberg, Inc.,
New York

Sketchbook #8, c. 1963-64
Hardbound
Graphite, ink, and watercolor
on paper
14 x 11 in.
(35.6 x 27.9 cm)
Private collection, Courtesy
Lennon, Weinberg, Inc.,
New York

Sketchbook #9, c. 1964-65
Hardbound
Graphite, ink, and watercolor
on paper
14 x 11 in.
(35.6 x 27.9 cm)
Private collection, Courtesy
Lennon, Weinberg, Inc.,
New York

Sketchbook #10, c. 1965-66
Hardbound
Graphite, ink, and watercolor
on paper
14 x 11 in.
(35.6 x 27.9 cm)
Private collection, Courtesy
Lennon, Weinberg, Inc.,
New York

Sketchbook #11, c. 1966
Hardbound
Graphite, ink, and watercolor
on paper
14 x 11 in.
(35.6 x 27.9 cm)
Private collection, Courtesy
Lennon, Weinberg, Inc.,
New York

Sketchbook #12, c. 1966
Hardbound
Graphite, ink, and watercolor
on paper
14 x 11 in.
(35.6 x 27.9 cm)
Private collection, Courtesy
Lennon, Weinberg, Inc.,
New York

Sketchbook #14, c. 1968-1972
Hardbound
Graphite and ink on paper
11 x 8 1/2 in.
(27.9 x 21.6 cm)
Private collection, Courtesy
Lennon, Weinberg, Inc.,
New York

Sketchbook #16, c. 1977
Hardbound
Graphite and ink on paper
12 1/2 x 9 1/2 in.
(31.8 x 24.1 cm)
Private collection, Courtesy
Lennon, Weinberg, Inc.,
New York

Untitled (Mysteriously
Abandoned New Home), 1958
Ink on paper
9 1/2 x 6 3/8 in.
(23.9 x 16.2 cm)
Private collection, Courtesy
Lennon, Weinberg, Inc.,
New York

Untitled (From the Museum
of Shattered Dreams), 1965
Ink on paper
14 1/8 x 16 3/4 in.
(35.9 x 42.5 cm)
Private collection, New York

Antimobile, 1965
Ink on paper
8 1/2 x 14 in.
(21.6 x 35.6 cm)
Whitney Museum of American
Art, New York

1.2.3., c. 1965 ◎
Ink on paper
14 x 11 in.
(35.6 x 27.9 cm)
Bill and Theresa Moll,
Northbrook, Ill.

Antimobile, 1965-66 (1 of 2)
Ink on paper
10 1/2 x 7 1/4 in.
(26.7 x 18.4 cm)
Private collection, New York

Antimobile, 1965-66 (2 of 2)
Ink on paper
10 1/2 x 7 1/4 in.
(26.7 x 18.4 cm)
Private collection, New York

Untitled (The Hands), 1978
Ink and watercolor on paper
13 1/4 x 9 3/8 in.
(33.7 x 23.8 cm)
Spencer Art Museum,
Lawrence, Kans.,
Anonymous gift

Technical description of
Texas Cactus, 1979-80 ◎
Ink and watercolor on paper
8 1/2 x 14 in.
(21.6 x 35.6 cm)
Alan and Dorothy Press
Collection, Chicago

Technical description of
*Death Ship, Out of San Pedro,
Adrift*, 1980 ◎
Ink and watercolor on paper
8 1/2 x 14 in.
(21.6 x 35.6 cm)
Alan and Dorothy Press
Collection, Chicago

Group Exhibition History

Exhibitions of Westermann's work in all media are listed in chronological order. The organizing institution of an exhibition is given first.

1954
Chicago, Mandel Brothers Art Galleries. *Paintings by Bennett, Stafford and Westermann.* October.

Chicago, La Boutique Gallery.

Chicago, Norths Gallery. 1954–55.

1955
Chicago, 1020 Art Center.

1956
Chicago, The Art Institute of Chicago. *59th Annual Exhibition: Artists of Chicago and Vicinity.* March 8–April 12. Cat.

Chicago, College of Jewish Education. *Momentum 1956.* May 23–June 20.

Chicago, Allan Frumkin Gallery. Fall.

Chicago, Navy Pier. *Navy Pier Show.*

New York, Barone Gallery. *Group Sculpture Exhibition.*

1957
Chicago, Navy Pier. *1957 Chicago Artists' No-Jury Exhibition.* February 12–26. Cat.

Chicago, 414 Art Workshop and Gallery. *Sculpture by H. C. Westermann and Paintings by Ivan Mischo.* Opened May 5.

Chicago, Allan Frumkin Gallery.

Chicago, 414 Art Workshop and Gallery. *Tom Kapsalis/ H. C. Westermann.*

Chicago, 1020 Art Center. *Momentum.*

1958
Chicago, The Loft Gallery. February.

Rockford, Ill., Rockford College Art Gallery (Middle Hall). *A Memorial to George Rouault.* March 9–31.

1959
Chicago, The Art Institute of Chicago. *62nd Annual Exhibition: Artists of Chicago and Vicinity.* May 13–June 28. Cat.

Lake Forest, Ill., Henry C. Durand Art Institute, Lake Forest College. *The New Chicago Decade 1950–1960: An Exhibition of Painting and Sculpture by Fourteen Artists Residing in Chicago and Vicinity.* May 27–June 13. Cat. with intro. by Allan Frumkin.

New York, The Museum of Modern Art. *New Images of Man.* September 30–November 29. Traveled to Baltimore, Baltimore Museum of Art, January 9–February 7, 1960. Cat. with preface by Paul Tillich, essay by Peter Selz.

Houston, Contemporary Arts Museum. *Out of the Ordinary.* November 26–December 27. Cat. with intro. by Harold Rosenberg.

Chicago, The Art Institute of Chicago. *63rd American Exhibition: Paintings, Sculpture.* December 2, 1959–January 31, 1960. Cat.

1960
Chicago, Renaissance Society, University of Chicago. *But—Is It Art?* October 17–November 12. Brochure.

1961
Urbana, Ill., Krannert Art Museum, University of Illinois. *Contemporary American Painting and Sculpture.* February 26–April 2. Cat. with text by Allen S. Weller.

New York, The Museum of Modern Art. *The Art of Assemblage.* October 2–November 12. Traveled to Dallas, Dallas Museum for Contemporary Arts, January 9–February 11, 1962; San Francisco, San Francisco Museum of Art, March 5–April 15, 1962. Cat. with text by William C. Seitz.

1962
Paris, Galerie du Dragon. *Huit Artistes de Chicago: Barnes, Campoli, Cohen, June Leaf, Golub, Petlin, Rosofsky, Westermann.* January 16–February 15. Cat. with intro. by Franz Schulze.

Chicago, The Arts Club of Chicago. *Wit and Humor.* February 28–March 31. Cat.

1963
Urbana, Ill., Krannert Art Museum, University of Illinois. *Contemporary American Painting and Sculpture.* March 3–April 7. Cat. with text by Allen S. Weller.

Hartford, Conn., Wadsworth Atheneum. *Eleven New England Sculptors.* July 18–September 15. Cat. with intro. by Samuel J. Wagstaff, Jr.

Oakland, Calif., Oakland Art Museum. *Pop Art USA.* September 7–29. Cat. with text by John Coplans.

Evanston, Ill., Unitarian Church of Evanston.

1964
Albuquerque, Art Gallery, University of New Mexico. *Selections from the L. M. Asher Family Collection.* January 20–February 23. Cat.

Los Angeles, Dwan Gallery. *Boxes.* February 2–29. Cat. with text by Walter Hopps, comments by John Weber.

Pasadena, Calif., Pasadena Art Museum. *New American Sculpture.* February 11–March 7. Cat. with foreword by Walter Hopps.

Chicago, The Art Institute of Chicago. *67th Annual American Exhibition: Directions in Contemporary Painting and Sculpture.* February 28–April 12. Cat. with foreword by A. James Speyer.

London, Tate Gallery. Calouste Gulbenkian Foundation. *Painting and Sculpture of a Decade: 1954–1964.* April 22–June 28. Cat. with texts by Alan Bowness, Lawrence Gowing, and Philip James.

San Francisco, Dilexi Gallery. *Selections—Gallery Artists.* July 1–August 12.

New York, American Federation of Arts (org.). *A Decade of New Talent.* Traveled to 21 galleries and museums, July 15, 1964–September 30, 1966. Cat.: special issue of *Art in America* 52, no. 4 (summer 1964).

Vienna, Museum des 20. Jahrhunderts. *Pop Etc.* September 19–October 31. Cat. by Georg Schmid.

Milwaukee, Wis., Milwaukee Art Center. *Wisconsin Collects.* September 24–October 25. Cat.

Berlin, Akademie der Künste. *Neue Realisten und Pop Art.* November 20, 1964–January 3, 1965. Cat. by Herta Elisabeth Killy.

New York, Whitney Museum of American Art. *1964 Annual Exhibition of Contemporary American Sculpture.* December 9, 1964–January 31, 1965. Cat.

1965

Worcester, Mass., Worcester Art Museum. *The New American Realism.* February 18–April 4. Cat. with intro. by Martin Carey.

Flint, Mich., Flint Institute of Arts. *American Sculpture, 1900–1965.* April 1–25. Cat.

Providence, R.I., Museum of Art, Rhode Island School of Design. *Contemporary Boxes and Wall Sculpture.* September 23–October 17. Cat. by Daniel Robbins.

1966

Boston, Institute of Contemporary Art. *Multiplicity.* April 16–June 5. Cat. with intro. by Molly Rannells.

New York, Public Education Association of the City of New York. *Seven Decades: 1895–1965, Crosscurrents in Modern Art.* April 26–May 21. Cat. by Peter Selz.

London, Hanover Gallery. *The Poetic Image.* June 28–September 9. Cat.

Providence, R.I., Museum of Art, Rhode Island School of Design. *Paintings and Constructions of the 1960's: Selections from the Richard Brown Baker Collection.* October 2–25. Cat. with intro. by Richard Brown Baker.

Minneapolis, Walker Art Center. *Eight Sculptors: The Ambiguous Image.* October 22–December 4. Cat. with intro. and essay by Martin Friedman.

Columbus, Ohio, Ohio State University Gallery of Fine Art. *Contemporary Sculptors' Drawings.* Cat.

1967

Bloomington, Ind., Indiana University Art Museum. *Exhibition of Contemporary Drawings.* Spring.

Los Angeles, Los Angeles County Museum of Art. *American Sculpture of the Sixties.* April 28–June 25. Traveled to Philadelphia, Philadelphia Museum of Art, September 15–October 29. Cat. with intro. by Maurice Tuchman, essays by Lawrence Alloway, Wayne V. Andersen, Dore Ashton, John Coplans, Clement Greenberg, Max Kozloff, Lucy R. Lippard, James Monte, Barbara Rose, and Irving Sandler.

Chicago, The Art Institute of Chicago. Society for Contemporary American Art. *Sculpture: A Generation of Innovation.* June 23–August 27. Cat. with intro. by A. James Speyer.

Pittsburgh, Museum of Art, Carnegie Institute. *1967 Pittsburgh International Exhibition of Contemporary Painting and Sculpture.* October 27, 1967–January 7, 1968. Cat. with foreword by Gustave von Groschwitz.

Syracuse, N.Y., Joe and Emily Lowe Art Center, Syracuse University. *Design and Aesthetics in Wood.* November 7–30. Cat. ed. by Eric A. Anderson and George F. Earle.

1968

West Lafayette, Ind., Purdue University Gallery. *Snoitcerid.* March.

New York, The Museum of Modern Art. *Dada, Surrealism, and Their Heritage.* March 27–June 9. Traveled to Los Angeles, Los Angeles County Museum of Art, July 16–September 8; Chicago, The Art Institute of Chicago, October 19–December 8. Cat. with text by William S. Rubin.

London, Institute of Contemporary Arts. *The Obsessive Image: 1960–1968.* April 10–May 29. Cat. with foreword by Roland Penrose.

Kassel, Germany, Museum Fridericianum. *Documenta 4.* June 27–October 6. Cat.

San Francisco, San Francisco Museum of Art. *Untitled, 1968.* November 9–December 29. Cat. with foreword by Gerald Nordland, intro. by Wesley Chamberlain.

New York, Whitney Museum of American Art. *1968 Annual Exhibition: Contemporary American Sculpture.* December 17, 1968–February 9, 1969. Cat.

Highland Park, Ill. *Ravinia Festival Art Exhibit.* Cat. by James Breckenridge.

1969

Minneapolis, Walker Art Center. *Twentieth-Century Sculpture: Selections from the Collection.* January 30–March 16. Cat. with intro. by Martin Friedman.

Grand Rapids, Mich., Grand Rapids Art Museum. *American Sculpture of the Sixties.* March 22–May 24. Cat. with intro. by Dore Ashton.

New York, Whitney Museum of American Art. *Contemporary Sculpture Selections II.* April 15–May 5.

New York, The Museum of Modern Art. *Tamarind: Homage to Lithography.* April 29–June 30.

Indianapolis, Indianapolis Museum of Art. *Painting and Sculpture Today! 1969.* May 4–June 1. Curated by Phillip B. Solomon. Cat.: special issue of *Indianapolis Museum of Art Bulletin* 55, no. 3 (1969).

Chicago, Museum of Contemporary Art. *Towers.* September 13–October 25.

Philadelphia, Institute of Contemporary Art, University of Pennsylvania. *The Spirit of the Comics.* October 1–November 9. American Federation of Arts Traveling Exhibition: Columbus, Ohio, Huntington Trust Gallery, February 22–March 15, 1970; Milwaukee, Wis., University of Wisconsin, June 28–July 19, 1970; Ames, Iowa, Memorial Union, Iowa State University, September 9–October 11, 1970; Pittsburgh, University of Pittsburgh, November 1–22, 1970; Edmonton, Alberta, The Edmonton Art Gallery, December 13, 1970–February 14, 1971; Johnson City, Tenn., Carroll Reece Museum, East Tennessee

State University, March 7–28, 1971; Brookings, S. Dak., South Dakota Memorial Art Center, South Dakota State University, April 18–May 9, 1971. Cat. by Joan C. Siegfried.

New York, Whitney Museum of American Art. *Human Concern/Personal Torment: The Grotesque in American Art.* October 14–November 30. Traveled to Berkeley, Calif., University Art Museum, University of California, January 20–March 1, 1970. Cat. with text by Robert Doty.

Denver, Denver Art Museum. *American Reports—The Sixties.* October 25–December 7.

Baltimore, Baltimore Museum of Art. *The Partial Figure in Modern Sculpture from Rodin to 1969.* December 2, 1969–February 1, 1970. Cat. by Albert E. Elsen.

Chicago, Allan Frumkin Gallery. *Group Exhibition.*

1970

Pittsburgh, Museum of Art, Carnegie Institute. *1970 Pittsburgh International Exhibition of Contemporary Art.* October 30, 1970–January 10, 1971. Cat. with intro. by Leon Anthony Arkus.

New York, Whitney Museum of American Art. *1970 Annual Exhibition: Contemporary American Sculpture.* December 12, 1970–February 7, 1971. Cat.

1971

La Jolla, Calif., La Jolla Museum of Art. *Continuing Surrealism.* January 15–March 21. Cat. with intro. by Lawrence Urrutia.

De Kalb, Ill., Northern Illinois University. *Arts USA: 2—An Invitational Art Exhibition in Conjunction with the 1971 Fine Arts Festival.* April 17–May 2. Cat. by Norman E. Magden.

Chicago, Renaissance Society, University of Chicago. *The New Curiosity Shop.* October 5–November 13.

Greensboro, N.C., Weatherspoon Art Gallery, University of North Carolina. *Art on Paper Invitational.* November 14–December 17. Cat. with intro. by James E. Tucker.

1972

New York, Solomon R. Guggenheim Museum. *Ten Independents: An Artist-Initiated Exhibition.* January 14–February 27. Cat. with intro. by Dore Ashton.

Birmingham, Ala., Birmingham Museum of Art. *American Watercolors 1850–1972.* January 16–February 13. Traveled to Mobile, Ala., Mobile Art Gallery, February 22–March 31. Cat. with text by Edward F. Weeks.

Chicago, Museum of Contemporary Art. *Chicago Imagist Art.* May 13–June 25. Smaller version traveled to New York, New York Cultural Center, July 21–August 27. Cat. with text by Franz Schulze.

Kassel, Germany, Museum Fridericianum. *Documenta 5.* June 30–October 8. Cat.

Cologne, Germany, Galerie Rudolf Zwirner. Opened November 3.

Sarasota, Fla., John and Mable Ringling Museum of Art. *After Surrealism: Metaphors and Similes.* November 17–December 10. Cat. with text by Leslie Judd Ahlander.

Los Angeles, Margo Leavin Gallery. *Sculptors' Drawings.* November 18–December 31.

Hartford, Conn., Wadsworth Atheneum. *A Selection of Contemporary American Painting and Sculpture.*

1973

New York, Whitney Museum of American Art. *1973 Biennial Exhibition: Contemporary American Art.* January 10–March 19. Cat.

New York, New York Cultural Center. *3D into 2D: Drawing for Sculpture.* January 19–March 11. Traveled to Brooklyn, N.Y., Art Gallery, Kingsborough Community College of the City University of New York; Vancouver, B.C., Vancouver Art Gallery; Ottawa, Ontario, National Gallery of Canada; Oberlin, Ohio, Allen Memorial Art Museum, Oberlin College; Santa Barbara, Calif., The Art Galleries, University of California. Cat. with intro. by Susan Ginsburg.

New York, Whitney Museum of American Art. *American Drawings 1963–1973.* May 25–June 22. Cat. with text by Elke M. Solomon.

New York, United Nations Building. Exhibition of works in charity auction held by Sotheby's to benefit Pan-American Development Foundation. June 5.

Budapest, Hungary. *IIème Biennale Internationale de la Petite Sculpture.* September 22–November 11. Cat.

São Paulo, Brazil, Museu de Arte Moderna. *XII Bienal de São Paulo.* October 5–November 20. Traveled to Bogota, Colombia, Museo de Arte Moderno, January 15–February 21, 1974; Santiago, Chile, Museo Nacional de Bellas Artes, March 25–April 29, 1974; Buenos Aires, Argentina, Museo Nacional de Bellas Artes, May 27–July 1, 1974; Mexico City, Museo de Arte Moderno, July 29–September 9, 1974. U.S. entry exhibited in Washington, D.C., and Chicago as *Made in Chicago,* 1974 (see below). Cat. with essay on U.S. entry by Don Baum.

New York, Whitney Museum of American Art. *Extraordinary Realities.* October 16–December 2. Traveled to Syracuse, N.Y., Everson Museum of Art, January 15–February 18, 1974; Cincinnati, Ohio, Contemporary Arts Center, March 8–April 27, 1974. Cat. with text by Robert Doty.

Chicago, Center for Continuing Education, University of Chicago. *The Chicago Style Prints, An Exhibition of Works by Contemporary Chicago Artists.* November 11–December 15.

Hanover, N.H., Jaffe-Friede Gallery, Dartmouth College. *Wood-Works: An Exhibition of Contemporary Sculpture in Wood.* December 7, 1973–January 14, 1974. Traveled to Andover, Mass., Addison Gallery, Phillips Academy, January 18–February 24, 1974; Boston, Institute of Contemporary Art, March 1–26, 1974; Durham, N.H., Paul Creative Arts Center, University of New Hampshire, April 4–May 3,

1974; Storrs, Conn., Williams Benton Museum of Art, University of Connecticut, May 25–August 11, 1974; Brunswick, Maine, Bowdoin College Museum of Art, August 16–September 22, 1974. Cat.

1974
Urbana, Ill., Krannert Art Museum, University of Illinois. *Contemporary American Painting and Sculpture 1974.* March 10–April 21. Cat. with intro. by James R. Shipley and Allen S. Weller.

Los Angeles, Margo Leavin Gallery. *Drawings.* April 11–May 9.

Los Angeles, Margo Leavin Gallery. *Recent Acquisitions.* May 18–June 30.

Chicago, The Art Institute of Chicago. *71st American Exhibition.* June 15–August 11. Cat. with intro. by A. James Speyer.

Washington, D.C., National Collection of Fine Arts, Smithsonian Institution. *Made in Chicago.* October 31–December 29. Expanded version of U.S. entry from the *XII Bienal de São Paulo,* 1973 (see above). Traveled to Chicago, Museum of Contemporary Art, January 11–March 2, 1975. Cat. with texts by Whitney Halstead and Dennis Adrian.

1975
Chicago, Museum of Contemporary Art. *Made in Chicago: Some Resources.* January 11–March 2. Cat. by Don Baum.

Chicago, The Art Institute of Chicago. *The Small Scale in Contemporary Art: Society of Contemporary Art 34th Exhibition.* May 8–June 15. Cat. with text by Peter Frank.

Portland, Oreg., Portland Art Museum. *Masterworks in Wood: The Twentieth Century.* September 17–October 19. Cat. by Robert Peirce and Polly Eyerly.

Washington, D.C., National Collection of Fine Arts, Smithsonian Institution. *Sculpture: American Directions, 1945–1974.* October 3–November 30. Cat.

Irvine, Calif., Art Gallery, University of California. *Private Spaces: An Exhibition of Small Scale Sculpture.* November 5–29. Cat. with text by Melinda Wortz.

1976
New York, Whitney Museum of American Art. *200 Years of American Sculpture.* March 16–September 12. Cat. with texts by Tom Armstrong, Norman Feder, Wayne Craven, Daniel Robbins, Rosalind E. Krauss, Barbara Haskell, and Marcia Tucker.

Chico, Calif., California State University. *Chicago Chic.* March 22–April 9.

Amherst, Mass., Fine Arts Center Gallery, University of Massachusetts. *Critical Perspectives in American Art.* April 10–May 9. Revised version shown as U.S. entry to the *Biennale di Venezia, 1976* (see below). Cat. with texts by Sam Hunter, Rosalind E. Krauss, and Marcia Tucker.

Venice, Italy. *La Biennale di Venezia, 1976.* July 18–October 10. Revised version of *Critical Perspectives in American Art,* 1976 (see above). Cat. with intro. to U.S. entry by Thomas M. Messer, text by Hugh M. Davies.

Chicago, The School of The Art Institute of Chicago. *Visions—Painting and Sculpture: Distinguished Alumni 1945 to the Present.* October 7–December 10. Cat. with intro. by Dennis Adrian.

Washington, D.C., National Collection of Fine Arts, Smithsonian Institution. *The Object as Poet.* December 14, 1976–June 26, 1977. Cat. by Rose Slivka.

1977
New York, Whitney Museum of American Art. *1977 Biennial Exhibition.* February 15–April 3. Cat. with texts by Barbara Haskell, Patterson Sims, and Marcia Tucker.

Chicago, The Art Institute of Chicago. Society for Contemporary Art. *Drawings of the 70s.* March 9–May 1. Cat. by Harold Joachim.

Sparkhill, N.Y., Thorpe Intermedia Gallery, St. Thomas Aquinas College. *Wood Sculptors and Their Objects.* March 27–April 17.

Los Angeles, Margo Leavin Gallery. *Fine Paintings and Drawings.* April 20–May 14.

Vancouver, B.C., Vancouver Art Gallery. *Studies and Other Initial Works.* May 7–June 5. Cat. with intro. and text by Christopher Varley.

Los Angeles, Margo Leavin Gallery. *Recent Acquisitions: Paintings, Drawings, and Sculpture.* Opened May 18.

New York, Whitney Museum of American Art. *Twentieth-Century American Art from Friends' Collections.* July 27–September 27.

Chicago, Museum of Contemporary Art. *A View of a Decade.* September 10–November 10. Cat. with intro. by Stephen Prokopoff, texts by Martin Friedman, Peter Gay, and Robert Pincus-Witten.

New York, Whitney Museum of American Art, Downtown Branch. *Small Objects.* November 3–December 7.

Bloomington, Ind., Indiana University Art Museum. *Contemporary American Printmaking.*

1978
Ann Arbor, Mich., University of Michigan Museum of Art. *Chicago: The City and Its Artists, 1945–1978.* March 17–April 23. Cat. ed. by Charles A. Lewis and Cynthia Yao.

New York, Whitney Museum of American Art, Downtown Branch. *Cartoons.* May 31–July 5.

Anchorage, Alaska, Visual Arts Center of Alaska. *Invitational Print Show.* Summer.

1979
New York, Whitney Museum of American Art. *1979 Biennial Exhibition.* February 6–April 8. Cat.

New York, Whitney Museum of American Art, Downtown Branch. *Enclosure and Concealment.* April 18–May 23.

New York, The Museum of Modern Art. *Contemporary Sculpture: Selections from the Collection of The Museum of Modern Art.* May 18–August 7. Cat. with foreword by Kynaston McShine.

New York, Whitney Museum of American Art. *Decade in Review: A Selection from the 1970's.* June 19–September 2.

New York, School of Visual Arts. *The Intimate Gesture.* October 1–22.

São Paulo, Brazil, Armando de Arruda Pereira Pavilion. *XV Bienal de São Paulo.* October 3–December 9. Cat.

Chicago, The School of The Art Institute of Chicago. *100 Artists, 100 Years: Alumni of The School of The Art Institute of Chicago.* November 23, 1979–January 20, 1980. Cat. by Katherine Kuh.

New York, Whitney Museum of American Art (org.). *Twentieth-Century Drawings from the Whitney Museum of American Art.* Traveled to San Antonio, San Antonio Museum Association, November 26, 1979–January 14, 1980; Iowa City, University of Iowa Museum of Art, February 8–March 23, 1980; Los Angeles, The Frederick S. Wight Art Gallery, University of California, June 18–July 25, 1980; Louisville, Ky., The J. B. Speed Art Museum, October 6–November 17, 1980; Orlando, Fla., Loch Haven Art Center, January 3–February 15, 1981. Cat. by Paul Cummings.

New York, Phillips Auction House. *Animals and Art.* Pamphlet.

1980
New York, Xavier Fourcade, Inc. *Small Scale: Paintings, Drawings, Sculpture.* January 12–February 23.

Chapel Hill, N.C., Ackland Museum of Art, University of North Carolina. *Some Recent Art from Chicago.* February 2–March 9. Cat. with intro. by Katherine Lee Keefe.

London, Waddington Galleries. *Groups III.* February 5–March 1. Cat.

Urbana, Ill., Krannert Art Museum, University of Illinois. *Selections from the Collection of George M. Irwin.* March 2–April 13. Cat. by Margaret M. Sullivan, foreword by Muriel B. Christison.

New York, Whitney Museum of American Art. *American Painting of the 1960's and 1970's—The Real, the Ideal, the Fantastic: Selections from the Whitney Museum of American Art.* April 3, 1980–May 23, 1981.

Washington, D.C., Vice-President Mondale's Residence. April 9, 1980–Jan. 20, 1981. Cat. by Mary Lou Friedman.

New York, Whitney Museum of American Art. *American Sculpture: Gifts of Howard and Jean Lipman.* April 15–June 15.

Washington, D.C., Middendorf-Lane Gallery. *Tableau: An American Selection.* September 2–October 11.

London, Camden Arts Centre. *Who Chicago?: An Exhibition of Contemporary Imagists.* December 10, 1980–January 25, 1981. Traveled to Sunderland, England, Ceolfrith Gallery, Sunderland Arts Centre, February 16–March 14, 1981; Glasgow, Third Eye Centre, March 21–April 30, 1981; Edinburgh, Scottish National Gallery of Modern Art, May–June 1981; Belfast, Ulster Museum, July–August 1981. Cat. with foreword on Westermann by Dennis Adrian.

1981
Murray, Ky., Clara Engle Gallery, Murray State University. *The Morgan Collection.* March 16–April 14. Cat. with text by Christy Kennard.

Norfolk, Va., The Chrysler Museum. *Crimes of Compassion.* April 16–May 31. Cat. with text by Thomas W. Styron.

Los Angeles, Margo Leavin Gallery. *Sculpture.* June–September.

Boston, Boston Athenaeum Gallery. *Sculpture.* June 3–30.

New York, Xavier Fourcade, Inc. *Sculpture.* July 8–September 17.

Des Moines, Iowa, Des Moines Art Center. *Possibilities for Collectors #3.* July 14–September 1.

Brooklyn, N.Y., Brooklyn Museum. *American Drawings in Black and White.* August 2–September 28.

New York, Whitney Museum of American Art. *Block Prints.* September 9–November 7.

Akron, Ohio, Akron Art Museum. *The Image in American Painting and Sculpture, 1950–1980.* September 12–November 8. Cat. with preface by I. Michael Danoff, intro. by Carolyn Kinder Carr.

Dayton, Ohio, Dayton Art Institute. *Woodworks I: New American Sculpture.* October 21, 1980–February 1, 1981. Cat.

New York, Xavier Fourcade, Inc. *New Sculpture and Watercolors.* October 28–November 28.

New York, Xavier Fourcade, Inc. *One Major New Work Each.* November 4–December 31.

New York, Whitney Museum of American Art. *Drawing Acquisitions, 1978–1981.* December 18, 1981–February 3, 1982. Cat. by Paul Cummings.

Des Moines, Iowa, Des Moines Art Center. *Selections from the Nathan Emory Coffin Collection.* Brochure by James Demetrion.

Houston, University of Houston, Lawndale Annex. *The Image of the House in Contemporary Art.* Cat. by Charmaine Locke.

1982
New York, Pace Gallery. *From Chicago.* January 15–February 13. Cat. with essay by Russell Bowman.

Chicago, Museum of Contemporary Art. *Selections from the Dennis Adrian Collection.* January 30–March 14. Cat. with essay by Dennis Adrian.

Milwaukee, Wis., Milwaukee Art Museum. *American Prints 1960–1980.* February 5–March 21. Cat. with text by Verna Curtis.

New York, Xavier Fourcade, Inc. *Sculpture.* July 8–September 14.

Los Angeles, Margo Leavin Gallery. *Works in Wood.* July 10–September 11.

London, Waddington Galleries. *Sculpture.* September 29–October 23.

Greensboro, N.C., Weatherspoon Art Gallery, University of North Carolina. *The 1982 Weatherspoon Annual Exhibition, Art on Paper . . . Since 1960.* November 14–December 12. Cat. with foreword by Gilbert P. Carpenter.

1983
Sunderland, England, Ceolfrith Gallery, Sunderland Arts Centre. *Drawing in Air: An Exhibition of Sculptors' Drawings, 1882–1982.* July 11–August 20. Traveled to Swansea, England, Glynn Vivian Art Gallery and Museum, September 3–November 5; Leeds, England, City Art Gallery and Henry Moore Study Centre, January 13–February 19, 1984. Cat. ed. by Tony Knipe.

New York, Xavier Fourcade, Inc. *Drawings.* July 12–September 16.

Oxford, Ohio, Miami University Art Museum. *Living with Art, Two: The Collection of Walter and Dawn Clark Netsch.* September 10–December 16. Traveled to Notre Dame, Ind., Snite Museum of Art, University of Notre Dame, January 22–March 25, 1984. Cat. with text by Sterling Cook.

Des Moines, Iowa, Des Moines Art Center. *Director's Choice.* September 13–November 13. Cat.

New York, Whitney Museum of American Art. *The Sculptor as Draftsman.* September 15–November 13.

New York, Rosa Esman Gallery. *Group Show.* October 8–22.

Fullerton, Calif., Visual Arts Center, California State University. *The House That Art Built.* October 28–December 7. Cat. with essays by Dextra Frankel, Jan Butterfield, and Michael Smith.

1984
Palm Springs, Calif., Palm Springs Desert Museum. *Return of the Narrative.* March 17–June 3. Cat. with essays by Katherine Plake Hough and Roberta Arnold Cove.

Chicago, Marshall Field's on State Street. *The Museum of Contemporary Art Selects: Paintings and Sculptures from Chicago's Best.* March 26–April 5. Brochure.

Chicago, Museum of Contemporary Art. *Selections from the Permanent Collection: Ten Years of Collecting.* April 14–June 10. Cat. by Lynne Warren.

Chicago, Museum of Contemporary Art. *Alternative Spaces: A History in Chicago.* June 23–August 19. Cat. with text by Lynne Warren.

New York, Xavier Fourcade, Inc. *Sculpture.* July 10–September 14.

Los Angeles, Margo Leavin Gallery. *American Sculpture.* July 17–Sept. 15.

Los Angeles, Museum of Contemporary Art. *Automobile and Culture.* July 21, 1984–January 6, 1985.

New York, Whitney Museum of American Art. *Print Acquisitions, 1974–1984.* August 29–November 25.

Miami, The Visual Arts Gallery, Florida International University. *The Sculptor as Craftsman.* September 21–October 17.

Oakland, Calif., The Oakland Museum. *The Dilexi Years 1958–1970.* October 13–December 16. Cat. with intro. by Christina Orr-Cahall.

Sacramento, Calif., Crocker Art Museum. *Contemporary American Wood Sculpture.* November 3, 1984–January 6, 1985. Cat. with intro. by Roger Clisby, text by Albert Stewart.

1985
Chicago, The Art Institute of Chicago. *The Mr. and Mrs. Joseph Randall Shapiro Collection.* February 23–April 14. Cat. ed. by Lyn Delli Quadri.

Philadelphia, Philadelphia Art Alliance. *Forms in Wood: American Sculpture of the 1950s.* April 19–May 25.

Chicago, Museum of Contemporary Art. *Selections from the William J. Hokin Collection.* April 20–June 16. Cat. ed. by Terry Ann R. Neff.

Paris, Ecole Nationale Supérieure des Beaux-Arts. Menil Collection, Houston (org.). *Cinquante ans de dessins américains 1930–1980.* May 3–July 13.

Oceanville, N.J., The Noyes Museum. *An Inside Place.* June 2–September 8. Cat. with text by Sid Sachs.

Utica, N.Y., Museum of Art, Munson-Williams-Proctor Institute. *Heart and Soul: Bodily Encounters.* June 29–September 8. Cat. with text by Sarah Clark-Langager.

1986
Fort Lauderdale, Fla., Museum of Art. *An American Renaissance. Painting and Sculpture Since 1940.* January 12–March 30. Cat. with essays by Sam Hunter, Harry F. Gaugh, Robert Morgan, Richard Sarnoff, Malcolm R. Daniel, Karen Koehler, and Kim Levin.

New York, Kent Fine Art, Inc. *Reality Remade.* March 15–April 19. Cat.

Mountainville, N.Y., Storm King Art Center. *Twenty-Nine Sculptures from the Howard and Jean Lipman Collection.* May 21–October 31. Brochure.

Los Angeles, Margo Leavin Gallery. *Sculpture.* September 6–October 4.

1987
New York, Xavier Fourcade, Inc. *Drawings.* January 9–February 7.

Berkeley, Calif., University Art Museum, University of California. *Made in U.S.A.: An Americanization in Modern Art, the '50s and '60s.* April 4–June 21. Traveled to Kansas City, Mo., Nelson-Atkins Museum of Art, July 25–September 6; Richmond, Va., Virginia Museum of Fine Arts, October 7–December 7. Cat. by Sidra Stich.

New York, Kent Fine Art, Inc. *Assemblage.* May 12–July 12. Cat. by Jeanne Marie Wasilik and Susan Harris.

Washington, D.C., National Gallery of Art. *Twentieth-Century Drawings from the Whitney Museum of American Art.* May 21–September 7. Traveled to Cleveland, Ohio, The Cleveland Museum of Art, September 30–November 8; San Francisco, Achenbach Foundation, California Palace of the Legion of Honor, March 5–June 5, 1988; Little Rock, Ark., Arkansas Art Center, June 30–August 28, 1988; Stamford, Conn., Whitney Museum of American Art, Fairfield County, November 17, 1988–January 25, 1989. Cat. by Paul Cummings.

Los Angeles, Margo Leavin Gallery. *Sculpture of the Sixties.* July 11–August 22.

Chicago, Museum of Contemporary Art. *Recent Acquisitions: The Permanent Collection.* August 1–November 3.

New York, Xavier Fourcade, Inc. *In Memory of Xavier Fourcade: A Group Exhibition.* September 11–October 17.

1988
New York, Whitney Museum of American Art, Equitable Center. *Sculpture since the Sixties, from the Permanent Collection of the Whitney Museum of American Art.* August 19, 1988–August 9, 1989. Cat. with essays by Patterson Sims and Susan Lubowsky.

1989
New York, P.P.O.W. *Broken Landscape, Discarded Object.* January 10–February 4.

New York, Lennon, Weinberg, Inc. *Group Exhibition.* January 14–February 25.

New York, Edward Thorp Gallery. *Around the House.* April 8–May 13.

New York, Lennon, Weinberg, Inc. *Painting and Sculpture.* May 2–June 3.

New York, Lennon, Weinberg, Inc. *Works on Paper.* June 13–August 11.

New York, Whitney Museum of American Art. *Art in Place: Fifteen Years of Acquisitions.* July 7–October 29. Cat. with essays by Tom Armstrong and Susan C. Larsen.

Los Angeles, Daniel Weinberg Gallery. *A Decade of American Drawing 1980–1989.* July 15–August 26.

Chicago, Museum of Contemporary Art. *Selections from the Permanent Collection: Promised Gifts.* October 3–November 28.

New York, Phyllis Kind Gallery. *Human Concern/Personal Torment: The Grotesque in American Art Revisited.* October 14–November 8. Traveled to Chicago, Phyllis Kind Gallery, December 1, 1989–January 6, 1990. Cat. with text by Robert Doty.

Washington, D.C., National Building Museum. *Tools as Art: The Hechinger Collection.*

1990
Washington, D.C., National Museum of American Art. *The Boat Show: Fantastic Vessels, Fictional Voyages.* April 7–August 6. Traveled to Portland, Maine, Portland Museum of Art, August 21–October 28.

Chicago, Museum of Contemporary Art. *Toward the Future: Contemporary Art in Context.* May 5–July 1990. Brochure by Lynne Warren.

Milwaukee, Wis., Milwaukee Art Museum. *Word as Image: American Art 1960–1990.* June 15–August 26. Traveled to Oklahoma City, Oklahoma City Art Museum, November 17, 1990–February 2, 1991; Houston, Contemporary Arts Museum, February 23–May 12, 1991. Cat. with essay by Russell Bowman.

New York, Lennon, Weinberg, Inc. *Drawings.* June 28–August 3.

New York, Lennon, Weinberg, Inc. *Group Exhibition of Gallery Artists.* September 6–29.

1991
New York, Lennon, Weinberg, Inc. *Spring Summer Exhibition, Part Two: Sculptors.* June 27–August 2.

New York, Whitney Museum of American Art. *American Life in American Art.* July 11, 1991–January 5, 1992.

Chicago, Museum of Contemporary Art. *Realism, Figurative Painting, and the Chicago Viewpoint: Selections from the Permanent Collection.* July 20–August 27. Brochure by Lynne Warren.

Greensboro, N.C., Weatherspoon Art Gallery, University of North Carolina. *Height x Length x Width: Contemporary Art from the Weatherspoon Collection.* August 18–September 22.

London, Royal Academy of Arts. *Pop Art: An International Perspective.* September 13–December 15. Traveled to Cologne, Germany, Museum Ludwig, January 23–April 19, 1992; Madrid, Museo Nacional Centro de Arte Reina Sofía, June 16–September 14, 1992. Cat. by Marco Livingstone.

1992
Palm Springs, Calif., Palm Springs Desert Museum. *Transforming the Western Image in Twentieth-Century Art.* February 21–April 26. Traveled to Boise, Idaho, Boise Art Museum, May 23–July 12; Tucson, Ariz., Tucson Art Museum, August 7–October 4; Corning, N.Y., The Rockwell Museum, October 25–December 20. Cat. with text by Katherine Plake Hough.

London, Waddington Galleries. *Sculpture.* April 29–May 30. Cat.

East Hampton, N.Y., Renee Fotouhi Fine Art East. *The Book Is Art.* August.

New York, Frumkin/Adams Gallery. *A 40th Anniversary Exhibition: Selections from the Richard Brown Baker Collection.* September–October 10. Brochure.

Los Angeles, Los Angeles County Museum of Art. *Parallel Visions: Modern Artists and Outsider Art.* October 18, 1992–January 3, 1993. Traveled to Madrid, Museo Nacional Centro de Arte Reina Sofía, February 11–May 9, 1993; Basel, Kunsthalle Basel, July 4–August 29, 1993; Tokyo, Setagaya Art Museum, September 30–December 12, 1993. Cat. by Russell Bowman.

New York, Maxwell Davidson Gallery. *Sculpture: Color and Motion.* October 20–November 21.

1993
New York, Lennon, Weinberg, Inc. *Collage and Assemblage.* February 20–March 27.

New York, Lennon, Weinberg, Inc. *Works on Paper by Gallery Artists.* July–September 25.

London, Waddington Galleries. *Works on Paper and Sculpture.* September 8–October 2. Cat.

1994
Chicago, Museum of Contemporary Art. *Toward the Future: Dreaming the MCA's Collection.* April 30–August 28. Cat.

Chapel Hill, N.C., Ackland Museum of Art, University of North Carolina. *Surprises from Storage.* June 5–September 4. Brochure by Timothy Riggs.

New York, Lawrence Markey. *Drawings by Bruce Nauman & H. C. Westermann.* June 14–July 15.

New York, Lennon, Weinberg, Inc. *Truth Be Told: It's All About Love.* June 17–July 29.

New York, Ubu Gallery. *The Box: From Duchamp to Horn.* October 29–December 10.

Davenport, Iowa, Davenport Museum of Art. *Chicago Imagism: A 25-Year Survey.* December 3, 1994–February 12, 1995. Cat. with text by Dennis Adrian.

1995
New York, Lennon, Weinberg, Inc. *Group Exhibition.* September 5–30.

New York, Knoedler Gallery. *American Interiors.* September 9–October 7.

New York, Whitney Museum of American Art. *Altered and Irrational: Selections from the Permanent Collection.* October 12, 1995–January 5, 1996.

1996
New York, Barbara Mathes Gallery. *The House Transformed.* January 12–March 2.

New York, Edward Thorp Gallery. *Epitaphs.* January 12–March 2.

New York, George Adams Gallery. *Out of Toon.* January 19–February 23.

New York, Ubu Gallery. *The Gun: Icon of Twentieth-Century Art.* January 27–March 9.

New York, Gagosian Gallery. *The Human Figure.* February 1–March 2.

New York, The Museum of Modern Art. *Deformations: Aspects of the Modern Grotesque.* February 21–May 21.

Des Moines, Iowa, Des Moines Art Center. *Sculptors Who Paint.* March 3–June 9.

Oceanville, N.J., The Noyes Museum. *Selected American Drawings 1945–1995.* April 7–June 23.

New York, Fotouhi Cramer Gallery. *Box.* May 17–June 22.

Windsor, Conn., Richmond Art Center, Loomis Chaffe School. *In Pursuit of the Invisible, Selections from the Collection of Janice and Mickey Cartin.* May 20–June 15. Cat. with foreword by Mickey Cartin, essay by John Yau.

Milwaukee, Wis., Milwaukee Art Museum. *Landfall Press: Twenty-Five Years of Printmaking.* September 13–November 10. Traveled to Chicago, Chicago Cultural Center, March 15–May 18, 1997; Davenport, Iowa, Davenport Museum of Art, September 14–November 17, 1997; Springfield, Ohio, Springfield Museum of Art, March 13–May 9, 1999. Cat. by Joseph Ruzicka with contributions by Jack Lemon, Vernon Fisher, and Mark Pascale.

Chicago, Museum of Contemporary Art. *Art in Chicago, 1945–1995.* November 16, 1996–March 23, 1997. Cat. ed. by Lynne Warren.

1997
New York, The Museum of Modern Art. *A Singular Vision: Prints from Landfall Press.* February 6–May 6.

New York, A/D Gallery. *Wood Not Wood, Work Not Work.* March 22–May 22.

Washington, D.C., National Building Museum. *Tools as Art II: Exploring Metaphor, The Hechinger Collection.* April 11–September 28.

Munich, Haus der Kunst. *Deep Storage.* August 3–October 12. Traveled to Berlin, Nationalgalerie SMPK, December 1997–January 1998. Düsseldorf, Kunstmuseum Düsseldorf im Ehrenhof, February 1998; Seattle, Henry Art Gallery, fall 1998. Cat. with text by Ingrid Scharleau.

Milwaukee, Wis., Milwaukee Art Museum. *Recent Glass Sculpture: A Union of Ideas.* September 5–November 2.

Lisbon, Centro Cultural de Belém. *The Pop '60s: Transatlantic Crossing.* September 11–November 17. Cat. ed. by Marco Livingstone.

Des Moines, Iowa, Des Moines Art Center. *Art at Work.* September 27, 1997–January 4, 1998.

New York, Ubu Gallery. *The Subverted Object.* October 26, 1997–January 4, 1998.

New York, Achim Moeller Fine Art. *An Exhibition Inspired by Paul Cummings: Drawings, Paintings and Sculpture.* November 20, 1997–January 19, 1998.

1998
Seattle, Meyerson & Nowinski. January 8–March 1.

1999
New York, Whitney Museum of American Art. *The American Century: Art and Culture, 1900–2000.* Part 2, *1950–2000.* September 26, 1999–February 13, 2000. Cat. by Lisa Phillips.

2000
Stamford, Conn., Whitney Museum of American Art, Fairfield County. *Chicago Loop: Imagist Art, 1949–1975.* September 15–November 29.

San Francisco, San Francisco Museum of Modern Art. *Celebrating Modern Art: The Anderson Collection.* October 7, 2000–January 15, 2001.

New York, Sperone Westwater. *American Bricolage.* November 2–December 18.

Houston, Texas Gallery. *Pop & Post Pop (on Paper).* January 23–March 3.

Bibliography

Entries that are solely illustrations include MCA numbers.

ADLOW 1963
Adlow, Dorothy. "Sculptors Explore in New England." *Christian Science Monitor,* July 26, 1963, p. 2F.

ADRIAN 1958
Adrian, Dennis. *H. C. Westermann: Recent Work.* Exh. cat. Chicago: Allan Frumkin Gallery, 1958.

ADRIAN 1963
———. "Some Notes on H. C. Westermann." *Art International* 7, no. 2 (February 1963), pp. 52–55.

ADRIAN 1967
———. "The Art of H. C. Westermann." *Artforum* 6, no. 1 (September 1967), pp. 16–22.

ADRIAN 1974
———. "H. C. Westermann." In *Made in Chicago.* Exh. cat. Washington, D.C.: National Collection of Fine Arts, Smithsonian Institution, 1974.

ADRIAN 1978
———. Unpublished transcript of gallery talk. New York, Whitney Museum of American Art, May 18, 1978.

ADRIAN 1980
———. "Introduction." In *H. C. Westermann.* Exh. cat. London: Serpentine Gallery; Arts Council of Great Britain, 1980.

ADRIAN 1985a
———. "Rummaging Among Twentieth-Century Objects." *Art Journal* 45, no. 4 (winter 1985), pp. 344–49.

ADRIAN 1985b
———. *Sight Out of Mind: Essays and Criticism on Art.* Contemporary American Art Critics, no. 5. Ann Arbor, Mich.: UMI Research Press, 1985.

ADRIAN 1989
———. Review of *Letters from H. C. Westermann,* ed. by Bill Barrette. *International Review* (The Drawing Society) 11, no. 3 (September–October 1989), pp. 62–63.

ADRIAN 1994
———. *Chicago Imagism: A 25-Year Survey.* Exh. cat. Davenport, Iowa: Davenport Museum of Art, 1994.

ADRIAN/BORN 2001
Adrian, Dennis, and Richard Born. *"See America First": The Prints of H. C. Westermann.* Exh. cat. Chicago: The David and Alfred Smart Museum of Art, The University of Chicago, 2001.

ADRIAN/FRIEDMAN 1966
Adrian, Dennis, and Martin Friedman. Unpublished interview with H. C. Westermann. Lowell Hotel, New York, June 28, 1966.

AHLANDER 1972
Ahlander, Leslie Judd. *After Surrealism: Metaphors and Similes.* Exh. cat. Sarasota, Fla.: John and Mable Ringling Museum of Art, 1972.

ALLEN/GUTHRIE 1972
Allen, Jane, and Derek Guthrie. "Improving the Image of the Chicago Imagists." *Chicago Tribune,* May 14, 1972, Art and Fun sec., pp. 3, 18.

ALLEN/GUTHRIE 1973
———. "Chicago Regionalism?" *Studio International* (November 1973), pp. 182–86.

ALLEN/GUTHRIE 1975
———. "The Tradition." *New Art Examiner* (Chicago) 2, no. 5 (February 1975), pp. 1, 4–5, 15.

ALLOWAY 1964
Alloway, Lawrence. "56 Painters and Sculptors." *Art in America* 52, no. 4 (August 1964), p. 60.

ALLOWAY 1972
———. "Art." *The Nation,* July 24, 1972, pp. 60–62.

AMERICAN ART 1996a
"Mysteriously Abandoned New Home" [MCA 37]. *American Art* (spring 1996), inside front cover.

AMERICAN ART 1996b
"Brinkmanship" [MCA 40]. *American Art* (fall 1996), frontispiece.

ANDERSON 1981
Anderson, Alexandra. "Selected Gallery Previews." *Portfolio* 3, no. 6 (November–December 1981), pp. 16–23.

ANDERSON 1975
Anderson, Wayne. *American Sculpture in Process: 1930/1970.* Boston: New York Graphic Society, 1975.

ARTFORUM 1967
"Antimobile" [MCA 132]. *Artforum* 6, no. 1 (September 1967), frontispiece.

ART GALLERY EXHIBITION GUIDE 1981
"Jack of Diamonds" [MCA 323]. *Art Gallery Exhibition Guide* (October 1981), unpag. ill.

ART IN AMERICA 1969
"Provocative Parallels." *Art in America* 57, no. 4 (July–August 1969), pp. 52–55.

ART IN AMERICA 1977
"The Dance of Death, San Pedro." *Art in America* 64, no. 4 (July–August 1977), ill. p. 38.

ART IN AMERICA 1981
"Obituaries: H. C. Westermann." *Art in America* 69, no. 10 (December 1981), p. 192.

ARTNER 1982
———. "MCA Rounds Up Dennis Adrian's 'Maverick' Herd." *Chicago Tribune,* February 7, 1982, Arts & Books sec.

ARTNEWS 1965
"Reviews and Previews." *Artnews* 64, no. 7 (November 1965), p. 58.

ART NOW GALLERY GUIDE INTERNATIONAL 1996
"The Museum of Contemporary Art Inaugurates Lakefront Home." *Art Now Gallery Guide International* (November 1996), pp. 6–7.

ART NOW/NEW YORK 1981
"Jack of Diamonds" [MCA 323]. *Art Now/New York, Gallery Guide* 12, no. 2 (October 1981), ill. p. 53.

ART QUARTERLY 1964
"A Small Negative Thaught" [MCA 67]. *Art Quarterly* 27, no. 3 (1964), ill. p. 391.

ART QUARTERLY 1967
"From the Museum of Shattered Dreams" [MCA 113]. *Art Quarterly* 30, no. 1 (spring 1967), ill. p. 88.

ART QUARTERLY 1969
"This Great Rock Was Buried Once for a Million Years" [MCA 185]. *Art Quarterly* 32, no. 1 (spring 1969), ill. p. 85.

ARTSCRIBE 1978
"Ebb Tide in New York." *Artscribe,* no. 14 (1978), pp. 50–51.

ARTWEEK 1979
"H. C. Westermann." *Artweek* 10, no. 18 (May 5, 1979), p. 20.

ARTWEEK 1997
"Review: H. C. Westermann at the Richmond Art Center and Sidney Gordin at the Berkeley Art Center." *Artweek* 28, no. 11 (November 1997), p. 17.

ASHBERY 1978
Ashbery, John. "Fabergé of Funk." *New York Magazine,* June 19, 1978, p. 63.

ASHTON 1963
Ashton, Dore. "New York Report." *Das Kunstwerk* 17 (December 1963), p. 23.

ATKINS [N.D.]
Atkins, Robert. "It's Playful, It's Ironic, But Is It Art?" In *H. C. Westermann Papers.* Washington, D.C.: Archives of American Art, Smithsonian Institution. Microfilm, 3171:1006.

BAKER 1989
Baker, Kenneth. "Promising Start for New Art Book House." *Review* (April 9, 1989), p. 14.

BAKER 1997
———. "An Indelible Stamp on Western Art." *San Francisco Chronicle,* September 25, 1997, p. C1.

BALDWIN 1978
Baldwin, Nick. "Artist of Paradox." *Des Moines Sunday Register*, November 19, 1978, p. 3B.

BARNES 1996
Barnes, Lucinda. "In the Shadow of Storms: Art of the Postwar Era." In *Collective Vision: Creating a Contemporary Art Museum.* Exh. cat. Chicago: Museum of Contemporary Art, 1996.

BARRETTE 1988
Barrette, Bill, ed. *Letters from H. C. Westermann.* New York: Timken Publishers, 1988.

BARRON 1975
Barron, Mary Lou. "Looking Into Private Spaces." *Artweek* 6, no. 40 (November, 22, 1975), p. 6.

BAUM 1975
Baum, Don. *Made in Chicago: Some Resources.* Exh. cat. Chicago: Museum of Contemporary Art, 1975.

BEAL/PERREAULT 1979
Beal, Graham W. J., and John Perreault. *Wiley Territory.* Exh. cat. Minneapolis: Walker Art Center, 1979.

BELL 1978
Bell, Jane. "Westermann/ Steinberg." *New York Arts Journal,* no. 10 (July 1978), pp. 30–31.

BENET 1997
Benet, Carol. "H. C. Westermann Had the Heart— and the Art For Giving." *Marin Independent Journal,* September 29, 1997.

BERGER 1992
Berger, Maurice, et al. *Eva Hesse: A Retrospective.* Exh. cat. New Haven, Conn.: Yale University Art Gallery, 1992.

BERGGRUEN 1986
Berggruen, John. *Catalogue of Gallery Artists.* San Francisco: John Berggruen Gallery, 1986.

BERKOWITZ 1974
Berkowitz, Marc. "The São Paulo Bienal: 'Changes Must Be Made, Urgently.' " *Artnews* 73, no. 1 (January 1974), pp. 42–44.

BERSTEIN 1998
Berstein, Jennifer. "Joe Wilfer: Collaborations in Paper Printmaking." *Hand Papermaking* 13, no. 1 (summer 1998), pp. 6–13.

BEVLIN 1984
Bevlin, Marjorie Elliott. *Design through Discovery.* New York: Holt Rinehart Winston, 1984.

BLEE 1988
Blee, John. "Soho Eye." *Art/World* (October 20– November 20, 1988), p. 8.

BLOOMFIELD [N.D.]
Bloomfield, Arthur. "Where There's Art, There's Hope." *Examiner* (San Francisco). In *H. C. Westermann Papers.* Washington, D.C.: Archives of American Art, Smithsonian Institution. Microfilm, 3171:1004.

BONESTEEL 1982
Bonesteel, Michael. "Hairy, Scary, Odd, and Daring." *Chicago Reader,* February 12, 1982, sec. 1, p. 34.

BONTEMPS 1989
Bontemps, Alex. "Beach Center Debuts with Winner." *The Virginian-Pilot and Ledger Star,* April 9, 1989, p. G12.

BORDEN 1972
Borden, Lizzie. "Cosmologies." *Artforum* 11, no. 2 (October 1972), pp. 45–50.

BOURDON 1978
Bourdon, David. "H. C. Westermann Sculptures." *Vogue* (U.S.), August 1978, p. 40.

BOWLES 1970
Bowles, J[erry] G. "H. C. Westermann." *Artnews* 69, no. 4 (summer 1970), p. 69.

BOWMAN 1978
Bowman, Russell. "An Interview with Jim Nutt." *Arts Magazine* 52, no. 7 (March 1978), pp. 132–37.

BOWMAN 1985
———. "Words and Images: A Persistent Paradox." *Art Journal* 45, no. 4 (winter 1985), pp. 335–43.

BROOKFIELD JOURNAL 1977
"Gone But Not Forgotten." *Brookfield Journal* (Conn.), April 21, 1977, p. 1.

BROOKFIELD JOURNAL 1998a
"Cross Returns." *Brookfield Journal* (Conn.), June 19, 1998, p. 7.

BROOKFIELD JOURNAL 1998b
"Glimpse of the Past." *Brookfield Journal* (Conn.), May 22, 1998.

BRUCKNER 1984
Bruckner, D. J. R., et al. *Art Against War: 400 Years of Protest in Art.* New York: Abbeville Press, 1984.

BRUGGEN 1988
Bruggen, Coosje van. *Bruce Nauman.* New York: Rizzoli International Publications, 1988.

BRUNETTI 1992
Brunetti, John. "H. C. Westermann." *New Art Examiner* (Chicago) 19, nos. 6–7 (February–March 1992), p. 39.

BURNHAM 1978
Burnham, Jack. *Beyond Modern Sculpture. The Effects of Science and Technology on the Sculpture of This Century.* New York: George Braziller, 1978.

BURR 1980
Burr, James. "Round the Galleries: An Alternative Art." *Apollo* 112 (December 1980), p. 428.

BUSH 1974
Bush, Julia M. *A Decade of Sculpture: The 1960's.* Philadelphia: Art Alliance Presses, 1974.

BUTLER 1957
Butler, Doris Lane. "Group Show's High on Humor, Talent." *Chicago Daily News,* June 28, 1957, p. 47.

BUTLER 1958a
———. "All This Art— and Right Here." *Chicago Daily News,* September 15, 1958, p. 22.

BUTLER 1958b
———. "Newest Art Gallery in an Industrial Loft." *Chicago Daily News,* February 13, 1958, p. 48.

BUTLER 1959
———. "Odd Creations in Wood." *Chicago Daily News,* February 23, 1959, p. 22.

BYER 1987
Byer, Robert H. "Sculpture and Laughter." *Artweek* 18, no. 27 (August 8, 1987), p. 3.

CAMERON 1985
Cameron, Dan. "Judith Linhares Weaves a Spell." *Arts Magazine* 60, no. 4 (December 1985), pp. 76–79.

CAMPBELL 1979
Campbell, R. M. "Westermann Defies Artistic Pigeon Holes." *Seattle Post-Intelligencer,* February 11, 1979, p. G6.

CAMPER 1997
Camper, Fred. "A Hairy Who's Who: *Art in Chicago, 1945–1995* at the Museum of Contemporary Art." *Chicago Reader,* January 10, 1997, sec. 1, pp. 38, 40–41.

CANADAY 1959
Canaday, John. "Art: *New Images of Man.*" *New York Times,* September 30, 1959.

CANADAY 1960
———. "New Talent U.S.A." *Art in America* 48, no. 1 (spring 1960), pp. 22–33.

CANADAY 1963
———. "Shabby Place: Art at the Museum of Natural History." *New York Times,* July 28, 1963.

CANADAY 1972a
———. "Bravo, Well Done, Don't Care, No No, and Bless You All." *New York Times,* January 23, 1972.

CANADAY 1972b
———. "No Need to Man the Barricades." *New York Times,* July 23, 1972, p. D15.

CARROLL 1964
Carroll, Paul. "Here Come the Chicago Monsters." *Chicago Perspective* 13, no. 2 (February 1964), pp. 32–37.

CARVLIN 1959
Carvlin, Thomas. "This Sculptor Gives Us a Grim Peek into Man." *Chicago Daily Tribune,* March 2, 1959, pt. 4, p. 12F.

CAVALIERE 1979
Cavaliere, Barbara. "Enclosure and Concealment." *Arts Magazine* 54, no. 1 (September 1979), pp. 25–26.

CHADWICK 1985
Chadwick, Whitney. "Narrative Imagism and the Figurative Tradition in Northern California Painting." *Art Journal* 45, no. 4 (winter 1985), pp. 309–14.

CHICAGO TRIBUNE 1964
"They Won $3,000 for Their Artists." *Chicago Tribune,* February 28, 1964, p. 2.

CHRISTCHURCH PRESS 1979a
Christchurch Press (New Zealand), September 6, 1979.

CHRISTCHURCH PRESS 1979b
"Home and People." *Christchurch Press* (New Zealand), August 17, 1979.

CLARK 1982
Clark, Orville O., Jr. "Sharing a Medium." *Artweek* 13, no. 26 (August 14, 1982), p. 5.

CLARK 1963
Clark, Robina C., ed. "Westermann Sculpture Exhibited in One-Man Show in New York." *Danbury News Times* (Conn.), October 17, 1963, p. 16.

COFFELT 1968
Coffelt, Elizabeth. "Retrospective Exhibition: Sculpture of H. C. Westermann." *Art Calendar* (Los Angeles) (December 1968–January 1969), pp. 12–17.

COLLIER 1981
Collier, Caroline. "Sam Smith and H. C. Westermann." *Arts Review* (London) 33, no. 1 (January 16, 1981), p. 11.

COPLANS 1963
Coplans, John. "Pop Art U.S.A." *Art in America* 51, no. 5 (October 1963), pp. 26–27.

COPLANS 1964
———. "Higgins, Price, Chamberlain, Bontecou, Westermann." *Artforum* 2, no. 10 (April 1964), pp. 38–40.

COPLEY 1968
Copley, William, ed. "Four facsimile copies of letters from H. C. Westermann to William Copley, June 1968." In *The Letter Edged in Black Press Inc.* Chicago: Public Building Commission of Chicago, 1968–70.

COURIER-JOURNAL AND TIMES 1973
"H. C. Westerman [*sic*] Wins $2,000 Award in São Paulo Show." *Courier-Journal and Times* (Louisville, Ky.), October 28, 1973, p. H18.

CRARY 1981
Crary, Jonathan. "H. C. Westermann." *Flash Art,* no. 105 (December 1981–January 1982), p. 55.

CRICHTON 1975
Crichton, Fenella. "London: H. C. Westermann at Felicity Samuel." *Art International* 19, no. 4 (April 1975), pp. 38–39.

CURTIS 1979
Curtis, Cathy. "Wartime Memories." *The Daily Californian* (Berkeley), May 4, 1979, pp. 21, 24.

DANIELI [N.D.]
Danieli, Fidel. "H. C. Westermann Constructions." In *H. C. Westermann Papers.* Washington, D.C.: Archives of American Art, Smithsonian Institution. Microfilm, 3171:1122.

DANOFF 1982
Danoff, I. Michael. "H. C. Westermann (1922–1981): An Appreciation." *Ohio Arts Dialogue* (January–February 1982), pp. 26–27.

DAVIS 1972
Davis, Douglas. "Monsters of Chicago." *Newsweek,* June 12, 1972, p. 109.

DEMETRION 1987
Demetrion, James. *An Introduction to the Hirshhorn Museum and Sculpture Garden, Smithsonian Institution.* 2nd ed. Washington, D.C.: Smithsonian Institution, 1987.

DES MOINES ART CENTER BULLETIN 1977
"Phantom in a Wooden Garden" [MCA 202]. *Des Moines Art Center Bulletin* (May–June 1977), frontispiece.

DICKERSON 1995
Dickerson, Paul. "Charles Ray." *Bomb* 52 (summer 1995), pp. 42–47.

DOMUS 1964
"54–64, mostra a Londra." *Domus,* no. 419 (October 1964), p. 55.

DONOHOE 1972
Donohoe, Victoria. "H. C. Westermann: Eccentric Blend of Camp, Craftmanship." *Philadelphia Inquirer,* October 29, 1972, p. 8H.

DONOHOE 1978
———. "Art: H. C. Westermann." *Philadelphia Inquirer,* July 9, 1978, p. 18G.

DOTY 1990
Doty, Robert. *Paintspitter: Paintings and Constructions by Robert Warrens.* Exh. cat. New Orleans: New Orleans Museum of Art, 1990.

EAUCLAIRE 1983
Eauclaire, Sally. "Comment: H. C. Westermann." *The Workshop* (summer 1983), pp. 8–9.

ELSEN 1969
Elsen, Albert E. *The Partial Figure in Modern Sculpture from Rodin to 1969.* Exh. cat. Baltimore: Baltimore Museum of Art, 1969.

FABER 1979
Faber, Monika, et al. *Kunst der letzen 30 jahre.* Vienna: Museum Moderner Kunst, 1979.

FARALDI 1981
Faraldi, Caryll. "American Humour." *Observer* (London), January 4, 1981.

FARBER 1959
Farber, Manny. "New Images of (ugh) Man." *Artnews* 58, no. 6 (October 1959), pp. 38–39, 58.

FEAVER 1980
Feaver, William. "Genuine Gilbert & George." *Observer* (London), December 21, 1980.

FINEBERG 1995
Fineberg, Jonathan. *Art Since 1940: Strategies of Being.* Englewood Cliffs, N.J.: Prentice-Hall, 1995.

FLANAGAN 1972
Flanagan, Barbara. "Westermann's Outrageous Quality." *34th St. Magazine* (Philadelphia), November 2, 1972.

FLOOD 1982
Flood, Richard. "H. C. Westermann: 1922–1981." *Artforum* 20, no. 7 (March 1982), p. 4.

FOLDS 1959
Folds, Thomas N. "The New Images of the Chicago Group." *Artnews* 58, no. 6 (October 1959), pp. 40, 52–53.

FORMAN 1972
Forman, Ness. "Artist at His Opening Steps Out of His Art." *Sunday Bulletin* (Philadelphia), November 5, 1972, sec. 1, p. 12.

FRANK 1973
Frank, Peter. "Reviews and Previews: H. C. Westermann." *Artnews* 72, no. 4 (April 1973), p. 81.

FRANKEL 1983
Frankel, Dextra. "The Architecture Within." In *Home Sweet Home: American Domestic Vernacular Architecture.* New York: Rizzoli International Publications, 1983.

FRANKENSTEIN 1962
Frankenstein, Alfred. "Art Assembled from the Scrap Pile." *San Francisco Chronicle,* March 18, 1962, pp. 31–32.

FRANKENSTEIN 1963
———. "Artist's View of Man and His Machines." *San Francisco Chronicle,* January 24, 1963.

FRANKENSTEIN 1971
———. "Satire, Irony, Absurdity in Westermann's Art." *San Francisco Chronicle,* April 9, 1971, pp. 42–43.

FRANKENSTEIN 1979
———. "Comedy of Menace, Humor in Sculpture." *Examiner and Chronicle* (San Francisco), May 20, 1979.

FRIED 1963
Fried, Alexander. "Digging into the Art Mind." *San Francisco Examiner,* January 20, 1963, p. 6.

FRIEDMAN 1966
Friedman, Martin. *Eight Sculptors: The Ambiguous Image.* Exh. cat. Minneapolis: Walker Art Center, 1966.

FRIEDMAN 1967
———. "Carpenter Gothic." *Artnews* 66, no. 1 (March 1967), pp. 30–31, 74–76.

FRIEDMAN 1969
———. *Twentieth-Century Sculpture: Selections from the Collection.* Exh. cat. Minneapolis: Walker Art Center, 1969.

FRISCHMANN 1978
Frischmann, Pat. "H. C. Westermann in Whitney Show." *Brookfield Journal* (Conn.), June 1, 1978.

FRUEH 1978
Frueh, Joanna. "Chicago's Emotional Realists." *Artforum* 17, no. 1 (September 1978), pp. 41–47.

FRUMKIN 1969
Frumkin, Allan. "Westermann in Chicago." *Art Scene* (Chicago) (February 1969), pp. 13–16.

FRUMKIN 1978
Frumkin, Jean. "Westermann Retrospective Opens at the Whitney." *Allan Frumkin Gallery Newsletter* (spring 1978), p. 1.

FRUMKIN 1989
———. "H. C. Westermann Redux." *Frumkin/Adams Gallery Newsletter* (spring 1989), p. 2.

GARVEY 1996
Garvey, Timothy. "Mysteriously Abandoned New Home." *American Art* (spring 1996), pp. 43–63.

GEDO 1982
Gedo, Mary Mathews. "Dennis Adrian Collection." *Arts Magazine* 56, no. 8 (April 1982), p. 9.

GENAUER 1959
Genauer, Emily. "*New Images of Man* 'Most Harrowing' Art Show Opens Today." *New York Herald Tribune,* September 30, 1959.

GLAUBER 1972
Glauber, Robert H. "Chicago Imagist Art: A Careful Look at an Important Show." *Skyline,* June 21, 1972, p. 4.

GLOWEN 1979
Glowen, Ron. "H. C. Westermann Retrospective." *Artweek* 10, no. 7 (February 17, 1979), pp. 1, 16.

GLUECK 1965
Glueck, Grace. "New York Gallery Notes: Allan Frumkin Gallery." *Art in America* 53, no. 6 (December 1965–January 1966), pp. 118–24.

GLUECK 1970
———. "Something for Every Appetite." *Art in America* 58, no. 2 (March–April 1970), pp. 148–152.

GLUECK 1978
———. "Art People." *New York Times,* June 2, 1978, p. C16.

GLUECK 1981
———. "H. C. Westermann, Sculptor, Is Dead." *New York Times,* November 5, 1981, p. D22.

GLUECK [N.D.]
———. "Tamarind: Homage to Lithography." *New York Times.* In *H. C. Westermann Papers.* Washington, D.C.: Archives of American Art, Smithsonian Institution. Microfilm, 3171:1113.

GODDARD 2001
Goddard, Stephen. "A Printable Box by H. C. Westermann." Forthcoming. Cambridge, Mass.: Harvard University Press, 2001.

GOLDBERG 1973
Goldberg, Lenore. "Contemporary Aspects of Primitivism." *Arts Magazine* 47, no. 7 (May–June 1973), pp. 59–63.

GOLLIN 1971
Gollin, J[ane]. "Reviews and Previews: H. C. Westermann." *Artnews* 70, no. 7 (November 1971), p. 84.

GRAND STREET 1998
"Portfolio: H. C. W." *Grand Street* 65 (summer 1998), pp. 80–85.

GREEN 1971
Green, Denise. "In the Galleries: H. C. Westermann." *Arts Magazine* 46, no. 2 (November 1971), p. 62.

GREEN 1982
Green, Lois Wagner. "Emphasizing Art: A San Francisco Setting Created for a Unique Collection." *Architectural Digest* 39, no. 7 (July 1982), pp. 34, 38–47.

GUSWILER 1968
Guswiler, Mert. "Metals, Woods Shaped to Art." *Herald-Examiner* (Los Angeles), November 28, 1968.

HALSTEAD 1968
Halstead, Whitney. "Chicago." *Artforum* 7, no. 2 (October 1968), pp. 69–70.

HALSTEAD 1975
———. "Fantasy and Self-Expression Among Our City's Artists." *Chicago Sun-Times,* January 5, 1975, pp. 1, 6.

HAMILL 1995
Hamill, Pete. *Tools as Art: The Hechinger Collection.* New York: Harry N. Abrams, 1995.

HANSON 1982
Hanson, Henry. "A Man of Modest Means." *Chicago Magazine,* January 1982, pp. 116, 159.

HASKELL 1978
Haskell, Barbara. *H. C. Westermann.* Exh. cat. New York: Whitney Museum of American Art, 1978.

HAYDON 1973
Haydon, Harold. "Time Trials for Art 'Olympics'?" *Chicago Sun-Times,* May 31, 1973, sec. 2, p. 2.

HAYDON 1975
———. "Two Shows Based on Local Styles." *Chicago Sun-Times,* January 26, 1975.

HAYDON 1979
———. "A Guide to the Art: An Extraordinary Range of Treasures in Institutions Big and Small." *Portfolio* 1, no. 1 (April–May 1979), pp. 118, 120–22.

H. C. WESTERMANN PAPERS
H. C. Westermann Papers, ca. 1925–1982. Washington, D.C.: Archives of American Art, Smithsonian Institution. Microfilm, 3170–73.

HIRSHHORN COLLECTS 1997
The Hirshhorn Collects. Washington, D.C.: Hirshhorn Museum and Sculpture Garden, Smithsonian Institution, 1997.

HIRSHHORN MUSEUM AND SCULPTURE GARDEN CALENDAR 1985
"Acquisitions." *Hirshhorn Museum and Sculpture Garden Calendar* (Washington, D.C.) (fall 1985), unpag. ill.

HOBHOUSE 1970
Hobhouse, J[anet]. "In the Galleries: H. C. Westermann." *Arts Magazine* 44, no. 8 (summer 1970), p. 68.

HOENE 1966
Hoene, A[nne]. "In the Galleries: H. C. Westermann." *Arts Magazine* 40, no.3 (January 1966), p. 57.

HOFFMANN 1966
Hoffmann, Donald. "Of Native Soil: Westermann's Works." *Kansas City Star* (Mo.), October 16, 1966.

HOFFMANN 1967
———. "Headless Painting Stirs Sculptor." *Kansas City Times* (Mo.), February 23, 1967, pp. 1D, 6D.

HOFFMANN 1982
———. "H. C. Westermann: On Life's Fragility." *Kansas City Star* (Mo.), January 10, 1982, p. 3D.

HOLG 1997
Holg, Garrett. "Art in Chicago, 1945–1995." *Artnews* 96, no. 4 (April 1997), p. 137.

HOLG 1998
———. "Joanna Beall." *Artnews* 97, no. 2 (February 1999), p. 118.

HOLLAND 1958
Holland, Frank. "Frumkin Exhibits Advanced Show." *Chicago Sun-Times,* August 3, 1958, sec. 3, p. 6.

HOLLAND 1959
———. "What Is It? Art, Architecture or Aberration, You've Got to Admit It's Different." *Chicago Sun-Times,* February 22, 1959, sec. 3, p. 10.

HOLLAND [N.D.]
———. "Outdoor Fair Season Starts Sunday." *Chicago Sun-Times.* In *H. C. Westermann Papers.* Washington, D.C.: Archives of American Art, Smithsonian Institution. Microfilm, 3171:1087.

HOPPS 1996
Hopps, Walter. *Edward Kienholz: 1954–1962.* Exh. cat. Houston: Menil Foundation, Inc., 1996.

HUGHES 1972
Hughes, Robert. "Midwestern Eccentricities." *Time,* June 12, 1972, pp. 58–60.

HUGHES 1978
———. "Westermann's Witty Sculptures." *Time,* June 19, 1978, p. 52.

HUNTER/JACOBUS 1973
Hunter, Sam, and John Jacobus. *American Art of the Twentieth Century.* New York: Harry N. Abrams, 1973.

JANUSZCZAK 1980a
Januszczak, Waldemar. "Chicago Defies You to Like Its Art." *Arts Guardian* (London), December 17, 1980, p. 10.

JANUSZCZAK 1980b
———. "Serpentine Gallery." *Burlington Magazine* 122, no. 933 (December 1980).

JENSEN 1984
Jensen, Dean. "Chicago Art Welcome in Its Own Home." *Milwaukee Sentinel,* July 13, 1984, pp. 3, 21.

JOHNSON 1988
Johnson, Ken. "H. C. Westermann at Lennon, Weinberg." *Art in America* 76, no. 12 (December 1988), pp. 150–51.

JOHNSON 1998
———. "H. C. Westermann." *New York Times,* March 20, 1998.

JOHNSON 1999
———. "Works on Paper." *New York Times,* March 5, 1999, p. B42.

JUDD 1963
Judd, D[onald]. "In the Galleries: H. C. Westermann." *Arts Magazine* 38, no. 1 (October 1963), pp. 57–58.

JUDD 1965
———. "To Encourage Sculpture: The Howard and Jean Lipman Collection." In *Contemporary Sculpture,* pp. 176–79. Arts Yearbook 8. New York: Art Digest, Inc., 1965.

KAHMEN 1971
Kahmen, Volker. *Erotic Art Today.* Greenwich, Conn.: New York Graphic Society, 1971.

KANSAS CITY STAR 1966
"Art Notes." *Kansas City Star* (Mo.), November 20, 1966, p. 11G.

KASS 1989
Kass, Ray. "H. C. Westermann." *Artforum* 27, no. 6 (February 1989), p. 132.

KELLY 1978
Kelly, Caitlin. "Flirting with the Artistically Morbid." *Toronto Globe,* July 15, 1978.

KESSLER 1989
Kessler, Jane, et al. *Made in America.* Exh. cat. Virginia Beach, Va.: Virginia Beach Center for the Arts, 1989.

KIMBALL 1992
Kimball, Roger. "Pop Art Then and Now." *National Review* (March 2, 1992), pp. 52–54.

KIND 1964
Kind, Joshua. "Sphinx of the Plains: A Chicago Visual Idiom." *Chicago Review* 18, nos. 55–56 (1964), pp. 38–55.

KING 1997
King, David. *H. C. Westermann: West.* Exh. cat. Richmond, Calif.: Richmond Art Center, 1997.

KINGSLEY 1978
Kingsley, April. "Narrating Life's Existential Fuck-Up." *Village Voice,* May 22, 1978, pp. 42–43.

KLEIN 1998
Klein, Michael. "Ingenious Simplicity: The Sculpture of H. C. Westermann." *Sculpture* 17, no. 5 (May–June 1998), pp. 52–57.

KOZLOFF 1964
Kozloff, Max. "Art: The Chicago Scene I." *The Nation,* April 6, 1964, pp. 352–54.

KOZLOFF 1965
———. "The Further Adventures of American Sculpture." *Arts Magazine* 39, no. 5 (February 1965), pp. 24–31.

KOZLOFF 1968
———. *H. C. Westermann.* Exh. cat. Los Angeles: Los Angeles County Museum of Art, 1968.

KOZLOFF 1972
———. "Inwardness: Chicago Art Since 1945." *Artforum* 11, no. 2 (October 1972), pp. 51–55.

KOZLOFF 1973
———. "Junk Mail: An Affluent Art Movement." *Art Journal* 33, no. 1 (fall 1973), pp. 27–31.

KRAMER 1967
Kramer, Hilton. "A Nostalgia for the Future." *New York Times,* May 7, 1967, p. D23.

KRAMER 1976
———. "Our Venice Offering: More a Syllabus than a Show." *New York Times,* May 2, 1976, p. 29.

KRAMER 1981
———. "H. C. Westermann." *New York Times,* November 13, 1981.

KRANTZ 1977
Krantz, Leslie J., ed. *The Chicago Art Review.* Chicago: The Krantz Co., 1977.

KRANTZ 1989
———. *The Chicago Art Review.* Chicago: The Krantz Co., 1989.

KUH 1959
Kuh, Katherine. "Disturbing Are These 'New Images of Man.'" *Saturday Review* (October 24, 1959), pp. 48–49.

KUH 1960
———. "New Talent USA." *Art in America* 48, no. 1 (spring 1960), pp. 23–32, 58.

KULTERMANN 1968
Kultermann, Udo. *The New Sculpture: Environments and Assemblages.* New York: Frederick A. Praeger, 1968.

KUNSTWERK 1964
"Pop Art Diskussion." *Das Kunstwerk* 17 (April 1964), p. 24.

KUNSTWERK 1976a
"Battle of Little Jack's Creek" [MCA 191]. *Das Kunstwerk* 29 (November 1976), ill. p. 22.

KUNSTWERK 1976b
"Pig House" [MCA 233]. *Das Kunstwerk* 29 (September 1976), ill. p. 30.

KUSPIT 1976
Kuspit, Donald. "Regionalism Reconsidered." *Art in America* 64, no. 4 (July–August 1976), pp. 64–69.

KUSPIT 1979
———. "H. C. Westermann: Braving the Absurd." *Art in America* 67, no. 1 (January–February 1979), pp. 84–85.

LANES 1959
Lanes, Jerrold. "Brief Treatise on Surplus Value or, The Man Who Wasn't There." *Arts Magazine* 34, no. 2 (November 1959), pp. 28–35.

LANYON 1980
Lanyon, Ellen. "Seven by Nine Times Two." *Art Journal* 41, no. 2 (summer 1980), pp. 276–78.

LARSEN 1986
Larsen, S. C. "Michael McMillen." *Arts Magazine* 61, no. 4 (December 1986), p. 109.

LARSON 1981
Larson, Kay. "Sculpting Figuratively." *New York Magazine,* November 16, 1981, pp. 120–23.

LAWRENCE 1979
Lawrence, Sidney. "New Directions for Art." *Pittsburgh Press Roto,* November 25, 1979, p. 38.

LEADERMAN 1977
Leaderman, Pamela. "Contemporary Sculpture." *Midwest Art* (Milwaukee, Wis.), summer 1977, p. 7.

LEVIN 1981
Levin, Kim. "An Opinionated Survey of the Week's Events, November 11–17." *Village Voice,* November 11, 1981.

LEVIN 1988
———. "Art: H. C. Westermann." *Village Voice,* November 1, 1988, p. 50.

LEWIS 1973
Lewis, Jo Ann. "Chicago Artists and Their World." *Christian Science Monitor,* June 15, 1973, p. 14.

LEWIS/YAO 1978
Lewis, Charles A., and Cynthia Yao. *Chicago: The City and Its Artists, 1945–1978.* Exh. cat. Ann Arbor, Mich.: University of Michigan Museum of Art, 1978.

LIPPARD 1966a
Lippard, Lucy R. "Eccentric Abstraction." *Art International* 10, no. 9 (November 1966), pp. 28, 34–40.

LIPPARD 1966b
———. "New York Letter: Recent Sculpture as Escape." *Art International* 10, no. 2 (February 1966), pp. 48–58.

LOS ANGELES COUNTY MUSEUM OF ART MEMBERS' CALENDAR 1968
"Rosebud" [MCA 85]. *Los Angeles County Museum of Art Members' Calendar* (1968), ill. p. 3.

LOS ANGELES HERALD-EXAMINER 1967
"Antimobile" [MCA 132]. *Los Angeles Herald-Examiner,* April 26, 1967, Women's World sec., ill. p. D2.

LOS ANGELES TIMES 1981
"Artist Carved New Territory with Humor, Craftsmanship." *Los Angeles Times,* November 9, 1981.

LUBELL 1979
Lubell, Ellen. "Enclosure and Concealment, Whitney Museum–Downtown Branch." *Soho Weekly News,* May 16, 1979.

LUCIE-SMITH 1981
Lucie-Smith, Edward. "London Letter: Chicago Artists." *Art International* 24, nos. 7–8 (March–April 1981), pp. 128–31.

LYNCH 1996
Lynch, Kevin. "'Sincerely Cliff.'" *The Capital Times* (Madison, Wis.), December 18, 1996, Life Style sec., pp. 1D, 6D.

LYON 1984a
Lyon, Christopher. "For Chicago Artists, the Price of Recognition May Be the Loss of a Unique Self Sufficiency." *Chicago Magazine,* May 1984, pp. 156–69, 196.

LYON 1984b
———. "Surrealism Sets Tone of MCA Retrospective." *Chicago Sun-Times,* May 13, 1984, p. 22.

MAHSUN 1981
Mahsun, Carol Anne Runyon. "Pop Art and the Critics." Ph.D. diss., University of Chicago, 1981.

MARKS 1991
Marks, Claude, ed. *World Artists, 1980–1990.* New York: H. W. Wilson Co., 1991.

MARTER 1994
Marter, Joan. "Recollections of *New Images of Man.*" *Art Journal* 53, no. 4 (winter 1994), p. 65.

MARTIN 1976
Martin, Henry. "The 37th Venice Biennale: The Show's the Thing." *Art International* 20, nos. 7–8 (September–October 1976), pp. 14–24, 59.

MARTIN 1978
Martin, Marcelle. "La Scene." *New Orleans Times-Picayune,* August 26, 1978, sec. 5, p. 2.

MARVEL 1972
Marvel, Bill. "Stubborn Chicagoans Still Deal with Humanity." *National Observer,* June 24, 1972.

MARZORATI 1978
Marzorati, Gerald. "H. C. Westermann: Built to Last." *Soho Weekly News,* May 25, 1978, pp. 23–24.

MARZORATI 1981
———. "Art Picks: H. C. Westermann." *Soho News,* November 10, 1981.

MARZORATI 1982
———. "H. C. Westermann, 1922–1981." *Portfolio* 4, no. 1 (January–February 1982), pp. 54–55, 57.

MCCARTHY 1996
McCarthy, David. "H. C. Westermann's *Brinkmanship.*" *American Art* (fall 1996), pp. 50–69.

MCCRACKEN 1991
McCracken, David. "Gallery Scene: H. C. Westermann." *Chicago Tribune,* November 29, 1991, sec. 7, p. 76.

MCDANIEL 1972
McDaniel, Charles-Gene. "Art Is Possible in Chicago." *The Progressive* (September 1972), pp. 46–47.

MCKENNA 1989
McKenna, Kristine. "In the Galleries: Santa Monica." *Los Angeles Times,* June 9, 1989, sec. 4, p. 61.

MCNAUGHT 1984
McNaught, William. "H. C. Westermann." *Archives of American Art Journal* 24, no. 2 (1984), pp. 34–35.

MEILACH 1968
Meilach, Dona Z. *Contemporary Art with Wood: Creative Techniques and Appreciation.* London: George Allen and Unwin Ltd., 1968.

MEILACH/HOOR 1973
Meilach, Dona Z., and Elvie Ten Hoor. *Collage and Assemblage, Trends and Techniques.* New York: Crown Publishers, 1973.

MELCHER 1978
Melcher, Victoria Kirsch. "Artist Keeps Fear of Death at Bay." *Kansas City Star* (Mo.), December 24, 1978.

MELVILLE 1964
Melville, Robert. "Prospect for the Future." *Architectural Review* (London), no. 136 (August 1964), pp. 135–36.

MERKLING 1978a
Merkling, Frank. "Westermann: Colorful Past, Colorful Present." *News-Times* (Danbury, Conn.), June 27, 1978.

MERKLING 1978b
——. "Whitney Retrospective: A Worldly Innocence." *News-Times* (Danbury, Conn.), June 27, 1978.

MILLIER 1968
Millier, Arthur. "Ferus Gallery Abstracts Plus Surrealist Sculptures." *Herald-Examiner* (Los Angeles), December 1, 1968.

MOGELON/ LALIBERTÉ 1981
Mogelon, Alex, and Norman Laliberté. *Art in Boxes.* New York: Van Nostrand Reinhold Co., 1981.

MORGAN 1982
Morgan, Ann Lee. "A Chicago Letter." *Art International* 25, nos. 9–10 (November–December 1982), pp. 70–72.

MOSS [N.D.]
Moss, Stacey. "Westermann: Relentlessly Obsessive." *Times* (Palo Alto, Calif.). In *H. C. Westermann Papers.* Washington, D.C.: Archives of American Art, Smithsonian Institution. Microfilm, 3171;1007.

MUCHNIC 1979
Muchnic, Suzanne. "Art News." *Los Angeles Times,* April 15, 1979, Calendar sec., p. 87.

MUCHNIC 1981
——. "A Fitting Memorial for a Tough-Minded Artist." *Los Angeles Times,* November 30, 1981, pp. 1, 4.

NAHAS 2000
Nahas, Dominique. "H. C. Westermann: Death Ships." *Review* 5, no. 10 (February 15, 2000), pp. 24–25.

NATIONAL OBSERVER 1971
"Tamarind Revives the Art and Prestige of Prints." *National Observer,* August 9, 1971.

NAYLOR 1989
Naylor, Colin. *Contemporary Artists.* Chicago: St. James Press, 1989.

N'DIGO 1994
"Op Ed: Fred Wilson." *N'Digo,* April 28, 1994.

NEFF 1984
Neff, Terry Ann R., ed. *In the Mind's Eye: Dada and Surrealism.* Exh. cat. Chicago: Museum of Contemporary Art, 1984.

NEW ART EXAMINER 1996
"Mad House" [MCA 36]. *New Art Examiner* (Chicago) 23, no. 9 (May 1996), cover.

NEWSLETTER A 1982
"A New Piece of Land" [MCA 242]. *Newsletter A* (Alumni Association, The School of The Art Institute of Chicago), 1982, frontispiece.

NEWS-TIMES 1981
"Well-Known Artist Dies at 58." *News-Times* (Danbury, Conn.), November 5, 1981, p. 14

NEWSWEEK 1981
"Transition [obituary]." *Newsweek,* November 16, 1981, p. 125.

NEW YORKER 1978
"Whitney Museum." *New Yorker,* June 26, 1978, p. 9.

NEW YORKER 2000
"H. C. Westermann." *New Yorker,* March 6, 2000, p. 17.

NEW YORK TIMES 1974
"Walnut Death Ship in a Chestnut Box" [MCA 253]. In Hans Rosenhaupt, "The No-Holes-in-the Shoes Blues." *New York Times,* November 24, 1974.

NEW YORK TIMES 1975
"The Dance of Death, San Pedro." In A. J. Langguth, "Carnival in Brazil." *New York Times,* February 10, 1975.

NORDLAND 1963
Nordland, Gerald. "Pop Goes the West." *Arts Magazine* 37, no. 5 (February 1963), pp. 60–61.

NORDLAND 1964
——. "Collecting in Los Angeles." *Artforum* 2, no. 12 (summer 1964), pp. 12–18.

NUZUM 1962
Nuzum, Thomas. "Paris Takes a Look at Chicago's Art." *Chicago Tribune,* March 25, 1962.

OBEJAS 1998
Obejas, Achy. "Take Me to Your Leader?" *Chicago Tribune,* May 27, 1998, sec. 5, p. 1.

OHFF 1981
Ohff, Heinz. "H. C. Westermann, Sam Smith." *Das Kunstwerk* 34, no. 2 (1981), p. 68.

OSBORNE 1981
Osborne, Harold, ed. *The Oxford Companion to Twentieth-Century Art.* Oxford: Oxford University Press, 1981.

PACKER 1980
Packer, William. "A Joke Is a Joke." *Financial Times* (London), December 22, 1980.

PATTON 1980
Patton, Phil. "Craftsmanship and Humor in New Wood Sculpture." *Horizon* (January 1980), pp. 51–57.

PATTON 1982
——. "H. C. Westermann: Exit Laughing." *Artnews* 81, no. 1 (January 1982), p. 165.

PERLMUTTER 1975
Perlmutter, Elizabeth Frank. "Reviews: H. C. Westermann." *Artnews* 74, no. 1 (January 1975), p. 106.

PERREAULT 1973a
Perreault, John. "Dream Machinery." *Village Voice,* March 22, 1973, pp. 29–30.

PERREAULT 1973b
——. "H. C. Westermann [transcript of lecture given at MCA Gallery]." *Moore College of Art Journal* (Philadelphia) 1 (winter 1973), pp. 6–8.

PERREAULT 1974
——. "A Cliff in the Woods." *Village Voice,* December 9, 1974, p. 100.

PERREAULT 1978
——. "An Artist's Artist." *Soho Weekly News,* May 25, 1978, pp. 24, 26.

PERREAULT 1982
——. "Second City, Second Thoughts." *Soho News,* February 16, 1982, p. 56.

PFEIFFER 1971
Pfeiffer, Gunter. "H. C. Westermann." *Das Kunstwerk* 24 (March 1971), pp. 115–16.

PHAIDON 1973
Phaidon Dictionary of Twentieth-Century Art. London: Phaidon Press, 1973, pp. 408–09.

PLESSIX 1964
Plessix, Francine Du. "William Copley, the Artist as Collector." *Art in America* 52, no. 6 (December 1964–January 1965), p. 75.

PRESTON 1961
Preston, Stuart. "Twentieth Century Sense and Sensibility." *New York Times,* May 7, 1961, p. X13.

PRICE 1997
Price, Mark. "Interview with Roger Brown." *Sculpture* 16, no. 7 (September 1997), pp. 38–43.

RATCLIFF 1970
Ratcliff, Carter. "New York Letter." *Art International* 14, no. 7 (September 1970), pp. 90–96.

RATCLIFF 1971
——. "New York Letter." *Art International* 15, no. 10 (December 1971), pp. 52–61.

RATCLIFF 1976
——. "Notes on Small Sculpture." *Artforum* 14, no. 8 (April 1976), pp. 35–42.

RATCLIFF 1984
——. "Art: Boxes of Mystery." *Architectural Digest* (August 1984), pp. 112–17.

RAYNOR 1984
Raynor, Vivien. "Sculpture." *New York Times,* August 3, 1984, p. C21.

RAYNOR 1985
——. "A Critic's Guide to Art Beyond the City Limits." *New York Times,* August 2, 1985, pp. C1, C20.

REGAN 1984
Regan, Kate. "Wry Mix of Death and Comedy." *San Francisco Chronicle,* November 3, 1984.

REICHERT 2000
Reichert, Herbert. "H. C. Westermann: Death Ship." *Review* 5, no. 10 (February 15, 2000), pp. 9–13.

RHEM 1997
Rhem, James. "Visual Art: Desolation Row." *Isthmus* (Madison, Wis.), January 3, 1997, p. 13.

RICHARD 1972
Richard, Paul. "Non-Arty Art of Chicago." *Washington Post,* May 17, 1972, p. C13.

RICHARDSON 1971
Richardson, Brenda. "Reports: Bay Area." *Arts Magazine* 45, no. 7 (May 1971), p. 47.

RIGGS 1994
Riggs, Timothy. "Surprises from Storage." *Ackland Quarterly* (Chapel Hill, N.C.) 41 (summer 1994), frontispiece, p. 3.

ROBINSON 1984
Robinson, John. "Group Show." *Arts Magazine* 59, no. 2 (October 1984), p. 36.

ROCKFORD REGISTER STAR 1956
"Versatile Chicago Sculptor Exhibits Work at College." *Rockford Register Star* (Ill.), October 30, 1956.

ROOKS 1997
Rooks, Michael. *Robert Barnes.* Exh. cat. Glen Ellyn, Ill.: Gahlberg Gallery, College of DuPage, 1997.

ROSE 1963
Rose, Barbara. "New York Letter." *Art International* 7, no. 9 (December 1963), pp. 61–65.

ROSENBERG 1972
Rosenberg, Harold. "The Art World: Place, Patriotism, and the New York Mainstream." *New Yorker,* July 1, 1972, pp. 52–57.

ROUKES 1980
Roukes, Nicholas. *Masters of Wood Sculpture.* New York: Watson-Guptill Publishers, 1980.

ROUKES 1988
——. *Design Synectics: Stimulating Creativity in Design.* Worcester, Mass.: Davis Publications, 1988.

ROUKES 1997
——. *Humor in Art: A Celebration of Visual Wit.* Worcester, Mass.: Davis Publications, 1997.

RUBINSTEIN 2000
Rubinstein, Raphael. "Westermann's Death Ships." *Art in America* 88, no. 5 (May 2000), pp. 140–43.

RUSSELL 1974
Russell, John. "Art: H. C. Westermann." *New York Times,* November 2, 1974.

RUSSELL 1978
———. "Art: Moral Sculptures." *New York Times,* May 19, 1978, p. C17.

RUSSELL 1982
———. "'The Hairy Who' and Other Messages from Chicago." *New York Times,* January 31, 1982, Gallery View.

RUSSELL 1983
———. "Art: Show of Drawings at Xavier Fourcade." *New York Times,* July 29, 1983, p. C20.

RUZICKA 2000
Ruzicka, Joseph. "H. C. Westermann: Death Ship." *Art on Paper* 4, no. 5 (May–June 2000), pp. 83–84.

SANDLER 1961
Sandler, I[rving]. "H. C. Westermann." *Artnews* 60, no. 3 (May 1961), p. 14.

SAN FRANCISCO EXAMINER AND CHRONICLE 1971
"Phantom in a Wooden Garden" [MCA 202]. *San Francisco Examiner and Chronicle,* April 4, 1971, This World sec., ill. p. 43.

SAN FRANCISCO EXAMINER AND CHRONICLE 1979a
"Antimobile" [MCA 132]. *San Francisco Examiner and Chronicle,* April 22, 1979, Datebook sec., ill. p. 10.

SAN FRANCISCO EXAMINER AND CHRONICLE 1979b
"Mad House" [MCA 36]. *San Francisco Examiner and Chronicle,* May 6, 1979, ill. p. 59.

SAWIN 1961
Sawin, Martica. "H. C. Westermann." *Arts Magazine* 35, nos. 8–9 (May–June 1961), p. 86.

SCHACK 1979
Schack, Katherine Von. "H. C. Westermann." *Vanguard* (Vancouver, B.C.), April 1979, p. 31.

SCHJELDAHL 1976a
Schjeldahl, Peter. "A Brief Account of 'Chicago-Type' Art." *Art in America* 64, no. 4 (July–August 1976), p. 55.

SCHJELDAHL 1976b
———. "Letter from Chicago." *Art in America* 64, no. 4 (July–August 1976), pp. 52–58.

SCHJELDAHL 1981
———. "Crimes of the Heartland." *Village Voice,* December 1, 1981, p. 88.

SCHLESINGER 1984
Schlesinger, Ellen. "Giving Primacy to Wood." *Artweek* 15, no. 44 (December 22, 1984), p. 3.

SCHNEDLER 1973
Schnedler, Jack. "Look Out, Brazil! It's the Hairy Who." *Chicago Daily News,* June 2–3, 1973.

SCHULZE 1959
Schulze, Franz. "Art News from Chicago." *Artnews* 57, no. 10 (February 1959), pp. 49, 56.

SCHULZE 1960
———. "Art News from Chicago." *Artnews* 59, no. 4 (summer 1960), p. 53.

SCHULZE 1962
———. "Art News from Chicago." *Artnews* 61, no. 8 (December 1962), p. 24.

SCHULZE 1964
———. "Good Show, Splendid Concept." *Chicago Daily News,* 1964, Panorama, p. 3.

SCHULZE 1966
———. "Chicago Popcycle." *Art in America* 54, no. 6 (November–December 1966), pp. 102–104.

SCHULZE 1967
———. "Chicago." *Art International* 11, no. 5 (May 1967), pp. 41–44.

SCHULZE 1969
———. "Inside that Huge Tarpaulin, There's Something Better." *Chicago Daily News,* February 1, 1969.

SCHULZE 1971a
———. "Art News in Chicago." *Artnews* 70, no. 7 (November 1971), pp. 45–55.

SCHULZE 1971b
———. "The Making of a Fantasy." *Chicago Daily News,* February 20–21, 1971, Panorama, p. 9.

SCHULZE 1972a
———. *Fantastic Images: Chicago Art Since 1945.* Chicago: Follett Publishing Co., 1972.

SCHULZE 1972b
———. "Let Plato's Heaven Wait; Chicago Art Is Alive and Defiant." *Chicago Daily News,* May 6–7, 1972, Panorama.

SCHULZE 1973a
———. "H. C. Westermann at Allan Frumkin." *Art in America* 61, no. 5 (September–October 1973), p. 122.

SCHULZE 1973b
———. "Yes, That's Chi Funk in São Paulo." *Chicago Daily News,* October 1973.

SCHULZE 1974
———. "'The Chicago Style': One of the More Original Urban Accents." *Artnews* 73, no. 1 (January 1974), p. 43.

SCHULZE 1975
———. "The Prodigal Funk." *Chicago Daily News,* January 11–12, 1975, pp. 2, 4.

SCHULZE 1976
———. "Art, 20 Years Ago and Today." *Chicago Daily News,* December 4–5, 1976, Panorama, p. 14.

SCHULZE 1978
———. *Paul Wieghardt, 1897–1969.* Exh. cat. Chicago: The Art Institute of Chicago, 1978.

SCHULZE 1979a
———. "The Art Scene." *Portfolio* 1, no. 1 (April–May 1979), pp. 114–18.

SCHULZE 1979b
———. "Chicago: Bigger and Livelier But. . . ." *Artnews* 78, no. 2 (February 1979), pp. 40–45.

SCHULZE 1983
———. "Made in Chicago: A Revisionary View." *Art in America* 71, no. 3 (March 1983), pp. 122–28.

SCHWARTZ 1972
Schwartz, Barbara. "Letter from New York." *Craft Horizons* 32 (April 1972), p. 58.

SCHWARTZ 1973
———. "New York." *Craft Horizons* 33 (August 1973), p. 28.

SCOTT 1978
Scott, Martha B. "H. C. Westermann's Fascinating Contradiction of Order, Mystery." *Sunday Post* (Bridgeport, Conn.), July 2, 1978, p. F7.

SELDIS 1962
Seldis, Henry J. "Dry Wit Imbues Westerman [sic] Parodies." *Los Angeles Times,* December 14, 1962, p. 9.

SELDIS 1964
———. "'New American Sculpture' on View." *Los Angeles Times,* February 16, 1967, p. 3.

SELDIS 1967
———. "Newness Theme of Sculpture Exhibit." *Los Angeles Times,* April 28, 1967, pt. 5, p. 4.

SELDIS 1974
———. "Art Walk: A Critical Guide to the Galleries." *Los Angeles Times,* March 29, 1974, pt. 4, p. 8.

SELZ 1985a
Selz, Peter. *Art in a Turbulent Era.* Ann Arbor, Mich.: UMI Research Press, 1985.

SELZ 1985b
———. "Surrealism and the Chicago Imagists of the 1950's: A Comparison and Contrast." *Art Journal* 45, no. 4 (winter 1985), pp. 303–306.

SENIE 1978
Senie, Harriet. "Up from the Caves." *New York Post,* June 3, 1978.

SENTINEL USA 1984
"H. C. Westermann." *Sentinel USA,* November 8, 1984, p. 13.

SHEFFIELD 1996
Sheffield, Margaret. "H. C. Westermann." *Review* (September 15, 1996), p. 23.

SHEPHERD 1979
Shepherd, Michael. "Chicago, Chicago. . . ." *Arts Review* (London) 31, no. 12 (June 22, 1979), p. 315.

SHEPHERD 1980
———. "Much Gladness." *Sunday Telegraph* (London), December 14, 1980.

SHEPHERD 1981
———. "Chicago Type." *Sunday Telegraph* (London), January 4, 1981.

SHIN BIJU TSU SHIN 1997
"Memorial to the Idea of Man if He Was an Idea" [MCA 38]. *The Shin Biju Tsu Shin* (New York), September 4, 1997, p. 3.

SHINN 1982
Shinn, Dorothy. "Images Rooted in Primitive Culture." *Beacon Journal* (Akron, Ohio), January 21, 1982.

SHIREY 1973
Shirey, David L. "12 Artists, First Since '67, Chosen for the São Paulo Biennial." *New York Times,* May 24, 1973, p. 53:2.

SIMS 1985
Sims, Patterson. *Selected Works from the Permanent Collection.* New York: Whitney Museum of American Art, 1985.

SMITH 1992
Smith, Roberta. "Long Island Shows: Small, Closely Focused and Odd: East Hampton." *New York Times,* August 21, 1992, p. C22.

SMITH 1994
———. "A Few Drawings from Nauman and Westermann." *New York Times,* July 1, 1994, p. C20.

SMITH 1996
———. "A Neo-Surrealist Show with a Revisionist Agenda." *New York Times,* January 12, 1996.

SMITH 2000
———. "H. C. Westermann: Death Ship." *New York Times,* February 18, 2000, p. E44.

SOLOMON/
ANDERSON 1988
Solomon, Holly, and
Alexandra Anderson. *Living
with Art.* New York:
Rizzoli International
Publications, 1988.

SPEYER 1956
Speyer, A. James. "Art News
from Chicago." *Artnews* 56,
no. 4 (summer 1956), p. 66.

STAFFORD 1998
Stafford, Amy. "H. C. Wes-
termann." *New Art Examiner*
(Chicago) 25, no. 6 (March
1998), p. 57.

STAUDEK 1998
Staudek, Tom. "WWW Pop
Art Index." http://www.fi.
muni.cz/~toms/PopArt/
contents.html. ISO 8859 11
(searched June 19, 1998).

STEVENS 1973
Stevens, Anne. "Behind
the Turquoise and Fuschia
Facade: São Paulo." *New Art
Examiner* (Chicago) 1, no. 1
(October 1973), pp. 3, 8.

STICH 1987
Stich, Sidra. *Made in U.S.A.:
An Americanization in
Modern Art, the '50s and
'60s.* Exh. cat. Berkeley,
Calif.: University of
California Press, 1987.

STORR 1994
Storr, Robert. *Jim Nutt.* Exh.
cat. Milwaukee: Milwaukee
Art Museum, 1994.

STORR 1999
———. *Jim Nutt: Portraits.*
Exh. cat. Chicago: Museum
of Contemporary Art, 1999.

STUMBO 1975
Stumbo, Bella. "Lonely
Couples: The Times When
Being Together Just Isn't
Enough." *San Francisco
Examiner and Chronicle,*
May 18, 1975, p. 7.

SUNDAY POST 1978
"H. C. Westermann's
Fascination: Contradiction
of Order, Mystery." *Sunday
Post* (Bridgeport, Conn.),
July 2, 1978, p. F7.

SWENSON 1963
Swenson, G. R. "H. C. Wes-
termann." *Artnews* 62,
no. 6 (October 1963), p. 12.

TALLMER 1968
Tallmer, Jerry. "Bengston
and Westermann." *Arts
Magazine* 43, no. 3 (December
1968–January 1969), p. 56.

TALLMER 1978
———. "Knock on Wood
Bottle Caps." *New York Post,*
June 3, 1978, p. 18.

TAMARIND 1989
Tamarind Lithography
Workshop. *Catalogue
Raisonné: Tamarind
Lithography Workshop, Inc.,
1960–1970.* Albuquerque:
University of New Mexico
Art Museum, 1989.

TARSHIS 1979
Tarshis, Jerome. "Sculpted
Fate." *Christian Science
Monitor,* August 28, 1979,
Home Forum sec., p. 24.

TAYLOR 1980
Taylor, John Russell.
"Feeling of a Performance
Glimpsed." *Times* (London),
December 9, 1980.

TAYLOR 1987
Taylor, Sue. "Westermann
Cages Wartime Demons."
Chicago Sun-Times, April 2,
1987, p. 62.

TAYLOR 1988
———. *Don Baum: Domus.*
Exh. cat. Madison, Wis.:
Madison Art Center, 1988.

TERBELL 1968
Terbell, Melinda. "In the
Museums: Bengston and
Westermann." *Arts Magazine*
43, no. 3 (December 1968–
January 1969), p. 56.

TERBELL 1974
———. "Bad Dreams."
Artnews 73, no. 5 (May 1974),
p. 48.

THOMPSON 1978
Thompson, Jennifer.
"Westermann's Sculptures
Show Skill, Sense of Humor."
Greenwich Times (Conn.),
June 7, 1978.

TIME 1964
"Sculpture: Era of the
Object." *Time,* December 11,
1964, pp. 84–85.

TIME 1965
"H. C. Westermann." *Time,*
November 19, 1965.

TIME 1968
"Fishhooks in the Memory."
Time, December 20, 1968,
pp. 66–69.

TOBLER 1999
Tobler, Jay, ed. *The American
Art Book.* Harrisburg, Pa.:
Phaidon Press, 1999.

TONGEREN 1978
Tongeren, Herk Van.
"H. C. Westermann."
Sculptor's News Exchange 11,
no. 10 (June 1978), unpag.

TONO 1960
Tono, Yoshiaki. "From a
Gulliver's Point of View."
Art in America 48, no. 2
(June 1960), pp. 54–59.

TRIER 1954
Trier, Marilyn Robb.
"Art News from Chicago."
Artnews 53, no. 5
(September 1954), p. 45.

TUCKER 1976
Tucker, Marcia, et al. *Critical
Perspectives in American
Art.* Exh. cat. Amherst,
Mass.: Fine Arts Center
Gallery, University of
Massachusetts, 1976.

TURNER 1983
Turner, Evan H. *The Ackland
Art Museum: A Handbook.*
Chapel Hill, N.C.: The
Ackland Art Museum, 1983.

TUTEN 1967
Tuten, F[rederick]. "H. C.
Westermann." *Arts Magazine*
41, no. 6 (April 1967), p. 60.

UNIVERSITY OF CHICAGO
MAGAZINE 1971
"Whatnots." *University of
Chicago Magazine*
(November 1971), pp. 32–33.

VAIZEY 1980
Vaizey, Marina. "The Yankee
Doodles." *Sunday Times*
(London), December 28, 1980.

WADDINGTON 1997
Waddington Galleries,
London. *American Art: A
Selection from Waddington
Galleries.* London:
Waddington Galleries, 1997.

WASSERMAN 1971
Wasserman, Emily. "New
York: H. C. Westermann."
Artforum 10, no. 4 (December
1971), pp. 81–82.

WEBER 1964
Weber, John. "Boxes."
Art in America 52, no. 3
(June 1964), pp. 98–102.

WEBSTER 1997
Webster, Mary Hull. " H. C.
Westermann at the Richmond
Art Center and Sidney
Gordin at the Berkeley Art
Center." *Artweek* 28, no. 11
(November 1997), pp. 17–18.

WEIGLE 1960
Weigle, Edith. "But—Is
It Art?" *Chicago Tribune,*
November 6, 1960.

WEISS 1982
Weiss, Hedy. "Dennis
Adrian's Collection: A Trib-
ute to the Art of Aggression."
New Art Examiner (Chicago)
9, no. 6 (April 1982), p. 10.

WELLER 1968
Weller, Allen S. *The Joys and
Sorrows of Recent American
Art.* Urbana, Ill.: University
of Illinois Press, 1968.

WESTART 1968
"Westermann Retrospective."
Westart (Rocklin, Calif.),
December 6, 1968.

WESTFALL 1989
Westfall, Stephen.
"Reviews: H. C. Westermann."
Flash Art, no. 145 (March–
April 1989), p. 116.

WILKINSON 2000
Wilkinson, Jeanne C. "H. C.
Westermann at Lennon,
Weinberg." *Art International*
3, no. 2 (fall 2000), p. 37.

WILLIS 1968
Willis, Thomas. "At Ravinia,
Art By Native (?) Sons."
Chicago Tribune, June 30,
1968, sec. 5.

WILLIS 1969
———. "Westermann's Art
Unreal but Honest." *Chicago
Tribune,* January 31, 1969.

WILSON 1968
Wilson, William. "Works of
Westermann at the County
Museum." *Los Angeles Times,*
December 8, 1968, Calendar
sec., p. 34.

WILSON 1970
———. "Should N.Y. Road-
show Have Stopped Here?"
Los Angeles Times, June 21,
1970, Calendar sec., p. 58.

WILSON 1978
———. "Bird's-Eye View of
Vignettes in the Urban
Landscape." *Los Angeles
Times,* July 2, 1978, p. 80.

WINTERTHUR
PORTFOLIO 1982
"Im Goin' Home on the
Midnight Train" [MCA 255].
Winterthur Portfolio 17,
no. 4 (winter 1982), ill. p. 201.

WOODWORK 1998
"Strong Man's Chair"
[MCA 207]. *Woodwork,*
February 1998, ill. p. 2.

YALKUT 1981
Yalkut, Jud. "Woodworks I:
'New American Sculpture.' "
*Dialogue: The Ohio Arts
Journal* (March–April 1981),
pp. 4 5.

YOOD 1993
Yood, James. "Sculptural
Assets." *New Art Examiner*
(Chicago) 20, no. 9 (May
1993), pp. 29–31.

ZEITZ 2000
Zeitz, Lisa. "Westermann's
Todesschiffe." *Kunstmarkt*
(Leipzig), February 26, 2000,
p. 54.

ZIMMER 1985
Zimmer, William. "Enigmatic
Interiors at Noyes." *New York
Times,* August 25, 1985, p. 20.

ZUCKER 1978
Zucker, Barbara. "H. C.
Westermann." *Artnews* 77,
no. 6 (September 1978),
pp. 170–71.